The Six-Gun Mystique Sequel

The Six-Gun Mystique Sequel

John G. Cawelti

Bowling Green State University Popular Press
Bowling Green, OH 43403

Copyright 1999 © Bowling Green State University Popular Press

Library of Congress Cataloging-in-Publication Data
Cawelti, John G.
 The six-gun mystique sequel / John G. Cawelti.
 p. cm.
 Includes bibliographical references.
 ISBN 0-87972-785-3- (clothbound)
 ISBN 0-87972-786-1 (pbk.)
 1. West (U.S.) -- In mass media. 2. Western stories -- History and criti-
cism. 3. Western films -- History and criticism. I. Title.
 P96.W48 C393 1999
 700'.4278--dc21 98-47399
 CIP

Cover design by Dumm Art

Once again, to Katie

And to Ray and Pat Browne

CONTENTS

FOREWORD

In his excellent study *Westerns: Aspects of Movie Genre* (1977), Philip French kindly referred to the original edition of *The Six-Gun Mystique* as an "elegant monograph." This revised and expanded edition might well make my readers ask whether it was wise to inflate the work, whose best virtue was undoubtedly its brevity, into something more resembling another full-length book. After all, I did revise the original 1970 monograph in 1984 without adding substantially to its length.

However, as I approached the task of what would no doubt be the final revision of this work, nearly thirty years after the original publication, I felt that I should either do the job thoroughly or not at all. For one thing, there were substantial portions of the original which now read to me like the punishing of dying if not dead horses. That clearly needed to be cut out. In addition, so much excellent and thoughtful critical work on the Western has appeared in recent decades that I wanted to acknowledge some of the other studies that influenced and changed my own understanding of the genre. Most significantly, the rich creativity of Western films and novels has continued to outrun the best efforts of critics to define and place the genre. I felt that to do any justice to the further development of the genre required not only a reexamination of what I had originally done, but a thorough recasting of the purpose and scope of *The Six-Gun Mystique*.

Thus, I beg the reader's indulgence for adding to the amount of material I am setting before her/him, and fondly hope that there will be enough new insights to justify the expansion.

This book is a compound of work done on and off between 1970 and the present along with a sizeable amount of new attempts to reexamine the central issues and to replace the least insightful of my earlier observations. What began in 1970 was partly revised in 1984 and has now been completely recast. Most of what survives of the original appears in chapter two as the analysis of the Western's major formal elements, most of which seemed still valid to me. From that point I add two chapters dealing with the history of the Western and a final chapter five that reexamines some of the central critical issues and critics connected with the genre. Some of this material comes from the 1984 revision and some from essays I have published since that time, but all of it has been

reviewed and rewritten. In some cases I found myself coming to conclusions almost antithetical to those I originally stated.

The bibliographies and filmographies have also been changed and revised.

I have incurred innumerable obligations, and more delightfully, developed many friendships over the now nearly thirty years I have worked off and on with the Western. I have acknowledged many of these in the text, but I will happily take advantage of this opportunity to list some of those who have been so helpful to me.

Art Wrobel, Armando Prats, David Durant, Greg Waller, Steve Weisenburger, Walt Foreman, Kervin Kiernan, J. A. Bryant, Jr., Jonathan Allison, Ellen Rosenman, Larry Swingle, Bill Campbell, Joan Hartwig, John Clubbe, Joan Blythe, Joe Gardner, Dana Nelson, Tom Blues, Michael Green, Theda Perdue, Ray Betts, David Hamilton, William Freehling, Michael Marsden, Gary Yoggy, Jack Nachbar, Ray Merlock, Steve Tatum, A. Robert Lee, Herb Dieterich, Mort Ross, John Gerber, Alexander Kern, Richard Etulain, Sam Girgus, Delbert Wylder, Stuart Kaminsky, Horace Newcomb, Frances M. Nevins, Jr., J. Dudley Andrew, Richard Slotkin, Janel Mueller, Thomas Schatz, Walter Blair, Gerhard Hoffmann, Gunnar Hallingberg, Virginia Wexman, Bruce Rosenberg, Peter Homans, William Veeder, Gene Gressley, Robert Hemenway, Sheldon Sacks, Elder Olsen, Gwin Kolb, Wayne Booth, Edward Rosenheim, Jr., Ronald S. Crane, Julia Bettinotti, Wil Verhoeven, Denis Saint-Jacques, Paul Bleton, Elsebeth Hurup, Jan Bakker and innumerable students at the University of Kentucky, the University of Chicago, and several other universities where I have taught.

Barbara Bernstein assisted me with the original edition, particularly in the compilation of the filmographies. Caren Mulford Slagel helped with this revised edition. I'm also indebted to Armando Prats for suggestions about the image of Native Americans and for reading and comment on much of this draft. Art Wrobel also cast his superb editorial eye over much of the manuscript at various stages and Walt Foreman helped with scanning filmographies for me.

Earlier versions of parts of the text appeared in *Adventure, Mystery and Romance*. University of Chicago Press, 1976 and in the *Journal of Popular Culture*. Chapter Four on "The Post-Western" appeared in the Spring 1998 issue of *Paradoxa*. The editor of that journal, Dave Willingham, did a wonderful job of editing that chapter for its appearance in *Paradoxa* and I have largely adopted his version.

The original edition of this book was dedicated to Norman Maclean who was for many years my colleage and friend at the University of Chicago. He seemed the "ultimate Westerner" to me and one of the great

experiences of my life was co-teaching a course on Western literature with him. Norman has gone to his last roundup, though not without becoming a major Western writer himself with his two wonderful books, *A River Runs through It* and *Young Men and Fire.* I like to think that he would have liked this book and that something of his sense of the West is in it.

I owe a great debt to the staff of the English department of the University of Kentucky who have over the years typed manuscripts, rescued me from all sorts of mechanical disasters, and helped with funding and other administative matters. I'd especially like to express my continuing gratitude to Pat Current and Lucy Combs.

The second edition was dedicated to my wife, Mary Catherine Flannery, who has continued to be the most important person in my life, and I rededicate this edition to her.

Ray and Pat Browne brought this book into existence nearly thirty years ago and they have nursed it along ever since. I would like to add them to the dedication of this third and doubtless final edition of *The Six-Gun Mystique.*

1

THE SIX-GUN MYSTIQUE

Who of my generation can ever forget bolting dinner and rushing to the radio to hear the opening bars of Rossini's *William Tell Overture* followed by the thundering hoofbeats of the great horse Silver? Three times a week, year in and year out, the Lone Ranger rode the radio networks from station WXYZ in Detroit. Those of us who were true addicts came to know every conceivable regularity and variation within the halfhour program format. To this day, though it has been nearly 60 years since I last heard the great cry "Hiyo Silver," on my parents' Philco radio, I can still remember the shape of the program. I believe I could state almost to a minute the time that elapsed between the opening and the first gunshot, a time that varied little from year to year. In fact, during the several years of my regular listening to the masked man's exploits, I can remember few exceptions in the basic pattern of the program. Everything was precisely worked out from the opening introduction to the last dying away of the Lone Ranger's voice as he, Silver and Tonto rode away after bringing law and justice into the life of still another western community. Even a change in commercials became a noticeable and almost disturbing event in this grand stylized parade from beginning, through middle, to end. The compelling thing about it was not so much the particular content of any of the episodes—I have long since forgotten what happened on any particular program and doubt that I even paid much attention to it at the time—but the vigorous clarity and the dynamic but somehow reassuring regularity of the form itself.

I was hardly alone in my enthusiasm for the Western, for few twentieth century Americans and probably few Europeans need to have the Western's importance as a cultural form demonstrated. Innumerable Westerns mark the course of American history. To get some statistical picture of the form's significance, let us take the period of the late 1950s, when the Western's popularity was at one of its major peaks. Expressed in terms of numbers of booktitles published, Westerns constituted 10.76% of the works of fiction published in 1958 and 1.76% of all books published. In 1959 eight of the top ten shows on television, as measured by Neilsen ratings, were Westerns and 30 of the primetime shows were horse operas. At least 54 Western feature films were made in 1958.

Some falling off in quantity and in popularity occurred in the course of the 1960s. In 1967, Westerns constituted 7.08% of published works of fiction and .74% of the total book production. During a typical week of TV (Saturday, September 16, to Friday, September 22, 1967) eighteen hours of Westerns were screened on Chicago's four major stations between the hours of six and ten in the evening, comprising approximately 16% of the total viewing time. And, in the same year Hollywood turned out approximately 37 major Western features.

After a brief decline, the Western received a new lease on life through the popularity of the "Spaghetti Westerns" filmed largely in Spain by the Italian director Sergio Leone. These films were an international version of the genre and they created a new type of hero, most notably embodied in the Man with No Name enacted by Clint Eastwood in *A Fistful of Dollars* (1964) and recreated in two further Leone movies. The new themes and style of Leone's Westerns inspired a surge of Western production that led to the films of the American director Sam Peckinpah, perhaps with the exception of Clint Eastwood, the last of the great Hollywood masters of the Western film. Beginning in 1970, the Western began a long decline that was accelerated by the disastrous failure of Michael Cimino's *Heaven's Gate* in 1980. Since then, though there have been brief flurries of Western production and a few great successes like *Dances with Wolves* and Eastwood's own *Unforgiven,* the Western no longer occupies the central position in the system of popular genres that it held throughout most of the twentieth century.

Though there were important predecessors, we can begin the history of the modern Western with Owen Wister's novel *The Virginian.* A best seller in 1902-03, it has accumulated total sales of many millions. Zane Grey, Wister's successor as the most popular author of Westerns, occupied the bestseller lists continuously from 1917-1925. Louis L'Amour, Grey's successor as the poet laureate of Westerns has, if anything, exceeded Grey's sales figures to become one of the best-selling authors of all time. It is significant, however, that since L'Amour's death in 1988 no author of Westerns has successfully claimed his mantle. L'Amour may well be the last of the major popular Western novelists.

The Western movie was a basic commodity of the American film industry from 1903, when Porter's *The Great Train Robbery* demonstrated the Western's immense potential for exciting cinematic action to around 1970 when the Western film began its accelerating decline. Hundreds of Western movies were turned out during the silent era by such stars as Bronco Billy Anderson, Tom Mix, and William S. Hart, and from the late thirties to the early sixties, the production of major Western features rarely fell below 50 each year.

Along with movies, during the 1930s and 1940s the pulp Western magazine was a major industry. In 1945, 30 Western adventure pulps and 6 Western love magazines were published regularly. By 1968 this number had fallen off precipitously to 9 Western magazines, many of which specialized in popular history rather than in romantic adventure. During the 1950s, television had largely replaced the pulp magazines. However, during the 1970s the television Western also went into eclipse insofar as new productions were concerned. Innumerable reruns of older Western films and television programs still fill the airwaves, testifying if nothing else to the nostalgic attachment Americans have to old Westerns. However, despite occasional one shot remakes of long running series like *Gunsmoke* and *Bonanza*, and a few successful new mini-series, mostly based on Larry McMurtry's *Lonesome Dove* and its sequels and prequels, the television Western has virtually disappeared. Only one recent series has lasted for more than a season as of this writing (1998), and it is only by extending the definition that one can call that series, *Dr. Quinn, Medicine Woman*, a Western.

Westerns will no doubt continue to be an important aspect of American culture. Established Western authors like Owen Wister, Zane Grey, Ernest Haycox, Jack Schaefer and Louis L'Amour still find many readers, and new western adventure novelists will appear. There will doubtless be occasional revivals of the Western film, in the wake of highly successful individual films using Western materials. However, by 1997, the Western had been largely displaced as the popular genre representing the crucial American myths. Richard Slotkin suggested in 1992 that "we require a myth that can help us make sense of the history we have lived and the place we are living in" (*Gunfighter Nation* 655) and that the Western no longer does this for us.

I

Though we need to understand the Western in terms of its expression of American myths, it was first and foremost a kind of story. Thus, to begin to understand its power and significance, we must first define the narrative patterns that gave Westerns their recognizable and distinctive shape. When it first appeared in 1970, *The Six-Gun Mystique* was primarily an attempt to define what sort of characters, actions, settings and themes made the Western into a recognizable popular genre. The book grew out of the then new scholarly development of popular culture studies. It was published, as it still is, by the Popular Press of Bowling Green State University under the editorship of Ray and Pat Browne, who have done more to facilitate the development of popular culture studies than anyone else.

Rereading the 1970 text of this book, my strongest impression is the degree to which the book was an exercise in structuralism, though at the time I was hardly familiar with the structuralist critical theories that became so important in the 1970s. My own critical background was the New Criticism and to an even greater extent the neo-Aristotelianism of the University of Chicago which inspired my version of structural analysis. The connection between New Criticism, neo-Aristotelianism and structuralism was that all three critical methods tended toward a radical decontexualizing of the literary text. It was this approach, which, applied to popular culture in the 1960s, brought about a dramatic transformation in popular culture studies. The structuralist method involved an insistence on the relative artistic and cultural autonomy of popular genres in opposition to the earlier tendency of intellectuals to see popular culture as little more than the degradation of traditional cultural forms through the impact of industrialized mass production and commercialization. The new scholars of popular culture insisted on the validity of popular forms as artistic expression and attempted to formulate the concept of a popular aesthetic which would validate the artistic significance of popular works in their own right. As I put it in 1970 in *The Six-Gun Mystique* "works of art, whether popular or elite, highbrow or lowbrow . . . are governed first by their own laws and secondarily and indirectly by social and psychological dynamics." This orientation led to the development of a variety of new and more complex techniques for analyzing the distinctive structures, symbolism and narrative methods of popular works and a de-emphasis on the relationship between these works and the societies and cultures which produced them.

This was a critical strategy, which, as it turned out, I shared with many other students of popular culture and I think that it was at the time a very fruitful one. In the case of the Western, it certainly led to a great richness of scholarly and critical analysis of the generic tradition, of individual writers and directors, and of different sub-genres.

II

Critical theory and cultural studies have greatly expanded since 1970, however, and though I think that the structuralist approach can still generate valuable studies it is clearly time for a more complex recontextualizing of popular culture. In fact, several recent studies have attempted to do just that with various analyses of the Western in relationship to the cultural context of the evolving American myth of the frontier (Slotkin), gender (Tompkins, Davis and Mitchell) and modernization (Klein). Though *The Six-Gun Mystique* talked about the need for exploring the Western in its social and cultural context, one weakness of the

book was its failure to indicate how the more complex version of the Western formula defined by structuralist analysis might lead to a fuller contextualization of the genre. In the 1984 second edition of *The Six-Gun Mystique,* I attempted to rectify that oversight by briefly exploring some of the major contexts in which I had come to feel the Western needed to be (re)placed.

However, that revision was only a partial one and for this third, and doubtless final, revision of the book, I have decided to rethink my analysis completely and to treat the historical and cultural contexts of the genre much more fully.

First of all, it seems to me that the first *Six-Gun Mystique* largely failed to deal with the relationship between the Western and images and conceptions of regional and national identity. This has seemed increasingly important to me as an aspect of both the American and the international significance of the Western. Of all the major popular genres, the Western most seemed to express some sense of the uniqueness of the American experience and of the imagined exceptionalism of America. Other popular genres like the detective story, the spy story, the romance, the gothic, have their American versions but aside from the Western, perhaps only the gangster saga is uniquely American and that, too, has of late taken on an increasingly international flavoring as in the two sequels to *The Godfather.* But the Western, even when made in Italy or Spain, or enacted in theme parks in Germany or quick-draw clubs in France, retains its deep connection with the American West. One recent example of the kind of study I have in mind is Richard Slotkin's analysis of the myth of the frontier, which brilliantly analyzes the relationship between the Western and an evolving sense of American identity.

However, even Slotkin does not deal very much with the regional aspect of the Western, particularly in the later nineteenth and twentieth centuries, and this is clearly an area of great importance. It is the presence of the West as a major American region that has always been one of the central defining factors of our national identity, but the way this region has been defined and the characteristics ascribed to it have undergone considerable change in the course of our history. For example, up until World War II, the American West was above all associated with future possibilities, though at the same time, there was a strong element of nostalgia for the bygone era of the Wild West. Since 1945, however, the West has become increasingly symbolic of traditional American rugged individualism, the values more associated with Eastern business men in the twenties, for example. Connecting this ethos to the heroism of cowboys and the Wild West was a symbolic posture which Theodore Roosevelt helped create, but which Barry Goldwater exploited and

Ronald Reagan rode to the presidency. Since American heroic images of this kind were mainly distributed through the Western genre, late twentieth-century politicians, both liberal and conservative have made tremendous use of Western images and styles. Ronald Reagan responded to Kennedy's "New Frontier" with cowboy hats, a ranch near Santa Barbara and Clint Eastwood's "make my day."

The West as region is mentioned in almost every significant discussion of the Western hero as archetypal American or of the Western landscape as a uniquely American setting, but the various American visions of the distinctive moral, cultural and geographical landscape of the West still await sustained and systematic analysis. Recent historians have rightly tended to emphasize other factors such as race, urbanization, immigration, and industrialization as shaping factors of American culture. However, it seems to me time for students of American culture to revitalize the analysis of regional symbolism in American culture which once flourished in such works as Taylor's *Cavalier and Yankee,* Henry Nash Smith's *Virgin Land,* or Constance Rouke's studies in American humor.

I suspect that the decline of the Western reflects our growing uncertainty about American uniqueness and about the special place of the West in establishing that uniqueness. This erosion of the Western genre is clearly connected to the increasing abandonment of the Turner thesis and other concepts of American exceptionalism which have so long dominated the historical imagination of Americans. Realizing that these long-standing myths of the West, and along with them the Western as a popular genre, are being increasingly relegated to history brings to mind another major weakness of the original *Six-Gun Mystique*. In general, I failed to recognize the Western as a time and culture bound historical production. By emphasizing the archetypal nature of the Western (as a good modernist critic should have) I was largely ignoring the importance of the Western as an evolving and changing expression of different stages of American cultural history. I tried to rectify this somewhat in my discussion of the Western in *Adventure, Mystery and Romance*. In addition, other scholars like Will Wright, Jon Tuska, John Lenihan, Kevin Brownlow and many others have dealt with particular phases of the history of the Western, greatly enriching our sense of its development over time.

By far the most comprehensive and definitive analysis of the evolution of the myth of the West is to be found in Richard Slotkin's important trilogy. The first volume of Slotkin's study, *Regeneration through Violence* appeared in 1973, defining his initial conception of the myth of the West and tracing its emergence in the New World and its develop-

ment up until the mid-nineteenth century. The second volume, *The Fatal Environment* (1985) followed transformations in the myth of the West as it was reshaped by the industrial society of the later nineteenth century using frontier symbolism to glorify the destruction of "savagery" and the revitalization of "civilization" in the New World. Now the rhetoric of the frontier was adapted to the war between capital and labor, and to the explanation and justification of the rise of classes and class conflict, including race conflict in an ostensibly democratic society. *Gunfighter Nation* (1992) brought Slotkin's analysis up to the present and emphasized the adaptation of the myth of the West to the justification of America's position as a global power. In this volume Slotkin showed how the explanation of Cold War confrontations and third world imperialism became a third and final phase in the evolution of the myth of the frontier. Any future studies of the developing meaning of the myth of the West and the Western over the course of American history must depend upon and respond to Slotkin's great accomplishment. However, Slotkin only partly addresses several different cultural contexts that other scholars have begun to examine. One is the area of gender, which has already inspired Jane Tompkins in *West of Everything* and Lee Clark Mitchell in *Westerns*. Second, there is the significance of the Western as an arena for the interplay of conflicting value systems. Actually I suggested this in *The Six-Gun Mystique,* but failed to systematically pursue it. Slotkin hints at this aspect of the evolution of the Western in his discussion of "progressive" and "populist" styles of Western (*Gunfighter Nation* 125-230) suggesting that, throughout its history, the Western embodied alternative visions of America in narratives which sought to synthesize differing ideas of the American future. Finally, the recent period, in which the Western seems to be declining as a myth of America and a mass entertainment, but still serves as a residual reservoir of political rhetoric and symbolism, needs further analysis.

The *Six-Gun Mystique*'s usefulness over its twenty-five year history would seem to have resulted from its emphasis on the artistic autonomy of the genre and from its paradigmatic analysis of the Western's structure as a particular kind of story in a particular symbolic setting. This is still an important consideration, but it is now clearly time to put the Western back in its complex historical and cultural context. I have tried to indicate some of the ways in which that might be done in this revised edition. I hope it will help a younger generation of scholars to further enrich our understanding of the myth of the West and its significance in American cultural history.

III

I'll conclude this opening chapter with a note on definition and ter-
minology which will, I hope clear up some of the apparent inconsisten-
cies with which some of the central terms of this study are used. In
particular, the terms **myth, genre,** and **formula,** problematic enough to
begin with, develop complexities of their own when the adjective "West-
ern" is append to them. When I first wrote this book, I was particularly
influenced by the term **formula,** which I had originally thought to sub-
stitute for genre and myth. To me, **formula** meant a well-known, often
repeated, narrative pattern and I was hoping to use this term to bypass
the more complex artistic meanings of **genre** and the kind of cultural and
archetypal meanings associated with **myth**. This turned out to be impos-
sible and I found myself needing the other terms as well. In the end, the
idea of formula became almost, though not entirely, redundant which
was a good thing since most other scholars refused to use the term
because it implied something negative and stereotypical about Western
novels and films. I still find myself occasionally drawn to use the term
formula to describe the sort of low-level patterns of character, episode
and theme associated with the Western, but not as a single formulaic pat-
tern which can define the genre.

By **genre** I mean the body of texts which a culturally knowledge-
able person would call Westerns, and whatever patterns of narrative,
theme, historical development and artistic achievement that body of texts
implies. I realize that "knowledgeable person" is not very illuminating,
but there doesn't seem to be any other way of describing those with the
competence to decide whether a particular text is or is not a Western.
Needless to say, I would fully acknowledge that "knowledgeable per-
sons" will often differ as to whether a particular marginal or new work
really is a Western. Is *Dr. Quinn, Medicine Woman,* a Western, for exam-
ple, or is *Lonely Are the Brave*? But these discussions can be very inter-
esting and I would argue that there would be little doubt among
"knowledgeable persons" about the great majority of generic Westerns.

Myth is a term richly imbedded in our intellectual culture in so
many ways that it is impossible to deal with it in a brief paragraph.
Indeed, it may be impossible to define it at all. In general, I find it useful
to differentiate between the Western genre as a group of specific texts,
and the myth or myths of the West, which are important cultural themes
or ideas embedded in stories or fragments of stories. For example, the
"Vanishing American" is a Western myth that can be used as the main
narrative line of a particular Western, such as Zane Grey's *The Vanishing
American* or the recent movie *Dances with Wolves,* or as a subplot within
a Western or simply as an image used in a specific Western. Within the

genre of the Western, there is, in fact, a subgenre of Vanishing American stories, but in addition, the myth of the Vanishing American is almost invariably present whenever the Indian appears as a character within the genre. For my purposes, I don't make much use of the important differentiations scholars have made between ancient and modern myths, or between myths as aspects of oral cultures and the myths of a modern media culture. In general, the myths in Westerns are modern myths, which is to say that they are mainly political, cultural, and socio-psychological rather than religious.

Defining the **Western genre** is a complex process that it takes me most of Chapter Two to carry through. Even then I'm sure there are many who would rightly question the particular way in which I have related the major elements of setting, character, plot and theme. Still others would argue that there is no single way to define a Western and that the genre consists of works that are connected by resemblances between elements rather than by overall patterns. I'm more and more inclined to agree with the "family resemblance" school, though I still think it is useful to try to sort out the dominant patterns which seem present in the great majority of Westerns. For me, the Western is essentially defined by setting. I refer here not so much to a particular geographic setting like the Rocky Mountains or the Great Plains, but to a symbolic setting representing the boundary between order and chaos, between tradition and newness. It is this setting which generates certain kinds of crises which involve certain kinds of characters and call for the intervention of a particular kind of hero. And all of this is related to America and what was once its sense of itself and its destiny as a New World.

2

THE WESTERN AS POPULAR GENRE

The Western has been analyzed in many different ways—as an American myth, a cinematic art form, an imperialist ideology, a mass cultural narrative, a distorted form of history, and a sexist epic, to mention just a few of the lenses through which it has been viewed. In chapter five of this study, I will discuss the evolution of analytical approaches to the Western more fully, but at the beginning let us try to establish a fundamental definition of the Western as a basis for a more complex treatment of its history and significance.

Peter Homans originally suggested to me how one might analyze the basic story pattern of the Western in relationship to its special cultural position. Even though Homans' otherwise excellent discussion finally seemed to me to make a mistake characteristic of early critics of popular culture by reducing a fairly complex artistic construction to a simplistic cultural explanation, his initial approach seemed very useful to me. Homans suggests that we define the Western by attempting to understand it as a unified narrative construction. His method involves three main steps: 1) isolation of the characteristic elements, the setting, characters, events and themes of the Western; 2) analysis of the distinctive way in which the Western organizes these elements into an ordered pattern or plot; and 3) finally, a determination of the cultural significance of this pattern.

Using this approach, Homans concludes that the basic pattern of the Western is a plot "in which evil appears as a series of temptations to be resisted by the hero, most of which he succeeds in avoiding through inner control. When faced with the embodiments of these temptations, his mode of control changes, and he destroys the threat. But the story is so structured that the responsibility for this act falls upon the adversary, permitting the hero to destroy while appearing to save." Homans ascribes this pattern to the cultural influence of "Puritanism" because it has the same emphasis on the necessity for inner control and repression of "the spontaneous, vital aspects of life." He attributes the popularity of the Western to its representation of a legitimated indulgence in violence while at the same time it reasserts the "Puritan" norm of the primacy of will over feeling. Therefore, Homans believes there is a connection

11

between the popularity of the Western and the cyclic outbursts of religious revivalism in the United States.

Thus, Homans recognizes that the Western is not simply a collection of characters or themes, but a culturally significant narrative, an artistic construction that results in "an ordered vision of character, event and detail." Furthermore, he points out that the analyst must not only identify typical settings, characters and events, but go on to discover and state their relationship to each other in terms of some "basic organizing and interpretive principle for the myth as a whole." A mere summary of events will not suffice, for episodes and characters in any dramatic work cannot be correctly interpreted except in relation to the structure of the whole work. Many critics point with alarm to the violence that occurs so frequently in contemporary popular cultural forms, but simply to count with horrified fascination the number of beatings, murders, eyegougings, etc., which one can encounter in a day of television viewing will lead to little in the way of illumination. Imagine what a viewer-with-alarm might say about a television program that began with murder and moved through suicides, poisonings and suggestions of incest to end up with the screen littered with corpses. Pretty terrible, and doubtless indicative of the alienation, sadism and nihilism which dominates contemporary popular culture, except that these events were not taken from a television Western but from Shakespeare's *Hamlet*. The point, of course, is that in an artistic construction, events, even violent ones, take their meaning from the whole structure. There is quantitatively just as much violence in Shakespeare or in *Oedipus the King* (a nice bit of eyegouging) as there is in *Gunsmoke,* but it does not mean the same thing. In the Western violence is characteristically the hero's means of resolving the conflict generated by his adversary; in Shakespeare it is the means by which the hero destroys himself or is destroyed; in the classic detective story, violence is the adversary's means of protection and the hero's clue. In each instance violence cannot be understood simply as violence, for its meaning depends on the place it plays in the overall structure of the action.

Thus, the first step in the analysis of any artistic construction, canonic or popular, must be the definition of its elements and their relations. In the case of a narrative or dramatic construction the elements are characters, events, settings, themes or ideas and language, and the pattern is that of a plot or action, a chain of events growing out of the motives and ideas of a group of characters and having a definable beginning, middle and end.

Social scientists may well object at this point that the method of analysis I propose is essentially a humanistic approach and is therefore hopelessly subjective and unscientific, for everyone knows that human-

ists are continually quarreling over the interpretation of the works of art with which they deal. It is true that to isolate and quantify the elements of a pattern seems more scientific than the attempt to define their complex relationships to one another. But, such a procedure is so false to the nature of artistic constructions that it is about as scientific as it would be to think one had analyzed an election by counting the number of polling places. Nor is the kind of plot analysis I have suggested as subjective as it seems, for there is the direct empirical test of whether the analyst's model of the plot actually fits the work itself. To put it another way, does the suggested organizing principle actually account for the various elements in the work? A good model should provide a basis for explaining why each event and character is present in the work, and why these events and characters are placed in the setting they occupy. If some element remains unexplained, it is clear that the organizing principles have not been adequately stated.

However, in creating a model pattern for a generic tradition like the Western one must be careful not to confuse a typical Western plot with the genre itself. In analyzing a popular genre, we are not as concerned with individual works, such as a single episode of *Gunsmoke* or a particular novel by Zane Grey, but with the genre, itself. This is partly because the circumstances in which most popular narratives are produced and consumed do not encourage the creation of unique individual works of art but lead to the production of particular realizations of a conventional formula. Therefore the culturally significant phenomenon is not the individual work but the generic set of formulas or recipes which writers, producers, and directors follow in turning out individual novels, films, or television programs.

Aside from a few exceptional individual works by producers with the ability to place the special stamp of their genius on popular formulas, the individual works are ephemeral. It is the formula or genre that lingers on, evolving and changing with time, yet still basically recognizable. Therefore, a popular form, like the Western, may encompass a number of standard plots. Indeed, one important reason for the continued development of a genre is its very ability to change in response to the changing interests of audiences. A genre that cannot be adapted and transformed will finally disappear, as the Western, after its long history, seems finally to be disappearing into its own sunset.

One problem with Homans' analysis of the Western is that he does take one kind of Western plot for the genre as a whole. There are many Westerns of the type Homans describes in which an outsider comes into a community, is tempted by evil, overcomes the temptation, destroys the evil and leaves again. But this plot would also describe many hard-

boiled detective stories and some horror novels. There are also a good many Westerns in which the central action is the initiation of the hero into the world of men—as in stories of the dude-become-hero variety— or in which the plot hinges on the resolution through violence of a conflict between love and social prejudice—as in Owen Wister's classic *The Virginian*. What is needed is a definition of the Western which can account for the many different varieties of Western plots.

II

How, then, can we best define the basic pattern of the Western during its long history? The simple answer is that the Western is a popular genre about the West. However, to understand the multiple implications of this seemingly simple statement, we need, first, to have some idea about what sort of thing is a popular genre. The term often turns up in an ambiguous interplay with the idea of myth. Insofar as both terms seem to imply a kind of culturally significant narrative, there is a certain confusing interchangeability between them. Part of the confusion comes from the many different meanings that have accreted over the last three hundred years to the concept of myth. Some people talk about myths as if they were basically the same as cultural themes or ideologies, as when they speak of the "myth of progress" or the "myth of success." Still another common meaning of the term uses it to describe a common belief that is perniciously false such as the "myth of the Master Race," the "myth of whiteness" or the "myth of masculine superiority." Many cultural studies are organized around the opposition between myth and reality, for example. Depending on the context of its use, "myth" can mean a false belief or simply a belief, or something still more complicated like an archetypal pattern. Moreover, the term is traditionally related to a group of stories that have survived from ancient cultures, particularly the Greco-Roman. The scholar who uses the concept in the analysis of contemporary popular culture sometimes finds himself drawn into another kind of reductionism which takes the form of attributing the impact of contemporary popular forms to their occasional plot parallels with classical myths.

To avoid this confusion, I try to differentiate between the concept of popular genre and that of myth, thereby giving us two concepts to work with. Genres are groupings of texts which become recognized by creators, critics, and audiences over the course of time and which are seen in terms of complex structures of conventions, consisting of things like recurrent plots, stereotyped characters, accepted ideas, commonly known metaphors and other linguistic and narrative devices. Conventions reflect familiar shared images and meanings and they assert an ongoing conti-

nuity of values while the more original elements in art works confront us with a new perception or meaning which we have not realized before. Both these functions are important to culture. Conventions help maintain a culture's stability while inventions help it respond to changing circumstances and provide new information about the world.

Most works of art contain a mixture of convention and invention. Both Homer and Shakespeare show a large proportion of conventional elements mixed with inventions of great genius. *Hamlet,* for example, depends on a long tradition of stories of revenge, but only Shakespeare could have invented a character who embodies so many complex perceptions of life that every generation finds new ways to interpret him. So long as cultures were relatively stable and homogeneous over long periods of time, the relation between convention and invention in works of literature posed relatively few problems. Since the Renaissance, however, modern cultures have become increasingly heterogeneous and pluralistic in their structures and discontinuous in time. In consequence, while public communications have become highly conventionalized in order to be understood by diverse audiences, intellectual élites have placed ever higher valuation on originality perhaps out of a sense that rapid cultural changes require continually new perceptions of the world. Thus we have arrived at a situation in which the archetypal great work of literature is Joyce's *Finnegan's Wake,* a creation which is as original as it is possible to be without making some sort of shared meaning impossible. At the same time, there is a vast amount of popular culture characterized by a very high degree of conventionality.

Popular generic patterns or conventional systems for structuring cultural products are indispensable to the vast area of popular or mass culture. However, modern popular genres seem to be somewhat different from traditional ideas of genre and myth. Classical genre, in the sense of tragedy, comedy, romance, and satire, seems to be based on a difference between basic attitudes or feelings about life. Northrop Frye's suggestion that the major genres embody fundamental mythic patterns reflecting stages of the human life cycle seems a fruitful idea here, though this is not necessarily true of all genres. For Frye myths are universal patterns of action which manifest themselves in all human cultures. Following Frye, let me briefly suggest a formulation of this kind: genre can be defined as a structural pattern embodying a universal life pattern or myth in the materials of language. Popular genre, on the other hand, is cultural; it represents the way in which a particular culture has embodied both mythical archetypes and its own preoccupations in narrative form.

Sheldon Sacks suggests another interesting hypothesis about the nature of genres: that they are known intuitively by human beings

because the human mind possesses innate capacities to make distinctions between the comic and the tragic. Sacks' view, if correct, is similar in its implications to Frye's. Classical genre is universal, basic to human perceptions of life. Popular genres are linked to particular cultures and historical periods.

This was the way I presented these matters in 1970 in the first edition of *The Six-Gun Mystique*. At that time I was so sure that we could sharply differentiate between traditional and popular genres that I gave them two different names: formula and genre. I no longer see that distinction so clearly and, as the reader can see, I have mostly substituted the more ambiguous term "popular genre" for the concept of formula. As it happens, this is in accord with general practice in popular culture studies, for, though many people were apparently influenced by the concept of formula as I originally expounded it, few have actually continued to use that term and here, I must confess, I think they are right.

As someone who had absorbed the ideologies of modernism during my education in the forties and fifties, I thought that there were archetypal human values reflected in great art and more limited cultural ideologies that shaped the more conventional popular arts. Since the heyday of artistic modernism, art and especially critical theory and cultural studies have shown us over and over again that even the canonic works reveal ideological limitations when held up to such mirrors as gender and race. It no longer seems possible to differentiate between formulaic and canonic works simply on the basis of convention vs. originality or culturally limited vs. universal values. For me, the idea of popular genres implies not only a certain combination of narrative elements, but also a specific history, and this makes it more useful than formula. In other words, as I now see it, we must define a popular genre both in terms of its structural patterns and in terms of its historical development. Trying to set this straight has been a major purpose behind the revisions and expansions of this edition of *The Six-Gun Mystique*. For example, in this chapter I deal with the structural paradigms characteristic of the Western genre, while in chapters three and four, I attempt to delineate the main outlines of the genre's specific history.

Though we must be careful not to reify the distinction between universal paradigms and cultural ideologies, the difference between transcultural archetypes and specific cultural formulas remains useful on certain levels. The Western and the spy story can both be interpreted as elements of the archetypal pattern of the hero's quest discussed by Northrop Frye under the general heading of the mythos of romance. Or if we prefer psychoanalytic archetypes, these genres can be seen as expressions of the Oedipal myth since they deal with the hero's struggle

with a dangerous, powerful and usually an older, figure. However, though we can doubtless characterize both Westerns and spy stories in terms of these universal archetypes, we have not thereby explained the basic and important differences in setting, characters and action between them. These differences reflect the particular preoccupations and needs of the time in which they were created and the group that created them: the Western shows its distinctively American roots, even when created in late twentieth-century Italy. The spy story, on the other hand, mainly originated in late nineteenth- and early twentieth-century England and reflected the cultural paranoia leading up to the catastrophe of World War I. These differences are evident in the structural paradigms underlying the development of these two popular genres.

However, a paradigm created by one culture can easily be taken over by another and we will often find important changes in a genre as it moves from one culture or from one period to another. This is where the specific history of a popular genre becomes important in defining it. The gunfighter Westerns of the 1950s were significantly different from the cowboy romances of Owen Wister and Zane Grey, just as the American spy stories of Donald Hamilton and Richard Condon differed from the British secret agent adventures of Eric Ambler, Graham Greene, and John le Carré.

Why do certain genres come into existence and enjoy such wide popularity? Why of all the possible subjects for stories do a certain few like the adventures of the detective, the secret agent and the cowboy so dominate the field? I suggest that these genres fulfill several important cultural functions that, in modern cultures have been partly taken over by the popular arts. Let me suggest just one or two examples of what I mean.

In earlier, more homogeneous cultures, religious ritual performed the important function of articulating and reaffirming primary cultural values. Today, with cultures composed of a multiplicity of differing religious groups, the synthesis of values and their reaffirmation has become an increasingly important function of the mass media and the popular arts. Thus, one important dimension of formula is social or cultural ritual. Homogeneous cultures also possessed a large repertory of games and songs which all members of the culture understood and could participate in both for a sense of group solidarity and for personal enjoyment and recreation. Today the great spectator sports provide one way in which a mass audience can participate in games together. Popular genres are also semi-ritualistic in that they are narrative patterns with rules known to everyone. Thus, a very wide audience can follow a Western, appreciate its fine points and vicariously participate in its pattern of suspense and resolution.

The game dimension of popular genres has two aspects. First, there is the patterned experience of excitement, suspense and release. Second, there is the aspect of play as ego-enchantment through the temporary resolution of inescapable frustrations and tensions through fantasy. As Piaget sums up this aspect of play:

Conflicts are foreign to play, or, if they do occur, it is so that the ego may be freed from them by compensation or liquidation whereas serious activity has to grapple with conflicts which are inescapable. The conflict between obedience and individual liberty is, for example, the affliction of childhood [and, we might note, a key theme of the Western] and in real life the only solutions to this conflict are submission, revolt, or cooperation which involves some measure of compromise. In play, however, the conflicts are transposed in such a way that the ego is revenged, either by suppression of the problem or by giving it an acceptable solution . . . it is because the ego dominates the whole universe in play that it is freed from conflict. (71)

The game dimension of popular genres is a culture's way of simultaneously entertaining itself and of creating an acceptable resolution of the inescapable complications and limitations of human life. In popular stories, the detective always solves the crime, the hero always determines and carries out true justice, and the agent accomplishes his mission or at least preserves himself from the omnipresent threats of his enemy.

Popular genres also seem to be a way in which individuals in a culture act out certain unconscious or repressed needs, or express in an overt and symbolic fashion certain latent motives they must give expression to, but cannot face openly. This is the most difficult aspect of formula to pin down. Many would argue that one can not meaningfully discuss latent contents or unconscious motives beyond the individual level or outside of the clinical context. Certainly it is easy to generate a great deal of pseudopsychoanalytic theorizing about literary formulas and to make deep symbolic interpretations which it is clearly impossible to substantiate convincingly. Though it may be difficult to develop a reliable method of analysis of this aspect of popular genres, Freud and Jung were surely right when they argued that recurrent myths and stories embody a kind of collective dreaming process, though it is uncertain how effectively we can analyze this process.

However, in my view, one major dimension of popular genre transcends all these others. Beyond the various aspects of ritual, game, and collective dream which shape successful popular genres, the most important factor in the continuing development of genres like the Western, the

detective story, the horror story or the popular romance is that they make possible highly effective works of art. Thus, in the end, our analysis of the Western as a genre must focus on those elements of the Western that make it a unified and effective narrative or drama.

In short, I think that popular genres are essentially structures of narrative conventions that carry out a variety of cultural functions in a unified way. We can best define these genres in terms of paradigms for the selection of certain plots, characters, and settings of such a sort that these narrative elements not only create effective stories, but become endowed with certain aspects of collective ritual, game and dream. To analyze these genres we must first define them as narrative structures of a certain kind.

III

In one obvious way, the Western is easier to recognize than the detective story, for when we see a couple of characters dressed in ten-gallon hats and riding horses we suspect we are in a Western. On the other hand, the Western tradition contains a much greater variety of plot patterns than the detective story with its single line of criminal investigation. Frank Gruber, a veteran writer of pulp Westerns, suggests that there are seven basic Western plots: 1) The Union Pacific Story centering around the construction of a railroad, telegraph or stagecoach line or around the adventures of a wagon train; 2) The Ranch Story with its focus on conflicts between ranchers and rustlers or cattlemen and sheepmen; 3) The Empire Story, which is an epic version of the Ranch Story; 4) The Revenge Story; 5) Custer's Last Stand, or the Cavalry and Indian Story; 6) The Outlaw Story; and 7) The Marshal Story. One could doubtless construct other lists of plots that have been used in Westerns, though Gruber's seems quite adequate. Though there are basic patterns of action the Western tends to follow whether it be about ranchers, cavalrymen, outlaws or marshals, the possibility of such diversity of plot patterns suggests that we know a Western primarily by the presence of ten-gallon hats and horses. In other words, the Western is initially defined by its setting.

1. Setting

Tentatively we might say that the Western setting is a matter of geography and costume; that is, a Western is a story that takes place somewhere in the western United States in which the characters wear certain distinctive styles of clothing. However, this formulation is clearly inadequate since there are many stories of the American West we would not call Westerns under any circumstances—for example the novels and

stories of Hamlin Garland or Ole Rolvaag, the detective stories of Raymond Chandler, or the postmodern novels of Thomas Pynchon set in California. Moreover, there are novels set in the eastern United States that are really Westerns, for example, the Leatherstocking Tales of James Fenimore Cooper. Our geographical definition must immediately be qualified by a social and historical definition of setting: the Western is a story which takes place on or near a frontier and consequently the Western is generally set at a particular moment in the past.

The frontier of the Western is related to Frederick Jackson Turner's frontier, but usually defined somewhat differently. For Turner, the frontier was less important as "the meeting point between savagery and civilization" than as a social and economic factor in American history. His well-known frontier thesis consisted of two central propositions: first, because the American frontier lay "at the hither edge of free land" it had maintained the democratic mobility and fluidity of American life; and second, there tended to grow up in frontier settlements a distinctively individualistic way of life which continually revitalized the democratic spirit in America. Though a view of the frontier resembling Turner's sometimes plays a role in the structure of more complex and serious Westerns, the central purport of the frontier in most Westerns has simply been its potential as a setting for exciting, epic conflicts. The Western formula tends to portray the frontier as "meeting point between civilization and savagery" because the clash of civilization ("law and order") with savagery, whether represented by Indians or lawless outlaws, generates dramatic excitement and striking antitheses without raising basic questions about American society or about life in general. In the Western formula savagery is implicitly understood to be on the way out. It makes little ultimate difference whether the creator of the Western portrays Indians as savage and diabolical (as in many dime novels) or as living a meaningful way of life for which he feels a certain degree of elegiac nostalgia (an attitude in many Westerns from Cooper to the movies of John Ford). The Indians are always vanishing, just as in the detective story there is never really a doubt that the criminal will ultimately be exposed.

Some American writers, like Thoreau and Whitman have sought "natural" values as a means of transcending the limits of society. Others have portrayed characters deeply torn between different ways of life. The Western hero never has to make a basic choice between values, for like Cooper's Leatherstocking, however close he may be to the Indians, he is a "man without a cross." Insofar as he is a hero it must be in relation to the triumph of civilization over savagery, even if this victory, as it often does, puts him out of a job. Edwin Fussell suggests that in the first

half of the nineteenth century the frontier retained enough of an air of mystery that it could represent a fundamental confrontation between human history and the possibility of a society transcending it. However, Fussell believes that as actual settlement progressed, the frontier lost its power as a fundamental moral antithesis to society. Therefore, by 1850, the frontier was no longer a major theme for the greatest American writers.

Fussell's discussion resembles Henry Nash Smith's definition of the mythical West as the potential locus of a new and more natural human society. Like Fussell, Smith defines the early American conception of the frontier as a serious antithesis to existing society. Smith also believes that the moralization of nature implicit in this conception of the frontier was too simple to support a serious literature. Thus, after Cooper, the Western story declined to a point where "devoid alike of ethical and social meaning, [it] could develop in no direction save that of a straining and exaggeration of its formulas" (135).

Smith's treatment of the Western story is overly negative, ignoring as it does the rich flourishing of the Western in literature and film in the twentieth century. Partly this is because Smith, like most scholars of his generation, views popular culture as a means of finding easy resolutions to cultural problems and conflicts rather than confronting them directly. Lee Clark Mitchell, in his recent book on *Westerns* (1996) illustrates how more recent scholars and critics have qualified this view. He observes that "the Western is a form not committed to *resolving* these incompatible worlds but to *narrating* all those contradictions involved in what it means to be a man, in a way that makes them seem less troubling than they are" (27).

The frontier setting and the role of the savage have usually been presented in the Western as occasions for action rather than as symbols of opposing values. In other words, the Indian almost never represents a meaningful alternative way of life implying a serious criticism of American society. This only happens with the emergence of what I will later call the "Post-Western" in the later twentieth century. Though a complex presence in much American literature, the Indian remains a stereotypical figure in all but the most complex and interesting Westerns. Leslie Fiedler points out how often a relationship between a young white boy and an Indian or Negro is the central focus of major American novels. In his *The Return of the Vanishing American,* Fiedler suggests that the Indian way of life became an important countercultural symbol for many young hippies in the 1960s. Yet the Indian rarely played such a role in the Western, because he was usually in the process of vanishing. In fact, the treatment of the Indian in the traditional Western bears out Roy

Harvey Pearce's analysis of the American idea of savagism. Pearce shows how a complex seventeenth- and eighteenth-century dialectic between the Indian as devil and as noble savage quickly gave way in the nineteenth century to a definition of the Indian way of life as an inferior and earlier stage in the development of civilization. This redefinition of the Indian justified his assimilation or extermination and therefore served the need of nineteenth-century American society for a philosophical rationale to justify its brutal elimination of the native Indian cultures. Even in Westerns quite sympathetic to the Indian, such as John Ford's version of Mari Sandoz' *Cheyenne Autumn* and the 1993 blockbuster *Dances with Wolves,* the focus of the action usually shifts from the Indians themselves to the dilemmas their situation poses for the white hero and heroine. Armando Prats has brilliantly anatomized how even more sympathetic recent Western treatments of Native Americans, in films like *Dances with Wolves, Geronimo,* and *The Last of the Mohicans,* justify the destruction of the Indian by having him hand on the torch to a sympathetic and understanding white character. Prats calls this rightly the "firsting" of the White American.

In short, the Western formula seems to prescribe that the Native American be more an aspect of the setting than a character in his/or/her own right. The reason for this is twofold. Giving the Indian a more complex role would increase the moral ambiguity of the story and thereby blur the sharp dramatic conflicts. Second, if the Indian represented a significant way of life rather than a declining savagery, it would be far more difficult to resolve the story with a reaffirmation of the values of American society.

The Western genre began to emerge as American attitudes toward the frontier went through significant transformations around the middle of the nineteenth century. Earlier, it was possible for Americans to treat the frontier as a symbol of fundamental moral antitheses between man and nature, and, consequently, to use a frontier setting, as Hawthorne and Melville did, to explore the nature and limitations of man and society. However, the redefinition of the frontier as a place where advancing civilization met a declining savagery changed the frontier setting into a locus of conflicts which were always qualified and contained by the knowledge that the advance of civilization would eliminate them. Or, to put it another way, the frontier setting now provided a fictional justification for enjoying violent conflicts and the expression of lawless force without feeling that they threatened the values or the fabric of society.

Thus, social and historical aspects of setting are even more important in defining the Western formula than geography. The Western story is set at a certain moment in the development of American civilization,

namely at that point when savagery and lawlessness are in decline before the advancing wave of law and order, but are still strong enough to pose a local and momentarily significant challenge. In the actual history of the West, this moment was probably a relatively brief period in any particular area. As contemporary historians have shown, western history was more significantly influenced by the complex struggle between different interest groups over the use of resources, the rise of industrialism, and the clash of cultures than by the struggle with Indians or outlaws. Nonetheless, the latter became central to the Western formula. The relatively brief stage in the social evolution of the West when outlaws or Indians posed a threat to the community's stability has been erected into a timeless epic moment when heroic individual defenders of law and order stand poised against the threat of lawlessness or savagery. But it is also the nature of this epic moment that the larger forces of civilized society are just waiting in the wings for their cue. However threatening he may appear at the moment, the Indian is vanishing and the outlaw about to be superseded. Because they, too, represent this epic moment we are likely to think of such Eastern novels as Cooper's *Last of the Mohicans,* Bird's *Nick of the Woods,* or more recent historical novels like Walter Edmonds' *Drums Along the Mohawk* as Westerns.

Why has this epic moment been primarily associated in fiction with a particular West, that of the Great Plains and the mountains and deserts of the "Far West" and with a particular historical moment, that of the heyday of the open range cattle industry of the later nineteenth century? Westerns can be set at a later time. Some of Zane Grey's stories take place in the twenties and some, like those of Gene Autry, Roy Rogers or "Sky King" in the present, but even at these later dates the costumes and the represented way of life tend to be those of the later nineteenth century. Several factors probably contributed to this particular fixation of the epic moment. Included among these would be the ideological tendency of Americans to see the Far West as the last stronghold of certain traditional values, as well as the peculiar attractiveness of the cowboy hero. But along with these ideological factors, the Western required a means of isolating and intensifying the drama of the frontier encounter between social order and lawlessness. For this purpose, the geographic setting of the Great Plains and adjacent areas has proved particularly appropriate, especially since the advent of film and television have placed a primary emphasis on visual articulation. Four characteristics of the Great Plains topography have been especially important: its openness, its aridity and general inhospitality to human life, its great extremes of light and climate, and, paradoxically, its grandeur and beauty. These topographic features created an effective

backdrop for the action of the Western because they exemplify in visual images the thematic conflict between civilization and savagery and its resolution.

In particular, the Western has come to center about the image of the isolated town or ranch or fort surrounded by the vast open grandeur of prairie or desert and connected to the rest of the civilized world by a railroad, a stagecoach or simply a trail. This tenuous link can still be broken by the forces of lawlessness, but never permanently. Geronimo can cut the telegraph wire, but a Western Union crew will be along to restore it once the dust has settled. The fragile Western town can easily be destroyed. The rickety wooden buildings with their tottering false fronts express the town's tenuous position against the surrounding desert. Nonetheless we do not see the town solely as an isolated fort in hostile country, like an outpost of the French foreign legion in *Beau Geste,* but as the advance guard of an oncoming civilization. Moreover, while the prairie or desert may be inhospitable, it is not hostile. Its openness, freshness and grandeur also play an important role in the Western. The open prairie around the town serves not only as a haven of lawlessness and savagery, but as a backdrop of epic magnitude and even, at times, as a source of regenerating power.

This characteristic setting reflects and helps dramatize the tripartite division of characters that dominates the Western pattern of action. The townspeople hover defensively in their settlement, threatened by the outlaws or Indians who are associated with the inhospitable and uncontrollable elements of the surrounding landscape. The townspeople are static and largely incapable of movement beyond their little settlement. The outlaws or savages can move freely across the landscape. The hero, though a friend of the townspeople, has the lawless power of movement in that he, like the savages, is a horseman and possesses skills of wilderness existence. The moral character of the hero also appears symbolically in the Western setting. The rocky aridity and climatic extremes of the Great Plains complement the hostile savagery of Indians and outlaws. On the other hand, the vast openness, the vistas of snowcovered peaks in the distance, and the great sunrises and sunsets (in the purple prose of Zane Grey, for example) suggest the epic courage and regenerative power of the hero. In every respect, Western topography helps dramatize more intensely the clash of characters and the thematic conflicts of the story. Western writers and film directors use these dramatic resources of setting more or less skillfully, but even at their flattest they have a tendency to elevate rather commonplace plots into epic spectacles. When employed with conscious and skillful intent, as in the Western films of John Ford, the lyrical and epic power of landscape can

transcend the inherent limitations of popular culture and raise escapist adventure to a level of high artistry.

The special qualities of the Western setting emerge still more clearly from a comparison with the treatment of setting in the colonial adventure novels of English writers like H. Rider Haggard. Since it, too, involved adventures on the periphery of what its readers defined as civilization, the colonial adventure is the closest European analogue to the American Western. Like the Western setting, the tropical jungles of the colonial adventure have both hostile and attractive qualities. Haggard's African veldts, like the Western plains, contain savagery and raw nature that threaten the representatives of civilization. They are also full of exotic animals, beautiful natural spectacles, glamorous and mysterious cults, hidden treasures and other exciting secrets. But, in contrast to the fresh and open grandeur of the Western landscape, these double qualities of the colonial jungle are superficially attractive, but essentially subversive and dangerous. They are associated not with a redeeming hero who saves civilization from the threat of lawlessness and savagery, but with temptations which undermine the hero's commitment to civilization. The Western landscape can become the setting for a regenerated social order once the threat of lawlessness has been overcome, but the colonial landscape remains alien. Its doubleness reflects the difference between the overt threat of savage hostility and the more insidious danger of the attractiveness of alien cults and exotic ways of life. This ambiguous antithesis between man and jungle has inspired one great literary masterpiece, Joseph Conrad's *Heart of Darkness*. The nearest analog to this in the Western genre would perhaps be a film like John Ford's *The Searchers*.

The first major writer who brought together the tripartite division of townsmen, savages and intermediate hero with a vision of the landscape was James Fenimore Cooper, who thereby became the precursor of the Western. Even though Cooper's novels are set in the Eastern forests and many of his thematic emphases are quite different from the later Western, his landscapes show the same basic pattern. The new settlement (*The Pioneers*) or fort (*The Last of the Mohicans, The Pathfinder*) or "ranch" (Hutter's "castle" in *The Deerslayer*) is surrounded by miles of forested wilderness. It is clear, however, that civilization has irreversibly begun its advance. Like many later Western writers, Cooper frequently called attention to the difference between the peaceful settlements of "today" and the dark mysterious forests of the earlier period of the story. He makes his readers aware that they are dealing with a stage of historical development that was definitely in the past. It is implicit in such a setting that the conflict between settlement and wilderness will soon be resolved. Cooper's

wilderness also exemplifies the two aspects of the Western landscape. The forest is dark and frightening, but also the place where one gets the strongest feeling of the divine presence; it is the locus of the bloodthirsty and savage "Mingos" but also of the noble and heroic Delawares.

The Western setting is both background and source of dramatic conflicts as well as a means of exploring certain historical themes and evoking a sense of epic grandeur. But we must not forget that one reason for the success of the Western as a popular form in the twentieth century has been its unique adaptability to film. Two major characteristics of the Western setting turned out to have an enormous potential for cinematic expression: its great openness of space and its powerful visual contrasts.

The special openness of the topography of the Great Plains and western desert has made it particularly expressive for the portrayal of movement. Against the background of this terrain, a skillful director can create infinite variations of space ranging from long panoramas to close-ups and he can clearly articulate movement across these various spaces. Even though it has become a visual cliche, there is something inescapably effective about that scene, beloved of Western directors, in which a rider appears as a tiny dot at the far end of a great empty horizon and then rides toward us across the intervening space. So too, it is uniquely thrilling when we see a group of horses and men plunging pellmell from the foreground into the empty distance. Nothing quite matches the feeling of suspense when the camera picks up a little group of wagons threading their way across the middle distance and then pans across the arid rocks and up the slopes of a canyon and suddenly comes upon a group of Indians waiting in ambush.

Moreover, the western landscape is uniquely adaptable to certain powerful visual effects. The sharp contrasts of light and shadow characteristic of an arid climate together with the topographical contrasts of plain and mountain, rocky outcrops and flat deserts, steep bare canyons and forested plateaus created a uniquely effective backdrop to heroic adventure. The characteristic openness and aridity of the topography also makes the contrast between man and nature and between wilderness and society visually strong. Perhaps no film exploits the visual resources of the Western landscape more brilliantly than John Ford's 1939 *Stagecoach*. After a brief introduction the film opens on a street in one of those western towns characterized by false fronts. The rushing motion of horses and wagons along the street and the long vista down the street and out into the desert immediately makes us aware of the surrounding wilderness and of the central theme of movement across it which will dominate the film. This opening introduction of the visual theme of fragile town contrasted with epic wilderness will be developed throughout

the film in the contrast between the flimsy stagecoach and the magnificent landscape through which it moves. Similarly, the restless motion of the opening scene will be projected into the thrust of the stagecoach across the landscape. Several brief scenes lead up to the departure of the stagecoach. These scenes are cut at a rather breathless pace, intensifying the sense of motion and flight generated by the opening. Visually, they dwell on two aspects of the town, its dark, narrow and crowded interiors and its ramshackle sidewalks and storefronts, symbolizing the restrictive and artificial character of town life. Then the stagecoach departs on its voyage and we are plunged into the vast openness and grandeur of the wilderness with the crowded wooden stagecoach serving as a visual reminder of the narrow town life it has left behind.

Ford chose to shoot the major portion of the stagecoach's journey in Monument Valley, a brilliant choice because the visual characteristics of that topography perfectly embody the complex mixture of epic grandeur and savage hostility that the film requires. The valley itself is a large, flat desert between steep hills. Thrusting up out of the valley floor gigantic monoliths of bare rock dwarf the stagecoach as it winds across this vast panorama. This combination of large open desert broken by majestic upthrusts of rock and surrounded by threatening hills creates an enormously effective visual environment for the story, which centers around the way in which the artificial social roles and attitudes of the travelers break down under the impact of the wilderness. Those travelers who are able to transcend their former roles are regenerated by the experience: the drunken doctor delivers a baby, the meek salesman shows courage, the whore becomes the heroine of a romance and the outlaw becomes a lover. By stunning photographic representation of the visual contrasts of desert, hills and moving stagecoach, Ford transforms the journey of the stagecoach into an epic voyage that transcends the film's somewhat stereotypical romantic plot.

Costume, another feature of the Western setting, also contributes greatly to the Western's success in film. Like the topography, Western costume gains effectiveness both from its intrinsic interest and from the way writers and filmmakers have learned how to make it reflect character and theme. In simplest form, as in the B Westerns, costumes symbolized moral oppositions. The good guy wore clean, well-pressed clothes and a white hat. The villain dressed sloppily or in black. The importance of this convention, simpleminded as it was, became apparent when, in order to create a more sophisticated, "adult," Western, directors frequently chose to dress their heroes in black.

However, the tradition of western costume also contains more complex meanings. An important distinction marks off both hero and villain

from the townspeople. The townspeople usually wear the ordinary street clothing associated with the later nineteenth century, suits for men and long dresses for women. On the whole this movie clothing is simpler than the actual, elaborate fashions of the period and this simplicity is one way of expressing the Westernness of the costume. Still, in the midst of the desert, the townspeople's clothing has an air of nonutilitarian artificiality somewhat like the ubiquitous false fronts of the town itself. It is perhaps significant that even in Westerns purportedly set in a more recent time, the women tend to wear the longer dresses of an earlier period.

The costumes associated with heroes and outlaws or savages are more striking. Paradoxically they are both more utilitarian and more artificial than those of the townspeople. The cowboy's boots and tightfitting pants or chaps, his heavy shirt and bandana, his gun and finally his tengallon hat all symbolize his adaptation to the wilderness. But utility is only one of the principles of the hero-outlaw's dress. The other is dandyism, a love of elegance for its own sake. In the Western, dandyism sometimes takes the overt and obvious form of elaborate costumes laid over with fringes, tassels and scrollwork like a rococo drawing room. But it is more powerfully exemplified in the elegance of those beautifully tailored cowboy uniforms that John Wayne so magnificently fills out in the Westerns of John Ford and Howard Hawks.

The enormous attraction of this combination of naturalness and artifice has played a significant role in both popular and avantgarde art since the middle of the nineteenth century. Baudelaire was fascinated by the dandyism of the savage which he described as "the supreme incarnation of the idea of Beauty transported into the material world." This was just one indication of the nineteenth century's delight in the mixture of savagery and elegance implicit in the costume of the Western hero from the beginning. Cooper's Leatherstocking even gained his name from his costume, suggesting the extent to which this particular kind of dress excited Cooper's imagination. Like later cowboys, Leatherstocking's outfit combined nature and artifice. His dress used the skins of animals and it was particularly adapted to the needs of wilderness life. Yet at the same time it was subtly ornamented with buckskin fringes and procupine quills "after the manner of the Indians." However, Leatherstocking's costume was not the same as the Indians, but a more utilitarian wilderness version of the settler's dress. His outfit exemplified the hero's mediating role between civilization and savagery.

Later the formula cowboy's costume developed along the same lines. In its basic outlines it resembled town dress more than that of the Indian, yet it was more functional for movement across the plains than

that of the townspeople. At the same time, the cowboy dress had a dandyish splendor and elegance based on Indian or Mexican models and absent from the drab fashions of the townspeople. In still later Westerns, the hero shared many of these qualities with the villain, just as Leatherstocking had a touch of the Indian, despite his repeated assurances that he was "a man without a cross," i.e., actual Indian kinship. The hero's costume usually differentiated him from the Indian or outlaw as savage, both by its basic resemblance to civilized dress and by its greater restraint and decorum. Thus costume, like setting, expressed the transcendent and mediating aspects of the hero. By lying between two ways of life, he transcended the restrictions and limitations of both.

2. Complex of Characters

Three central character roles dominate the Western: the townspeople or agents of civilization, the savages or outlaws who threaten this first group, and the heroes who are above all "men in the middle," possessing many qualities and skills of the savages but fundamentally committed to the townspeople. It is out of the multiple variations possible on the relationships between these groups that the various Western plots are concocted. For example, the simplest version of all has the hero protecting the townspeople from the savages, using his own savage skills against the denizens of the wilderness. A second more complex variation shows the hero initially indifferent to the plight of the townspeople and more inclined to identify with the savages. However, in the course of the story his position changes and he becomes the ally of the townspeople. This variation can generate a number of different plots. There is the revenge Western: a hero seeks revenge against the outlaws or Indians who have wronged him. In order to accomplish his vengeance, he rejects the pacifistic ideals of the townspeople, but in the end he discovers that he is really committed to their way of life (John Ford's *The Searchers*). A related plot is that of the hero who initially seeks his own selfish material gain, using his savage skills as a means to his end; but, as the story progresses, he recognizes his moral involvement with the townspeople and becomes their champion (cf. Anthony Mann's *The Far Country*). It is also possible, while maintaining the system of relationships, to reverse the conclusion of the plot as in those stories where the townspeople come to accept the hero's savage mode of action (cf. John Ford's *Stagecoach* or, to a certain extent, Wister's *The Virginian*). A third variation of the basic scheme of relationships has the hero caught in the middle between the townspeople's need for his savage skills and their rejection of his way of life. This third variation, common in later Westerns, often ends in the destruction of the hero (cf. *The Gunfighter* or *Invitation to a*

Gunfighter) or in his voluntary exile (*Shane, High Noon, Two Rode Together*). Such variations suggest, rightly I think, that exploring a certain pattern of relationships is more important to the Western than a particular outcome. It is also possible that these variants reflect different components of the mass audience, the simpler variations being more popular with the adolescents and the more complex ones with adults. In addition, changing cultural attitudes and situations have often inspired the emergence of different variations. Variation two is clearly more characteristic of early twentieth century Westerns, while variation three dominates the "classic" Western of the 1940s and 1950s.

The most important single fact about the group of townspeople is that there are women in it. Character groupings in the Western often show a dual as well as tripartite opposition: the hero and the savages are men while the town is strongly dominated by women. This sexual division frequently embodies the antithesis of civilization and savagery, since women are primary symbols of civilization in the Western. It is the schoolmarm even more than the entrepreneur who symbolically represents the end of the old wilderness life. There is also implicit in the presence of women the sexual fascination and fear associated with the rape of white women by savages. Though few Westerns explicitly develop this theme and many writers even try to deny its place in their narratives, there seems little doubt that the threatened capture of women plays a crucial role in many Westerns and an implicit role in most. Leslie Fiedler, among others, has analyzed the psychological undercurrents of the curious Western triangle between hero, savage and female. His interpretation stresses the strong emotional, cultural and even sexual ties between hero and savage that are disrupted by the female. He concludes that the violence endemic to this triangle reflects the terrible incompatibility between the free spontaneity and sexuality associated with savagery and the genteel restrictions of civilized monogamous domesticity. Fiedler interprets the Western as a popular myth embodying the psychological tensions that Freud describes in *Civilization and its Discontents*. Civilization represses spontaneous sexuality and creates a growing neurotic obsession with death and destruction. The hero's destruction of the savage in order to protect the chastity of the schoolmarm symbolizes the repression of his own spontaneous sexual urges and his acceptance of the monogamous sexual pattern of modern middle-class life.

A further indication of the significance of this Western triangle lies in the frequent presence of two different kinds of women in the Western. This dichotomy resembles the common (probably racist) nineteenth-century novelistic dualism of blonde and brunette. The blonde, like Cooper's Alice in *The Last of the Mohicans,* represents genteel, pure

femininity, while the brunette, like Cora in the same novel, symbolizes a more fullblooded, passionate and spontaneous nature, often slightly tainted by a mixed blood or a dubious past. In the contemporary Western, this feminine duality shows up in the antithesis between the schoolmarm and the dancehall girl, or between the hero's Mexican or Indian mistress and the white girl he ultimately marries.

The dark girl is a feminine embodiment of the hero's savage, spontaneous side. She understands his deep passions, his savage code of honor and his need to use personal violence. The schoolmarm's civilized code of behavior rejects the passionate urges and the freedom and aggressiveness that mark this side of the hero's character. When the hero becomes involved with the schoolmarm, the dark woman must be destroyed or abandoned, just as Cooper's Cora must die because her feelings are too passionate and spontaneous to be viable in the genteel world of Alice and Duncan Heyward. Even when the relationship between the hero and the dancehall girl seems to be permanent and almost domestic, like the longstanding friendship between Kitty and Marshal Dillon on the TV series *Gunsmoke*, it typically remains in suspension and never leads to marriage.

With women as central agents, the town projects a somewhat ambiguous view of the "blessings of civilization," an ambiguity which is invariably resolved in favor of social progress, but not without some reluctance and sense of loss. The town offers love, domesticity and order as well as the opportunity for personal achievement and the creation of a family, but it requires the repression of spontaneous passion and the curtailment of the masculine honor and camaraderie of the older wilderness life. These ambiguities are reflected in the hero's relationship with women. They are also embodied in the three main kinds of townspeople who recurrently appear in Westerns: the pioneers or decent folk, the escapees from civilization and the bankervillains.

The pioneers resemble the hero in being virtuous and honorable people, but they lack his ability to cope with savagery. In addition, their aims are fundamentally different. The hero tries to preserve himself with individual dignity and honor in a savage and violent environment. The pioneers, on the other hand are a collective force which seeks to transform the wilderness into a new social order. Their values center around the establishment of stable families and the building of homes, farms and businesses. Instead of individual honor, they value hard work, mutual loyalty and political and economic achievement; in short, the conventional American canons of success. Typically, much of the action of the Western centers around the initial mixture of conflict and sympathy between hero and pioneers, which eventually resolves itself into the

hero's commitment to the cause of the pioneers. Sometimes the commitment is happy in its outcome as in Wister's *The Virginian,* where the hero is able to synthesize his personal code with the morality of the pioneers and become a successful rancher and political leader. In other cases, the conflict cannot be overcome and the hero's commitment becomes sacrifical. Such was the result of the relation between Judge Temple and Natty Bumppo in Cooper's *The Pioneers,* though in that novel a synthesis between hero and pioneers was attempted in the figure of Oliver Effingham.

The sacrificial outcome also characterizes many of the significant twentieth-century Westerns. In Jack Schaefer's *Shane,* the hero becomes involved with pioneer Joe Starrett. Throughout the first part of the book we are shown the mixture of mutual sympathy and conflict which characterizes the relationship of two men of equal virtue but different aims and codes. Finally, Shane's commitment to the pioneer cause forces him to reenact his role as a gunman. But, as a killer, he can no longer remain a part of the pioneer community. Wounded in his battle for the pioneers he must ride off into the wilderness again. A similar pattern dominates John Ford's film *The Man Who Shot Liberty Valance.* The hero, Tom Doniphon, must sacrifice himself and his way of life to save the pioneer leader who will be instrumental in destroying the older anarchical society that is the only possible background for the hero.

A second group of townspeople, particularly prominent in later Westerns, combines in single individuals some of the ambiguities which otherwise appear in the conflict between hero and pioneers. This group consists of people who have fled the East. For them the West is not a place to build up a new civilization but a haven from failure or personal tragedy in the East. The masculine form of this figure is commonly the drunken professional, particularly a doctor or a lawyer who, we are given to understand, had a promising Eastern career which went sour. The female type is the dancehall girl who, like the drunken professional, has had some shattering experience in the East and has come West to lick her wounds. These figures are commonly alienated from the rest of the townspeople and consequently are better able to understand the hero's moral imperatives. Yet they cannot function on the hero's ground either since they lack his skills in violence or his strong sense of honor. They often play one or more of three important plot roles. First, they provide sympathy and even assistance to the hero at a crucial time. Second, they are better able to initiate the reluctant hero into the virtues represented by the pioneers since they share some of the hero's ambiguity and yet remain basically committed to the town. Finally, a savage attack on one of these figures often provides the final push behind the

hero's commitment to the cause of the pioneers. In *The Man Who Shot Liberty Valance* it is the savage outlaw's vicious attack on the drunken professional that finally convinces Tom Doniphon of the necessity of playing a role on the side of the pioneers.

Thematically the escape from civilization seems to be a means of expressing both some sense of the limitations of civilization and yet of reaffirming what the town stands for. The escapee gains our sympathy and that of the hero by his alienation and failure. Yet from this very position of alienation and failure, he represents the limitations of individualism and the ultimate necessity of commitment to the town, for he, like the hero, discovers that he cannot maintain his prideful isolation when the chips are down and the savage attack has begun. In addition, the escapee serves as an important foil to the hero. His garrulous weakness sets off the hero's silent strength, his enforced alienation and failure contrast with the hero's voluntary isolation and pride. Moreover, his very presence is a testimony to the failure of society to provide an honorable and meaningful role for some of its choice spirits, thus enhancing our sympathy for the hero's own initial alienation from society.

The escapee mediates between the hero and the town and in doing so represents some of the ambiguous feelings toward society that the Western embodies. A third type of town figure symbolizes the negative side of civilization. This is the unscrupulous banker, rancher or railroad agent who sometimes plays the role of central villain by becoming the employer or manipulator of the Indians or outlaws who actually perform the acts of savagery. This figure represents the decent ideals of the pioneer gone sour. In him the pioneer goal of building a good society in the wilderness has become avarice and greed for individual wealth and power. Instead of the pioneer's mutual respect and loyalty, the banker-villain possesses skill at manipulating and exploiting the townspeople to his own advantage. This figure appears as the tyrannical rancher Luke Fletcher in Schaefer's *Shane,* as the grasping banker in Richard Wilson's *Invitation to a Gunfighter,* as both the evil gambler Durade and the avaricious capitalist Lee in Zane Grey's *The U. P. Trail.* Sometimes he is the unscrupulous Indian agent who makes corrupt bargains with Indians on the warpath, or the mortgage forecloser who drives the romanticized outlaw into a life of crime. It is tempting to say that in the twentieth century this townsman-villain has increasingly usurped the traditional role of the savage as villain, but this would be an overstatement, for the banker-villain was implicit in the Western from the beginning. In *The Pioneers* Cooper clearly foreshadowed this figure in the scheming lawyer Hiram Doolittle and the greedy miner Jotham Riddle. In the dime novel, this character was a favorite villain. Characters like Hon. Cecil

Grosvenor of *Deadwood Dick on Deck* resemble such recurrent adversaries in the Horatio Alger stories as the greedy squire or avaricious relative who seeks to exploit the Alger hero by keeping him in a servile position. In Alger, this character's plot is foiled when the hero makes contact with the benevolent merchant (Alger's analogue to the pioneers).

The second major character role in the Western is the savage. In his simplest form the savage is the bloodthirsty Indian or lawless outlaw who is the irreconcilable adversary of hero and townspeople. While some Westerns do not get much beyond the simple opposition of good hero and evil savages, the relationship is rather more complex in most examples of the formula. The savages are not invariably villains, for, beginning with Cooper the idea of the noble savage played an important role in the tradition of the Western manifesting itself variously in virtuous Indians and "good" outlaws who exist in complex counterpoint with the evil savages. This double view of the savage mirrors the double meaning of wilderness on which I have already commented. The presence of both noble and diabolical manifestations of savagery reflects the same kind of ambiguity about the progress of civilization that I noted in discussing the townspeople. The savage symbolizes the violence, brutality and ignorance that civilized society seeks to control and eliminate. However, the Indian and even, sometimes, the outlaw, also commonly stand for certain positive values which are restricted or destroyed by advancing civilization: the freedom and spontaneity of wilderness life, the sense of personal honor and individual mastery, and the deep camaraderie of men untrammeled by domestic ties.

Whether violent or noble the savage must vanish, but in one case we rejoice and in the other feel nostalgically sorry. Two major modes of the Western derive from this distinction. There is the comic-heroic in novels like Wister's *The Virginian,* where the hero destroys the bad outlaws and achieves a synthesis between noble savagery and civilization in his own person. The second major mode is that of the elegiac which dominates the novels of Cooper and many recent Westerns. Here the imperatives of civilization and the good values of savagery prove irreconcilable and we are invited to lament the passing of these values as the price to be paid for civilization.

It is possible to have Westerns without Indians or outlaws, but some character must play the role of savage, for the antithesis between townspeople and savagery is the source of plots. Frequently we have a character change from savage to hero in the course of the story. For example, in John Ford's *Three Godfathers,* the three central characters are wild outlaws in flight from the law at the beginning of the film. Fleeing across the desert they come upon a lost woman who gives birth to a child and

then dies after having made the three outlaws promise to care for the baby. Accepting this responsibility changes the outlaws from savages into heroes by placing them in that typical posture of the Western hero: a situation of divided commitment. As outlaws they are committed to battling with the law, as godfathers to the peaceful domesticity of civilization. In resolving this conflict the film makes use of the comic-heroic mode of the Western. Two of the outlaws are killed while heroically struggling to bring the child safely across the desert. The third arrives in "New Jerusalem" where he refuses to give the child to anyone else for adoption, even though the judge tempts him with a suspended sentence. This proof of a basic commitment to domesticity enables the judge to mete out a minimal sentence and the movie ends happily with the whole town turned out to see the outlaw hero off to prison.

The role of savage is more or less interchangeable between Indians or outlaws since both groups are associated with lawlessness, a love of violence, and rejection of the town's settled way of life. More positively, the savages usually have the capacity to live and move freely in the wilderness, mastery of the tools of violence and strong masculinity. Insofar as the Western writer chooses to emphasize the villainous qualities of the savage it is primarily through his ruthless violence. When the writer wishes to present the nobility of savagery, he usually stresses the savage's code of personal honor and his complete physical courage in defending his honor, those qualities that relate him to the hero. In the twentieth-century Western, the outlaw has increasingly taken over the role of the "bad" savage, while the Indian seems more and more to embody the positive virtues of savagery. This reverses a relation common in the nineteenth-century dime novel in which the outlaw was often romanticized as a noble outcast and the Indian treated as a diabolical villain.

Another important aspect of savagery in the Western formula is its relation to madness. Cooper sometimes used this connection to distinguish between his noble and vicious savages. In *The Last of the Mohicans,* the noble savages Uncas and Chingachgook can be as bloodthirsty as the villainous Mingos but remain different because they are motivated by a code of personal honor. On the other hand, the diabolical Magua, their adversary, is obsessed by a mad desire for power and vengeance. The symbolic role of madness has flickered in and out of the Western throughout its history attaching itself to such varied figures as the nineteenth-century "Indian-hater" and the psychotic outlaw of the later Western. In general, its function seems to be one of distinguishing between the hero's disciplined and moral use of violence and the uncontrollable aggression that marks the "bad" savage. Both madness and savagery are forms of reaction against the lawful order of the town.

In the simplest Westerns, the townspeople and the savages represent a basic moral opposition between good and evil. In most examples of the genre, however, the opposition involves a more complex dialectic between contrasting ways of life or psychic states. The resolution of this opposition is the work of the hero. Thus the most basic definition of the hero role in the Western is as the character that resolves the conflict between pioneers and savages. Because there is a considerable range of complexity in the definition of this conflict, there is also a considerable range in the characterization of the hero. Thus the Western hero might be classified along a scale which runs from Hopalong Cassidy and the Lone Ranger to much more complex figures like Cooper's Natty Bumppo, Jimmy Ringo of Henry King's *The Gunfighter* and Tom Doniphon of John Ford's *The Man Who Shot Liberty Valance*. The Hopalong Cassidy-Lone Ranger figure is a character of minimal ambiguity. He is supremely good and masterful in his skills. His commitment to the pioneer cause creates no inner conflict, though this kind of Western often employs a simple device like the seeming outlawry of the Lone Ranger and Deadwood Dick to cast a mythical aura about the hero. This hero's difficulties spring primarily from the plots of the unregenerate savages and banker-villains who are the pioneers' adversaries. In the end these problems are resolved by a dazzling display of the hero's virtuosity in violence as in the climactic scene of *Hopalong Cassidy and the Forty Thieves,* where Hoppy shoots it out with a town full of outlaws and emerges victorious.

At the other end of the scale, the hero is a more complex figure because he has internalized the conflict between savagery and civilization. His inner conflict between the new values of civilization and the personal heroism and honor of the old wilderness tends to overshadow the clash between savages and townspeople. While he undertakes to protect and save the pioneers, this type of hero also senses that his own feelings and his special quality as a hero are bound up with the wilderness life. The outcome of Westerns which present this version of the hero is invariably more ambiguous and tragic. If we look for mythical archetypes for the Western hero, we might compare the Lone Ranger type with Perseus or Bellerophon, dragon-slaying bravos who have been provided with magical steeds and other aids by the gods and who face mainly strategic or technological problems in accomplishing their missions. Once they have managed to acquire the appropriate silver bullets or magic helmets they are able to move directly and without ambiguity to the destruction of the savage monster.

The archetype of the more complex Western hero would have to be a mythical figure more like Achilles, that great warrior torn between his loyalty to the Achaeans and his transcendent sense of personal honor.

When he is finally drawn into the conflict that will destroy him, his former joy in violence and war become a bitter and resigned acceptance of fate. This more complex Western hero is rather more elegiac than tragic and he does not reach the profound depths of grief and knowledge that Achilles does, but the similarity is unmistakable.

The tragic power of Homer's Achilles lies in the degree to which his fate confronts us with the inescapable mystery of life, the terrible limitations of the human desire for immortality and the inextricable relation between glory and death. Achilles' predicament of Achilles embodies these paradoxes in the most overpowering and universal terms. In the Western story, however, the hero's situation is linked to a particular period of history with its limited way of life. Achilles' problem would no more be resolved by a change in social conditions, than Hamlet would have lived happily ever after if he could only have availed himself of the services of a good psychoanalyst. But this is more or less the way we are made to see the Western hero. Insofar as he is the embodiment of a particular moment in history his failure or tragedy can make us sad, but it does not forcibly bring us face to face with ourselves and our lives. In the destruction of the gunfighter or the sad departure of Shane, we lament the hero's fate, and we feel nostalgic about the passing of a time when men were men, but at the same time we see their sacrifice as a necessary contribution to progress. Besides, even in losing they have been victorious over the villain. Their fate is not ours. Nonetheless, of all the popular action-adventure formulas, the Western sometimes comes closest to tragedy.

Between the eternally victorious Lone Ranger and the more ambiguous and tragic gunfighter, there exists a whole range of Western heroes more complex than the masked rider but less tragic than the gunfighter. Various types emerge from the variety of Western heroes. One is the wild cowboy who becomes a pioneer leader, frequently by marrying the schoolmarm. The classic embodiment of this hero is Wister's Virginian. Another type is the dude who comes to the West and becomes a true hero. This type starts out as an Easterner, usually a very aristocratic one. He has come to the West because he feels that his way of life has become corrupt and decadent and he seeks regeneration in the great, open spaces. Gradually, he becomes an initiate of the Code of the West, and by the end of the story he has become a cowboy of cowboys. This version of the hero can be found in such novels as Harold Bell Wright's *When a Man's a Man,* and in many of the stories of Zane Grey. He is of particular cultural interest because he was partly inspired by the actual western odysseys of a number of prominent eastern aristocrats. G. Edward White shows in *The Eastern Establishment and the Western*

Experience that Owen Wister, Theodore Roosevelt and Frederic Remington all made this pilgrimage to the West at the end of the nineteenth century.

The hero is a man with a horse and the horse is his direct tie to the freedom of the wilderness, for it embodies his ability to move freely across it and to dominate and control its spirit. The cowboy's special relationship to his horse suggests that human fantasy of unity with natural creatures seen in the centaurs of Greek mythology, in Siegfried's ability to understand the language of birds and in a hero whose popularity was contemporaneous with the flourishing of the Western: Tarzan of the Apes.

In addition, though the cowboy hero's actual work is never much of a presence in Westerns, his connection with horses and cattle is symbolically significant for they relate him to an ageless world of traditional work and pastoralism as well as to the symbolic wilderness. Some of the attractiveness of the cowboy figure derives from nostalgia for a vanishing way of life centered around the farm and work with animals and the soil. Until the twentieth century these activities were the concern of more people over a longer period of human history than any other. Wister thought of the cowboy as "the last romantic figure on our soil." He feared that the world replacing him was "a shapeless state, a condition of men and manners unlovely as that bald moment in the year when winter is gone and spring not come and the face of Nature is ugly" (xlviii). Like many of his contemporaries Wister evidently hoped that the ugly early stages of industrialism and urbanization would give way to a regenerated American life in which some of the traditional morals and manners represented by country life and the cowboy might be restored. The American twentieth-century flight to the suburbs, which sought to recreate some of the patterns of rural life on the outskirts of the city, was a similar response. It is significant that the heyday of the Western was also the climactic period of white suburbanization in America.

The Western hero is also primarily a man with a gun. The interaction of American attitudes toward violence and the image of the Western gunfighter is very complex. Critics of violence in the mass media once believed that the heroic violence of the Western hero was a dangerous model for young people and stimulated them to imitation of the man with the gun. Defenders of the mass media argued that Westerns simply reflected the culture's fascination with guns. Today, the violence of the Western seems pretty mild compared to the Armageddons typically enacted by its successors, the contemporary and futuristic war and crime thrillers centered around a new type of violent hero played by such stars as Sylvester Stallone, Arnold Schwarzenegger and Bruce Willis.

These films make most traditional Westerns seem peaceful by comparison and lead contemporary critics of film and television violence to look back with some nostalgia to what they now see as the much more moral and ordered violence of Westerns. However, in a less extreme fashion, Westerns may well have reflected the same larger cultural concern that even more intensely haunts these contemporary films of the 1990s: the sense of decaying masculine potency which has long obsessed American culture. The American obsession with masculinity appears in many aspects of our culture from serious artists like Ernest Hemingway to the immense range of gutsy men's magazines, Playboy images, and mass sports. It reflects a number of major social trends that undercut the sense of male security. Industrial work depends increasingly on the superior potency of machines, women are of increasing importance in the industrial economy, and the nationalizing trend of American life has eroded local communities and the individual's sense of control over his life. Finally the decline of parental authority in the family has undercut the basic source of masculine supremacy. Yet, at the same time, the American tradition has always emphasized individual masculine force; Americans love to think of themselves as pioneers, men who have conquered a continent and sired on it a new society. This radical discrepancy between the sense of eroding masculinity and the view of America as a great history of men against the wilderness has created the need for a means of symbolic expression of masculine potency in an unmistakable way. This means the gun, particularly the six-gun.

Walter Prescott Webb suggested that the development of Colt's revolver was the critical invention making possible the American assault on the Great Plains. As Webb sees it, the Plains Indians with their extraordinary skill with horses and the bow and arrow had a mobility and firepower unequalled until the adoption of the six-gun by the Texas Rangers. From that point on the Americans had a military advantage over the Plains Indians and the rapid development of the "Cattle Kingdom" followed. The historical and cultural significance of the gun as the means by which the cowboy drove out the Indian inhabitants of the plains shaped a new culture that grew out of the long tradition of chivalry and masculine honor, and its later offshoot, the code of the duel. According to Webb, the Westerner's six-gun and his way of using it in individual combat was the closest thing in the armory of modern violence to the knight's sword and the duelist's pistol. Thus in a period when violence in war was becoming increasingly anonymous and incomprehensible with massed attacks and artillery duels accounting for most of the casualties, the cowboy hero in his isolated combat with Indian or outlaw seemed to reaffirm the traditional image of masculine

strength, honor and moral violence. Standing between the uncontrolled violence of the savages and the evolving collective forces of the legal process the cowboy hero could be seen in terms of the older image of chivalrous adventure. Not surprisingly an age which so enjoyed the historical romances of Sir Walter Scott would color the cowboy with tints freely borrowed from *Ivanhoe* and *Rob Roy*.

Many critics of the Western have commented upon the gun as a phallic symbol. This bears out the emphasis on masculine potency already noted. However, this kind of phallic symbolism is an almost universal property of adventure heroes. The knight has his sword, the hard-boiled detective his automatic pistol, Buck Rogers his ray gun. The distinctive characteristic of the cowboy hero is not his possession of a symbolic weapon but the way in which he uses it.

While the knight encountered his adversary in bloody hand-to-hand combat, the cowboy usually meets his at a distance and goes through the complex and rigid ritual of the "draw" before finally consummating the fatal deed. The most important implication of this killing procedure seems to be the qualities of reluctance, control and elegance that it associates with the hero. Unlike the knight, the cowboy hero does not seek out combat for its own sake and he typically shows an aversion to the wanton shedding of blood. Killing is an act forced upon him and he carries it out with the precision and skill of a surgeon and the careful proportions of an artist. The six-gun is a weapon that enables the hero to show objectivity and detachment while yet engaging in individual combat. This controlled and aesthetic mode of killing is particularly important as the supreme mark of differentiation between the hero and the savage. The Indian or outlaw as savage delights in slaughter, entering into combat with a kind of manic glee to fulfill an uncontrolled lust for blood. The hero rarely engages in violence until the last moment and he never kills until the savage's gun has already cleared his holster. Suddenly it is there and the villain crumples.

This peculiar emphasis on the hero's skilled and detached killing from a distance has been a part of the Western since its inception. One thinks, for example, of that climactic scene in *The Last of the Mohicans* where Leatherstocking picks the villainous Magua off the cliff top with a single shot from his unerring long rifle. The cowboy hero fights in a little closer within the smaller range of the six-gun, but the same basic pattern of individual combat at a distance with the hero's last-minute precision and control defeating the villain's undisciplined and savage aggression is the same. Careful staging of this final duel with all its elaborate protocol became a high point of the film Western, an element of the literary Western that turned out to have even greater potential for the film.

The hero sometimes fights with his fists at an earlier point in the action, but he never kills in this kind of direct hand-to-hand combat. Moreover, he rarely uses any weapon other than his fists, since knives and clubs suggest a more aggressive and uncontrolled kind of violence that seems wrong for the character of the cowboy hero. Thus, the hero's special skill at gun fighting not only symbolizes his masculine potency, but also indicates that his violence is disciplined and pure.

Thus, the old ideal of knightly purity and chastity survives in the cowboy hero's basic aversion to the grosser and dirtier forms of violence. In addition, the hero's reluctant but aesthetic approach to killing seems to reflect the ambiguity about violence pervading modern society. Twentieth-century America is perhaps the most ideologically pacifistic nation in history. Its political and social values are antimilitaristic, its legal ideals reject personal violence and it sees itself as a nation dedicated to world peace and domestic harmony through law and order. Yet this same nation supports one of the largest military establishments in history, its rate of violent crimes is enormously high and it possesses the technological capacity to destroy the world. Perhaps one source of the cowboy hero's appeal is the way in which he resolves this ambiguity by giving a sense of moral significance and order to violence. He is a reluctant killer who shoots only when he is forced to it. Even then, he imposes an aesthetic order upon his acts of violence through the abstract ritual of the shootout. Finally, his mode of killing cleanly and purely at a distance through the magic of his six-gun covers the nakedness of violence and aggression beneath a skin of aesthetic and moral propriety. These patterns were particularly important in the Western during the period of the 1940s through the 1960s when the genre was often interpreted as an allegory of America's role on the international scene.

Certain other characteristics were connected with the hero's role as middleman between the pacifistic townspeople and the violent savages. There is his oft-noted laconic style, for example. Not all Western heroes are tightlipped strong, silent types. Some, like Leatherstocking, are downright garrulous. But the laconic style was popularized by Wister in *The Virginian* and became a *sine qua non* of the twentieth-century Western hero. Stars like Gary Cooper, John Wayne, James Stewart, Henry Fonda and Clint Eastwood seemed to be holding a contest for who could say the fewest words with the least expression. Tight lips were far more appropriate for the Western hero than the torrent of didacticism that flows from the lips of Natty Bumppo, which most readers of Cooper resolutely ignore. Like his gun, language is a weapon the hero rarely uses, but when he does, it is with precise and powerful effectiveness. In addi-

tion, the hero's taciturnity reflects his social isolation and his reluctance to commit himself to the action that he knows will invariably lead to another violent confrontation.

Reluctance with words often matches the hero's reluctance toward women. As Smith points out in *Virgin Land* Cooper had a lot of trouble imagining Leatherstocking's relation to the fair sex. The one girl Natty falls in love with, Mabel Dunham in *The Pathfinder,* is too young and civilized to return his love and he gives her up to the younger, less wilderness loving, but appropriately named Jasper Western. On the other hand, the one girl who falls in love with Natty, Judith Hutter in *The Deerslayer,* is too wild and too passionate to capture the affection of the chaste and pure Leatherstocking. This romantic situation reflects Natty's position as a man who mediates between civilization and wilderness. Cooper found it increasingly difficult to resolve this antithesis and Natty remained caught in the middle between his beloved forest and the oncoming civilization that he had served.

In other periods, writers made their Western heroes into lovers, as in Wister's *The Virginian,* many of the novels of Zane Grey, and in the films of Tom Mix and W. S. Hart. However, even when the hero does get the girl, the clash between the hero's adherence to the "Code of the West" and the heroine's commitment to domesticity, social success or other genteel values usually play a role in the story. Heroes such as the Lone Ranger tend to avoid romance altogether.

The Western hero's true social milieu, until he is transformed by the commitment to civilization forced on him in the course of the story, is the group of masculine comrades, the boys at the ranch, the other horse soldiers, or the Indian sidekicks. However much he may be alienated from the town, the hero almost never appears without some kind of membership in a group of males. Often the group of comrades represents a marginal or alienated social class with an ethnic or national background different from that of the hero: the WASP cavalry officer has his Irish sergeant, the cowboy has his Indian, Mexican and in some recent Westerns his African American companions. Leslie Fiedler shows how the theme of good companionship between outcast white and men of darker skin plays a complex role in American literature by pointing to such examples as Cooper's Natty Bumppo and his Indian friend Chingachgook, Melville's Ishmael and the South Sea Islander Queequeg, Mark Twain's Huck Finn and Jim, Faulkner's Ike McCaslin and Sam Fathers. Fiedler argues that this relationship "symbolically joins the white man to nature and his own unconscious . . . and binds him in lifelong loyalty to a helpmeet, without the sacrifice of his freedom. This is the pure marriage of males—sexless and holy, a kind of countermatri-

mony, in which the white refugee from society and the darkskinned primitive are joined till death do them part" (*Love and Death* 211).

According to Fiedler, this theme is an implicit attack on middle-class ideals of gentility, success and domesticity that repress natural instincts and threaten masculine identity. As we have seen, the concern for masculine potency and the representation of a conflict between civilized order and savage freedom also play a vital role in the Western. However, the generic Western usually attempts to resolve this conflict and to evade some of its deeper implications. While there are Westerns in which the hero remains an outcast, it is more usual for him to move from the milieu of masculine comrades into a commitment to the town and even into a romance.

Though the Western often sought to evade the racial or radical undertones that Fiedler sees as typical of the treatment of masculine comradeship in American literature, association with the boys remained one of the most important aspects of the hero's life and style. Not only do the hero's ties of friendship motivate much of his behavior, but in most cases the great sense of honor and adherence to a highly disciplined code of behavior which sharply differentiates hero from savages and outlaws springs from his association with the masculine group. The "Code of the West" is in every respect a male ethic and its values and prescriptions relate primarily to relationships between men. In theory the code prescribes a role for women as an adjunct to masculine honor. Nevertheless the presence of women usually threatens the primacy of the masculine group. In many Westerns an interesting resolution of this conflict is worked out. The woman in effect takes over the role of the masculine comrades and becomes the hero's true companion. A good example of this is the case of the heroine Georgianna Stockwell of Zane Grey's *The Code of the West*. When she comes West, Georgiana is a flapper. Her promiscuity in word, though not in deed, sets her in complete opposition to the "Code." After nearly destroying young Cal Thurman, who falls in love with her, Georgianna realizes that her moral outlook has been wrong and that she has herself fallen in love with the simple but dedicated Cal. Once this transformation has taken place, the false eastern sophistication which placed Georgianna in opposition to the "Code" disappears and the strength of her new character enables her to confront the villain who threatens to kill her wounded husband. In effect Georgianna Stockwell becomes one of the boys herself and her final confrontation with Bid Hatfield takes the place of the usual shootdown. While this is an extreme transformation of the female heroine from a threat into a true comrade, the theme is a common one in those Westerns where the hero plays a romantic role.

The hero's membership in the masculine gang and his initial rejection of domesticity relates to another trait he commonly possesses: his desire to keep moving. Just as Natty Bumppo felt he had to move on when the settlers's cabins began to impinge on his wilderness, so the modern cowboy hero is represented as a bit of a drifter. As one of his pals tells the hero in Ernest Haycox's *The Man in the Saddle:* "That's your trouble. Always goin' off to take another look at a piece of country. Fiddlefooted. Always smellin' the wind for scent. And so you lose out" (9). This quotation neatly sums up the cowboy hero's instinctive rejection of the ethic of success at least in the early stages of the story. The cowboy hero is far from a hero of work and enterprise. Indeed he is rarely represented as working at all. Nonetheless, the formula requires that the hero somehow possess the necessary funds to maintain horses, food, ammunition and elegant costumes, though it is rarely clear just where or how he gets this money. In a more or less realistic narrative of cowboy life like Andy Adams' *Log of a Cowboy* or in Erwin Smith's photographs of cowboys in action, the thing that stands out most strikingly in comparison to the formula Western is the amount of hard, dirty, physical labor involved. As Robert Warshow puts it, "the Westerner is par excellence a man of leisure. Even when he wears the badge of a marshal or, more rarely, owns a ranch, he appears to be unemployed" (Warshow 92). Thus, in many respects the cowboy hero represents an image of man directly opposed to the official American pioneer virtues of progress, success and domesticity. In place of "getting ahead" he pursues the ideal of honor which he shares with his masculine comrades. Warshow neatly summarizes this aspect of the hero's character:

he fights not for advantage and not for the right, but to state what he is, and he must live in a world which permits that statement. The Westerner is the last gentleman and the movies which over and over tell his story are probably the last art form in which the concept of honor retains its strength. (94)

Even in this case, however, the tendency of popular formulas is to seek for a resolution of thematic conflicts or to evade them altogether. However, Westerns increasingly carried the antithesis between success and honor to its inevitable conclusion: the destruction or exile of the hero from the developing town which can no longer permit the explosions of individual will and aggression necessary to the defense of heroic honor.

In earlier Westerns a way was more typically found to reconcile hero and town and to assimilate the cowboy hero into the world of the pioneers. There are innumerable plot devices that perform this function. The hero falls in love and becomes committed to the pioneer cause. The

woman falls in love with the hero and her dedication to him enables her to take over the role of the true male companions. Or the hero simply becomes old and tired and decides that it is finally time to settle down.

Different periods in the history of the Western seemingly preferred different kinds of resolutions. For example, the early twentieth century usually solved the hero's clash of values through romance, while later Westerns more often favored the hero who reluctantly gives up the heroic way of life either because he accepts the necessity of civilization or because he is tired of insecurity. This type of hero often shaded over into the sacrificial hero who accepted death or exile because he could not ultimately reconcile the conflict between the town and his heroism. It was in treating this version of the Western hero that the formula Western commonly reached its most moving and significant level as art, a quality that Warshow brilliantly defines in his essay on the Western hero:

The Westerner is a . . . classical figure, self-contained and limited to begin with, seeking not to extend his domination but only to assert his personal value, and his tragedy lies in the fact that even this circumscribed demand cannot be fully realized. Since the Westerner is not a murderer but (most of the time) a man of virtue, and since he is always prepared for defeat, he retains his inner invulnerability and his story need not end with his death (and usually does not); but what we finally respond to is not his victory but his defeat. (96)

3. Types of Situation and Patterns of Action

As these remarks on the variety of herotypes indicate, a great variety of situations and plots that can be made into Westerns as long as the basic conventions of setting and character relations are maintained. Thus our treatment of situation and pattern of action can be very general and brief here. There is a kind of basic Western situation that develops out of what I have called the epic moment when society stands balanced against the savage wilderness. The situation involves a hero who possesses some of the urges toward violence as well as the skills, heroism and personal honor ascribed to the wilderness way of life. It places this hero in a position where he becomes involved with or committed to the agents and values of civilization. The nature of this situation, and of the conflict between town and wilderness which lies behind it imply that the formulaic pattern of action is that of chase and pursuit because it is in this pattern that the clash of savages and townspeople manifests itself. The savages attack the town and are pursued by the pioneers. Some of the pioneers leave the town and are pursued by the savages. The savages capture one or more of the townspeople and are pursued by the hero. An infinite number of variations are possible within the pattern of capture,

flight and pursuit and the great majority of Westerns are structured around one or more of these types of action.

Perhaps the most typical of all such patterns is that of the alternating flight and pursuit. The outlaws or Indians attack the town and are pursued by the hero and the pioneers; something happens to reverse the situation, an ambush or a mistaken splitting of forces, and the pursuers become the pursued. Finally, the hero succeeds in isolating the true villain from the group of savages and the situation reverses a third time, the hero's pursuit leading to the final confrontation that resolves the story. This built-in structural emphasis on the chase is of course one major reason why the Western has proved so adaptable to film and television presentation. Within these broad outlines the Western has been capable of absorbing many different plots from many different kinds of literature while retaining the flavor of a Western. Or to put it another way, so long as a story can be adapted to Western settings and characters and somehow reduced to the terms of flight, capture and pursuit almost anything can be reduced to a Western. Television Westerns in particular have adapted plots from every conceivable source; I recall one episode of *Bonanza* where the plot was clearly derived from a combination of Mary Shelley's *Frankenstein* and John Steinbeck's *Of Mice and Men* manipulated in such a way as to manifest a large proportion of pursuit. Such farfetched adaptations are generally inferior to Westerns that develop plots more directly articulating the implicit conflicts of the setting and character roles, but the possible range of Western plots is nonetheless quite wide.

IV

These, then, were the chief characteristics of the Western formula: a particular kind of setting, situation, and cast of characters with a strong emphasis on a certain kind of hero. I have indicated several ways in which this combination of elements possesses great dramatic power and unity. In the hands of skillful writers and directors who instinctively understood these relationships and knew how to exploit them, Westerns could become highly effective works of art. Their actions were capable of arousing strong feelings, their quality of spectacle imparted an epic sense to these actions and their structures were simple and clear enough to be widely understood and appreciated, even by children. This artistic power of unity of character, setting and action was surely the major source of the Western's longterm popularity as a formula.

However, though the intrinsic dramatic vigor and unity of the Western formula played the major role in its success, this is not the whole story of the Western's popularity. For we must still ask why a particular artistic form or structure of conventions possessed dramatic power for

the audiences who enjoyed it, and what sort of dramatic power this was. There seem to be two levels on which this question can be answered. First, we can refer a particular form to some universal conception of types or genres, based presumably on innate qualities or characteristics of the human psyche. According to the approach followed by various literary theorists from Aristotle to Northrop Frye, a particular work or group of works becomes successful insofar as it effectively carries out an archetypal structure. The archetype is based on innate human capacities and needs or on fundamental and universal patterns of experience. Using such a universal system as that suggested in Northrop Frye's *Anatomy of Criticism*, it is fairly simple to outline the relationship between the Western and archetypal forms. The Western is clearly an example of what Frye calls the mythos of romance, a narrative and dramatic structure which he characterizes as one of the four central myths or story forms in literature, the other three being comedy, tragedy and irony. As Frye defines it, "the essential element of plot in romance is adventure" (186), and the major adventure that gives form to the romance is the quest. Frye postulates that "the complete form of the romance is clearly the successful quest, and such a completed form has three main stages: the stage of the perilous journey and the preliminary minor adventures; the crucial struggle, usually some kind of battle in which either the hero or his foe, or both, must die; and the exaltation of the hero" (186). These characteristics certainly fit the Western. The central action of chase and pursuit dramatizes the quest. The climactic shootout embodies the crucial battle. Finally, the movement of the hero from alienation to commitment is an example of the "recognition of the hero, who has clearly proved himself to be a hero even if he does not survive the conflict" (186).

Other characteristics of romance, as Frye defines them, are also clearly present in the Western. The struggle between hero and villain; the tendency to present both figures as coming not from the town but from the surrounding landscape; the way in which the hero's action is commonly associated with the establishment of law and order. These qualities also relate the Western to romances of many different cultures and periods:

The central form of romance is dialectical: everything is focussed on a conflict between the hero and his enemy, and all the reader's values are bound up with the hero. Hence the hero of romance is analogous to the mythical Messiah or deliverer who comes from an upper world, and his enemy is analogous to the demonic powers of a lower world. The conflict however takes place in, or at any rate primarily concerns, our world in the middle. (186)

Even smaller details of the basic pattern of romance discussed by Frye find their echo in the Western. The contrast between schoolmarm and dancehall girl shows "a polarization may thus be set up between the lady of duty and the lady of pleasure." The central role of the horse is reflected in Frye's observation that "the dragon [has] his opposite in the friendly or helping animals that are so conspicuous in romance, among which the horse who gets the hero to his quest has naturally a central place." Finally, there is the noble Indian, the natural man who lends some of his power to the hero: "the characters who elude the moral antithesis of heroism and villainy generally are or suggest spirits of nature. They represent partly the moral neutrality of the intermediate world of nature and partly a world of mystery which is glimpsed but never seen, and which retreats when approached. . . . Such characters are, more or less, children of nature who can be brought to serve the hero" (196-97).

Many Western writers have been fully aware of the relationship between the cowboy and the traditional figures of romance. Owen Wister, who created his influential Virginian at least partly in the model of the chivalric knight of the middle ages, explicitly expressed this relationship in his essay on "The Evolution of the CowPuncher":

No doubt Sir Launcelot bore himself with a grace and breeding of which our unpolished fellow of the cattle trail has only the latent possibility; but in personal daring and in skill as to the horse, the knight and the cowboy are nothing but the same Saxon of different environments, the polished man in London and the man unpolished in Texas; and no hoof in Sir Thomas Mallory shakes the crumbling plains with quadruped sounds more valiant than the galloping that has echoed from the Rio Grande to the Big Horn Mountains. (*Red Men and White* xxvii)

Though we can probably ascribe some of the shape and effectiveness of the Western to its embodiment of a literary pattern with widespread appeal in many different cultures, we still need to explain the particular cultural formulas that have shaped the Western genre. In addition to the genre's artistic unity and its relation to archetypal patterns, we must also examine some of its primary cultural dimensions.

Romance, as Frye indicates, has many different levels of complexity and sophistication. There are romances as elaborate and arcane as Spenser's *Fairie Queen* and as simple as the comic strip adventures of Superman and Batman. These differences in complexity and sophistication reflect the cultural area in which the romance functions. The romances of a leisured aristocratic class with elaborately developed manners are different from folktales that have grown out of homoge-

neous village cultures. The conditions of successful mass romances are, in turn, something else than aristocratic and folk romance. In heterogeneous modern societies, widely successful romances must be so constructed as to be accessible to diverse groups with divergent interests and values. Consequently they tend to resemble games in the clarity of their rules and patterns of action. This gamelike aspect of the formula permits anyone who knows the rules to enjoy and appreciate the fine points of play, as well as to experience the sense of ego enhancement that comes when "our side" wins. During much of the twentieth century, American children were instructed in the rules of the Western through children's games like "cowboys and Indians" from a very early age.

Popular genres also function as social rituals and this, too, played its part in the Western's success. Rituals reaffirm cultural values, resolve tensions and establish a sense of continuity between present and past. The Western, with its historical setting, its thematic emphasis on the establishment of law and order, and its resolution of the conflict between civilization and savagery on the frontier, was a kind of foundation ritual. It presented for our recurrent contemplation that epic moment when the frontier passed from the old way of life into the present. By dramatizing this moment, and associating it with the hero, the Western ritually reaffirmed the creation of America and explored not only what was gained, but what was lost in the movement of American history. Within its basic structure of resolution and reaffirmation, the Western confronted the many uncertainties and conflicts of values that troubled twentieth-century Americans.

The dialectical structure of the Western, its opposition of townspeople and savages with the hero in the middle, made possible the presentation and resolution of conflicting values. The same kind of plot patterns which made it possible for Cooper to explore his ambiguous feelings about civilization and nature, served Owen Wister's concern with the differences between traditional and modern American. Still later Westerns reflected midtwentieth-century conflicts about the relation between law and order and private violence, and about America's role in the world. Once Wister showed how the nineteenth-century Western formula could be resurrected from the dime novel, and made to embody contemporaneous adult attitudes and value conflicts, the Western became important as a popular mode of exploring and resolving cultural tensions. This continued down into the 1960s and 1970s with Westerns exploring some of the primary concerns of our own time such as racial conflict, issues of gender equality, and the Vietnam war.

The commercial circumstances of Western productions, its definition as popular entertainment, and the broad audience to which it

appealed placed a premium on the dramatic resolution of conflicts and the affirmation of existing cultural values. Until recently, the highly conventionalized tradition of the Western did not encourage new interpretations of the American past. Within its limits, the Western genre enabled skillful producers and directors to relate contemporaneous conflicts to a compelling vision of the American past. However, eventually the cultural conflicts the Western sought to contain became too great and the Western lost its ability to function as a social ritual.

Until the mid-1970s, the Western renewed its basic plot patterns in order to deal with changing cultural issues. We will discuss that process more fully in the next chapter, but here we can give some indication in a more general way of the relation between the Western and American social values by exploring how the Western typically resolved certain central American ambiguities.

One such ambiguity has centered around the idea of progress, an important concept of collective social development in America just as success has been a primary individual ideal. Both sets of values emphasize change and improvement; they celebrate leaving behind the past and the status quo for a better, richer, happier future. The hero of progress is the pioneer who struggles against hardships to advance civilization. Initially, the heroic pioneer was the farmer who faced the dangers of nature and the Indian to bring civilization to the frontier. Somewhat later, the westering farmer was transformed into the industrial pioneer, the industrialist and inventor who struggled to bring the country to a new technological level. The success ideal produced its hero in the self-made man, the poor country boy or immigrant who rose to wealth and power in the burgeoning city.

However, though progress and success were central values, the experience of many Americans did not after all coincide with them. For every self-made man, there were at least two who never made the leap out of the lower or lower-middle classes, and there was a third who experienced a progressive decline in wealth and status. Nor did progress invariably appear as a collective improvement. In actuality every advance benefited some groups while it seriously harmed others. For example, the advance of the agricultural frontier benefited many, but it destroyed the Indians and ruined those engaged in the fur trade. The development of industry was progressive for much of the middle-class but a threat to the traditional landed gentry and to the small entrepreneur. Many technological advances were ambiguously mixed blessings. Every important new invention greatly improved some aspects of life but brought with it a whole range of new problems. In general, then, every

individual success and every aspect of collective progress had its price. Some person or group had to pay the cost in economic loss, changed status or psychological readjustment to a new situation.

However, the ideals of progress and success had no room for those who didn't make it. On the whole, Americans, at least in their public faith, did not acknowledge the costs and ambiguities of progress and success. Faith in the guiding hand of divine providence and confidence in the special historical mission of their country assured them that progress and success were benevolent processes. Thus, those individuals who paid the cost, instead of being offered sympathy and compassion, were stigmatized as failures or even as villains. Groups who did not fit in with the general trend of social progress were forced to adjust or be eliminated. The destruction of the Indians and the exploitation of African Americans and some European immigrant groups represented in an extreme form the American way of exploiting minority groups to foster the advance of the white majority.

Though the public ideology had no meaningful consolation to offer those who suffered from progress, the experiences of failure and obsolescence were common enough that substantial groups of Americans did not accept the ideals of success and progress without reservation. The most articulate of these groups consisted of writers, intellectuals and members of social élites whose traditional authority was threatened by social change. In the nineteenth century both serious writers and status-threatened aristocrats had reason to be aware of the ambiguities of success and progress for they were certainly not among its beneficiaries. Nineteenth-century American novels often dealt with the cost of progress and the ambiguities of success. Cooper as both writer and member of the landed gentry sensed the loss of social authority claimed by his class. He created the first significant Western novels out of a thematic exploration of the cost of advancing civilization, which he saw in terms of the destruction of the wilderness and the loss of "natural" society. In still more complex ways, Hawthorne and Melville explored the implications of the ideal of progress and warned in their rich and dark allegories that its price was even greater on the moral and psychological level. In *Pierre,* Melville tried to analyze some of the ambiguities of success, taking as his protagonist that archetypal success-hero, the young man from the country coming to the city to make his way. But instead of fame and fortune, Melville's Pierre found horror and death. Later writers, Howells and his naturalistic followers in particular, explored the failure of success more fully, until Dreiser could portray the drive to succeed as the chief cause of the sordid and pathetic story of crime and punishment he called *An American Tragedy.*

Serious American literature, then, quickly became critical of the ideals of success and progress. For much of the nineteenth century, however, popular formula literature, those stories of adventure, domestic romance, sentiment and didacticism created by writers like T. S. Arthur, Mrs. Southworth and Horatio Alger, fully affirmed the dreams of success and progress. In the later nineteenth century, however, popular adventure stories began to develop another kind of fictional pattern. This pattern initially appeared in the pulps and dime novels which dealt with the adventures of benevolent outlaws like Deadwood Dick or which romanticized the violence of actual western badmen like Billy the Kid, Jesse James and Wild Bill Hickock. Typically in these stories the outlaw was represented as a decent person who had been unjustly treated by the rich and powerful, or by women. Often these stories represented the benevolent outlaw's discovery, judgment and punishment of the respectable villains whose treachery had originally branded him an outlaw.

There is doubtless some connection between this literature and the long tradition of sensational literature dealing with criminals and rogues, a literature which probably also expressed resentment and rebelliousness against the upper classes. However, the American glorification of the outlaw was significantly different from this tradition. The sensational literature of crime and roguery did not present the outlaw hero as a supremely moral man whose "crimes" were actually heroic acts of private justice. However much his skill and daring might be admired, the traditional rogue was an immoralist who rejected moral restraints whether they were manmade or decreed by God. Moreover, in most instances, the traditional rogue either reformed or came to a bad end. On the other hand, the benevolent outlaw, like the earlier mythical Robin Hood, not only proved to be the most honorable and moral character in the story, but he also usually defeated those who tried to use the cloak of respectability and legality to justify their evil acts.

The pattern of the marginal hero exposing corruption and decadence among the seemingly respectable members of society eventually developed into the contemporary Western. Rather than facing the ambiguities and failures of these ideals directly like Cooper, Melville, Howells and Dreiser, the creators of popular adventure fiction worked out a pattern of action that resolved the conflict between ideals of success and progress and the actual pressures and tensions of American life. By creating a marginal hero whose style of behavior and mode of life identified him with those individuals and groups who, like the cowboy, belonged to a class that was rapidly becoming obsolete through social progress, these writers created a hero whose predicament reflected the ambiguities of these ideals. However, instead of exploring the cost of success and

progress by representing their destructive impact on this hero, the creators of Westerns made their heroes into men of honor, physical strength and skill who were fully capable of withstanding the pressures and frustrations of their marginal social positions. Despite the pressure of temptation and threat, these heroes lived by an individual standard of justice and honor. With such a hero, the creators of Westerns were able to express their doubts about these ideals and at the same time reaffirm the essential benevolence of American progress. While the hero rejected many of the values of the pioneer and the self-made man, and had the courage and strength to act in accordance with his personal code, it was the pioneer and the self-made man who ultimately prevailed. Either the hero joined them and became himself a success, like Wister's Virginian, or he used his skill in violence to help found the pioneer community and then rode off into the desert, like Shane. From the point of view of social ritual, the Western's action typically offered the hero a choice between civilization with its ideals of progress and success and anarchistic savagery with its spontaneity and freedom. The ritual was accomplished when that hero, despite his own ambiguities about the new society, nonetheless chose to act in such a way as to further a social order based on the ideals of progress and success. Like many figures in American literature, the Western hero is something of an antihero to the self-made man and embodies strong feelings of hostility to the symbols and values of progress and success. Nonetheless his ritual role is one of resolving this hostility by concentrating it upon particular villains.

Though the Western remained officially on the side of progress and success, shifting generic patterns in the twentieth century reflected an increasing disillusion with these myths. In Wister, Zane Grey, Harold Bell Wright and many of the pulps of the twenties and thirties, the hero is a cowhand who, after proving his honor and independence, marries the schoolmarm or the rancher's daughter and settles down to become a self-made man, himself. Such Westerns clearly expressed the sense that there was a possible synthesis between social progress, success and the heroic virtues of individual honor and masculine independence. However, in the Westerns of the second half of the twentieth century, the ritualistic affirmation of progress and success became more and more ambiguous and strained. In gunfighter Westerns like Jack Schaefer's *Shane,* the hero destroyed the villains, but at the cost of his own relation to the new society. The heroic marshal found himself increasingly at odds with the pioneering townspeople whose avarice, selfishness and cowardice played a central thematic role in many later Westerns. Two of the most successful Westerns of 1969, *The Wild Bunch* and *Butch Cassidy and the Sundance Kid,* reversed the usual pat-

terns of the generic Western and presented the unregenerate, lawless outlaw as a sympathetic figure. Though the Western had often portrayed sympathetic outlaws in the course of its history, the outlaw heroes of these two films have fewer of the conventional marks of nobility and virtue than ever before. They are professional criminals rather than men driven to a life of crime by some wrong done them. Yet, since they represent a more spontaneous, individualistic and free way of life, their destruction by the brutal, massive and corrupt agencies of the state appears regrettable. Evidently, we have come to a point where it is increasingly difficult to imagine a synthesis between the honor and independence of the Western hero and the imperatives of progress and success, law and order. Such films accepted the inevitability of the new modern society, but suggested increasing disillusion and uncertainty about its consequences.

Though particularly central in later Westerns, the discrepancy between the demands of society and the heroic individual's honor and freedom has always been latent in the Western. The legendary Daniel Boone, inspiration of Cooper's Leatherstocking, appears in Caleb Bingham's famous painting at the head of the column of men, women and children bringing civilization to the wilderness of Kentucky. In this role Boone was the ultimate pioneer. Yet Boone, as the man who had to move further West because the other settlers kept getting too close, was the original subversive and exile from civilization. Put the two together and we have the Lone Ranger, a hero who fights to bring law and order to the West yet continually flees the very communities he has helped to found. This seemingly paradoxical aspect of the Western, this recurrent implicit contradiction of the surface message of affirmation, suggests how the Western both affirmed the necessity of law and order and asserted the need for heroic individual actions.

However, despite its ritual affirmation of the central values of American society, a tension remains which is never quite fully resolved, particularly in the most powerful and artistically significant Westerns. Sometimes this tension shows itself in a deep sense of loss. When Leatherstocking heads for the wilderness again, we cannot help but feel that for all of Cooper's assurances there is something lacking in the new social order. The same thing is true of Shane's disappearance, or the decline of Tom Doniphon in Ford's *The Man Who Shot Liberty Valance.* In other instances, like *The Virginian,* the resolution, though happy, is touched with a sense of artificiality and fantasy, as if it were a little too good to be true. These qualities of feeling, which are difficult to define precisely, reflect, I believe, a deeper aspect of popular formulas which is part of some sort of process of collective dreaming.

America in the twentieth century has had to confront a number of profound and disturbing ambiguities about violence in the history of our culture. The popular nineteenth-century vision of America as a redeemer nation bringing the world a new peace-loving Christian democracy, or the myth of the Westward movement as Anglo-Saxon conquest of the wilderness were compelling cultural self-images. Yet the vision contrasted profoundly with the reality of an inordinately high level of individual and social aggression, beginning with the revolution which created the new nation and continuing through domestic and foreign wars of moralistic conquest and the violent subjugation of black people and Indians. To preserve our self-image it has been necessary to disguise the realities of these historical movements under the masks of moral purity and social redemption through violence. There have always been many similarities between the justifying rhetoric used to defend American imperialism, both internal and external, and the basic patterns of the Western formula, as Richard Slotkin has brilliantly shown in his important study. Indeed, one of our basic nineteenth-century military and political goals, the expropriation of the Native American Indian, served as one major initial historical model for the Western.

These ambiguities created a need for a fictional pattern that would disguise the hero's aggressive impulses while permitting them a full and legitimated indulgence. This pattern has shaped many aspects of the Western formula, in particular the way in which it works toward a moral and stylistic differentiation of the hero's violence as legitimate and good, from that of the outlaws or savages. Many elements contribute to this differentiation. The hero is initially reluctant, he dislikes violence for its own sake and therefore the villain must force violence upon him. When it happens, the hero dispatches the villain in a controlled style that reveals the hero's strict code of honor and integrity in contrast to the villain's uncontrollable impulses.

It is unfair to dismiss all Westerns as simple fantasies of legitimated violence. Though this pattern may be one basic ingredient of the formula, serious writers and directors of Westerns struggled to bring the problem of individual and collective aggression to a level of conscious awareness and to explore it in a more profound and complex fashion. Thus, Robert Warshow is quite correct when he argues that the serious Western's major claim to a high level of artistic significance lies in the fact that "it offers a serious orientation to the problem of violence which can be found almost nowhere else in our culture" (103). While it is true that the commitment to romantic entertainment and to the figure of a transcendent hero made it difficult to do so, the best Westerns always managed to suggest a more complex recognition of the ambigui-

ties of violence than the formulaic fantasy of legitimated moralistic aggression.

V

In the preceding pages I have argued, in essence, that a popular formula like the Western cannot be understood as the effect of any single factor. However simple the formula may be, the artistic elements and the social and psychological implications it synthesizes are extremely complex. It seems clear no single social or psychological dynamic caused the Western's popularity any more than any one set of factors convincingly accounts for its recent decline. The Western's capacity to accommodate many different kinds of meaning, the archetypal pattern of heroic myth, the need for social ritual and for the disguised expression of latent motives and tensions made the genre successful as popular art and entertainment over several generations. No one of these factors was probably more basic than any other except perhaps the artistic. Above all, it was the ability of Western writers and filmmakers to respond creatively to changing cultural themes and concerns that mattered. With popular culture, as much as with the fine arts a genre needs the interest of original and imaginative artists who are capable of revitalizing its conventions and stereotypes to express contemporaneous concerns. Only by understanding that many factors have interacted in the complex process of the Western's evolution can we hope to understand the Western as a cultural phenomenon and as an artistic creation.

3

FROM MEDICINE BOW TO DALLAS:
THE WESTERN'S HISTORIC JOURNEY

The history of the Western can be analyzed in several different ways. It is possible, for example, to discuss the **myth** of the West, as Richard Slotkin does so brilliantly in his trilogy, *Regeneration Through Violence, The Fatal Environment,* and *Gunfighter Nation.* Such a study can include many things that would not necessarily be included in a study of the Western **genre.** Western art, music, and clothing as well as the many uses of the myth of the West in politics and other aspects of culture are not, as I define it, parts of the genre of the Western, but are important expressions of the **myth.** In *Virgin Land,* the central part of Smith's analysis was rightly based on the way the West was represented in political, economic and scientific documents.

The Western **genre,** which I defined in chapter two as a certain kind of story, has itself many different parameters, depending on how one deals with the origins of the genre and what media one chooses to focus upon. In some ways the history of the Western genre begins with that writer who many also see as the first major figure of American literature in general, James Fenimore Cooper. However, what we think of as the Western really started at the beginning of the twentieth century with Wister and others. In addition, it is possible to focus on particular phases of the genre, or on its expression in literature, in film, or in television. There are several good histories of the Western film by scholars such as Fenin and Everson, Jon Tuska and Kevin Brownlow. Other books, such as Christine Bold's *Selling the Wild West,* study Western fiction in novels and stories. There are also a number of studies of the Western on television by J. Fred McDonald and Ralph and Donna Brauer, and most notably Gary Yoggy's nearly definitive *Riding the Video Range: The Rise and Fall of the Western on Television.*

Excellent as many of these works are, they do not offer an overview of the Western genre's development in the three major media of fiction, film and television, as I will attempt to do in this chapter. I'll begin with the nineteenth-century origins of the generic Western and then try to account for the major phases of its development from the end of the

nineteenth century to its final flourishing in the aftermath of World War II. Here, with the great "classic" film Westerns of directors like John Ford, Howard Hawks and Anthony Mann and the virtual dominance of television in the late 1950s, the Western genre reached the peak of its development. In the fourth chapter, I will continue this story into the contemporary "Post-Western" period when the generic Western declined, though at the same time it continued to inspire the use of Western materials in a variety of new ways. One can imagine this development in good Western fashion as an epic journey between two imaginary [but also real] places. The first is Medicine Bow, still today a small and obscure town in one of many thinly settled areas of the state of Wyoming, but, in fiction, the place where the Eastern narrator of Owen Wister's *The Virginian* meets the heroic cowboy whose story he will tell. Medicine Bow is also the place where the hero, in the heat of a poker game with his antagonist Trampas, utters the immortal Western injunction, "smile when you say that." Dallas is, of course, a large Texas city and for our purposes, the setting of a highly popular television series which is still rerunning nightly both in America and in much of Europe. Much of the action of *Dallas* also takes place on a ranch, but this is no longer a pastoral scene where men use horses to work cattle, but a rich man's hobby which centers around a suburban mansion complete with swimming pool. The South Fork Ranch is supported by profits from the oil that fuels a modern technology gradually destroying whatever is left of the old West.

Other differences between *The Virginian* and *Dallas* highlight the transformations that the Western has undergone in the course of its development and point to some of the reasons why the traditional Western no longer functions as a primary myth of America. Wister's novel, like the vast majority of Westerns, is set in an epic moment from the immediate past that makes possible both personal and cultural regeneration through encounter with the West. It is a story of grand dramatic contrasts between heroes and villains, cowboys and Indians, Easterners and Westerners, and it eventuates in a climactic shootout which rids the town of marauding outlaws, and a successful romance between the schoolteacher from New England and the dashing cowboy. *Dallas,* on the other hand, portrays our own world of postmodernity in which the real action takes place in the clubs and boardrooms of city skyscrapers, where violent shootouts are replaced by devious plots and conspiracies. In this world, it is difficult to tell the heroes from the villains and the most popular character is the devious J. R. whose ruthless selfishness is moderated only by his incompetence. No unified climax of violence or romance brings redemption to this decadent world; instead corrupt strug-

gles for power on both the social and the personal levels lead to a soap opera-like succession of minor crises which are never fully resolved. *Dallas* is clearly a Post-Western, a story in which the trappings and symbols of the West have become separated from their original meanings and no longer evoke the mythic significance they once carried. *Dallas* reflects instead a world where accountants and brokers wear Stetson hats and cowboy boots, Indians operate gambling casinos, men work cattle from pickup trucks and jeeps, and in which the nearest wide open space is usually an air-conditioned sports arena. *Dallas* premiered in 1978 and was enormously successful. In fact, one might truly say that the mythical West was never the same again. Thus, the success of *Dallas* might be noted as one of the many things that ushered the traditional Western into the sunset. In that long journey from Medicine Bow to Dallas, the Western went through several important transformations.

1. Precursors and Origins: James Fenimore Cooper

When Owen Wister's narrator stepped off the train in Medicine Bow and inaugurated the modern Western, the epic myth of the West had long been a staple of American literature and popular culture. Though *The Virginian* was published in 1902 and the first Western film, *The Great Train Robbery,* appeared one year later in 1903, these "pioneering" modern Westerns had many precursors, including dime novels, earlier regional novels with Western settings and Buffalo Bill's enormously popular Wild West Show and its many imitators. Already in 1898 when Stephen Crane wrote "The Blue Hotel" and "The Bride Comes to Yellow Sky," the generic conventions were well enough established to inspire Crane's irony and satire.

These immediate precursors of the modern Western grew out of a long tradition of mythic narrative going back to the very threshold of the European occupation of America in the seventeenth century and to European myths about the New World even before that. Myths about the unique nature of the American "wilderness" and its "Indian" inhabitants had proliferated even before the first settlements in the early seventeenth century as studies by Henry Nash Smith, Wilcomb Washburn, Robert Berkhofer and others have shown. The first highly popular "Western" story was Mrs. Mary Rowlandson's 1682 narrative. As one of the first accounts of Indian captivity, Rowlandson's story established one of the themes which would be central to the Western tradition, the supposed threat of Native Americans to the welfare and morality of white women. This would become a central subject for the man who gave the incipient frontier myth its first major literary embodiment, James Fenimore Cooper.

The brilliance of Cooper's greatest inventions made him one of the most popular writers of the nineteenth century, outselling in some cases even his great rival Sir Walter Scott. Even up until World War II Cooper was still widely read by American young people outside the high school or college curriculum. The legion of Cooper's followers and successors in romanticizing the American wilderness—Henry Nash Smith calls them the "Sons of Leatherstocking"—have continued until recently to be an important part of popular culture both in America and in Europe. In fact, Cooper's stories continue to be successfully adapted to film and television: one recent cinematic adaptation of the Leatherstocking tales was a video series produced by the BBC, and another was a very successful film of *The Last of the Mohicans* directed by Michael Mann.

But what exactly did Cooper invent that his work continues to be a primary inspiration for the mythical treatment of the American West. Essentially, Cooper articulated the saga of America in terms of a complex myth of the frontier, which gains much of its richness and complexity from the anti-myth which it contains within itself.

Cooper's most striking creation was his hero, the Leatherstocking. Though based in part on the lives of such historical frontiersman as Daniel Boone, Cooper's Natty Bumppo became, in the course of the Leatherstocking saga, a unique protagonist for the mythical American frontier. The qualities of Cooper's hero were those of a "Lone Ranger" the title accorded one of his much later avatars, the masked Western hero of radio, film, and television. Leatherstocking is utterly alone in the world, except for his longtime Indian companion. (I use the word companion because it seems a bit strange to refer to the rather ritualistic relationship between Hawkeye and Chingachgook as friendship.) He is an orphan, and has no progeny. Though raised by the Indians, he does not consider himself in any way Indianized. He is a man "without a cross" —i.e., pure white—and has "different gifts" from the redskins. Indeed, in some of his statements about Indian ways, particularly with reference to the followers of such demonic characters as Magua in *The Last of the Mohicans,* he seems as racist as the most anti-Indian of the other white characters.

Significantly, though we do not know the exact social background of Bumppo's parents, it is clear that he is not a lost heir of some great aristocratic family, like the Oliver Edwards (Effingham) who he befriends in *The Pioneers*. On the contrary, he is a virtually nameless, or rather name-shifting, product of a frontier classlessness which stands in striking contrast to the hierarchical, gentrified, culture which Cooper felt was the appropriate social form for a more settled American democracy.

He is also a ranger. In the course of the Leatherstocking series Natty not only moves many miles across the wilderness in pursuit of, or escaping from, the Indians, but also across the continent from central New York State to the plains of Missouri. However, unlike most Americans his mobility is purely geographical. Socially, he does not rise or fall, succeed or fail. In fact, Leatherstocking uses his mobility not to rise in society, but to elude it. In this respect he is the cousin or progenitor of several of the most important American literary creations, Rip Van Winkle, the Thoreau of Henry David Thoreau's *Walden,* the Walt of Walt Whitman's *Song of Myself,* and Twain's Huckleberry Finn. Leatherstocking's many names symbolize this mobility; his name changes make it difficult to "address" him and thereby pin him down geographically and socially. Moreover, his names are given to him by Indians, thereby suggesting that he really belongs to a society which he cannot feel part of, or rather that he doesn't belong to society at all.

Years ago Leslie Fiedler pointed out that the male figures most representative of American literature had their closest personal relationships with a male of another race. Cooper's Leatherstocking was surely the literary origin of this important fictional and mythical pattern, but the nature of Natty's connection to Chingachgook was significantly different from Huckleberry Finn's relationship with Jim. For one thing, *Huckleberry Finn* is about the development of Jim and Huck's relationship and Twain is specifically concerned with the deep conflict between Huck's humanity and the racism he has inherited from his culture. To represent this conflict he must show how Huck's feelings toward Jim change. Cooper, on the other hand, shows us almost nothing about the development of the relationship between Chingachgook and Hawkeye. It is already full-blown in *The Deerslayer* and doesn't seem to change significantly over the next several decades, though of course it ends with the death of Chingachgook in *The Pioneers.* That this relationship began in the last of the series to be written and ended in the first suggests that it had nowhere to go. Both Hawkeye and Chingachgook belong to a state outside of society, a "territory" or "wilderness" which cannot last, a "virgin land" which must inevitably give way to the maturity of civilization. Perhaps to emphasize this inescapable fate, Cooper made Hawkeye's Indian companion one of the last survivors of a vanishing race, the noble tribe of the Mohicans. The relationship between them can be nothing but barren since Cooper killed off the only offspring, Chingachgook's son Uncas, in the second-written volume of the series. Thus, Leatherstocking and Chingachgook enact that moving elegiac myth of the Vanishing American, whose mysterious power must yield to the further development of civilization. Is it possible that Twain, unable to see

how the relationship between Huck and Jim could develop any further in the society he knew, resorted to Cooper's solution of the "territory" to keep its possibility alive?

The central paradox of the Vanishing American is that he becomes the savior and leader of the pioneers whose primary mission is to settle and civilize the "territory." The central symbolic question Cooper posed in *The Pioneers,* first-written volume of The Leatherstocking Series, was whether that seduction of the virgin wilderness was a wedding or a rape. Never again, in the four Leatherstocking tales did Cooper deal so explicitly with the negative ecological consequences of pioneering. Perhaps he hoped that the development of an American gentry class might lead to a balance between the interests of the ecology and the needs of the pioneers in the way that Judge Temple seeks to balance these interests in *The Pioneers.* While it is too much to credit Cooper as a precursor of the ecological and wilderness movements in America, his vision of the American wilderness was as important to the development of our mythology as his conception of the Leatherstocking hero.

Cooper's myth of the wilderness was greatly influenced by the romantic conception of nature as pervaded by spirit and the aesthetic ideal of sublimity shared by many of his poet and painter friends. However, Cooper's particular notion of the wilderness was also shaped by what he had come to believe about the American Indian and his relationship to the land. Cooper thought that "property is the base of all civilization" and that the "existence and security [of property] are indispensable to social improvement" (*American Democrat* 133) and also that "[Property] is desirable as the groundwork of moral independence, as a means of improving the faculties, and of doing good to others, and as the agent in all that distinguishes the civilized man from the savage" (138). However, he was also fascinated by the idea that the American Indian did not believe in ownership of the land. Though Cooper's conception of Native American attitudes toward the land and the idea of property have been seriously questioned by some anthropologists and historians, it has been widely accepted as *the* Indian view of nature, even by Indians themselves.

The essential components of this view are the following:

1. Nobody owns the land; it was put there by the Great Spirit to be used by all.
2. The land should be used only for personal survival needs and not exploited for profit or speculation.
3. There is danger that the land and its flora and fauna can be destroyed by greed and rapacity; those who do not respect the land may end up by destroying it and themselves.

4. The wilderness is full of Spirit and should be revered as the expression of the Great Spirit or Manitou.

If nothing else about this version of Native American attitudes toward the land might give us pause, its remarkable similarity to European romantic ideologies of Nature and even to Marxian versions of the ideal state after the revolutionary destruction of capitalism, should make us suspicious. However, as a pastoral critique of modern European and American civilization, the wonderful myth of the American Indian's deep dedication to communal ownership, to the religious veneration of the land and to a sort of proto-ecological consciousness has been a remarkably powerful literary and cultural device. A famous advertisement of a few years ago showed an American Indian who resembled the traditional figure on the penny with tears in his eyes from air pollution. This was a striking modern instance of this very effective formula.

Cooper's romantic idea of the wilderness gave the idea of the frontier a mythical significance that has deeply influenced our basic conception of the American character and of the uniqueness of American culture. In a similar fashion, just half a century after Cooper published the last volume in the Leatherstocking Series, Frederick Jackson Turner's "Significance of the Frontier in American History" helped to establish the myth of the frontier as the first half of the twentieth century's most fundamental interpretive ideology of American history, society and culture.

The original American myth of the frontier, as many scholars have shown, originated with the Puritan "errand into the wilderness" to shine the light of Calvinist Christianity into the heathen darkness. This myth was transformed into the epic of the pioneers bringing law and order to a savage land. During the nineteenth century, the myth developed a further set of meanings that had dire consequences for the future. The romantic image of nature as a source of regeneration and rebirth became the myth of the frontier where civilized man once again encountered his savage and barbarian roots and after engaging in violence recovered the original potency that he had somehow lost in the development of civilization. In the later nineteenth century, this myth of "regeneration through violence" became in Theodore Roosevelt's version of the "Winning of the West," a return to Anglo-Saxon roots. It can be further traced, as Richard Slotkin so persuasively has, into the twentieth-century nightmare of the American quest for regeneration and the recovery of lost world power through the invasion of Asia and South America.

Cooper accepted some aspects of the myth of the frontier as a place where civilized man could recover lost potency. His aristocratic heroes,

the Temples, Heywards, and Middletons enact a version of this myth. But, even from the beginning of the saga, which in the paradoxical chronology of the Leatherstocking Tales is actually near the end, Natty is never fully embedded in that version of the myth. Actually, after he has initiated his aristocratic "dudes" into the code of the West, Natty seems a rather pathetic figure in Cooper's plot of dynastic reconciliation and aristocratic recovery on the frontier. This Natty is the one who, at the end of *The Pioneers* tells the young aristocratic couple that he is terribly pleased to be memorialized as the faithful servant of his master. But there is obviously another Natty, the one who D. H. Lawrence in his own bitter and rebellious way recognized as a true killer. This is the Hawkeye whose rescue of the young aristocratic couple is far less important than his own instinctive flight from civilization. This Hawkeye knows that he and everything else he holds dear has no future. Yet he persists in looking for the wilderness where he can be his true self, the man who ranges freely, in isolation, whose very movement, keeps him from ever being pinned down.

Thus, Cooper's antimyth exists rather uncomfortably side by side with the epic of the pioneers and the "Winning of the West." The antimyth is the story of the hero's flight from a civilization that he fears as totally destructive of nature and spirit. This was not a vision of ecological balance. The hero is running away not only from society but also from any idea of a balance between society and nature. In this very American saga, Cooper's Leatherstocking is one of those typical American heroes who seeks himself alone somewhere, anywhere, away from civilization, whether in the deep forests (Leatherstocking) or in sleep (Rip) at Walden Pond (Thoreau) on the great river (Huck) or the road (Walt Whitman-Jack Kerouac) or, in desperate finality in the sea (Kate Chopin's *The Awakening*). These are visions of the isolated individual who can never get far enough from civilization, and Cooper's Natty Bumppo, childless as he was, was their progenitor. This antimyth continually vitalized the most powerful examples of the Western genre like Owen Wister's *The Virginian,* or A. B. Guthrie's *The Big Sky,* and the Western films of John Ford. It has left its mark on other areas of American popular culture, as in the Hawkeye Pierce and Trapper John of *M*A*S*H*. Above all, it continually recurs in American literature where the Leatherstocking has many avatars in such figures as Faulkner's Ike McCaslin, Saul Bellow's Henderson and Augie March, and Thomas Pynchon's Tyrone Slothrop. Whatever Cooper's shortcomings as a realist and a stylist, his creation of the ambiguous American epic of the frontier and its deeply divided hero was one of the most important mythical creations in the history of American culture.

2. The Emergence of the Modern Western: Owen Wister and the Progressive Era

Cooper's influence was pervasive, ranging from the next generation of serious novelists—Hawthorne and Melville, as well as lesser lights like Robert Montgomery Bird—to the emergent popular literature which flourished in new media like the weekly story paper and the dime novel. In fact, one of the first successful dime novels, Edward Ellis' *Seth Jones* (1860), was a direct imitation of Cooper. However, Ellis' hero, unlike the Leatherstocking turned out to be the scion of an aristocratic Virginia family and could therefore become united with the heroine after he had saved her from her Indian captors.

Dime novels turned Cooper's complex dialectic between myth and antimyth into a simplified narrative machine. As it proliferated in the later nineteenth century the dime novel's mythic power became increasingly attenuated. Dime novelists did develop the trans-Missisippi west as a setting for their tales and experimented with many new sorts of characters, especially such figures of the new West as Buffalo Bill, George Armstrong Custer, and Wild Bill Hickok. They also fictionalized the cowboys, lawmen, and outlaws, who, like the James Gang, the Daltons and Billy the Kid had their heyday in the aftermath of the Civil War in the West. These developments, along with the Wild West Show of Buffalo Bill and his many imitators, had created, by the end of the nineteenth century, a whole new range of potential Western settings and characters. It remained for more complex and ambitious writers to create new models for the Western making use of these new materials. The most important of these writers was Owen Wister.

Wister's *The Virginian* topped bestseller lists in the year of its publication, 1902, and was the fifth highest seller in 1903. Since that time it has sold millions of copies and has inspired a number of movies and a TV series, to say nothing of a host of imitations. More than any other book, it created the link between dime novels and modern literary and cinematic Westerns. Its characters and the chief incidents of its plot have been repeated many times, but above all, Wister brought back to the tale of Western adventure something of the thematic seriousness and complexity that were increasingly absent after Cooper.

Like Cooper, Wister was a man of upper-class background who found himself in a world in which the status of his class seemed increasingly tenuous. As White has shown in *The Eastern Establishment and the Western Experience,* Wister's childhood experience and cultural situation rather closely paralleled that of two friends who also became early twentieth-century apostles of the West. Frederic Remington and Theodore Roosevelt were also from long-established eastern families now in

competition with much more aggressive, newly rich entrepreneurs con-
nected with the rise of industrialism. All three men felt considerable
uncertainty about their role in a changing American society, underwent
neurotic crises in their youths, and found personal regeneration in the
West. Wister became the exponent of the West in fiction, Remington its
artistic interpreter and the illustrator of many of Wister's books, while
Roosevelt created a political symbolism that drew heavily on the West-
ern mystique.

This elite concern with personal regeneration emerged at a time
when many Americans feared a decline in American morality and a rise
of personal and political corruption spurred by industrialism, the new
immigration, the decline of rural life, and by the increasing demands of
women for jobs, education and above all, the vote. In its first phase, the
modern Western expressed a desire for moral and political regeneration
brought about by a new kind of hero whose staunch masculinity and skill
in violence became a rallying point for the forces of reform. It was thor-
oughly appropriate that Wister dedicated the second edition of his arche-
typal Western to Theodore Roosevelt, the epitome at once of the new
politics and the new masculinity and the man who old-line political boss
Mark Hanna once referred to as that "damned cowboy."

Wister's own experience of regeneration in the West was reflected
in his portrayal of a young man who left a decaying Virginia to find a
new life in Wyoming and of a New England heroine who was trans-
formed by her Western experience. Of course, Wister's new treatment of
the West drew on literary precedent as well as personal experience and
need. There had emerged in the later nineteenth century a new kind of
Western literature that, unlike most of the dime novels, was written by
men with an actual experience of the area. The humorous, satirical,
sometimes sentimental sketches written by Bret Harte, Mark Twain, and
Stephen Crane, and their numerous imitators embodied an image of the
West far different from Cooper's romantic wilderness.

This new version of the frontier was social rather than natural, and
it was of a society distinctively different from that of the East. A new
kind of dialectic emerged, replacing the opposition between nature and
civilization with a cultural dialectic between the East and the West.
Twain's *Roughing It* embodied this tension in its portrayal of the narrator
as greenhorn being initiated into the new society of the West. However,
Twain was far too familiar with his subject to make a heroic romanti-
cization of this new society. In *Roughing It,* Western life has its delights,
but it is also profoundly corrupting.

The essence of Twain's West was not wild nature, but a new kind of
social order in which the traditional restraints were off and the hierarchy

changed every day as one man's claim played out and another struck it rich. Twain was fascinated by this new society and the men it produced. Yet, at the same time that he feels its glamour and excitement, Twain cannot accept this life and its values without reservation. His ambiguity reveals itself clearly in his treatment of the very type that later Western writers would so strenuously romanticize: the gunfighter. One such character, the desperado Slade, so intrigued Twain that he devoted two chapters to a discussion of the man's character. Occasionally Twain speaks of Slade in something resembling the accents of a dime novelist: "an outlaw among outlaws and yet their relentless scourge, Slade was at once the most bloody, the most dangerous, and the most valuable citizen that inhabited the savage fastnesses of the mountains" (*Roughing It* 34). In his own final evaluation of the gunfighter there is none of the haze of romance that later clustered around this character.

Bret Harte was far more sentimental in his treatment of the West. Like Twain, he portrayed a uniquely colorful society in which the traditional moral and social restraints no longer operated. But Harte was particularly fascinated with the way in which traditional middle-class values and attitudes might reappear in such a society among individuals who seemed to have left such virtues as domesticity, purity, and love far behind. In other words, Harte loved stories of regeneration. Thus his classic situation was the appearance in a wide-open mining camp of some symbol of traditional middle-class innocence—a baby, an innocent maiden, a feeling of true romantic love or self-sacrifice—and he delighted in tracing the impact of this symbol on the rough and lawless souls who encountered it.

Harte's chief stock in trade was sentimental and ironic paradox. The brutal and violent miner gives his life in an attempt to save the baby from drowning. The innocent young girl dies in the arms of a prostitute and both are redeemed by the experience. The dance-hall girl who has nothing but contempt for the most handsome and virile men falls in love with a man who has been totally paralyzed in an accident and devotes her life to service as his nurse. Thus, for Harte, the Wild West was a place where people rediscovered and reaffirmed the most important values of life, and this vision of the West led directly to the romances of Wister and Zane Grey.

The modern Western inherited from Harte, Twain, and other Western writers like Jack London, a new sense of the Western setting as well as elements of humor and sentiment that persisted in such stock characters as those created by movie actors Andy Devine and Walter Brennan. But, above all, what the Western needed was a new hero. As writers came to treat the West not as the embodiment of nature but as a different

social environment, the Leatherstocking hero, defined by his adherence to natural values and his flight from society, was no longer appropriate. Actually, the Leatherstocking figure was transformed into the early fur trapper of twentieth-century Western literary epics by writers like A. B. Guthrie, Frederick Manfred, and Vardis Fisher, but he tended to disappear from the generic Western because the values he symbolized were not associated with the West of the cattle kingdom. The benevolent outlaw, so beloved of the dime novel, was a more important part of the legend of the West, but this character was so obviously mythical that he could not operate much beyond the limits of the dime novel. Harte, Twain, and other Western writers peopled the Western town and gave a distinctive shape and character to its society, but they were not primarily interested in heroes. Owen Wister initiated the modern Western by creating a hero type who belonged to the new image of the West. This new figure was the heroic cowboy.

Wister certainly did not invent the cowboy-hero, but he did give this already popular figure a new thematic significance. The cowboy had already become an American hero, along with other legends of the Wild West like Wild Bill Hickok, Wyatt Earp, and General Custer through the dime novel, newspaper stories, books, and plays about Western figures and, above all, through the enormously popular spectacle of the Wild West Show. In *The Virginian* Wister created a story that made the cowboy-hero a central figure in a narrative which romanticized the Twain-Harte tradition of Western stories and highlighted the theme of regeneration.

The novel begins with the relationship between the narrator and the Virginian, the first of a number of studies in cultural contrast between East and West. The narrator, a somewhat effete easterner on his first visit to friends in the West, encounters the hero at the railway station of Medicine Bow when he disembarks for the long overland journey to the ranch of his friend, Judge Henry. The Virginian, a cowboy on the Henry ranch, has been delegated to meet the "tenderfoot." Their first encounter immediately establishes the basic contrast between East and West. The easterner is tired and confused. The railroad has somehow misplaced his trunk, and he feels utterly cast adrift in a savage wilderness:

I started after [the train] as it went its way to the far shores of civilization. It grew small in the unending gulf of space, until all sign of its presence was gone save a faint skein of smoke against the evening sky. And now my lost trunk came back into my thoughts, and Medicine Bow seemed a lonely spot. A sort of ship had left me marooned in a foreign ocean; the Pullman was comfortably steaming home to port, while I—how was I to find Judge Henry's ranch? Where in the unfeatured wilderness was Sunk Creek? (*Virginian* 6)

In the midst of the narrator's despair, the Virginian politely introduces himself with a letter from Judge Henry. When the narrator adopts a condescending and familiar attitude toward this "slim young giant" who radiates an air of "splendor" despite his "shabbiness of attire," he is met by a sharp but civil wit that shakes him to the core and leads him to his first realization about the West. This is not simply a savage wilderness but a land where the inner spirit of men counts more than the surface manners and attitudes of civilization. In such a setting a man must prove his worth by action and not by any assumed or inherited status:

This handsome, ungrammatical son of the soil had set between us the bar of his cold and perfect civility. No polished person could have done it better. What was the matter? I looked at him and suddenly it came to me. If he had tried familiarity with me the first two minutes of our acquaintance, I should have resented it; by what right, then, had I tried it with him? It smacked of patronizing; on this occasion he had come off the better gentleman of the two. Here in flesh and blood was a truth which I had long believed in words, but never met before. The creature we call a *gentleman* lies deep in the hearts of thousands that are born without chance to muster the outward graces of the type. (9)

After this realization, the narrator soon comes to a new view of the West. Despite the appearance of wildness or squalor, this landscape is a place where deep truths of human nature and life, overlaid in the East by the artifices and corruptions of civilization, can be discovered anew. Soon he begins to see the apparent chaos and emptiness of Medicine Bow in very different terms:

I have seen and slept in many like it since. Scattered wide, they littered the frontier from the Columbia to the Rio Grande, from the Missouri to the Sierras. They lay stark, dotted over a planet of treeless dust, like soiled packs of cards. Each was similar to the next, as one old five-spot of clubs resembles another. Houses, empty bottles, and garbage, they were forever the same shapeless pattern. More forlorn they were than stale bones. They seemed to have been strewn there by the wind and to be waiting till the wind should come again and blow them away. Yet serene above their foulness swam a pure and quiet light, such as the East never sees; they might be bathing in the air of creation's first morning. Beneath sun and stars their days and nights were immaculate and wonderful. (9-10)

The purity of the landscape reflects the inner nobility of the cowboys who people it:

Even where baseness was visible, baseness was not uppermost. Daring, laughter, endurance, these were what I saw upon the countenance of the cowboys. And this very first day of my knowledge marks a date with me. For something about them, and the idea of them, smote my American heart, and I have never forgotten it, nor ever shall, as long as I live. In their flesh our natural passions ran tumultuous; but often in their spirit sat hidden a true nobility, and often beneath its unexpected shining their figures took a heroic stature. (25)

Wister's image of the West is dominated by the idea of moral regeneration. To some extent, his treatment of this theme reflects a primitivism not unlike Cooper's. Because civilization and its artificial traditions have not yet taken a firm hold in the West, the influence of nature is more strongly felt in that "pure and quiet light, such as the East never sees." But the influence of nature is less important for Wister than the code of the Western community, a distinctive set of values and processes that is in many respects a result of the community's closeness to nature but also reflects certain basic social circumstances. Because institutional law and government have not yet fully developed in the West, the community has had to create its own methods of insuring order and achieving justice. As Judge Henry explains when the heroine is distressed by vigilante justice, the code of the west is not inimical to law. On the contrary, the vigilantes represent the community acting directly, instead of allowing its will to be distorted by complex and easily corrupted institutional machinery. Of course, Judge Henry insists this situation will change when civilization reaches the West, yet in his praise of the principle of vigilante justice, the judge intimates that the Western type of direct action is not merely a necessary expedient, but a rebirth of moral vitality in the community:

In Wyoming the law has been letting our cattle-thieves go for two years. We are in a very bad way, and we are trying to make that way a little better until civilization can reach us. At present we lie beyond its pale. The courts, or rather the juries, into whose hands we have put the law, are not dealing the law. They are withered hands, or rather they are imitation hands made for show, with no life in them, no grip. They cannot hold a cattle-thief. And so when your ordinary citizen sees this, and sees that he has placed justice in a dead hand, he must take justice back into his own hands where it was once at the beginning of all things. Call this primitive, if you will. But so far from being a *defiance* of the law, it is an *assertion* of it—the fundamental assertion of self-governing men, upon whom our whole social fabric is based. (340-41)

Wister presents the code as the true moral will of the community partly because it also gives full weight to individual honor. The funda-

mental principles of honor and the will of the community transcend the official agencies of government and the codified, written law. Thus, the Virginian must participate both in a lynching and a duel, illegal actions according to the written law, but recognized by all his fellow Western males as inescapable obligations.

The Virginian's difficulties don't come from the code, which causes him little inner conflict. His real problem is that he has fallen in love with the eastern schoolteacher, Molly Wood. Women pose a basic threat to the code, because they are the harbingers of law and order enforced by police and courts, and of the whole machinery of schools and peaceful town life. These institutions make masculine courage and strength a much less important social factor. When his love tempts him to transgress the code by speaking to the heroine about another man, he knows he is in trouble.

The hero's romantic interest in the schoolmarm draws him away from the code, but his struggle with the villain Trampas reaffirms his dedication to it and ultimately demonstrates what seems to be Wister's main thesis: that the kind of individual, masculine, moral courage and community responsibility embodied in the code is a vital part of the American tradition and needs to be reawakened in modern American society.

Romance and the struggle against villainy are interspersed throughout the novel. At the very beginning of the novel, the Virginian confronts Trampas over a card game and puts him down with the immortal phrase, "When you call me that, *smile*." Honor cannot be compromised, but the true hero, as opposed to a lawless man like Trampas, always lives within distinct moral limits. Mitchell also observes this concern with restrained violence in his recent study of masculinity in the Western genre. The ideal man only fights to preserve his honor or to enact the community's just sentence. In this initial incident, the Virginian is supremely in control of himself and no inner conflict gives him any doubt about the proper course of action.

Soon, however, the snake enters this garden of honorable masculinity. Careening across the countryside in a stagecoach driven by a drunken driver, Miss Molly Stark Wood of Bennington, Vermont, descendant of revolutionary heroes, is nearly tumbled into a dangerously high creek before a dashing man on horseback rides out of nowhere and deposits her safely on the other shore. After saving her life, a gallant gentleman can hardly avoid falling in love with the lady. When they meet again, some time later, the Virginian announces his determination to make Molly love him, even though she has just unmercifully roasted him for his part in some masculine high jinks. Thus begins a conflict

between the masculine code of the West and the genteel ideas of civility that Molly brings from the East. The Virginian's courtship of Molly and his conflict with Trampas develop in counterpoint until the two lines of action intersect and the hero must choose between his two commitments.

Molly first resists his courtship, recoiling from what seems to her the Virginian's crudity, childishness, and lack of civility. However, she soon discovers that, despite his lack of formal education and social graces, the hero has an instinctive gentility as well as a strong native intelligence. When the Virginian is seriously injured by Indians, Molly's interest is intensified. Wister represents this as a great moment of truth for her. Molly shows that she still possesses the courage and daring of her revolutionary ancestors when she rescues the Virginian, and nurses him back to health. This experience is the first real step in the Westernizing of Molly, clearly a kind of atavistic return to the spirit of her ancestors and a rebirth in the West of the revolutionary generation's vigor.

With this awakening of the deeper instincts in her blood, Molly's love for the Virginian blossoms and she agrees to marry him. The story now moves toward the final confrontation between Molly's eastern values and the code of the West. When Trampas increasingly threatens the good community of the ranch, the code of the West swings into action against him and his gang of rustlers. The Virginian must reluctantly join in the lynching of his former friend Steve, while Trampas escapes. When Trampas returns to town and the Virginian prepares to meet him, Molly threatens to break off their relationship and return to the East. Caught in this conflict of love, duty, and honor, the Virginian does not hesitate. He explains to Molly why the code of masculine honor must always take precedence over other obligations:

"Can't yu' see how it must be about a man! It's not for their benefit, friends or enemies, that I have got this thing to do. If any man happened to say I was a thief and I heard about it, would I let him go on spreadin' such a thing of me? Don't I owe my own honesty something better than that? . . . What men say about my nature is not just merely an outside thing. For the fact that I let 'em keep on sayin' it is a proof I don't value my nature enough to shield it from their slander and give them their punishment. And that's being a poor sort of a jay." (371)

So the Virginian confronts Trampas, believing that his defense of his honor will lose him the woman he loves. But, of course, it doesn't work out that way. Once Molly sees her sweetheart in danger, she realizes that her love for him transcends all her moral compunctions. Their reunion quickly follows this moment.

Thus did her New England conscience battle to the end, and, in the end capitulated to love. And the next day, with the bishop's blessing, and Mrs. Taylor's broadest smile, the Virginian departed with his bride into the mountains. (428)

Wister synthesized Cooper's opposition of nature and civilization with the gospel of success and progress, thus making his hero both an exponent of natural law and of the major ideals of American society. This shift is particularly evident in Wister's treatment of the code of the West, which, as we have seen, is based on both the individual's sense of personal honor and the moral will of the community. In the final conflict with Trampas, the hero not only maintains the purity of his individual image but acts in the true interest of the community. For Wister the Western hero possesses qualities that civilized society badly needs. It is not his lack of refinement that prevents the Virginian from assuming his rightful place as a social leader, but the shallow prejudices of an over-refined and effete society that has lost contact with its own most significant values. When the Virginian goes east to meet Molly's family, it is Molly's great aunt, the one closest to the family's revolutionary heritage, who understands and fully appreciates the Virginian's qualities. This representative of an earlier order sees the basic resemblance between the Virginian and General Stark, the founder of the family. Because of this she understands that the West is not a barbarous land, but a place where the original American traits of individual vigor, courage, and enterprise have been reborn: "'There he is,' she said, showing the family portrait. 'And a rough time he must have had of it now and then. New Hampshire was full of fine young men in those days. But nowadays most of them have gone away to seek their fortunes in the West.'"

Wister resolved the old ambiguity between nature and civilization by presenting the West not as a set of natural values basically antithetical to civilization, but as a social environment in which the American dream could be born again. As Wister summed up the message of his book in the "Rededication and Preface" that he wrote for a new edition:

If this book be anything more than an American story, it is an expression of American faith. Our Democracy has many enemies, both in Wall Street and in the Labor Unions; but as those in Wall Street have by their excesses created those in the Unions, they are the worst; if the pillars of our house fall, it is they who will have been the cause thereof. But I believe the pillars will not fall, and that, with mistakes at times, but with wisdom in the main, we people will prove ourselves equal to the severest test to which political man has yet subjected himself—the test of Democracy. (ii)

There are many similarities between Wister's view of the West and his near contemporary Frederick Jackson Turner's frontier hypothesis. Like Wister, Turner characterized frontier society in terms of revitalization. He argued that America's recurrent frontier experience was the source of many of the values and institutions of democracy, just as Wister portrayed the West as a place of social and cultural regeneration, where the vigor and enterprise of revolutionary America might be rediscovered. Turner saw the closing of the frontier and the growth of large industrial corporations, labor organizations, and governmental bureaucracies as signs that American culture was entering a new phase of development. Because he believed that the most important aspects of American democracy had depended on the open frontier, he feared that in the new institutional context these values might be lost.

Wister, too, represented the East in terms of decaying values and the West as a source of social and moral regeneration. His comments in the 1911 "Rededication" echo Turner's view of the danger of large organizations in the absence of an open frontier. In actuality, however, Turner and Wister's politics and their views of the frontier were quite different. The similarities between them suggest how much they reflected widespread cultural preoccupations with the final settlement of the continental United States, the growing awareness of the changes wrought by industrialism, the resultant fear of moral decay in American life, and the search for some sense of reassurance and regeneration. Similar preoccupations influenced people as diverse as Wister's dedicatee Theodore Roosevelt and the sentimental religious novelist Harold Bell Wright to become fascinated with the West. Roosevelt used the myth of the West to make national regeneration a basic topic of his political rhetoric while Wright published bestseller after bestseller by sending his jaded urban protagonists to the Ozark Mountains or the West in search of redemption. Out of the same complex of ideology and feeling Turner stimulated American historical interest in the Western experience and Wister created the modern Western.

Turner's West was that of a liberal progressive, and he laid considerable stress on the necessity for social action to conserve democratic institutions and ideas in a period when the natural safety valve of free land would no longer operate to prevent the formation of rigid classes. Wister, however, saw the significance of the West in terms of the revitalization of American aristocracy. For him the rise of the Virginian symbolized the emergence of a new kind of elite capable of providing the vigorous and moral political leadership that America desperately needed.

Yet Wister's conservatism and Turner's liberal progressivism come together in seeing a need for national regeneration associated with the

West. Turner wondered whether the regenerative influence of the frontier could be replaced, just as Wister was uncertain that his friend Theodore Roosevelt could roll back the "political darkness" that "still lay dense upon every State in the Union [when] this book was dedicated to the greatest benefactor we people have known since Lincoln." Despite the success of his hero, Wister still retained some of the elegiac tone with which Cooper orchestrated his Leatherstocking series. For the society that had begun to evolve in the West after the disappearance of the cowboy looked ominously like that new American society that Cooper, too, hoped would be only a passing phase. At times Wister feared that the Western hero was not that different from his Indian counterpart, the vanishing American. All the romance and excitement and honor seemed to be disappearing with the coming of modern society:

What is become of the horseman, the cowpuncher, the last romantic figure upon our soil? For he was a romantic. Whatever he did, he did with his might . . . the cowpuncher's ungoverned hours did not unman him. If he gave his word, he kept it. Wall Street would have found him behind the times. Nor did he talk lewdly to women; Newport would have thought him old-fashioned. He and his brief epoch make a complete picture, for in themselves they were as complete as the pioneers of the land or the explorers of the sea. A transition has followed the horseman of the plains a shapeless state, a condition of men and manners unlovely as that bald moment in the year when winter is gone and spring not come, and the face of Nature is ugly. I shall not dwell upon it here. Those who have seen it know well what I mean. (xlviii)

Such statements of belatedness foreshadow the dominant theme in the last phase of the Western, the end of the Wild West and the loss of the hero. The elegiac tone was usually more muted in Wister and *The Virginian* helped create a new vision of the West as source of regenerative potentiality in American life and culture. On the basis of this vision, the Western increasingly became for a time **the** American genre, bringing together in fictional harmony many conflicting forces or principles in American life.

One reason Wister was able to link together so many important late nineteenth-century themes in *The Virginian* was that, like his hero, he was a Southerner. The very title of Wister's novel symbolized the link between the modern Western and certain aspects of the Southern mythic tradition, as did the two central themes of pastoralism and justified vigilantism. If Wister had put more emphasis on the savagery of the racial other, *The Virginian* would be even more like a contemporaneous best seller, Thomas Dixon's *The Clansman*. Like the typical southern protag-

onist in writers like Dixon and Thomas Nelson Page, the hero of the Western was also an individual in the midst of historic transformation, trapped between the old and the new. Owen Wister summed up this Western sense of belatedness and nostalgia for a vanished past when he lamented the ending of the open range cattle industry and the passing of the romantic figure of the cowboy.

Other Southerners dreamed the pastoral of the antebellum plantation, but Wister expressed his fascination with the world of the cattle kingdom, another pre-industrial world characterized by the relationship between men and horses instead of machines. This late nineteenth-century pastoral was based on large estates, like the ranch and the plantation, rather than the family farm. In the myths, these large enterprises produced their own distinctive cultures celebrating a heroic elite of brave men, who are good with horses, who respect women, and who live according to a traditional code of honor. Significantly Wister's analysis made the further claim that this pastoral world, though now threatened, was like the original America of the founders and the pioneers. Therefore, "this brief epoch" of the cowboy culture represented the time of mythic origins, from which American society is increasingly drifting away. In this way, Wister's celebration of the cowboy synthesized the most important common themes in the myths of the South and the West.

Horses were a distinctive feature of both myths, and men who controlled horses, the Western cowboy and the Southern gentleman-cavalryman were always portrayed as brilliant horsemen. They were the most important heroes of this version of pastoral. The horse represented a mythic force out of the primal wildness of nature, which was a major source of energy, mobility, military power and status in traditional societies. In Southern fiction as in the Western, the hero had great skill with horses. Along with this, he was a master of restrained and controlled violence, for only through his willingness to risk encountering the dangerous power of the horse and overcoming it with a combination of strength and gentleness could he become a true horsemen. Villains, as in Wister, were often characterized by their cruelty to horses, by beating them or riding them too hard, or by not knowing how to care for them. The hero, on the other hard, often established a transcendent friendship with a horse that no other man could control or even ride.

The horse not only symbolized the hero's adherence to a rigorous moral code of honor, bravery, and gentleness, it also indicated his place in a traditional pastoral aristocracy where the control of horses was a true test of a man's worth and standing. The Southern myth of the Lost Cause doted on the exploits of the confederate cavalry and on the gallant heroics of cavalry leaders like Stuart, Morgan, and Forrest. Faulkner

understood the traditional social significance of horses well when, in *The Hamlet,* he told how the wretched poor white Henry Armstid was willing to go to any length to possess one of Flem Snopes' uncontrollably wild spotted horses. In fact, Faulkner himself was a victim of the myth of horsemanship. In spite of years of effort he remained a mediocre rider and was frequently injured by being thrown from his mounts.

Significantly, the historical periods represented by both the Southern and the Western mythologies were times in which, for the last time, the horse was a major source of actual power, though it was rapidly being replaced by the "iron horse" and the "horseless carriage." As it became more the symbol of a traditional world than a significant part of the industrial age, the horse was often represented in Westerns as being challenged by the intrusion of the railroad, the telegraph, and the automobile.

The horse was also linked to another important feature of the two myths: the presence of a racial other. The Indian tribes of the great plains, the Sioux, the Cheyenne, the Comanche, the Kiowa, who quickly replaced Cooper's Eastern woodland Indians as the mythical antagonist in the Western were masterful horsemen. The Southern myth also postulated a special linkage between black slaves and horses. However, there is a strong ambivalence about this connection between horses and the other. While the black slave or servant is often shown to have a special understanding and skill with horses, in mythic representations of the post Civil War era the connection between African Americans and horses is usually severed. Blacks are now associated with mules and are sometimes portrayed as frightened of horses.

The generic Western had few black cowboys until the sixties, though recent studies have shown that many actual cowboys in the later nineteenth century were African Americans. However, the most important racial other in the Western was the Indian, whose horsemanship could hardly be questioned. Even here the mythic representations found a way of emphasizing the otherness of the Indian's relationship to horses not by separation but by suggesting an even closer kinship. If the cowboy's horse was his friend, the Indian's horse was an extension of himself. Mythical Indians invariably rode bareback while the cowboy had an elaborate saddle and harness implying a relationship of control rather than similarity. Indians never used spurs but directed their horses through some occult communication with them. A fellow being for the Indian, the horse symbolized a tool of control, conquest, and ultimately of civilization for the cowboy and the pioneer. For the Indian, the horse intensified his wildness and savagery. The archetypal Western scene of the Indian attack on the stagecoach, first developed as a favorite specta-

cle in Wild West Shows and later as a set piece in Western movies neatly exemplifies the differences in the Indian and white relationships to the horse. Hitched to the elaborate harness of the stagecoach, the horse brings the forces of civilization to the wilderness. Riding wildly out of the desert, the Indians seek to destroy that vehicle and the representatives of a new order of control and settlement it carries.

These examples illustrate the ambiguous duplicity of the related roles of the racial other in these major American myths. In the later nineteenth century both Indians and African Americans were subjected to brutal exploitation, removal, segregation, and in some cases, genocide. These actions were justified by the supposed wildness and savagery of the racial other. Such projections resulted in the archetypal figure of the Black or Indian rapist, which still lingers in the demonic half-light of the Southern and Western myths despite considerable evidence that Indians rarely molested their female captives. Moreover, for every white woman raped by a black there were hundreds of African American women raped by whites. Yet though the racial other became the scapegoat for all sorts of sexual aggression and violence, it was also invoked over and over again in connection with certain positive qualities. Indians symbolized the purity and potency for patent medicines, foodstuffs, and tobacco in advertisements. Similarly, Blacks came to represent such qualities as down-home warmth and goodness (Aunt Jemima pancakes), irrepressible good humor and a joyous attitude toward life (the Sambo figure), and goodhearted endurance along with patient, almost sainted wisdom (the Uncle Tom and Uncle Remus stereotypes.)

Treating the racial other as both scapegoat and symbol of mysterious and desirable powers has a long tradition in Western civilization. At the time of America's discovery, this doubleness reflected the seventeenth-century ambivalence toward newly discovered African and Native American cultures as children of the devil on one hand and noble savages on the other. To put it mildly, this ambivalent mythicization of savagery and nobility was murky indeed.

Two important cultural patterns of the later nineteenth century influenced the transformation of these images of the South and the West into a national mythology of America. One was the widespread concern about the rampant materialism and corruption associated with the social upheaval accompanying the rapid development of capitalistic industrialism and urbanization in the later nineteenth century. These developments created a new social elite of newly rich millionaire businessmen whose cultural power increasingly threatened the established hegemony of the traditional Eastern aristocracy. In *The Burden of Southern History,* Vann Woodward has shown how such scions of the New England aristocracy

as Henry Adams and Henry James made use of a new image of the Southerner to criticize the increasing corruption of Northern business and politics. The great national magazines like *Scribner's, Harper's,* and *The Century,* perhaps the media most analogous to television in the period, representing what later became known as the genteel tradition, first gave a national hearing to fiction and nonfiction reflecting the myths of the lost cause and the antebellum plantation. This was the very same context out of which Wister's version of the Wild West emerged. It is not surprising that the Western shared many themes with this new myth of the South.

The other factor, particularly important in the growing popularity of the Western, was a significant extension of middle-class childhood and the related rise of a literature of juvenile magazines and novels, including dime novels, especially responsive to the needs of this tremendously important new reading public. Mark Twain was certainly one of the first to perceive the intimate connection between middle-class childhood and the lust for fantasy adventure. He brilliantly exploited it in *Tom Sawyer* and satirized it in *Huckleberry Finn.* In Twain's mind the leading adventure fantasies of comfortable middle-class youths derived from the nineteenth-century romantic novelists, particularly Scott, Cooper, and Dumas. In his own lifetime, however, youthful readers increasingly refocused their fantasy life on the Wild West and devoured thousands upon thousands of mythic tales of cowboys, Indians, outlaws, and gunfighters. By the end of the nineteenth century, the dime novel tales of the Wild West had been transformed into a new kind of adult fiction, without losing the audience of young men who had made the dime novel popular. Combining elements of the Southern and Western myths and crossing age and class lines, the Western became a new form of popular American art, and a new political rhetoric. No wonder the Western increasingly became a central myth of America.

3. The Western and the 1920s: Zane Grey, W. S. Hart and the Romantic Western of the 1920s

The publication of *The Virginian* coincided with another event of great importance in the history of the Western, the production of Edwin S. Porter's *The Great Train Robbery* (1903), the first significant Western on film. Porter's film certainly did not revolutionize the content of the Western since it consisted of a loosely episodic presentation of a train robbery followed by pursuit of the outlaws on horseback and a final shootout. In fact, the film made little attempt to generate character or plot beyond what was necessary for the basic situation. What Porter's film did demonstrate in an unmistakable way was that the already popu-

lar Western spectacle could be translated directly from the Wild West Show into film. Moreover, even though it was shot in New Jersey, *The Great Train Robbery* showed the effectiveness of Western costumes, horses, guns, riding, roping, and shooting. Later filmmakers intensified this by using the actual Western landscape; the drama and beauty of which had been discovered through the work of painters and photographers.

With the great proliferation of Westerns in films and later on television, the history of the Western in the twentieth century becomes increasingly complex. Many writers, directors, performers, and technical people made important contributions to the art of the Western creating an enormous variety of Westerns in many different media. In the course of this complex development, the genre evolved in a way that reflected the impact not only of changing public interests and values, but also of important artistic discoveries and technical innovations and by the development of different types of Westerns for different audiences. Popular genres tend to generate a continuum of subgenres ranging from simple exciting stories for younger and less sophisticated audiences to more complex and "realistic" treatments for the adult public. A continuing tradition of Western adventure for juveniles passed from the dime novel into movie serials, radio programs, comic books, and television series like *Hopalong Cassidy* and *The Lone Ranger* until it peaked in the later 1950s. There was also a consistent public for the B Western film and for the paperback Western novel. These subgenres change slowly and changes tend to be superficial rather than basic. A Western novel written by Louis L'Amour in the 1970s might be somewhat franker and more graphic in its portrayal of sex and violence. In addition, the hero's moral qualities might be slightly more ambiguous than in one of the sagas of Max Brand from the 1920s, but the basic patterns of action and character were similar. Today, paperback oaters tend to be even more openly sexual in their approach, but still strongly resemble the simplicities of action and character typical of this tradition since the nineteenth century.

The "adult" or A Western had a more complex process of evolution. When a major new Western or group of Westerns achieved box office success, other producers, hoping to profit from the new vogue, would create their own version of what they took to be the popular elements. Eventually these imitations became mechanical and uninspired enough that the public would tire of them. At the same time public attitudes and interests changed. From this point, profits and production will tend to fall off until a new version of the formula appealed to a large public and the cycle began over again. Thus the development of the high-quality Western in the twentieth century has been marked by a series of such

cycles in which new "adult" Westerns became temporarily appealing to the general public and then declined, only to be replaced by another version of the formula. The first such cycle followed on the success of Wister's *The Virginian* and reached a peak in the early 1920s, declining after 1925. During this period writers like Harold Bell Wright, Zane Grey, and Emerson Hough achieved consistent bestseller status with their Western novels, and this success was mirrored in the great popularity in film of W. S. Hart, Tom Mix, and of such films as *The Covered Wagon* and *The Iron Horse.*

The two most important Western creators in the period of great popularity following Wister were the writer Zane Grey and the filmmaker W. S. Hart. In their work the early twentieth-century version of the Western came to fruition and achieved a broad popularity. Though many other writers and filmmakers were important during this era, Grey and Hart produced the most effective and successful work of the period 1910-25. Grey was not only the leading writer of Westerns but also the single most popular author of the post-World War I era, with at least one book among the top bestsellers for almost ten years straight. Other Western stars, especially Tom Mix, eventually eclipsed Hart, but during his relatively short filmmaking career he dominated the "adult" Western.

Grey and Hart never worked together perhaps because Hart's work had begun to decline before movies based on Grey's novels were being produced on a large scale. Eventually over one hundred Western films were based on Grey novels, several being produced in as many as four different versions over the years. Nevertheless, their works have so many points in common that it seems reasonable to view them as exponents of the same essential version of the genre. In fact, though he never appeared in a Grey film, Hart would have been the perfect embodiment of many of Grey's central figures with their mixture of maturity and innocence, of experience and purity, of shyness and latent violence. Hart's stories shared with Grey's novels similar plot patterns, characters and themes, as well the same combination of hard-bitten heroic adventure, concern for verisimilitude, religiosity, and sentimentalism.

Grey began his writing career with an attempt at historical romance in the mold of the early twentieth-century successes of Winston Churchill, but met with little public response. It was after he, like Owen Wister, took a trip to the West and began to write of Western adventures in the manner of *The Virginian* that his popular success blossomed. Hart came to films through the stage, and the stamp of Wister was on him, too, since one of his most successful roles had been in a dramatic adaptation of *The Virginian*. Hart certainly felt that his version of the West was more realistic than Wister's, and I suspect that Grey did, too, though

from today's perspective, the opposite seems to be the case. While Wister's novel remains fairly plausible, given the archetypal patterns of heroic adventure, the works of Hart and Grey seem overly sentimental and melodramatic treatments of the drama of individual and social regeneration in the West.

Like Wister, Grey and Hart portray the West as a distinctive moral and symbolic landscape with strong implications of regeneration or redemption for those protagonists who can respond to its challenge by recovering basic human and American values. Wister's dialectic of the cultivated but enervated East versus the vigorous, vital, and democratic West plays an important role in their works, usually in connection with the developing love between hero and heroine. In many instances the heroine's commitment to eastern genteel values of culture and social order provide a major obstacle to the romance, since, despite her initial attraction to the hero, she is distressed by his apparent ignorance of the finer things and his code of violent individualism. Like Wister's Molly Wood, the heroines of Grey and Hart usually come around in the end, the deep force of their love driving them back into the hero's arms when his life is threatened.

Grey and Hart also followed Wister in placing great emphasis on the unwritten and extralegal "Code of the West" as a basic factor in the hero's identity and in the problems he confronts. They also built their stories around patterns of gradually increasing violence moving toward a climactic confrontation between hero and villain in a shootout. Each developed and elaborated in his own way the same quasi-allegorical landscape of town, desert, and mountains and the same social and historical background of large cattle and sheep ranching with their attendant episodes of rustling, range wars, and wide-open towns. Evidently in the minds of both writers and their publics the uniqueness of the West and its difference from the rest of the country was most fully symbolized by the open-range cattle industry.

However, Grey and Hart added several new emphases of their own, contributing to the process by which the Western became, in the first quarter of the twentieth century, a popular mythology for grownups as well as children. In works like *Riders of the Purple Sage* (1912) and *Hell's Hinges* (1915), this involved, among other things, a new treatment of the hero. Wister's Virginian, despite his skills in violence, was not a gunfighter or an outlaw, and, though he adhered to the unwritten law of the West, he was a part of the community of the ranch and the town from the very beginning. As Grey and Hart developed their conception of the hero, however, he shed his close ties with society and became the more mysterious and alienated figure of the heroic gunfighter or outlaw.

Grey's Lassiter, in *Riders of the Purple Sage,* was probably the first widely successful version of the gunfighter in the Western. Complete with fast draw, special costume, and a mysteriously sinister past, Lassiter adumbrates such favorite Western heroes of a later era as Shane, Destry, Doc Holliday, and Wild Bill Hickok. Hart, too, made something of a specialty of the heroic outlaw in figures like Draw Egan (*The Return of Draw Egan*) and Blaze Tracy (*Hell's Hinges*).

The new Western hero was typically an older man and very much a loner, at least at the beginning of his adventures. Even when he was not explicitly an outlaw, he was an outcast from society, either because of his violent past or his inability to settle down:

And he reflected that years of it had made him what he was—only a wild horse wrangler, poor and with no prospects of any profit. Long he had dreamed of a home and perhaps a family. Vain, idle dreams! The romance, the thrilling adventure, the constant change of scene and action, characteristic of the life of a wild-horse hunter, had called to him in his youth and fastened upon him in his manhood. What else could he do now? He had become a lone hunter, a wanderer of the wild range, and it was not likely that he could settle down to the humdrum toil of a farmer or cattleman. (Grey, *Wild Horse Mesa* 12-13)

Yet, the Grey hero has a deep yearning to become part of society. This action—the domestication of the wild hero—was one major theme of this period. In Grey and Hart, a mature, hard-bitten hero with a violent past encounters a young woman with whom he falls in love. But there are serious obstacles to their love. As a good daughter of Wister's Molly Wood, the heroine initially rejects the hero's violence or, in some cases, finds herself committed by kinship or loyalty to the hero's enemies. There must be a violent climax to eliminate the enemies and to overcome the heroine's scruples. In the end, hero and heroine are clearly on their way to marriage, a family, and a settled life thereafter.

The other major theme of this period also reflected Wister. Grey and Hart were both fascinated by the idea of the West as a testing ground of character and idea. Time after time their stories represented a protagonist—often a female, but sometimes a male "dude" or "greenhorn"—whose personal qualities and attitudes, formed in the East, were challenged and tested by the West. Grey's novels were populated with one heroine after another, who, searching for lost identity, found regeneration and happiness in the West under the influence of its inspiring scenery, its opportunities for romance with a devastatingly glamorous and wild member of the opposite sex, and its purging, redemptive violence.

Though this basic pattern is obviously reminiscent of *The Virginian*, Grey and Hart invested it with mythical and melodramatic overtones that are quite different from Wister. For example, they placed much greater stress on sexual and religious motifs. Their leading men and women typically combine hints of dazzling erotic intensity and prowess with an actual chastity, purity, and gentility that would barely bring blushes to the cheek of a Victorian maiden. In presenting his heroines Grey loved to dangle a seemingly corrupted and soiled dove before the reader's eyes only to assure him that the lady in question was truly virginal, sweet, and bent on monogamous domesticity. A favorite female type was the eastern sophisticate whose flirtations soon give way to deep and powerful love for the hero. Another was the wild heroine who appears on the scene like a sexy nature girl but soon reveals, beneath her sassy manner, her artfully torn chemise, and apparent promiscuity, a heart as pure as the driven snow.

The same melodramatic polarities characterize the Grey-Hart hero's sexuality. Mature, experienced, and an outcast, with a past that hints not only at terrible deeds of violence but at smoldering erotic prowess, he is sometimes suspected of sexual relationships with Indian girls or Mexicans. Given the racist attitudes of the period such relationships were ineffably fascinating and deeply disturbing. Actually, it usually became clear that the hero's seamy past was a myth. Though he might be a killer, his sexual life, despite manifold temptations, was usually above reproach.

Grey and Hart typically created a strong tension between symbolic sexuality and actual purity. Jean Isbel and Ellen Jorth of Grey's *To the Last Man* come from opposing families in a feud, but are irresistibly drawn together. At one point in their relationship, Jean leaves a small gift for Ellen, which she is reluctant even to look at. Grey's description of her reaction nicely illustrates how Grey hinted at sexuality while maintaining his heroine's chastity:

By and by she fell asleep, only to dream that the package was a caressing hand stealing about her, feeling for hers, and holding it with soft, strong clasp. When she awoke she had the strangest sensation in her right palm. It was moist, throbbing, hot, and the feel of it on her cheek was strangely thrilling and comforting. She lay awake then. The night was dark and still. Only a low moan of wind in the pines and the faint tinkle of a sheep bell broke the serenity. She felt very small and lonely, lying there in the deep forest, and, try how she would, it was impossible to think the same then as she did in the clear light of day. Resentment, pride, anger—these seemed abated now. If the events of the day had not changed her, they had at least brought up softer and kinder memories and emotions than she had known for long. (*To the Last Man* 86-87)

For the ardent lovers of Grey and Hart, sex and religion are intermixed. Sexual passion is treated as a semimystical moral and religious experience and is often associated with the redemptive and healing qualities of the simpler life and morally elevating landscape of the West. Georgianna Stockwell, the flapper heroine of *Code of the West* at first scorns the simple, unsophisticated passion of Cal Thurman and the sexist Western code of feminine behavior by which he and his family live. But she soon comes to see herself in a new perspective:

Stranger from the East . . . she had come with her painted cheeks, her lipstick, her frocks, and her bare knees, her slang and her intolerance of restraint. She saw it all now—her pitiful little vanity of person, her absorption of the modern freedom, with its feminine rant about equality with men, her deliberate flirting habits from what she considered a pursuit of fun and mischief, her selfish and cruel desire to punish boys whose offense had been to like her. (*Code of the West* 219)

But now under the influence of her growing love for Cal Thurman, this flapper heroine becomes a new person. Such total transformations also hit the W. S. Hart character when he meets and falls in love with the heroine.

The Western of the 1920s tried to affirm a deep connection between sexuality, romance, religion, and traditional middle-class social values in its heroic version of the West, thus domesticating in fantasy the threatening new sexual mores and attitudes toward religion which seemed to be taking root in the Eastern cities. Indeed the melodramatic violence which seems a necessary component of the hero's confrontation with evil in Grey and Hart may reflect an apocalyptic sense of corruption displaced from the East to a West portrayed as the land of the gun and the saloon. In *Hell's Hinges,* for example, the town is symbolically divided between the saloon and the church. Grey's novels also frequently dwell on the violence, lawlessness, and immorality of the West. In fact, Western violence seems much more pervasive in Grey and Hart than in Wister. Violence has always been a crucial element of the Western. In Cooper, it resulted from the clash between Indian and white and in Wister from the heroic necessity of upholding the community's unwritten law and defending a code of honor. Grey's heroes engage in still larger orgies of violence as avengers of the innocent and destroyers of evil. Their acts are carried out with a kind of transcendent religious passion resembling the moralistic zeal that led Americans to participate in the contemporaneous crusade of prohibition. There is perhaps no better image of this presentation of violence than the climactic scene of *Hell's Hinges* in

which the religious symbolism always just beneath the surface of Grey's violent climaxes is made quite explicit as we watch Hart as avenging angel with six-guns purging the devil's alcoholic lair, the saloon, with fire, like a sort of masculine Carrie Nation.

The intensification of violence seems connected to a more melodramatic and symbolic treatment of the landscape in Grey and Hart. There is not, in the history of Western literature, a purpler prose than that of Zane Grey. Much of his notorious overwriting is devoted to lengthy paeans to the beauty, mystery, and moral force of the Western landscape. Important as the Western landscape was to Wister, his treatment of it is sober and restrained when put beside an analogous passage in Grey:

She looked, and saw the island, and the water folding it with ripples and with smooth spaces. The sun was throwing upon the pine boughs a light of deepening red gold, and the shadow of the fishing rock lay over a little bay of quiet water and sandy shore. In this forerunning glow of the sunset, the pasture spread like emerald; for the dry touch of summer had not yet come near it. He pointed upward to the high mountains which they had approached, and showed her where the stream led into their first unfoldings. . . . They felt each other tremble, and for a moment she stood hiding her head upon his breast. Then she looked round at the trees, and the shores, and the flowing stream, and he heard her whispering how beautiful it was. (Wister 380)

He felt a sheer force, a downward drawing of an immense abyss beneath him. As he looked afar he saw a black basin of timbered country, the darkest and wildest he had ever gazed upon, a hundred miles of blue distance across to an unflung mountain range, hazy purple against the sky. It seemed to be a stupendous gulf surrounded on three sides by bold, undulating lines of peaks and on his side by a wall so high that he felt lifted aloft on the rim of the sky. . . . For leagues and leagues a colossal red and yellow wall, a rampart, a mountain-faced cliff, seemed to zigzag westward. Grand and bold were the promontories reaching out over the void. They ran toward the Westerning sun. Sweeping and impressive were the long lines slanting away from them, sloping darkly spotted down to merge into the blank timber. Jean had never seen such a wild and rugged manifestation of nature's depths and upheavals. (Grey, *To the Last Man* 19)

W. S. Hart's cinematic landscapes fall short of Grey's rhapsodies, but they share at least three central qualities, vastness, emptiness, and wildness. These qualities, in Wister, are mostly subordinate to the human dimension. Wister's landscapes have often rightly been compared to the paintings of Remington and Russell which have a similar focus on human activity against a spectacular background. In Grey, however, the

landscape is more reminiscent of earlier painters like Albert Bierstadt or Thomas Moran in whose work the human image is swallowed up by the transcendent spectacle of mountainous vistas.

For Grey, the Western landscape symbolized transcendent religious and moral forces of wilderness. This vision of the landscape, combined with the image of purgative violence and the religious-erotic treatment of hero and heroine, added a new dimension to the Western in the work of Grey, Hart, and many of their contemporaries. Culturally, the popularity of this new version suggests that the West had come to have a new meaning for many Americans. First of all, by this time the West had become more important as a moral symbol than as a social or historical reality. Of course, the American view of the West had been strongly colored by allegory from the very beginning, but with the closing of the frontier the distance between the public and the events of the old West increased. In the absence of direct experience the West became, for a time, a landscape of enchantment and myth, a land onto which Americans could project their hopes and dreams and deepest values.

Grey and Hart and their contemporaries established the Western as one of the major twentieth-century American literary and cinematic genres. Blending Western heroism and the wilderness, they created protagonists whose courageous encounter with the challenge of the West led to the reaffirmation of traditional values and the purging of threatening new evils. These heroic deeds did not carry the broader political and social implications so important to the actions of *The Virginian*. In fact, the violent purgation that so often climaxes a novel by Grey or a film by Hart sometimes goes so far as to wipe out everybody but the hero and heroine. The ultimate result of this confrontation with wild nature and violent men affirmed such traditional American values as monogamous love, the settled family, the basic separation of masculine and feminine roles, and the centrality of religion, even if this means the wholesale destruction of those forces which challenge those traditions.

In a period when traditional American values were under attack, Grey and other contemporary novelists and filmmakers transformed the Western formula into a vehicle for reaffirming them. Within this framework of reassertion they created stories that dealt with some of the basic conflicts in social roles and values that were sources of anxiety to early twentieth-century Americans. Two major causes of uncertainty were new ideas about the relationship between the sexes and the increasing doubts about the transcendent meaning of nature. These tensions reached a peak in the disillusion following World War I and the emergence in the 1920s of what was referred to as the "new morality" under the influence of such social and intellectual currents as Darwinian naturalism, Freudian-

ism, feminism, and socialism. The period in which Grey and Hart reached the peak of their success and influence as popular creators was the same period in which Hemingway, Fitzgerald, T. S. Eliot, and Sinclair Lewis were major cultural spokesmen and, in this perspective, we can see some of the reasons why Grey and so many of his contemporaries turned to the fantasy of the Western in order to express some of their major concerns. Like Hemingway, Grey wrote his fictions as a means of exploring and coping with the threat of a meaningless universe, but he sought to imagine an image of heroism and a vision of relation between the sexes that would bring some kind of meaning out of a world of violence and chaos. Where Hemingway confronted the tragic condition of man in a godless world, Grey, by developing his elaborate fantasy of a heroic West, passed beyond tragedy into melodrama. By absorbing many of the elements of earlier naturalistic writers like Jack London and Frank Norris—from whom he probably garnered some of the semi-mystical rhapsodizing about wild nature that lards his novels—and reintegrating this with a more traditional set of American values, Grey made of the West a magical enclave where the strains and uncertainties of a modern urban-industrial culture could be temporarily forgotten and where the truth of wild nature turned out to be not the meaningless Darwinian jungle but an uplifting and elevating moral force.

Along with their reassertion of the moral meaning of nature, these highly popular Western writers and filmmakers of the 1910s and 1920s developed the West as a place where traditional ideals of male and female roles and of moralistic romance were part of the pattern of heroic virtue. In contrast to contemporary American society where women were increasingly challenging their traditional roles, the West of Grey and Hart was, above all, a land where men were men and women were women. In novel after novel, Grey created strong, proud, and daring women and then made them realize their true role in life as the adoring lovers of still stronger, more virtuous, more heroic men:

Those shining stars made her yield. She whispered to them that they had claimed her—the West claimed her—Stewart claimed her forever, whether he lived or died. She gave up to her love. And it was as if he was there in person, dark-faced, fire-eyed, violent in his action, crushing her to his breast in that farewell moment, kissing her with one burning kiss of passion with wild, cold, terrible lips of renunciation. "I am your wife!" she whispered to him. In that moment, throbbing, exalted, quivering in her first sweet, tumultuous surrender to love, she would have given her all, her life, to be in his arms again, to meet his lips, to put forever out of his power any thought of wild sacrifice. (*The Light of Western Stars* 213)

Grey and Hart imagined the West for their admiring contemporaries as a symbolic landscape in which the vastness and openness of nature and the challenge of violent situations and lawless men could lead to a rebirth of heroic individual morality and ideal relationships between men and women. However, there seems an increasing sense in their work that this happy resolution cannot be spread to society as a whole. It is difficult to see a Grey or Hart hero as a successful entrepreneur, as Wister's Virginian became, or to imagine the transition between the mythic landscape of their stories and the modern world. Grey's heroes and heroines existed in a timeless, suspended world where their romance and heroism could be complete and pure. As Henry Nash Smith observed of the dime novel, the cost paid for this purity was that this vision of the West could not become involved in a meaningful dialectic with the urban industrial society of modern America. Thus, in Grey's hands, and in that of the many pulp Western novelists and makers of B films who followed his lead, the West became an object of escapist fantasy for adults seeking temporary release from the routine monotony and moral ambiguities of twentieth-century American life. There is some indication that Grey himself sensed the essential fantasy of his vision in the fact that so many of his stories eventuated in the formation of an ideal society of two people in some isolated enclave in the mountains. For me, the ultimate symbol of Grey's version of the West is the secret mountain valley into which Lassiter and Jane Withersteen flee at the end of *Riders of the Purple Sage,* sealing themselves off forever with a massive rock slide that wipes out the evil pursuers. From such a Garden of Eden there can be no fall or anything else.

4. The "Classic" Western: John Ford and the Western as the Myth of America in the World

In the later 1920s and the 1930s the B Western, singing cowboys, and the pulp story and novel flourished but the "adult" Western went into decline. Perhaps the increasing uncertainties of the depression era and anxieties about another world war made the theme of Western regeneration seem ironic and hollow. Few Western novels reached the bestseller list and the production of high-budget Western films fell off significantly. W. S. Hart retired, and John Ford, whose *Iron Horse* was one of the great successes of the twenties, did not make another Western until his 1939 *Stagecoach.*

Zane Grey remained a popular writer and a perennial source of new material for Western films. New Grey books were published annually until 1961, more than twenty years past his death in 1939, and many of his novels are still in print in 1999. However, his amazing mass popular-

ity of the 1920s faded. After his record run of a decade, Grey does not appear among the top bestsellers after 1925. Similarly, there is a considerable hiatus between the major silent Westerns of the 1920s—W. S. Hart, Tom Mix, and grand epics like *The Covered Wagon* and *The Iron Horse*—and the new A Westerns of the 1940s and 1950s by directors like John Ford, Howard Hawks, Anthony Mann, Fred Zinneman, William Wyler, George Marshall, Fritz Lang, Michael Curtiz, George Stevens and many others. Most Westerns produced in the 1930s were B adventures for the Saturday matinee and triple feature audiences. In the 1930s, Westerns of this sort still strongly depended on the moralistic and sentimental version of the genre articulated by Zane Grey. However, a few exceptional writers and directors such as the novelist Ernest Haycox and the director King Vidor, had begun to evolve a new treatment of the Western.

This new version flowered in John Ford's *Stagecoach* (1939), based on a story by Ernest Haycox. *Stagecoach* placed a lasting mark on the Western film, though without detracting from its unique artistry, we should note that a number of contemporary Westerns showed similar generic transformations. Among them were George Marshall's *Destry Rides Again* (1939), Henry King's *Jesse James* (1940), Fritz Lang's *The Return of Frank James* (1940), and William Wyler's *The* Western*er* (1940).

Like Grey, Ford, in *Stagecoach,* emphasized the theme of regeneration through the challenge of the wilderness, using the spectacular forms of the Western landscape to give a symbolic background to the drama. Monument Valley in northern Arizona, where Ford shot so many of his films, is a landscape as spectacular as Grey's Tonto Basin, also in Arizona. A number of Ford's basic character types also echo Grey's—the gunfighter hero driven by an obsession to avenge a past wrong (Grey's Lassiter and Ford's Ringo Kid) and the seemingly corrupt heroine who turns out to be morally pure (Grey's Ellen Jorth and Ford's Dallas). Nevertheless, *Stagecoach* presents a very different vision of the West from *Riders of the Purple Sage,* and not only as a result of its subtler and more complex handling of setting, plot, character, and theme. Ford's landscape is indeed a symbolic one, but not in terms of the evangelical mysticism and moralistic allegory that pervade Grey's sweeping mountains and canyons. Instead, Ford uses the great isolated monoliths of Monument Valley in *Stagecoach* to project something much more richly enigmatic. Ford's panoramic long shots of the stagecoach threading its way among these massive rock formations reflected the basic uncertainty and ambiguity of human existence, and were a fitting image for a nation struggling to survive a terrible depression and on the verge of war.

The same qualities of greater subtlety and richness extend to character and action. While Ford and other Western directors of this period worked with casts of stereotyped characters not dissimilar to those in a novel by Grey or a film by W. S. Hart, these stereotypes are typically made more complex by touches of comedy and irony. In *Stagecoach* the virginally pure romantic ingenue is, in fact, a prostitute. The hero materializes out of the wilderness, bent on revenge, but instead of being a mysterious figure in black, he is a nice young cowboy who has just escaped from prison and is a bit shy and awkward about breaking into society on same day. Larger patterns of action also have comic or ironic resonance and complexities. As in *Hell's Hinges, Stagecoach* centers around the conflict between churchgoers and sinners, represented by the anti-thesis between the daylight town of Tonto and the night town of Lordsburg. But Hart melodramatizes this conflict by placing all our sympathies on the side of the church people. Ford, on the other hand, presents the Ladies' Law and Order League who claim to represent the "good folk" of Tonto as rigid and repressive Puritans. Moreover, he exposes Tonto's most respectable citizen as a hypocritical embezzler, and gives our fullest sympathies to a prostitute, a drunken doctor, an escaped convict, a whiskey drummer, and a dubious gambler. This unlikely group triumphs over the enigmatic and hostile wilderness, just as those oddly assorted bomber crews and infantry squads would redeem themselves and defeat the enemy in many later movies of World War II. But even regeneration had its ironic qualifications. The drunken doctor sobers up and officiates at the birth of a baby in the middle of the desert, heroically faces the attacking Apaches, and, finally, helps the hero in his climactic confrontation with the villains. Yet at the end of the film it is clear that he is going to go on drinking. The hero and his prostitute sweetheart go off together "into the sunset," though they actually leave in the middle of the night, and as fugitives. There is no reintegration into society in the footsteps of Hart and Grey's regenerated outlaws.

The artistic power of the Westerns of the 1940s and 1950s reflected the increasing gap between an inherited moral universe and the ambiguities of social and cultural change. The American public shared this uncertainty. It was unwilling to give up traditional moral values, and thus supported the moralistic censorship of films by self-appointed guardians of the faith, like the Hays office and the Legion of Decency. Yet, the public also indicated its doubts about the traditional moral vision by turning to more socially critical novels and films. Sinclair Lewis and John Steinbeck replaced Harold Bell Wright and Zane Grey on best seller lists, while the snarling gangsters of Edward G. Robinson,

James Cagney, and Humphrey Bogart became more popular than the morally regenerate outlaws of W. S. Hart or Tom Mix's happy cowboys.

Facing such ambiguities, the Western was still a vital enough genre to enter upon a new phase of creative activity that appears in retrospect to be its greatest period. A new vision of the meaning of the West inspired a formula more responsive to the conflicts of value and feeling that characterized the period from 1940 to 1960. Instead of simply affirming the traditional morality and dramatically resolving conflicts within it, this new image of the West encouraged a richer exploration of the tensions between old moral assumptions and new uncertainties of experience. It also expressed a sense of loss associated with the passage of a simpler and less ambiguous era while acknowledging its inevitability. Thus, in contrast to the sense of moral triumph and regeneration through violence that characterized the Western of the 1910s and 1920s, the new "classic" Western was typically more elegiac and even sometimes tragic in its pattern of action. This new richness of implication enabled the Western to become widely accepted during this time as the essential body of legend and myth about America. In this context, making and viewing Westerns became something of a cultural ritual as well as a popular entertainment.

The essential characteristic of this new version of the West was the concept of the "Wild West" as a heroic period of American society and history, now moving into the past. The symbolic drama of the Wild West's passing generated new and more complex kinds of stories. While this elegiac sense of the West turned up in Natty Bumppo's occasional laments for the passing of the old wilderness life, or in Wister's preface to *The Virginian,* when he remarked that the cowboy "will never come again. He rides in his historic yesterday," there are two major differences between these earlier notions of the West as bygone era and the "Wild West" of the 1940s and 1950s. First, this earlier phase of the West was usually associated with the wilderness and the Indians. It was, in effect, a version of pastoral. The new meaning of the "Wild West" referred, on the contrary, to a social epoch, now past or passing, which was deeply connected to the meaning of America. Walter Prescott Webb, a great historian of the West, and a twentieth-century exponent of a global version of Turner's "frontier theory" eloquently expressed this view of the "Wild West" in his analysis of the cattle kingdom:

The cattle kingdom was a world within itself, with a culture all its own, which, though of brief duration, was complete and self-satisfying. The cattle kingdom worked out its own means and methods of utilization; it formulated its own law, called the code of the West, and did it largely upon extra-legal grounds. The

existence of the cattle kingdom for a generation is the best single bit of evidence that here in the West were the basis and promise of a new civilization unlike anything previously known to the Anglo-European-American experience. . . . Eventually it ceased to be a kingdom and became a province. The Industrial Revolution furnished the means by which the beginnings of this original and distinctive civilization have been destroyed or reduced to vestigial remains. Since the destruction of the plains Indians and the buffalo civilization, the cattle kingdom is the most logical thing that has happened in the Great Plains, where, in spite of science and invention, the spirit of the Great American Desert still is manifest. (206)

Thus, the classic Western shifted its focus from the myth of foundation to a concern with social transition—the passing from the old West into modern society. The hero became not the founder of a new order but a somewhat archaic survival, driven by motives and values that are somewhat anachronistic in the new social order. His climactic violence, though legitimated by its service to the community, does not integrate him into society. Instead, it separates him still further, either because the pacified community has no need for his unique talents, or because the new society cannot quite contain his honor and his violence. In this situation, the hero increasingly tended toward isolation, separation, and alienation.

This theme was particularly striking in a film like John Ford's *My Darling Clementine* (1946) where there is really no necessity for the hero to depart at the end. Yet Ford obviously felt that it was artistically and emotionally right for Wyatt Earp to say farewell to his new love, Clementine, and to leave the town he had purged of evil, only hinting that he will ultimately return. Similarly, the hero and heroine of *Stagecoach* cannot remain in the town but must take their love and their heroic courage off to some mythical ranch across the border. Again, the events of the story do not require this ending. Ford could certainly have arranged for his hero to be exonerated for killing the villains. Somehow it seemed to him inappropriate for these two representatives of the heroic West to stay in the orderly and pacified town, with the Indians driven back to the reservation, the unrestrained men of violence killed, and the army and the law firmly in control. Ford did not deal with the theme of the changing West as explicitly in his films of the 1940s as he did later. However, some of the richness of his work comes from the way in which exciting adventure and good-humored social comedy, the dominant tones of *Stagecoach* and *My Darling Clementine,* are inextricably mixed with a subtle feeling of regret that a more heroic life is passing.

Concern about the end of the Wild West and ambiguity about the new society that was replacing it became a more explicit thematic con-

cern in Ford Westerns of the 1950s and 1960s such as *The Searchers* (1956), *The Man Who Shot Liberty Valance* (1962), and *Cheyenne Autumn* (1964). In *Liberty Valance,* for example, the old Western hero, Tom Doniphon, is morally and emotionally destroyed when he kills the last anarchic outlaw and enables the new-style Western leader, a young lawyer from the East, to become the community's representative man. Though the result is progress and happiness, there is, nonetheless, a deep sense that something valuable has been lost. There is also an ironic twist in the fact that the young lawyer's political success is based on his false reputation as the heroic killer of the outlaw Liberty Valance, a deed actually performed by Doniphon. The new society is founded on a false legend of heroism, created by a man who cannot find what he needs in the new world his act has made possible. *Cheyenne Autumn,* based on Mari Sandoz's moving account of the attempts of a band of Cheyenne Indians to leave their arid southern reservation and return to their northern homeland, is an even more elegiac if less coherent account of the passing of the old West. With its heroic band of Indians set against the rapacity, greed, and bureaucratic inhumanity of the Indian Bureau and the government, *Cheyenne Autumn* and *The Searchers* foreshadowed some of the central themes of the Post-Western, including a new treatment of the Native American.

The Searchers has many of the same elements as *Stagecoach* and was filmed against the same landscape, Ford's favorite Monument Valley. However, where Monument Valley in the latter film symbolizes "Indian country" and is clearly marked off from the towns around it, in *The Searchers* time and space are much more ambiguously mixed, just as the relationship between whites and Indians becomes blurred. John Wayne's Ringo Kid helps fight off the Indians and save his fellow passengers, but Ethan Edwards, main figure of *The Searchers,* and also portrayed by Wayne, becomes increasingly indistinguishable from his Indian adversary Scar. In the end he has as little place in the new pioneer society as the now exterminated Native Americans and his final departure into nowhere is the last scene of the film. In the difference between these two Westerns, one from 1939 and one from 1956, Ford ran the course between the beginning of the classic Western and its end. It remained for Ford's disciple, Sam Peckinpah to carry the theme of the end of the Wild West to its ultimate completion in *Ride the High Country* (1962) and *The Wild Bunch* (1967).

The dramatic ambiguities of the classic Western produced a particularly interesting type of hero. Unlike the natural gentleman of Owen Wister, or the romantic heroes of Zane Grey and W. S. Hart, the classic hero's role as a man-in-the-middle between groups that represent the old

and the new West is far more important than his relations with the opposite sex. Indeed, in many classic Westerns there is relatively little romantic interest of the sort that was so important to Wister and Grey. Instead, the plot concerns situations in which the hero finds himself both involved with, and alienated from, society. In this type of story, the gunfighter often takes the place of the cowboy as hero, because the gunfighter's position with respect to the law is, by convention, ambiguous. According to the mythical code of the old West, the gunfighter is not a criminal, though he may have killed many men. By the standards of the new West, he is illegally taking the law into his own hands. Split between old and new concepts of law and morality, the town finds itself torn between its disapproval of what the gunfighter stands for and its need for his services. The gunfighter's own motives are also likely to be ambivalent. He may be tired of his violent way of life and hopeful of settling down to a peaceful old age, but he is usually unable to do so because of his reputation and the need to prove himself anew against younger gunmen. Or else he may resent the town's inability to purge itself of evil through the regular processes of the law.

The classic hero usually cannot resolve his inner conflict by committing himself to one of the two courses of action or ways of life that divide him. Thus, such Westerns often end in the hero's death or in violence, reluctantly entered upon, that does not fully resolve the conflict. Wister's Virginian chose to live out the code of the West as a matter of honor and duty, even though his sweetheart threatened to leave him. But his problem was solved when she saw him in danger and realized that her love was greater than her genteel antipathy to violence. The hero thus overcame his enemy and gained a respectable place in society. In contrast, the sheriff in *High Noon* is deserted by the town he elects to save and forced to fight the villains alone. However, his victory is such a bitter one that he can only turn his back on society in disgust. In *Shane,* the hero must adopt the part of gunfighter he has tried to leave behind in order to save the farmers from being driven off their land. But once he has destroyed the old order by killing the tyrannical rancher and his hired gunfighter, he has no place in the new community and must ride into lonely exile. In a more comic vein, Howard Hawks's heroic sheriff in *Rio Bravo* destroys the tyrannical rancher and gets the girl, but the film's predominant image is that of the small heroic group isolated from the rest of society in its fortress jail.

Whether it reached toward the tragic and elegiac as in Ford, the comic in Hawks, or the mythic in Anthony Mann, the classic Western became a vehicle for exploring the ambiguities in American life generated by the traumatic events of the depression and the seeming failure of

traditional values. As the Cold War developed, the classic Western was also increasingly understood as a fable of the ambiguities of America's role as global sheriff in the aftermath of World War II. Conflicts such as those between traditional and progress, individualism and organization, violence and legal process, or conformity and individual freedom were explored through the classic Western's parable of the antithesis between the individual heroism of the Wild West and the new order's drive toward organization and stability.

Many Westerns of the classic period such as *High Noon* and *The Ox-Bow Incident* were explicitly understood as allegories with strong implications for the contemporary scene. Critics, also, began to interpret Westerns in terms of contemporary situations and to point out analogies between the Western film and such events of the period as World War II, the Korean conflict, the Cold War, the "crusade" against communism, and finally, the Vietnam War. Whatever one may think about the validity of such interpretations, the tendency to make them indicates the degree to which more sophisticated members of the public responded to the classic Western as an explicit myth of American society and of America's place in the new world order.

The patterns of the classic Western also flourished in the new medium of television as what was commonly referred to as the new "adult" Western. *Bonanza* was far less pure as a Western than *Gunsmoke*, since its variety of central characters made it possible for the show to borrow plots from such diverse popular traditions as the detective story and the social melodrama. Still, the main line of both series was that of the classic Western: the representation of a heroic figure (or in the case of "Bonanza" a group of heroes) as mediators between the aggressive individualists of the old West and the new values of the settled town.

Certainly not everyone who enjoyed Westerns during the classic period interpreted them in this way. Yet the special character of the classic Western hero as played by Gary Cooper, John Wayne, James Stewart, Henry Fonda, Joel McCrea, and Randolph Scott, reflected the conflict between traditional heroic individualism and new needs for commitment to society. He was characterized by his reluctance to commit himself to any particular social group, his ambivalence about what social groups were right and wrong, and his strong desire to retain his personal integrity and the purity of his individual code. Yet, at the same time this hero found himself forced to help the very society he had doubts about.

The appeal of such a heroic figure was considerable at a time when tradition and change were increasingly in conflict. In such a period, the extraordinary hero is one who, torn by the conflicting demands of different social roles and value systems, yet manages to assert his identity in

action. In this respect, the classic Western hero bears a strong resemblance to the hard-boiled heroes of Hemingway, Hammett, and Chandler, those protagonists of what later become known as *film noir,* which flourished around the same time as the classic Western and shared many of the Western's stylistic and thematic traits. Many critics have remarked how much *High Noon,* an archetypal classic Western, can also be seen as a Western *film noir.* The same heroic type who peopled the classic Western was also represented in the film performances of Humphrey Bogart at the same time, though interestingly Bogie's few attempts at playing the Western were failures. In fact, the classic Western hero's basic pattern of initial reluctance and ambivalence finally resolved by violence was practically identical to that developed by the Bogart persona in such films as *The Big Sleep, To Have and Have Not,* and *Casablanca.* Significantly, Howard Hawks, who made two of these films, was also very active in Westerns during this period. In these contemporaneous films, the conflict between a traditional world and a new social order is represented by urban corruption or by the coming of war. As in the Western, the hero has rejected the traditional world, but he is not prepared to commit himself to the new order, for he senses that it will destroy his individual identity. In the end, he finds a mode of action, usually through violence, that reaffirms his individual code. Or, to put it in terms that were popularized by the best known sociologist of the period, David Riesman, this type of hero insists upon asserting his inner-directed self in an increasingly other-directed world.

Riesman's concept of changing social character offers some insight into the meaning of the hero's violence in the classic Western. In earlier Westerns, the hero's violence was the means by which the evil and anarchic forces were finally purged and the hero integrated with society. But in the classic Western, as in the hard-boiled detective story, the hero's violence was primarily an expression of his capacity for individual moral judgment and action, a capacity that separates him from society as much as it makes him a part of it. In *Casablanca* Bogart's commitment to the Free French cause was a powerful but romanticized expression of wartime Hollywood patriotism. The more detached and mythical setting of the classic Western made the hero's violence more ambiguous and individualistic.

In general, then, the classic Western projected contemporary tensions and conflicts of values into a mythical past where they could be balanced against one another and resolved in an increasingly ambiguous moment of violent action. The popular success of *Stagecoach* was thus the beginning of a new cycle of "adult" Westerns which led to a great flourishing of the Western film. This reached a peak in the wonderful

Westerns of John Ford and in films like *High Noon* and *Shane,* which were among the most successful and esteemed productions of 1952 and 1953. Westerns continued to be highly popular throughout the 1950s and this new "adult" version was successfully adapted to television in enormously popular series like *Gunsmoke* and *Bonanza.* The Western reached its peak of appeal to the general public in the later 1950s when eight of the top ten television series were Westerns.

This was the period when the Western rode highest. Not only were Westerns frequently among the best films with major male stars like Gary Cooper, John Wayne, Henry Fonda, James Stewart, and Richard Widmark, they could also be counted on to have some of the best supporting casts and highest production values. Hollywood and the public lavished attention and money on Westerns, because throughout this period, the Western served as an unofficial myth of America's situation in the world. The central themes of the Western between 1939 and 1960 centered around the role of the gunfighter or marshal called upon to save a somewhat unwilling town from the domination of outlaws, a mythic parable which seemed increasingly to define America's perception of her role on the international scene during World War II and in the early years of the Cold War.

However, in the films of the middle 1960s, the patterns of the "classic" film of the 1940s and early 1950s were beginning to break up. In the early 1960s the number of television Westerns dropped off. High-budget Western films continued to be produced but few of them achieved the broad popular success of the earlier works of John Ford or of *High Noon* or *Shane.* Though several striking new versions of the formula brought audiences to films like *Butch Cassidy and the Sundance Kid, True Grit, The Wild Bunch,* and above all to the "Spaghetti Westerns" of Sergio Leone and Clint Eastwood, these did not lead to the emergence of another cycle of traditional Westerns. In fact, these films marked the end of the "classic" Western, and the emergence of what we will treat in the next chapter as the "Post-Western."

4

THE POST-WESTERN

Somewhere between the past and the present lies the disruptive point where the Western no longer responds to our present needs or the too urgent demands made upon it, where the rituals and our understanding of them will destroy themselves. We do not appear to have reached that situation yet, but it would be foolhardy to believe that the genre is capable of such infinite renewal that such a time will not come.

—Philip French (*Westerns* 47)

In the middle of the 1990s a series of television advertisements for McDonald's made the Western hero appear as a nostalgic ghost from the past. In these commercials, aging stars of Western series from the 1950s like Hugh O'Brien [*Wyatt Earp*] and Chuck Connors [*The Rifleman*] rode up in spectral black and white to a full-color McDonald's and ordered a new barbecue sandwich. These dusty shades were a distant echo of the mythical presence of the Lone Ranger as he rode "out of the past" heralded by the thundering hoofbeats of the great horse Silver. It seemed clear that in the era of the Big Mac and the Golden Arches the Western was only a ghost of its former self. What had led to this dramatic decline in a once powerful American mythology?

The 1988 British Film Institute *Companion to the Western* blamed the financially disastrous Western *Heaven's Gate* (1980) for a radical drop in Western production. "Michael Cimino may go down in history as The Man Who Killed the Western, in that this incredibly expensive box-office disaster effectively dissuaded the studios from investing in Westerns in the '80s" (268). Though this lays too much at one door, the confusions of Cimino's film and its subsequent box office failure did indicate that late twentieth-century audiences could no longer be counted on to respond automatically to the symbols of the Wild West. In this context, moviemakers were no longer sure how to make a Western.

Cimino had had a great success with *The Deer Hunter* (1978), which made many references to Cooper and the Western tradition, while presenting a story about a modern counterpart to the mythical figure of the good hunter involved in the war between races. Having, so to speak, done Cooper, Cimino turned to the famous Western episode of the John-

son county war, which had also been the historical basis for Owen Wister's *The Virginian* and Jack Schaefer's *Shane*. However, when he tried to treat the conflict between ranchers and farmers in terms of the contemporary themes that he had explored so effectively in *The Deer Hunter,* Cimino ran into difficulties. The result simply exploded the limited boundaries of the Western genre. In its initial version, reported to have lasted 3 1/2 hours, the film apparently both exasperated and exhausted its audience by its murky complexity and ambiguity. In the drastically cut version released to theaters and shown on cable television, the film was still profoundly puzzling, particularly if one brought to it the traditional expectation of dramatic and symbolic clarity, associated with the Western genre. In spite of his success in *The Deer Hunter,* Cimino was somehow unable to make his multicultural vision of America work as a Western.

Cimino's failure reflected the increasing obsolescence of the Western as a myth of America. In *Gunfighter Nation* (1992), Richard Slotkin suggested that the disillusionment resulting from our disastrous involvement in the Vietnam War and our growing uncertainty about the American future have deeply eroded the ideology of American uniqueness which the traditional Western mythicized. Slotkin thought that the notable decline of the Western in the 1980s meant that "the Western has therefore been relegated to the margins of the 'genre map'" (633) and will never again occupy the central place that it once held in the expressive patterns of American culture. Though, according to Slotkin, the Western film "reached the peak of its popularity and cultural pre-eminence from 1969 to 1972" (627) its decline has been precipitous since then. Therefore, "the failed attempts to revive the Western after Vietnam indicate the character and strength of the social and cultural forces that fractured the myth/ideology of the liberal consensus" (628). Just as almost exactly a century ago Frederick Jackson Turner redefined the meaning of American history for his contemporaries with his frontier thesis, today "it may be time for a post-mortem assessment of the significance of the Frontier *Myth* in American history" (627).

Slotkin goes on to suggest that "the rejection of the Western had gone beyond antipathy for a particular ideology to a rejection of the very idea that the Frontier could provide the basis of a national public myth" (632). We have arrived at a "'liminal' moment in our cultural history" when we are "in the process of giving up a myth/ideology that no longer helps us see our way through the modern world" (654). In particular we need new mythical patterns, which express "the fact that our history . . . was shaped from the beginning by the meeting, conversation and mutual adaptation of different cultures." In short, the old epic of the American

frontier as the myth of White America's conquest of a savage wilderness is in the process of giving way to a new mythical dialectic of multiculturalism which cannot be contained within the patterns of the Western.

1. The Emergence of the Post-Western

Folks. This here is the story of the Loop Garoo Kid. A cowboy so bad he made a working posse of spells phone in sick. A bullwhacker so unfeeling he left the print of winged mice on hides of crawling women. A desperado so onery [sic] he made the Pope cry and the most powerful of cattlemen shed his head to the Executioner's swine. (9)

So begins Ishmael Reed's hilarious send-up of the Western, *Yellow Back Radio Broke-Down* (1968), an important precursor of Mel Brooks's *Blazing Saddles* (1974), a film which not only demolished the traditional myths and symbols, but became one of the most popular Westerns of all time. Like *Blazing Saddles,* Reed's hilarious deconstruction of the Western flayed such central Western myths as the whiteness of the hero and rigid gender boundaries between men and women. Brooks and Reed both feature African American studs as heroic protagonists while hinting at all manner of bisexuality and perversion. Both works were pervaded by the campy style associated with homosexuality, and, in addition, frequently broke through the mythic frontiers of the Wild West with a maze of anachronisms and references to cultural traditions far beyond the boundaries of the traditional Western. When the black hero of *Blazing Saddles* rides off into the sunset with his gay pardner it is in a Cadillac "pimpmobile" suggesting a whole range of cultural references completely missing from the conventional Western. Reed's tale of the Loop Garoo Kid not only projects images of modernity, but also mixes characters and episodes that symbolize many different historical eras and cultures. The "Western" town of Yellow Back Radio, site of the adventure, is set in the midst of the Black Forest. The adventure ends with Loop Garoo (a name out of Creole Voodoo tradition) riding his horse into the sea after the Pope.

Works like *Yellow Back Radio Broke-Down* and *Blazing Saddles* reflected an increasing sense of the limits and inaccuracies of Western generic formulas. Doubts about the Western and what it stands for increasingly inspired one important kind of Post-Western: the ironic parody of the Western myth. Of course, like any very distinctive literary form, the Western has always been a prime target for parody and irony—witness Mark Twain's attack on Cooper, or Stephen Crane's "The Bride Comes to Yellow Sky." However, from the mid 1960s on, many of the

most successful Westerns depended heavily on comedy and/or parody, like *Cat Ballou* (1965), *Support Your Local Gunfighter* (1971), *The Life and Times of Judge Roy Bean* (1972), *Blazing Saddles* (1974), and *The Duchess and the Dirtwater Fox* (1976) or were anti-Westerns with moral ambiguities similar to the contemporaneous urban thriller or spy story, such as *McCabe and Mrs Miller* (1971), *Bad Company* (1972), *The Great Northfield Minnesota Raid* (1972), *Pat Garrett and Billy the Kid* (1973), *Buffalo Bill and the Indians* (1976), *The Missouri Breaks* (1976), and *Goin' South* (1978)

Ishmael Reed's surrealistically multicultural version of the Western went a good deal further than most of these other parody Westerns. Reed's new "Hoo-Doo" mythos subjects the traditional symbolism of the West, to a process of transformation, deconstruction, and re-mythologizing which moves toward the new multicultural vision of America which Richard Slotkin sees as the likely successor to the frontier as a source of American myth for the next century. *Yellow Back Radio Broke-Down* and *Blazing Saddles* illustrate one of many directions in which the use of traditional Western material has gone in this era of the "Post-Western."

One of the first critics to suggest that the traditional Western was in the process of being replaced by a Post-Western was Philip French who added a chapter on "The Post-Western" to the 1977 edition of his excellent 1973 book on Westerns. However, French used the term mainly in the sense of "modern" Westerns "set in the present-day West where lawmen, rodeo riders, and Cadillac-driving ranchers are still in thrall to the frontier myth" (19-20). Thus for him, "Post-Westerns" were really just another kind of Western, like Civil War Westerns or "pre-Westerns" (e.g., those which "deal with the coonskin-capped frontiersman armed with a flintlock musket and traveling by foot in the late eighteenth-early nineteenth century. The Fenimore Cooper Leather-Stocking figure" [18]). At the time he wrote, French saw the Western as a still-flourishing genre as indeed it was in the mid 1970s.

However, by the later 1990s, "Post-Western" had taken on another set of meanings. It now pointed to the kinds of films and novels that continued to make use of or to refer to Western images or myths in spite of the decline of the genre as a major component of American popular culture. Though it was not fully clear at the time, by the middle of the 1970s, the artistic and cultural synthesis that had inspired so many classic Westerns was breaking apart and Westerns were becoming more critical and self-reflexive about their own traditions.

As the Western became increasingly tenuous as a coherent generic tradition in the 1980s and 1990s, the symbolism, the landscape and the central themes associated with this tradition found expression in a

number of different forms. The symbolism of the West not only became a subject of parody, but also inspired a number of new developments in film, literature and history. One important aspect of the Post-Western is what Paul Bleton calls "deterritorialization" both in the sense that Westerns are now made in other countries and that these non-American Westerns have increasingly redefined and expanded the meaning of the West itself as mythic terrain or territory.

This transformational aspect of Western themes and motifs has made it possible for characters, themes and motifs originally associated with the generic Western to become influential in other media and in other countries. A recent essay by a French Canadian scholar showed us how the image of the cowboy, transmuted into American country music had been adapted by the Francophone popular culture of Quebec, and mingled with their own folk traditions, to generate Quebec Country Western music. This music now plays an important role in expressing the nostalgia of urban workers displaced from a traditionally rural society.

In the Post-Western era, Western myths and images have become adapted to a wide variety of transnational contexts and some of these have, in turn, come back to America to reshape developments in the Western. Christopher Frayling and others have pointed out how much Leone's spaghetti Westerns influenced American Westerns. Indeed, both Sam Peckinpah and Clint Eastwood, two of the most successful Western directors of the Post-Spaghetti era were strongly influenced by Leone. Eastwood's *Unforgiven* (1992), the last Western to gain both great popularity and a high degree of critical acclaim, reshaped Leone's image of the gunfighter, his treatment of violence, and his visualization of the "Western" terrain, infusing them with more traditional Western patterns and themes.

The major themes of some of these new Westerns were: 1) stories of the end of the Wild West, the old gang's last ride, the hero's last shootout, etc.; 2) A new more favorable and complex view of Indian culture and a more critical view of the white treatment of Native Americans; 3) Studies of the hero as alienated professional rather than as man of the wilderness, displaying critical and ironic attitudes toward some of the most important traditional myths associated with the Western, such as that of the heroic gunfighter; and 4) films and novels which were Post-Westerns in that they made use of Western symbolism and themes but in connection with contemporary urban or futuristic settings.

When I first wrote *The Six-Gun Mystique* in the late 1960s, the Western still seemed to me, as it did to Philip French in the mid 1970s, a flourishing popular genre, and in some ways *the* archetypal American

genre. However, thirty years later, the production of successful Westerns, particularly in film and for television has become a rare event. This decline in the Western's hold over the public imagination was foreshadowed by some important thematic changes in the major Westerns of the 1960s. While early modern Westerns tended to deal with stories from the period of pioneering and the beginning of settlement, 1960s' and 1970s' Westerns more often centered around the end of the West, the passing of its heroic and mythical age and its entry into the modern world of cities and technology. In Sam Peckinpah's *Ride the High Country* (1962), the aging heroes seem out of place in a world of policemen and automobiles. The climactic shootout is clearly one last apotheosis of the Wild West. By the time of *The Wild Bunch* (1969) Peckinpah's aging bandits confronted a modern world of machinery, militarism and social revolution which destroyed them. The sense of the myth's obsolescence was even stronger in films like Sydney Pollack's *The Electric Horseman* (1978) or Clint Eastwood's *Bronco Billy* (1980) in which the protagonists represented only a ghostly image of the mythic past.

John Wayne's death in 1979, after a battle against cancer, was widely mourned as the end of an era, and in many ways it was. No younger actor has become such a widely recognized symbol of the Western hero. Those, who, like Charles Bronson first became famous in Spaghetti Westerns, have increasingly turned to other genres like the police saga and the spy thriller. The one exception seems to be Clint Eastwood who interspersed his portrayals of Dirty Harry and other modern heroes with occasional Westerns like *The Outlaw Josey Wales* (1976), *Pale Rider* (1985), and—above all 1992's prize-winning *Unforgiven*—though, increasingly, these films have become self-reflexive commentaries on the Western myth.

2. Complex Indians and the Legacy of Conquest

In the middle of the 1990s, there seemed to be a momentary revival of the Western. "Today Westerns are back, guns blazing" a lead essay in the November 15, 1993, issue of *Time* announced with great eclat (Zoglin 90). *Time* traced this upsurge in the production of Westerns to the 1989 television mini-series based on Larry McMurtry's *Lonesome Dove,* the popular TV series *Dr. Quinn, Medicine Woman,* and the combined critical and popular acclaim which greeted two films, Kevin Costner's *Dances with Wolves* and Clint Eastwood's *Unforgiven.* The popular success of these works paved the way for several other productions. There were three versions of Geronimo (PBS, TNT, and Walter Hill) two variations on the Wyatt Earp saga, a new Maverick, a plethora of new TV documentary series (Wests "Untold," "Real," Native American and

by Steven Ives and Ken Burns). McMurtry's audience pleaser spawned a *Return to Lonesome Dove,* as well as three further installments of the McMurtry Texas Ranger saga. Even gender Westerns like *The Ballad of Little Jo* appeared as well as still another Larry McMurtry miniseries based on his Calamity Jane novel, *Buffalo Girls,* which premiered in the spring of 1995.

This flurry of new Westerns made it clear the genre had not completely expired, but there was some question as to just what it did mean. Was it a revival, a rebirth, or a last gasp? While it is clearly premature to attempt a definitive answer to this question, some attempt to see these new Western films in the context of other contemporary developments in our understanding of the American west may offer at least some preliminary guesses.

Dances with Wolves seemed to be at once a radical departure and a significant reaffirmation of the major traditions of the Western film. Most obviously, by making a group of Native Americans the sympathetic protagonists and by showing the U.S. Cavalry as an aggressive and brutal invader the film reversed the Western's mythical polarity between savage Indians and civilizing pioneers. However, as many critics have pointed out, this was not as much a departure from tradition as it might seem. From the earliest European encounters with non-European cultures there has always been a certain ambivalence about Native Americans which manifested itself in divided portrayals of native peoples as diabolical savages on the one hand and noble innocents on the other. As Richard Slotkin points out, this doubleness toward the Native American was always a significant part of the myth of the west from James Fenimore Cooper's magnificent Mohicans to what Slotkin calls the "cult of the Indian" in modern Westerns. Was there any significant difference in the way the Native American was portrayed in *Dances with Wolves* from earlier "cult of the Indian Westerns" like *Broken Arrow, Soldier Blue,* or *Little Big Man*?

Certainly the film could be criticized for further romanticizing the old stereotype of the white man's ambiguous encounter with the noble savage. One Native American critic observed acerbically that *Dances with Wolves* should really be called *Lawrence of South Dakota.* The movie is clearly connected to earlier Westerns, and to the long tradition of frontier narrative going back to the seventeenth century by its adaptation of the theme of "captivity" which has always been one of the most potent of Western themes. But there are significant departures. The leading female character, Stands-with-a-Fist, is actually a white woman captured as a girl and raised by the Indians. She has even married a warrior, who has recently died and she sincerely mourns him. Though in tradi-

tional terms she has suffered a "fate worse than death" she seems to have thrived on it and has become so completely integrated into the tribe that she has almost forgotten her original language. She becomes the teacher and guide for Lt. Dunbar's willing "captivity" by the tribe. Dunbar, himself has "lit out for the territory" after being symbolically killed and reborn in the violent madness of the Civil War. He seeks something better than the "civilized" military culture of madness and destruction. Eventually he relinquishes his former identity and becomes a member of the tribe. When the madness of civilization follows after him he is forced to leave the tribe. However, he vows to continue his opposition to the destructiveness of white civilization.

There were many similarities between *Dances with Wolves* and *Little Big Man* (1970) which appeared just before the Western began its precipitous decline in the early 1970s. Both were strongly influenced by the tragedy of the Vietnam War and portrayed the invasion of the American west very critically. Both had a white protagonist who became integrated into a tribe which was undergoing the destruction of its traditional culture, that of the migratory buffalo hunters of the Great Plains. Finally, both treated Native American cultures—the Sioux in *Dances with Wolves* and the Cheyenne in *Little Big Man*—with some attempt at historical accuracy and complexity as well as great sympathy.

Though *Dances with Wolves* may be overly romantic in its view of Native American cultures, it is still a remarkably effective film and a unique attempt to represent the Native American perspective in a popular cultural form. Despite similarities with *Little Big Man,* it has some important new elements. Jack Crabb of *Little Big Man* is captured as a child and brought up by the Cheyenne. He has already been acculturated as a Cheyenne when he is taken back by the whites, recaptured again by the Indians and so on. This is an excellent premise for satirizing cultural differences and inverting conventional perceptions, which *Little Big Man* effectively does. But throughout his story Jack Crabbe remains essentially external to both the cultures he is involved in. To the end he is, like Huckleberry Finn, always on the outside. Dunbar is not a more complex character, but his role is different. He enables us to participate vicariously in his initiation into a different culture. In addition the producers decided to use Native American actors in the most important Sioux roles. In the traditional Western, white actors commonly played the major Indian roles. Jeff Chandler's portrayal of Cochise in *Broken Arrow* was so successful that he repeated it in *The Battle of Apache Pass* and *Taza, Son of Cochise.* Chief Dan George's delightful portrayal of Old Lodge Skins in *Little Big Man,* was really more caricature than character. On the other hand, Graham Greene's portrayal of Kicking Bird in

Dances with Wolves was a fully rounded and persuasive portrayal of a strong and dignified human being who represented a different set of cultural norms. This effect was reinforced by the use of the Sioux language, which helped give a more complex sense of entering the world of another culture. Finally, the film's choice of location was extremely important. Instead of the conventional Western landscape of desert, mountain and frontier town, *Dances with Wolves* was filmed in South Dakota on the Great Plains which was, in fact, the real locale of the Sioux culture. This landscape differs enough from the traditional Western setting that our sense of the mythical frontier world is subtly displaced and we do not immediately recognize the familiar mythic West.

Armando Prats best sums up the mixture of tradition and innovation in such recent Westerns as *Dances with Wolves, Geronimo,* and Michael Mann's *The Last of the Mohicans.* He observes that these films "produce not so much a new Indian as an updated version of what I would like to call *mythological historicism:* the Indian, whom revision would present as an authentic historical person, still complies with the demands of the mythology of conquest" (197). Prats's analysis shows how in each of these films there is a "tension between historical consciousness and what might be called the *mythic postulates* . . . that guide and frame the story of the supposedly historical Indian" (198). In these films this framing especially works through the device of the sympathetic white hero— Dunbar in *Dances,* Britton Davis in *Geronimo,* and Natty in *Mohicans.* By showing sympathy and understanding of Indian culture the hero establishes a sort of moral right to take the Indian's place—to "outfirst" him as Prats puts it. Thus, these New Indian Westerns ultimately affirm the myth of conquest, albeit critically and nostalgically, in much the same way the recent "end of the West" films nostalgically lament the loss of a heroic past.

Interestingly two of the films which attempted to acknowledge more fully a Native American perspective, dealt with the most feared and hated of Indian war leaders, the Apache Geronimo. Can anyone forget the famous opening scene of Ford's *Stagecoach* where the soldiers at an isolated cavalry post suddenly realize that the telegraph wire has been cut and one of them pronounces in awed tones the dread word, "Geronimo?" In TNT's version, the story is narrated by the aged Geronimo who has been ironically made into a celebrity by his former enemies, though never really freed from the imprisonment he entered after his surrender. From this standpoint at the end of his life, Geronimo tells a younger Apache warrior, now a West Point Cadet, about his long resistance to the white incursion. This film also contains a few scenes of Apache religious ceremonies and other cultural episodes beyond the

stereotypical image of Apaches as fearsome raiders and torturers. Walter Hill's *Geronimo* is an even more complex and powerful film, which suggests that the destruction of the Apache culture was not only a betrayal but a historical tragedy.

These new representations of the Native American situation in the history of the West are not without unintentional ironies or occasional reversions to the sentimentalizing stereotypes of the noble savage tradition. It seems particularly difficult for Westerns set in the the past to completely escape from the stereotypes of Native Americans especially in relation to the more sympathetic and appealing treatments of Indians associated with the tradition of the noble savage. Another film achieving considerable success in the early 1990s was Michael Mann's update of Cooper's *Last of the Mohicans* (1992). Mann not only offered a slick new version of the noble savage and the violent redskin but transformed Cooper's confirmed bachelor Natty Bumppo into a romantic hero glamorously portrayed by the extraordinarily handsome English actor Daniel Day-Lewis. Clearly, the old myths of the Indian still had a lot of life in them.

One filmmaker who worked hard to break down these established stereotypes was inspired by the efforts of the American Indian Movement to resist the continuing exploitation and mistreatment of Native Americans in part by seeking to recover their lost spiritual heritage. Michael Apted's two 1992 films, the semidocumentary *Incident at Oglala* and the fiction film, *Thunderheart,* based on similar material, represents another reaction to the clash of cultures in the West. Apted responded to the American Indian Movement's activities on the Sioux reservation and to the violent standoff between Native Americans and federal agents that ensued when the AIM attempted to protest white injustice and the dictatorial regime of the Sioux tribal council. This episode inevitably called up memories of the terrible massacre, less than a century before, of Sioux ghost dancers by federal troops at Wounded Knee, South Dakota. Apted felt that the American Indian Movement had been unjustly repressed by a combination of tribal and government authorities and that the AIM leader Leonard Peltier had been railroaded into prison for killings he was not responsible for. In *Incident at Oglala,* he presented a semidocumentary account of the episode as he saw it, making it clear that Peltier was probably innocent of the crimes of which he had been accused.

In *Thunderheart,* Apted sought to draw on more popular cinematic traditions to present the story of an FBI agent of part Native American ancestry, who is sent to the reservation to solve a series of killings and to arrest a Native American leader modeled loosely on the figure of Peltier.

Instead, he uncovers a corrupt alliance between the chief FBI agent for the area and the established tribal leaders and realizes that these are the true criminals. At the same time, he begins to recover his Native American heritage through his own visions and the assistance of an old Sioux shaman who guides him on the path of rediscovery. Apted's films portray the desperate plight of contemporary Native Americans and the attempt to revitalize the Indian cultural heritage as a bulwark against the devastating transformations of modernity. Apted's work reflected in film the project of cultural recovery central to contemporary Native American literature since Scott Momaday's *Way to Rainy Mountain,* and *House Made of Dawn* in the late 1960s.

These more complex portrayals of Native American characters and culture reflected a larger reinterpretation of the history and significance of the American West that stressed the complex interactions between different cultures rather than the myth of white conquest of the savage wilderness. The new Western history has been particularly concerned with exploding the stereotypes and myths of Native American and Hispanic American cultures as they have been traditionally portrayed in the literature of the West. Historians have deconstructed such images as those of the violent marauder, the noble savage, and the fat, happy Mexican, replacing them with more complex and historically accurate portrayals of these cultures. The new history has been reflected in much recent criticism of Western films and television programs, particularly with respect to their portrayal of Indians. Moreover, the new vision of the West has been deeply influenced by the work of Native American and Hispanic American writers, who, since the 1960s, have produced an increasingly rich literature. The fiction, poetry, and polemics of writers like N. Scott Momaday, Leslie Silko, Louise Erdrich, James Welch, Vine DeLoria, Gerald Vizenor, Rudolfo Anaya, Rolondo Hinojosa, and many others have transformed our view of Native American and Hispanic cultures. This literature has in turn had considerable influence on a number of Post-Western films like *Dances with Wolves, Geronimo, The Milagro Beanfield War, Thunderheart,* and *Lone Star,* which portray the historic conflict between cultures in the West.

John Sayles's brilliant 1996 film *Lone Star* exemplifies several ways in which the Western genre has been critiqued and transformed by the new theme of the frontier as a place of encounter between cultures. Set in a Texas border town, the film portrays a young sheriff's discovery of the real meaning of his heritage and of the truth about his father, a lawman whose life has been mythicized into that of the heroic Western marshal. When events in the present uncover new evidence about the life of his father, Sayles's protagonist must face a number of disturbing real-

izations, which show that the reality of his past is far different than the legend would suggest. In fact, the heroic father murdered a vicious lawman who was sheriff before him, mainly because this predecessor brutally exploited and abused Chicanos and African Americans. In addition, events reveal that the father had been the longtime lover of a Mexican woman who had immigrated to Lone Star, and was the real father of the young Chicana teacher with whom the protagonist had once had a passionate affair.

Such a situation was virtually unthinkable in an earlier Western and if it had happened convention would certainly have required a tragic ending, the usual fate of intercultural, to say nothing of incestuous, love affairs in traditional Westerns. Sayles's resolution of this situation is significantly Post-Western. The protagonist not only now understands his father's actions, but he comes to see this killing of a violent racist as a more admirable kind of act than the mythical heroism the father had been credited with. Moreover, he decides to continue his love affair with his half-sister. The final words of the film are spoken by the hero's Chicana lover-sister and are appropriately and ironically just: when told the truth about their joint parentage, she says, "forget the Alamo."

Sayles's cinematic celebration of the intricate and passionate encounter of cultures and races along the Texas border represents one approach to the Post-Western theme of multiculturalism. Such films illustrate a new concern for historical complexity and for the acknowledging of different cultural perspectives. In this way, they relate to other important developments in our treatment of the Western past.

3. Ambiguous Gunfighters

A second kind of recent Western dealt more tangentially with Native Americans. Clint Eastwood's film *Unforgiven* and the television series based on Larry McMurtry's bestselling novel, *Lonesome Dove* deconstructed other well-established generic traditions. *Unforgiven* takes off from gunfighter Westerns, such as *Shane* and *High Noon,* while *Lonesome Dove* puts a new spin on cattle-drive Westerns like Howard Hawks's *Red River.* In addition, both films make continual allusions to earlier Western films. Sometimes, this allusive texture almost resembles modernist novels and poems by writers like Joyce, Faulkner, Eliot, and Pound where layers of the mythical past are continuously invoked. In these films, Western generic traditions are haunted by a constant sense that the characters and actions are in danger of falling out of the mythical world. In *Unforgiven,* for example, the gunfighter is almost unable to carry out his mission when he nearly dies from a bad case of the flu. In *Lonesome Dove,* accidents, chance encounters, and sudden revelations

continually undercut and reduce to absurdity the significance of the pro-
tagonists' mythical quest. As if to remind us of the falsity of the gun-
fighter myth, *Unforgiven* provides us with a dime novel hero
accompanied by his writer. English Bob is in good postmodernist fash-
ion ambivalently referred to throughout his episode as the "Duke (Duck)
of Death" and is literally deconstructed by the sadistic sheriff Little Bill
who reduces him to a pathetic wreck. On the other hand, in the film's
violent climax Will Munny actually improves on dime novel shootouts
by escalating the body count when he kills the bar-and-brothel owner,
the sheriff and three deputies.

These works neither affirm nor reject the myth, nor like many ear-
lier Westerns do they proclaim that they will present, at last, the "true"
history which lies behind the myth, a "reality" that, more often than not,
turns out to be another mythical invention. *Lonesome Dove* and *Unfor-
given* express something still more complex. They portray both the
power of myth and its dangers, exploring both the ambiguity of the
myths, and the way in which myth and history are engaged in a problem-
atic dialectic. In these films, the chaos, randomness and futility of his-
tory calls forth the great excitements and simplicities of myth, but once
evoked or entered, the mythic world develops an impetus of its own that
can impose itself on reality.

In *Lonesome Dove* and *Unforgiven,* the mythic world is associated
with the violence and heroism of the protagonists' youths just as the
mythic era of the Wild West was associated with an earlier period of
America's history. In *Lonesome Dove* Gus and Call have a nostalgic
feeling about their earlier lives as Texas Rangers and they seek to recre-
ate this time of adventure by leaving behind the dull and predictable
world of Lonesome Dove. William Munny of *Unforgiven* looks back on
his violent youth with fear and regret, but he, too, feels trapped in the
present on a wretched hardscrabble farm trying to raise pigs. The lure of
money and adventure draws him once again into a vortex of drunkenness
and violence which leaves his African American best friend dead amidst
a trail of corpses. Perhaps the ultimate irony is that, after this, he is
rumored to have become a successful merchant in San Francisco.

The ambivalence of these Westerns toward the traditional mythic
world of the frontier is also related to a more complex treatment of
gender issues. A key traditional characteristic of the Western was its
gender stereotyping, either by simplification (as in the limitation of
women's roles to schoolmarms and dance hall girls) or subordination
(by arranging for any important women characters to be converted to
the patriarchal code of values). *Lonesome Dove* and *Unforgiven* unfurl
a variety of new gender possiblities from the virtual marriage of Gus

McCrae and Woodrow Call to the employer-employee relationship between the victimized prostitutes of *Unforgiven* and the retired gunfighter Willliam Munny. The complexities of gender were even more fascinatingly deployed in another recent Western *The Ballad of Little Jo* in which the central character was forced to masquerade as a man in order to make a decent life for herself in the West. But possibly because this film went even further in its exploratory probing of the absurdity of traditional gender stereotypes as a foundation of the myth of the West, it did not achieve the wide popularity of *Lonesome Dove* and *Unforgiven*.

4. New Visions of the West

Late twentieth-century fiction, history, and film reflected many important changes in the perception of the West. The vitality of Native American and Hispanic voices as well as other kinds of new Western writing hinted that the West might be on the verge of the kind of literary and cultural awakening that occurred to another major American region, the South, in the 1920s and 1930s. In those years a new generation of Southern writers struggled to free themselves from the burden of Southern history and its dominant myths of white supremacy and the lost cause. The result was some of the greatest novels and stories ever written about the American dream and its tragic failure. Perhaps the final decay of the myth of the frontier will inspire such a renaissance in the American West.

While it may have lost much of its mystery, the Western landscape is still symbolically associated with frontiers and pioneering. As Lee Clark Mitchell suggests, "the West in the Western matters less as verifiable topography than as space removed from cultural coercion, lying beyond ideology" (4). Thus, in many contemporary films, the desert landscape of the West is seen as a terrain where individuals can escape from the past and the limits of tradition. This use of the Western landscape is most obvious in contemporary science fiction films in which the Western desert represents a future in which survivors must seek to recreate human society after a nuclear holocaust. This was the landscape of the Mad Max trilogy, and of the Terminator films, for example. The Mad Max films were made in Australia, but were set in no particular national location, indicating the extent to which the Western landscape, particularly through the impact of Spaghetti Westerns with their Western deserts shot in Italy and Spain, became in the 1980s and 1990s, a deterritorialized international symbolism.

A similar symbolism also played an important role in the setting of another kind of Post-Western movie, a type represented by such films as

Thelma and Louise, Ruby Jean and Joe, and *Leaving Las Vegas.* These quest romances typically featured unconventional couples such as two women seeking liberation from the emptiness of their lives and the abusiveness of men, or a young African American woman and a broken down alcoholic rodeo performer struggling toward change in their lives. *Leaving Las Vegas* portrayed a suicidal alcoholic and a prostitute looking for one last chance. These characters found love and understanding for each other against the background of a liminal desert landscape. The Western setting of these films seemed an appropriate symbolic context for the way in which these characters attempted to cross conventional personal and social frontiers. That these quests usually ended in disaster suggests the strength of the traditional boundaries these characters seek to cross.

These films reflected a new vision of the West as liminal space in which established social and psychological frontiers become weakened. But another vision of the West also played a vital role in the contemporary imagination: the West as pastoral tradition threatened by modernity. Several recent Western novels are like the work of Faulkner and Wolfe in the 1930s in being about the initiation of young men into a world where there is no longer any room for the kind of heroic and meaningful action that once seemed possible. The concern for the loss of a traditional way of life was also apparent in the recent reactions of some Westerners against the Federal Government's control of public lands and environmental regulations. These are reported in a cover story in *Time* magazine (23 Oct. 1995: 52-71). Ironically, if these movements succeed they will probably accelerate the very transformations they seem to deplore. The period of the Southern literary renaissance, the 1920s and 1930s, was also counterpointed by a reactionary resurgence of social movements like the Ku Klux Klan, and Protestant fundamentalism, which sought desperately to hold on to the traditional social, racial, and economic patterns of the "Solid South."

Many recent Western fictions reveal a deep sense of belatedness and nostalgia for a more unified traditional culture. Larry McMurtry pioneered this genre of Western literature with his two early novels of Thalia, Texas, *Horseman, Pass By* (1961) and *The Last Picture Show* (1966). In these novels, protagonists confront the usual strains of growing up, but also must deal with the sense of diminishing expectations and the loss of the greater excitement and meaning associated with the bygone era of the cattle industry and the great cattle drives of the nineteenth century. In *Horseman, Pass By,* the young narrator feels a deep sense of loss: " 'Things used to be better around here,' I said. 'I feel like I want something back' " (123). Such loss directly affects young Lonnie's

world when his beloved grandfather's diseased cattle must be destroyed and the grandfather himself is killed by an accident. *The Last Picture Show* ends with the closing of Thalia's one movie theater. With it, the dream of the old West that inspired so many of the pictures shown there, vanishes. Peter Bogdanovich, who directed the excellent movie based on McMurtry's novel, appropriately ended the film with the great scene from Howard Hawks' Western *Red River* (1947) in which John Wayne sets off on the first great cattle drive from Texas. In contrast to this heroic moment the young people of Thalia are left only with the vacuous emptiness of a depressed oil boomtown.

The end of the heroic West also hovers over Norman Maclean's *A River Runs through It* (1976). In this novella, an old man is haunted by memories of his long-dead father and brother and the fishing that they shared, but he still mourns his inability to save his brother from the fate that destroyed him. In other stories, Maclean brilliantly evokes a lost world of skill with tools and heroic physical labor, showing how wonderful an experience it was to be initiated into such a world. His non-fiction study *Young Men and Fire* (1992) was narrated by an old man confronting his own death by studying the heroism and tragedy of traditional work manifested in the last hours of a Montana firefighting crew destroyed by fire in 1949. Like the mythical Western, these works portrayed a West that has largely disappeared. However, unlike the traditional Western tales of cow towns and cattle drives, outlaws and marshals, gunfighters and schoolmarms, these stories celebrate the work of those ordinary people who built the West and then saw it transformed into something else.

The writer who most powerfully treats the new Western themes of initiation and belatedness is a transplanted Southerner, Cormac McCarthy. In *All the Pretty Horses* (1992), McCarthy replaces the mythical fantasy world of wild Western gunfighters, outlaws, and savage Indians with the last remnant of an age-old world of traditional work. In this world, men were part of the unity of life and found great fulfillment because their actions were integral with horses and the rest of nature. Horses, which had been man's primary instrument in the use of nature and the creation of culture for centuries are, as the novel's title would suggest, the symbol of a traditional unity between man and the world that is being increasingly destroyed by modern technology and industrialism. As McCarthy portrays it, West Texas, once one of the last bastions of the pastoral world and the supposed setting of John Ford's great Western, *The Searchers,* has already become a wasteland of oil derricks. In McCarthy's novel, it is on the verge of the postwar oil boom which will utterly destroy the traditional cattle culture.

Like Larry McMurtry's earlier work, *All the Pretty Horses* begins in a depressed West Texas in the immediate aftermath of World War II. Its protagonist, John Grady Cole, is sixteen years old and very much alone in the world. His father is separated from his mother and is slowly dying from a condition incurred in a prison camp in the war. Cole's grandfather is a rancher and Cole, himself, loving horses and ranching, would like nothing better than to continue the ranch, but the old man dies and Cole's mother plans to sell the family ranch and leave the area. To continue the work he loves, Cole crosses the border into Mexico with a young friend and the two find work on a large hacienda where the traditional work with horses and cattle is still carried on.

However, this momentary recovery of paradise is disrupted when Cole falls desperately in love with the daughter of the great hacienda's proprietor. When she returns his love and the two embark on a passionate affair, her powerful family has Cole wrongfully arrested. After being nearly killed in a Mexican prison, Cole is freed when his lover promises never to see him again. The last section of the novel deals with Cole's revenge on the corrupt Mexican policeman who has betrayed him and stolen his horses. Finally, hardened and matured by his ordeal and deeply saddened by the loss of his love and his encounters with death, Cole returns to Texas.

The Texas he finds is on the verge of the postwar oil boom which will destroy the traditional cattle culture, the same process which McMurtry portrayed in his series of Thalia novels and which furnished the background for television's popular Western soap opera *Dallas*. While the traditional culture still exists in the late 1940s on the great haciendas of Mexico, it too is clearly on borrowed time. The wealthy *hacendado* of McCarthy's novel keeps his ranch more as a hobby than a way of life, and uses an airplane to fly back and forth between the hacienda and his other life in Mexico City.

John Grady Cole is not only a master of horses, but something of a visionary as well and the story is punctuated by his dreams of horses, which envision an eternal paradise where wild horses symbolize the possibility of man's redemption:

That night as he lay in his cot he could hear music from the house and as he was drifting to sleep his thoughts were of horses and of the open country and of horses. Horses still wild on the mesa who'd never seen a man afoot and who knew nothing of him or his life yet in whose souls he would come to reside forever. (117-18)

One of the most striking moments in the novel comes in a conversation between Cole, his young friend Rawlins, and an old man who sym-

bolizes the traditional wisdom of the world of natural work. It is this old man who expresses most clearly the full spiritual significance of horses in this traditional vision of the world:

Finally he said that among men there was no such communion as among horses and the notion that man can be understood at all was probably an illusion. Rawlins asked him in his bad spanish if there was a heaven for horses but he shook his head and said that a horse had no need of heaven. Finally John Grady asked him if it were not true that should all horses vanish from the face of the earth the soul of the horse would not also perish for there would be nothing out of which to replenish it but the old man only said that it was pointless to speak of there being no horses in the world for God would not permit such a thing. (111)

What John Grady Cole learns in the process of his initiation into mature life is the hardest for him to accept: that such a world no longer exists for him. The Mexican hacienda is, for him, a Paradise Lost. Even in Mexico, the modern world of politics and revolution, technology and cities is eroding and destroying the traditions of the country side. In the Texas to which he finally returns, the only vestiges of the traditional world of man and nature are the few remaining Indian encampments in the midst of the oil fields:

In four days' riding he crossed the Pecos at Iraan Texas and rode up out of the river breaks where the pumpjacks in the Yates Field ranged against the skyline rose and dipped like mechanical birds. Like great primitive birds welded up out of iron by hearsay in a land perhaps where such birds once had been. At that time there were still indians camped on the Western plains and late in the day he passed in his riding a scattered group of their wickiups propped upon that scoured and trembling waste. They were perhaps a quarter mile to the north, just huts made from poles and brush with a few goathides draped across them. The indians stood watching him. He could see that none of them spoke among themselves or commented on his riding there nor did they raise a hand in greeting or call out to him. They had no curiosity about him at all. As if they knew all that they needed to know. They stood and watched him pass and watched him vanish upon that landscape solely because he was passing. Solely because he could vanish. (301)

In this profoundly elegiac conclusion McCarthy evokes that mythical Western scene of the hero riding off into the sunset, but for John Grady Cole there is no more mythical world to cross over into, there is only "the darkening land, the world to come" (302).

The new Western literature and history, like that of the Southern renaissance before it, is more concerned with the failures than the successes of American history and particularly with the burden of guilt left by the exploitation of nature and the tragic heritage of racism. The South and the West, regions once so important as sources of romantic myths of otherness in American culture, have produced compelling reevaluations of the basic myths of American exceptionalism and superiority and powerful critiques of the multiple failures of the American dream. Ironically, these deeply critical literary movements have emerged almost simultaneously with a new surge of political conservatism and fundamentalism in America, also centered in the South and the West and seeking to manipulate the same symbolic and ideological traditions for their own very different purposes. As many commentators have noted, Ronald Reagan tried to reenact the Western myth of the shootout between the heroic marshal and the lawless outlaw on the national and international scenes. The new breed of Southern republicans who have recently become so important in American politics have found that a new Southern-Western rhetoric of less government, family values, localism, and even a coded white supremacy disguised as opposition to affirmative action has proved highly effective on the national scene. Such reactions are antithetical to those of serious contemporary Southern and Western writers. However, though differently focused, these writers are responding to the same uncertainties that have beset America in the last quarter of the twentieth century: a profound loss of confidence in America's uniqueness, moral superiority, and global omnipotence. In the context of this ongoing spiritual crisis, the South and the West, which once helped define America mythically and symbolically through their otherness are now being pursued by both intellectual critics and conservative fundamentalists as symbols of the real truth of America.

5. Why the West Was Lost

The decline of the Western as American myth and popular genre suggests, among other things, that writers and directors have felt increasingly uncomfortable about the racial and gender stereotypes that long dominated the popular Western. In addition, the impact of the Vietnam War and the ending of the Cold War deeply eroded the Western's acceptability as a myth of America's role on the international scene. The obsessive pursuit of victory in Vietnam, allegorically associated in later Westerns like *Little Big Man* and *Dances with Wolves* with the destruction of Native Americans, made the idea of the Winning of the West seem increasingly ironic. Growing doubts about America's role as global sheriff have made it increasingly difficult for the president to justify the

commitment of American troops to other troubled areas like Bosnia and Somalia, despite the superficial success of the Gulf War. In this new global climate, the Western parable of the heroic gunfighter seems an increasingly dubious interpretation of America's international position. As Slotkin suggests, America is badly in need of a new mythology.

Certainly the fate of the Western has also resulted, as we have seen, from changing perceptions of the West. The new Western history and the new Western literature have not only deconstructed the long-standing mythical traditions on which the Western was largely based, but have offered striking new visions of the West in its place. Moreover, the West as a place has become something quite different than it once was. During the last part of the nineteenth century, the West was simultaneously actual place and mythical landscape. Americans attending the opening of the great Philadelphia World's Fair of 1876, which celebrated a hundred years of American progress, could read in their newspapers about the devastating defeat of General George Armstrong Custer by Sioux and Cheyenne warriors at the Little Big Horn. Similarly, readers of dime novels encountered stories about cowboys, marshals, and outlaws purportedly based on recent Western events and characters. In other words, the Western conflated time and space so that the "Wild West" was a place of mysterious excitement and great deeds, but was also somehow present and real. As Mircea Eliade has taught us, one of the central characteristics of traditional myths is that they take place in a sacred time which is understood to be recurrently present, both in and out of history, both past and present. For a long period in the history of American culture, the West possessed these mysterious mythical qualities.

In the years since 1970 this mysterious landscape has become increasingly demythologized. The West itself has become more like the rest of the country, complete with standardized fast food franchises, shopping malls, housing developments, and postmodern cities increasingly alike from Dallas to Los Angeles. The increasing sameness of West and East has finally accomplished what Frederick Jackson Turner prophesied in 1893: the closing of the spatial frontier has led to the closing of a spiritual and cultural frontier. No more free and open land; only real estate values.

The heroic westward journey is now a weekend package while Western places, customs, and styles have become the stuff of calendar landscapes and mail order catalogues, increasingly familiar throughout the country and indeed throughout the world. When one can fly in a few hours to ski in Colorado, to gamble in Las Vegas, or to share the excitement of Frontier Days in Cheyenne, the result is tourism rather than mythical adventure. Cowboy boots and a Stetson worn by a New York

City businessman soon shed their mythic significance and become just another style of clothing.

With the Western frontier rapidly receding into the past, Americans still seem to need some sense of heroic adventure on the boundaries of civilization. The public has recently become fascinated by two new landscapes which seem to have some of the mythic power once associated with the Wild West: the inner city and outer space. Films set in these landscapes often make use of Western images and allusions and thus constitute one important kind of "Post-Western," i.e., a work which draws on Western themes and imagery but treats the Western tradition in a subversive, ironic, or otherwise critical fashion.

Films like *Taxi-Driver* (1976) and *Fort Apache, The Bronx* (1981) or *The Star Wars Trilogy* (1977-1983), *Westworld* (1973), and *Outland* (1981) have often been perceived as urban and science fiction Westerns. Outer space can, of course, be treated as a frontier, and like the West in an earlier time, it is both a mythical landscape and a contemporary actuality. Not surprisingly, films about astronauts like *The Right Stuff* and *Apollo 13* frequently allude to Western images, while *Outland* was an explicit attempt to recreate *High Noon* as science fiction. More recently, the trilogy of *Alien* films not only drew on a number of Western patterns with the aliens playing the role of "Indians," but created a highly successful female hero modeled in many ways on the heroic Westerner.

However, there are important differences between most science fiction films and the traditional Western. Space adventures portray a mastery of technology requiring both group efforts and an interfacing between man and machine very different from the heroic individualism of the classic Western. Such popular successes as the Star Trek and Star Wars series reflect very different values and styles from the pastoral and individualistic ethos of the Western. In addition, there are important themes of multicultural cooperation in these genres that are very different from the racial and cultural conflicts so characteristic of the Western. Even though the Western hero often had a sidekick who was Indian or Mexican, this figure was generally either comic or idealized. Perhaps the Western sidekick survives to some extent in Chewbacca, the Wookee of *Star Wars,* or in *Star Trek's* Mr. Spock, but these are not comic or racial inferiors. Similarly, women usually play a much more active role as members of the heroic group than they do in the Western. In that tradition strong and aggressive women were usually either déclassé dancehall girls like Marlene Dietrich's Frenchy in *Destry Rides Again* and Angie Dickinson's Feathers in *Rio Bravo,* or tomboys like Jean Arthur's Calamity Jane.

It's hard at first to understand how the city can be treated as a heroic frontier until one remembers that the inner city is a strange and frightening place associated with the fear of increasing crime and violence by most middle-class white Americans. For a large portion of the white suburban audience, the inner city is a dark and bloody ground, and it is comforting to imagine a lone individual hero acting out the Code of the West against gangsters, drug dealers, pimps and pornographers. In the long-running TV series *McCloud,* based on an early Post-Western, the Clint Eastwood vehicle *Coogan's Bluff* (1968), Marshal Dillon's onetime sidekick Dennis Weaver, played a Western lawman from Taos, New Mexico, on temporary assignment to the New York City Police Department. McCloud ritually demonstrated that his Western individualism and cowboy skills were more effective against criminals than the organization and technology of his urban counterparts. *McCloud* can be very charming as a heroic fantasy but it depends on a good bit of tongue-in- cheek to make its adventures believable. Another sort of "urban Western" was represented by such films as *Midnight Cowboy* (1969), *Taxi Driver* (1976), and *Urban Cowboy* (1980) which are much more ironic and ambiguous than traditional Westerns. In general, the urban frontier seems to evoke a more dubious kind of hero than the mythic Westerner. Clint Eastwood's Dirty Harry Callahan was an urban avatar of some of his earlier Western heroes, but Harry's callous attitude toward law and order made him a more ambiguous hero than the heroic marshal, except, of course, for Ronald Reagan who idealized him. Like the science fiction adventure, the urban Post-Western also frequently requires complex organizations, multicultural cooperation, and elaborate technology.

One major source of the moral ambiguity characteristic of popular genres since the early 1970s was the emergence of new and conflicting attitudes toward violence, sexism, and racism as aspects of American culture. Not that our culture places any less emphasis on violence. Recent horror movies and action thrillers with their unremittingly graphic portrayals of all sorts of gore clearly indicate that Americans are still obsessed with violence. The difference lies in the way that violence is represented and what it symbolizes. In the traditional Western a very strong distinction was made between good violence (perpetrated by the hero) and bad violence (that used by the villains in pursuit of their evil aims). Moreover, the hero was usually portrayed as very reluctant to enter into violence. Of course, once he did, his skill in the shootout was glorified not only as appropriate punishment for the villain but as the apotheosis of the hero's unique identity. In the end the hero's violence seemed graceful, aesthetic and, even, fun.

However, in a society so forcibly aware of the actual horrors of violence in Vietnam and the Middle East, and of the rate of violent crime in America itself, violence portrayed as graceful or fun rings very hollow. One movie of the late 1960s, Arthur Penn's *Bonnie and Clyde,* powerfully presented this transformation within the context of the film's plot. At the beginning, the Barrow gang's violence seems like farcical highjinks, but Clyde's brutal and accidental murder of a bank teller shatters the sense of fun. By the time the movie reaches a final shootout in which Bonnie and Clyde are riddled with bullets by a sheriff's posse, violence has become a force which, once unleashed, destroys the innocent along with the guilty. The Western hero's reluctance to initiate violence, and his "grace under pressure" seem archaic in an age of mass terror and potential nuclear catastrophe. Some years ago, many people who saw the television movie *The Day After* (1983) reported feeling disappointed because its portrayal of nuclear holocaust was not violent or "gory" enough. Such reactions may seem terribly callous until one realizes that young people have grown up in a world of escalating terrorism and atomic horror in which the individual feels vulnerable to violent attack at any moment. In such a world, the relatively orderly rituals of violence characteristic of the traditional Western seem sanitized and pale. Yet, to increase the level, the randomness and the ambiguity of violence in the Western destroys one of its major themes: that there is a kind of redemption, or to use Richard Slotkin's phrase, a regeneration through violence, when it is appropriately applied by the heroic individual.

Another problem with the Western genre is our contemporary awareness of sexism and the limits of traditional sexual roles. Even though I adapted the title of *The Six-Gun Mystique* from Betty Friedan's feminist work *The Feminine Mystique,* I made very few significant comments on the role of sex and sexism in the Western in the original edition. In the years since the 1970 publication of *The Six-Gun Mystique,* I, like many other males of my generation, have become increasingly aware of the role of sexism in American life and in the Western. Throughout most of its history the Western has played down the importance of women in a man's life by making love a reward for heroism rather than a integral part of life. The hero must clean up the town before he can settle down with his woman, and even then he often rejects domesticity. Thus, one of the stereotypical scenes which ends so many Westerns shows the hero riding off with a vague promise to return and marry the heroine. In *Blazing Saddles,* this conventional scene was devastatingly burlesqued by having the hero ride off into the sunset with another man!

Another aspect of sexism in the traditional Western was pointed out long ago by Henry Nash Smith in *Virgin Land* and further developed by Leslie Fiedler in *Love and Death in the American Novel.* This was the archetypal contrast between virginal blond and sexier but also tainted brunette so typical of nineteenth-century melodrama. It entered the Western with Cooper's characters Alice and Cora Munro in *The Last of the Mohicans* and, transmuted into the dialectic between the Eastern schoolmarm and the dance-hall girl, it has been almost as stable a feature of the Western formula as the horse and the gun. Of course there has been considerable change in the values assigned to these two archetypal women. Cooper deemed it necessary to kill Cora off before she could mate with Uncas, the Mohican. However, in the middle decades of the twentieth century, the dance-hall girl became increasingly appreciated and approved. Marlene Dietrich's wonderful portrayal of Frenchie in *Destry Rides Again,* Amanda Blake's Miss Kitty of the Long Branch saloon (*Gunsmoke*), and Marilyn Monroe's portrayal of a blonde dance hall girl in Arthur Miller and John Huston's *The Misfits* are all characters of considerable strength and morality. While this suggests a gradual decrease in sexism, certain other developments in the Western during this time are more ambiguous.

For one thing, the schoolmarm dance-hall girl antithesis still lurked at the heart of the genre and was embodied in many of the most success-ful Westerns of the mid-twentieth century. Let me note here just two instances, one is a film generally acknowledged to be one of the truly great Westerns of the forties and the other, of the fifties.

In John Ford's My *Darling Clementine* the schoolmarm is actually a nurse who has come to Tombstone from the East to find Doc Holiday, formerly her fiancée. However, for reasons none too clear, Doc has turned his back on the East and all it represents to become a gambler and saloon owner in Tombstone. He has also become sexually involved with Chihuahua, a half-breed girl who hangs around his saloon. This girl, jealous at what she believes to be Doc's interest in nurse Clementine, falsely accuses him as a murderer to Wyatt Earp, then is shot by another of her lovers and dies. In the meantime, Wyatt Earp has fallen in love with Clementine, whom he leaves behind in Tombstone as he continues his quest, with a promise to return someday. Clementine, of course, is staying in Tombstone to take up school teaching.

The second instance is *High Noon.* In this movie aging Marshal Gary Cooper has recently married the chastely blond and cultivated Grace Kelly, who wants her husband to give up his dangerous and vio-lent job. Before he can do so, news arrives that a vicious murderer who hates the marshal has been released from prison and will arrive in town

on the noon train to join his gang of killers in avenging himself. The marshal seeks help from the townspeople but is refused. He finally visits sensuously brunette Katy Jurado, a dance-hall girl with whom he has had a long-standing affair. Jurado offers to help him if he will leave his wife. The marshal refuses her offer and goes off to face the killers alone. In the end, with a change of heart similar to that of Molly Stark in *The Virginian,* Kelly shoots the last remaining killer in the back before he is able to shoot her husband.

Film critic Molly Haskell suggested another sexist tendency in Westerns of the fifties and sixties. Her book, *From Reverence to Rape,* described a new kind of film which she called the "buddy" movie. In this type of movie, the relationship between men is far more important than any encounters between men and women. It is true that in Westerns like *Butch Cassidy and the Sundance Kid, The Wild Bunch,* and *The Professionals* women and sex are pushed into the background, with the major emotions in the film derived from male friendship. Haskell thought that the flourishing of such films in recent times reflected a male backlash on the part of creators and audiences against women's demands for equality and independence.

Whether or not Haskell's interpretation of the buddy movie is correct, a strong emphasis on male bonding has always been an important tendency in the Western. Leslie Fiedler suggested that this theme reflected the desire of American males to escape from the civilizing and moralizing restraints of women. The frequently double-edged portrayal of the schoolmarm in the Western represented a gentility toward which the hero aspired but also the restriction on his actions that he feared. In *The Virginian,* the hero finally had to tell his schoolmarm sweetheart that "a man's got to do what a man's got to do." John Ford makes a similar point in *Stagecoach* when he has the "Ladies Law and Order League" expel from town the only free spirits in it: a dance-hall girl (prostitute) with a heart of gold and a drunken doctor. Thus, despite some surface changes the Western genre has always had a basically sexist orientation, and this, too, makes it difficult to create an effective contemporary Western. However, it is doubtless significant that the one successful television series with a Western setting still running in the late 1990s, *Dr. Quinn, Medicine Woman* featured a woman doctor as its protagonist.

6. The European Western and the Post-West

The Western originated over five hundred years ago in European imaginings about America as the New World. Such imaginings still play an important role in European culture. The Post-Western *Dallas* remains

one of the most popular television programs in Europe, playing regularly on the small screens of England, France, Germany, the Netherlands, Denmark, and other countries. Earlier mythical versions of the American West also frequently turn up in the form of Wild West sections in amusement parks, in fast draw clubs, in Western-style saloons and restaurants, and in the widespread popularity of bluejeans, cowboy hats, and other kinds of Western clothing. Denmark's Legoland, an amusement park in which the attractions are largely constructed from the popular building blocks produced in nearby Billund, features a delightful Wild West area with Western saloons and street. It offers, as well, a ride through a mine and large replicas of Sitting Bull and the Mount Rushmore statues of American presidents made out of Legos.

The generic Western or some version of it has been widely popular in Europe since the original international impact of Cooper's Leatherstocking series. The French writer Gustave Aimard, and the German Karl May, invented their own imaginary Wests after Cooper, who inspired many Europeans to mythicize the American frontier. May and Aimard were major nineteenth-century cultural figures. May is said to have been Hitler's favorite writer and he certainly had a profound impact on generations of Germans.

In the twentieth century, the Western film has gained international popularity. In addition American fictional Westerns have been translated and republished in the major European countries. But since World War II films and novels based on the Western mythic tradition have appeared in many different countries. French, English, German, and Scandinavian writers have all produced highly popular Western series, some of which have become popular in the U.S. such as the English Western writers J. T. Edson, George Gilman [Terry Harknett], Jeff Sadler [Geoff Sadler], and Matt Chisholm [Peter Watts].

Indeed, the returning influence of European versions of the generic Western has had an important influence on the development of the American Western, particularly in the transition between the classic Westerns of the fifties and sixties and the Post-Westerns of the seventies and eighties. As Christopher Frayling tells the story, a German cinematic revival of Karl May, combined with the specific impact of Akira Kurosawa's *Yojimbo,* a Japanese samurai film profoundly influenced by traditions of the American Western inspired the Italian director Sergio Leone to make *A Fistful of Dollars.* This film launched the "Spaghetti Western' which had such a powerful influence on the American Western film, but also inspired what Frayling calls "Sauerkraut," "Paella," "Camembert," "Chop Suey," and "Curry" Westerns produced in Germany, Spain, France, Hong Kong, and India. As it undergoes such transformations, the

Western becomes increasingly "deterritorialized," to use Paul Bleton's word, and gradually fades into other forms of heroic adventure.

However, if the Western continues to decline as a popular genre, its myths, images, and forms will continue to haunt the American and European imaginations. The mythology and symbolism of the frontier and the Wild West are among the great imaginative constructions associated with America and their implications continue to haunt us even though we may increasingly find the traditional vehicles of character, plot, and theme that have expressed them stereotypical and outdated. Most major contemporary American writers now find it almost *de rigeur* to tackle the mythology of the West in one form or another. This is evident in the flourishing of a new Western literature in the wake of writers like Wallace Stegner, whose major novel *Angle of Repose,* was a complex treatment of the interplay between myth and history in the development of the American West. It appears in the growth of a new subgenre of the mystery story, particularly inspired by Tony Hillerman's extraordinarily successful Navaho detective stories. But it is also present in the work of other American writers whose roots are not in the West. Many of Thomas Pynchon's works explore the significance of frontier crossings, whether in the chaotic aftermath of World War II, or into the strange new world of modern Califorinia. His most recent work, *Mason & Dixon,* looks back to a crucial time in the eighteenth century when a boundary line of crucial historical implication was drawn across what was then the Western frontier.

European writers also continue to be drawn to the mythology of the American West just as European popular culture continues to exploit the symbolism of cowboys and Indians, outlaws and sheriffs in theme parks and other entertainments. In fact, for some European writers, the story of the West has become a parable of the ambiguous European involvement with America. It seems appropriate to end these reflections on the Post-Western with a work that seems on the surface to be an absolute antithesis to the Lone Ranger and yet is pervaded by a fascination with the mythology of the West. Created by a European who had successfully transformed himself into an American writer, it was published at the very height of the generic popularity of Westerns in 1955. The work was Vladimir Nabokov's *Lolita,* that perverse paean to forbidden love, which not only reenacts the captivity, pursuit and escape themes which have always been fundamental to the Western, but enacts these mythical patterns across a landscape that is clearly Nabokov's prescient imagining of the Post-Western West. *Lolita* is ostensibly the story of the innocent American white maiden captured by the European sexual pervert playing the role of Indian rapist at a resort appropriately entitled the Enchanted

Huntsman. Her captor is then replaced by another even more perverse player. But there is an even darker story lurking beneath this surface drama, that of the wicked European captivated and destroyed by the newness, openness and innocence of America. Many readers feel that this is the real story of *Lolita,* and, if so, it is surely a wry postmortem on the Western.

When he gave his delicious nymphet the name of Delores and the nickname of Lolita, Nabokov also prophetically projected onto his fable the Hispanic presence which would increasingly become part of many Post-Westerns. But, for our purposes, perhaps the most striking characteristic Nabokov ascribes to his archetypal American heroine is her love of Westerns, enabling him to inscribe his own marvelous description of the genre into the story:

There was the mahogany landscape, the florid-faced, blue-eyed roughriders, the prim pretty schoolteacher arriving in Roaring Gulch, the rearing horse, the spectacular stampede, the pistol thrust through the shivered windowpane, the stupendous fist fight, the crashing mountain of dusty old-fashioned furniture, the table used as a weapon, the timely somersault, the pinned hand still groping for the dropped bowie knife, the grunt, the sweet crash of fist against chin, the kick in the belly, the flying tackle; and immediately after a plethora of pain that would have hospitalized a Hercules (I should know by now), nothing to show but the rather becoming bruise on the bronzed cheek of the warmed-up hero embracing his gorgeous frontier bride. (172-73)

5

ANALYZING THE WESTERN

The revival of Western films around World War II and the flourish-
ing of "oaters" on television in the 1950s spurred an intellectual and crit-
ical interest in the genre that has continued unabated since that time. In
some ways this critical interest reflects the development of the genre.
During the Western's heyday as a national myth in the 1940s and 1950s,
criticism focussed on ethical and political issues like the relationship
between the Western and American values or the issue of violence. As
the genre became more self-conscious and more critical of its traditional
forms and values in the 1960s, criticism increasingly concerned itself
with formal and aesthetic matters. Finally, as the Western entered a
period of decline in the 1980s, criticism became increasingly retrospec-
tive presenting various historical and cultural interpretations of the
genre. Critics and scholars became particularly interested in exploring
what aspects of American culture accounted for the rise of the Western
and what kind of cultural constructions of American history, race and
gender were implied by the history of the genre.

Criticism of the Western also reflected changing critical ideologies
and practices. One could easily construct a history of the development of
literary and cultural analysis in the second half of the twentieth century
using studies of the Western as primary source material. Different
approaches and theories focussed on different aspects of the Western as
criticism evolved from the mass culture criticism, Marxism, and psycho-
analysis which dominated the 1950s into the myth-symbol approach of
American studies and the beginnings of popular culture analysis. The
1960s also saw the American importation of French structuralism and
the rise of *auteurism* in film studies. Finally, many varieties of critical
theory have proliferated in the last quarter of the century, including
deconstructionism, cultural studies, and gender theory. These have begun
to influence recent studies of the Western.

Studies of the Western using different critical discourses give us an
opportunity to examine various methods of interpreting the relation
between works of art, the society which produces them and the moral,
psychological, and cultural dynamics which they reflect. They also reaf-
firm the idea that the Western, like any popular genre, develops because

of its capacity to mean many different things to different people. When it loses this capacity it begins to change or decline.

In this chapter I will look at the development of several different kinds of criticism which have been applied to the Western in the second half of the twentieth century. Though these different critical approaches have developed concurrently and have influenced each other, they have each pursued somewhat different critical agendas and employed different methods of analysis.

These critical approaches are:

1. Ethical criticism or assessment of the moral meaning of the Western for its viewers and its effect upon them.
2. Artistic criticism, or the definition and evaluation of Westerns as artistic constructions.
3. Social and cultural criticism or analysis of the ways in which Westerns relate to American culture and the kind of social and psychological functions they seem to perform.

Specific acts of criticism often involve more than one of these critical "discourses," but most critical approaches or "theories" can be broadly subsumed into one of these categories.

1. Individualism and Violence: Ethical Criticism of the Western

Ethical criticism is the analysis and evaluation of literature to determine its moral content or effects. This was a dominant mode of literary criticism until the twentieth century when it was increasingly exiled to the margins of literary discourse by modernist ideologies like literary naturalism, art for art's sake, and the new criticism. However, ethical criticism has recently been resurrected along several different lines— including such diverse approaches as Wayne Booth's "ethics of fiction" and the so-called "political correctness" movement. In fact, some of the most significant recent books on the Western have taken an ethical approach.

Popular critics, like movie reviewers and reporters of popular culture, have been consistently concerned with moral themes and the effect of Westerns on various audiences. The moral themes of individualism and violence have long been treated as major concerns of the genre. As Martin Nussbaum put it in 1960, the Western hero was "a vanishing symbol of individualism in an age of togetherness and conformity" (26). Even earlier, in 1950, Frederick Elkin had suggested that "another group of values emphasized in the Western are derived more directly from frontier history and suggest that America has a rich and exciting her-

itage. These values focus on rugged individualism, frontier folk equality, and other characteristics of the Western way of life" (74).

Such criticism was generally quite positive about the way Westerns endorsed and promoted traditional American moral values, and reflected, I think, the sense that the Western was a basic American myth. The problem of violence in the Western was more troublesome, especially in the later 1960s after the impact of films like Leone's Italian Westerns and Sam Peckinpah's *The Wild Bunch,* which were noticeably more violent than earlier Westerns. In fact, the attempt to justify the presentation of violence in Westerns has been one of the most interesting and complex aspects of ethical criticism of the genre.

During the 1950s and 1960s, public concern about violence in popular culture inspired several studies and books on the subject. For a time, attacks like those of the psychoanalyst Dr. Frederick Wertham inspired widespread attempts to censor and control violent content in genres like television and the comic book. One of the first important responses to the wholesale condemnation of violence in the popular arts that was common at the time was the brilliant 1954 essay "Movie Chronicle: The Westerner" by Robert Warshow, which deserves to be called the source of serious criticism of the genre. Warshow argued that the Western "offers a serious orientation to the problem of violence such as can be found almost nowhere else in our culture" (103). He sees a "special validity" in the Western hero as a figure who "is there to remind us of the possibility of style in an age which has put on itself the burden of pretending that style has no meaning, and, in the midst of our anxieties over the problem of violence, to suggest that even in killing or being killed we are not freed from the necessity of establishing satisfactory modes of behavior" (105). In other words, the Western does not indulge in violence for violence's sake, but, at its best, is a serious attempt to present an ethic of violence for a violent age.

Warshow's approach has influenced many later ethical critics. For example, Peter A. French in his recent *Cowboy Metaphysics: Ethics and Death in Westerns* (1997) sees the Western as the serious presentation of a world view in which violence and death are the primary sources of moral meaning and value:

The dominant theme of the major Westerns is the conflict between . . . the "world view" of the westerner and that of the easterner, the cowboy/gunslinger and the settler/entrepreneur/townsperson/Christian. Death is the predominant element of the westerner's world view, death of a certain kind, that is, death understood in a certain way. And from that conception of death and the West— land of death, the ethics of the westerner both emerges and is given sense. The

easterner's radically different conception of death structures the world view away from which the westerner is ridin' West, but as the plots require, the easterner is forever catching up. (3)

The importance of the Western for French is that it exposits an alternative ethic to the Christian view that has dominated Western civilization. While this approach is limited to only a small number of "major" Westerns and certainly does not describe many Westerns which are quite Christian in their implication, French does derive some very interesting insights into Westerns like *Unforgiven, Shane,* and *The Man Who Shot Liberty Valance,* using this perspective.

Scott Emmert's *Loaded Fictions: Social Critique in the Twentieth Century Western* (1996) takes a different approach to the ethical dimension of the Western. Emmert discusses the genre in terms of what he calls "social critiques," by which he means finding the positions that different Westerns seem to express on various social or ethical questions like political morality, violence, feminism, and the treatment of Native Americans and other minorities. Emmert points out as Philip French did in his 1973 book on *Westerns,* that Westerns take many different positions on these social and political issues. Some Westerns seem to favor violence as the only solution to certain moral and political conflicts, others are more ambiguous about violence while still others show that "violence affects all the characters negatively; rather than an unambiguous solution, their complicity in violent acts becomes a moral burden that the characters must bear" (38). As examples, Emmert includes *Dances with Wolves* and *Unforgiven* in the latter category.

As a good citizen of the age of political correctness, Emmert believes that those Westerns which are critical of the traditional formulas of the genre are the most important:

Repudiation of violence and presentation of a feminist vision, are important because in their presentation of violence and their marginalization of women most Westerns reinforce prevalent ideologies; therefore any individual work in the genre which refuses to accept violence or stereotype women deserves attention. (3)

In a way, Emmert is trying to take ethical criticism in a direction quite different from Warshow and Peter French, by defining the Westerns he chooses to consider in terms of their positions on social and moral issues. This approach is useful in revealing the broad spectrum of political and moral positions implied by different works and creators in the course of the Western's history. It can also shed insight into particular films. But it is severely limited as a treatment of the Western as a

generic tradition because it requires a highly selective definition of the body of texts making up that tradition.

There is another problem that also limits the usefulness of the ethical approach. By making moral and political themes the primary focus of the analysis, the ethical critic tends to push the artistry of successful Westerns into the background. Warshow's essay has been powerfully influential on the development of Western criticism because of the way in which Warshow saw the Western's treatment of moral themes as related to its unique formal artistry:

By the time we see him, he is already "there": he can ride a horse faultlessly, keep his countenance in the face of death and draw his gun a little faster and shoot it a little straighter than anyone he is likely to meet. These are sharply defined acquirements, giving to the figure of the Westerner an apparent moral clarity which corresponds to the clarity of his physical image against his bare landscape. . . . Much of this apparent clarity arises directly from those "cinematic" elements which have long been understood to give the Western theme its special appropriateness for the movies: the wide expanses of land, the free movement of men on horses. As guns constitute the visible moral center of the Western, suggesting continually the possibility of violence, so land and horses represent the movie's material basis, its sphere of action. But the land and the horses have also a moral significance: the physical freedom they represent belongs to the moral "openness" of the West. (92-93)

[The Western] is an art form for connoisseurs, where the spectator derives his pleasure from the appreciation of minor variations within the working out of an established order. (99)

No other critic has better summed up the intricate interplay between ethical and artistic values in Westerns.

2. The Western as Work of Art: From Mass Culture to Popular Aesthetic

One important idea behind the transformation of popular culture studies in the 1960s was an insistence on the relative artistic and cultural autonomy of popular genres. Before the 1960s many intellectuals had criticized popular culture as little more than the degradation of traditional cultural forms through the impact of industrialized mass production and commercialization. In this climate, the analysis of popular genres tended to be either moralistic, condemning the way in which popular genres like the Western reduced cultural or artistic values to the "lowest common denominator," or Marxist, dwelling on the commercial

and ideological aspects of "mass culture." However, in the 1960s the work of Ray Browne and others made more complex studies in popular culture acceptable. The most important work of this period rejected the notion that popular works could best be understood as the result of some particular ideological or psychological purpose in order to investigate the way in which popular works reflected many different social, psychological, and artistic functions. These studies centered on two aspects of popular culture: the formal and aesthetic characteristics of popular genres and the way popular culture embodied or expressed the basic myths of American culture. These trends reflected two dominant academic critical movements of the time, the New Criticism and American Studies, and both reacted against the prevailing critique of popular culture as aesthetically and culturally worthless because it expressed only the conventional stereotypes and ideologies of mass culture.

Such studies led to an increasing recognition of the aesthetic potentialities of popular genres. They also inspired a revision in the artistic canon to include writers like Dashiell Hammett and Raymond Chandler and filmmakers like John Ford, Howard Hawks, and John Huston; these creative artists had not been fully appreciated by an earlier generation of critics because their work was largely in popular genres.

It no longer seems necessary to preface analyses of popular genres with an elaborate justification and apology for the "serious" consideration of such material. In fact, when an occasional article does so, one hears the screams of a long-dead horse hovering ghostlike in the air. The new scholars of popular culture insisted on the validity of popular genres as artistic expression and attempted to formulate the concept of a popular aesthetic which would validate the artistic significance of popular works in their own right. As I put it in the 1970 *Six-Gun Mystique* "works of art, whether popular or elite, highbrow or lowbrow . . . are governed first by their own laws and secondarily and indirectly by social and psychological dynamics" (80-81). The result of this approach was the development of a variety of new, more complex techniques for analyzing the distinctive structures, symbolism, and narrative methods of popular works and a de-emphasis on the relationship between these works and the societies and cultures which produced them.

This reorientation of popular culture analysis was related to other important critical and analytical developments in fields like film studies, mass communications, aesthetics, and the study of narrative. Several new approaches were instrumental in the development of an artistic approach to the Western. One was the idea of formulas or popular genres which the original edition of this book had some part in developing and which is illustrated by the definition of the Western genre offered in

chapter two. Actually the term "formula" has never caught on with most critics of popular culture, perhaps because it seems to suggest a negative valuation of the form as restrictive and repetitive, implications which I did not intend but which proved to be inherent in the term. Most critics and scholars have instead chosen to speak of the Western as a "popular genre" and I have increasingly found myself going along with this practice.

As we saw in chapter two, popular genres seem to be defined by a variety of formulaic patterns, most of which involve structures of story, character, setting, and theme which can be manipulated in a variety of ways. Depending on the skill of the writer or moviemaker these patterns can result in powerful and compelling novels and films, or in lackluster performances, satisfying mainly to those who have become addicted to the genre. For a popular genre to remain vital it must continue to support and encourage artistic transformations that bring about a continual evolution in the patterns of the genre. Some aspects of this evolution reflect the changing cultural background, but some must surely be attributed to the artistic creativity of those writers and filmmakers who have played a major role in shaping the development of the genre. Creators like Owen Wister, W. S. Hart, Zane Grey, John Ford, Jack Schaefer, Sam Peckinpah, and Clint Eastwood have placed a major stamp on the development of the genre.

One of the best treatments of the Western genre as a popular art form was presented by Philip French in his 1973 book *Westerns: Aspects of a Movie Genre* (revised 1977). French offers one of my favorite definitions of the Western as genre, though its general characteristics might apply equally well to all of the major popular genres. French suggests that:

The Western is a great grab-bag, a hungry cuckoo of a genre, a voracious bastard of a form, open equally to visionaries and opportunists, ready to seize anything that's in the air from juvenile delinquency to ecology. Yet despite this, or in some ways because of it, one of the things the Western is always about is America rewriting and reinterpreting her own past, however honestly or dishonestly it may be done. The inadequacy of the Western is less my immediate concern here than its power or persuasiveness. Take any subject and drop it down west of the Mississippi, south of the 49th Parallel and north of the Rio Grande between 1840 and World War I, throw in the mandatory quantity of violent incidents, and you have not only a viable commercial product but a new and disarmingly fresh perspective on it. (24)

French's definition is at times a little too open-ended and fails to account for the essential continuities of structure and theme that charac-

terize the Western, in the way that French himself does in his insightful analyses of particular Westerns. French's approach is essentially to catalog the artistic elements of a large variety of particular Westerns, showing how these effective examples of character, action, theme, and image exemplify the creative potential of the genre. The definition does place a useful emphasis on the flexibility of the genre and its ability to accommodate a wide variety of concerns and interests as well as many different levels of meaning. When a popular genre or sub-genre no longer seems to have the ability to reshape new material to its own dominant patterns, it begins to decline.

The concept of popular genres is one result of the general idea that there is an aesthetic of popular culture. This view assumes that there are certain artistic characteristics linked to wide popularity that can appeal to audiences on different levels of education and sophistication. In the future, the concept of a popular aesthetic will have still further implications as elements from particular national cultures enter the increasingly transnational and global realm of culture made possible by the electronic media. To a considerable extent, the Western showed its transcultural power even in the nineteenth century in the works of European writers like Gustave Aimard and Karl May. Recent English, German, French, Italian, and Spanish writers and movie directors have created their own versions of the Western, some of which, like the films of the Italian Sergio Leone or the Western novels of English writers J. T. Edson and Terry Harnett have been highly successful in America.

One important feature of the popular aesthetic is its acknowledgement of the value of building on existing formulas rather than striving for the kind of creative originality which has been considered a key feature of "true" or "serious" art since the rise of Romanticism. Jean Renoir, one of the great modern filmmakers who accomplished the remarkable feat of making films that were at once popular and comparable to the work of major literary and artistic modernists, once remarked almost wistfully that "Westerns are good because they always have the same scenario. That fact has helped the quality of the Western enormously. And people very often take to themselves the right to scorn the Western because it recounts the same story all the time. In my opinion, that is a virtue, that is an advantage" (Ross 158).

Another important aspect of the popular aesthetic is the idea of transferability from one media to another, without significant loss of effectiveness. One can make movies out of Faulkner novels, but few of them are even tolerable versions of the original text and even the best, like Clarence Brown's fine adaptation of *Intruder in the Dust* fail to transfer much of the original. On the other hand, it is often possible to

argue that the movie version of popular works is better than the original. This is clearly the case with *Shane, Stagecoach, The Searchers,* and *High Noon.* Any number of films are arguably more powerful works from an artistic point of view than the stories or novels on which they were based.

But perhaps the most important problem that the idea of a popular aesthetic had to deal with was the collaborative nature of most modern media in relation to the traditional aesthetic concept of the single artistic intention. Movies and television productions are the result of creative collaborations between many different people. Even popular novels and stories, though usually the work of single authors, are often more powerfully influenced by the concerns of editors and publishers, to say nothing of the greater role in popular literature of the conventional formulas on which the genre is based. Many 1950's mass culture critics saw the movies and television programs more as industrial productions than as creative works of art. These critics treated popular films as utilitarian objects with social and cultural functions rather than as expressions of individual sensibility and perception.

However, an important transformation of film studies emerged at this time in the work of French critics like Francois Truffaut and Andre Bazin who greatly admired American popular films, including Westerns. Their analyses led to the development of a new critical method that treated the film and television director as if he were the "author" or dominant creative force of the film. This *auteur theory* combined with the techniques of structuralism and semiotics, which had also developed in France, to create a new method for the analysis of film as art, a method which was soon extended to the Western and other popular films by English critics like Robin Wood, Jim Kitses and Peter Wollen, and the American Andrew Sarris.

For the "auteur" emphasis on the creativity of the director to be effectively adapted to discussion of the Western it had to be integrated with the concept of the Western as a popular genre. Jim Kitses made an important contribution to this critical task with his significant book *Horizon's West: Studies of Authorship within the Western* (1969). Kitses argued that in the case of the Western, the work of individual directors or auteurs had to be considered in the context of the generic tradition in which they were working. His own analyses of three major Western directors, Anthony Mann, Budd Boetticher, and Sam Peckinpah effectively fleshed out this approach by showing how each of these directors worked out his own structuring of the central thematic antitheses Kitses saw as defining the Western generic tradition. Though his analysis was not wholly systematic and was limited by his choice of directors, Kitses

did show how the *auteur* method of "honour[ing] all of a director's works by a systematic examination in order to trace characteristic themes, structures, and formal qualities" (7) could be integrated with a conception of the genre to reveal important aspects of the artistry possible within that tradition.

The development of *auteurism* with its various formal and thematic methods for analyzing the work of film directors has made possible major studies in the artistry of particular Western directors and these studies have greatly enriched our understanding of the artistic potentialities and accomplishments of the genre. Important books in this tradition like Tag Gallagher's study of John Ford, Paul Seydor's work on Sam Peckinpah, Christopher Frayling's discussion of the "Spaghetti Westerns" of Sergio Leone, and Stuart Kaminsky's treatments of John Huston and Clint Eastwood have richly expanded our sense of generic artistry in the Western.

In addition, the *auteur* method was soon applied to other partners in the collaborative process that results in a major movie or television production: the cinematographers, the scriptwriters, the producers, and the stars. In the case of the Western, analysis of the distinctive artistry of major stars has proved to be especially interesting. In books like Garry Wills' recent study of John Wayne, the cultural significance of the Western, or, perhaps more accurately, the complex relationship between the Western genre and the major stars who have been associated with it is insightfully explored. It is certainly no accident that the great period of the film Western from the late 1940s to the early 1970s was the time when a distinctive generation of male stars who frequently appeared in Westerns—John Wayne, Gary Cooper, James Stewart, Henry Fonda, Joel McCrea, and Randolph Scott—achieved huge popularity. With the single exception of Clint Eastwood, who in this context seems like a transitional figure, no male star of a later generation has had the kind of special association with Westerns characteristic of this period or of the silent stars like W. S. Hart or Tom Mix before them.

3. From Mass Culture to American Myth to Constructions of Masculinity: The Cultural and Psychological Analysis of the Western

In the first flush of enthusiasm inspired by new nineteenth-century developments in sociology and psychology, students of literature and art began to interpret works in terms of some principle of social or psychological determinism. Gradually three major forms of deterministic interpretation developed. The first, exemplified in Hippolyte Taine's axiom that literature is determined by race, moment, and milieu, assumed that literature could be understood as a reflection of the dominant intellectual

and political concerns of a period, and of the special and unique characteristics of a race or nation. Though the racial determinism so popular in the late nineteenth and early twentieth centuries has long been in disrepute, the concept of unique national cultures still plays a major role in literary analysis. Many early analysts of the Western interpreted it as an expression of certain unique aspects of the American national character, and to this day, the study of the Western as an American myth remains a central concern of students of the genre.

Interpreting the Western as an expression of certain cultural values or myths has proved very useful, though it had some major limitations. One major difficulty was that any complex work often seemed to have conflicting themes or to bring conflicting myths into play, as we saw in the case of writers like Cooper and Wister in chapter three. In the case of the Western, critics have called upon a remarkable variety of myths and themes, ranging from the Oedipus conflict, through individualism, to such motifs as innocence, primitivism, and racism. Some have seen the Western as an extreme expression of rampant individualism, while others have stressed its emphasis on the frontier community and the collective heroism of the pioneers. Many Westerns seem to suggest a basic incompatibility between heroic figures like the marshal and the gunfighter and the social order created by progress. Are we to say, then, that the theme of the Western is progress or anti-progress? Or both? How do we account for conflicting themes or values? Already these questions suggest that the simple equation of a work of art with some cultural idea or value requires further elaboration. This is the sort of problem that has recently been addressed in increasingly complex and sophisticated ways by the critical method known as "deconstruction."

Another difficulty with the method of theme analysis is the way in which it encourages us to take elements out of context and therefore to interpret not a total work, but a random selection of isolated elements. It seems axiomatic to me that we experience works of narrative or drama like the Western as wholes and that we understand individual elements within those wholes by virtue of their relation to a total structure of action, character and thought. In other words, a hero in a Western is a hero because he does certain kinds of things to certain types of people and we cannot understand this particular kind of heroism except in relation to the whole pattern of action. Similarly, a theme like individualism appears not in isolation, but in connection with a complex pattern of values. Insofar as this is true, our attempts to interpret the Western or any other narrative or dramatic work by concentrating our attention on particular themes do not seem to adequately reflect the complex unity of significant works of art like the most powerful of Westerns. Cultural crit-

icism of the Western has needed to develop more complex ways of situating the Western and its myth in the various cultural contexts from which it sprang.

I

Probably the most powerful forms of literary determinism in the twentieth century have derived from the work of Marx and Freud rather than that of Taine. The Tainean axiom that literature reflects "race, moment and milieu" leaves us at sea in a turbulent ocean of social and cultural themes with no guiding principles to find our way to land. Anything may be important, since the concept of reflection is far too vague to provide a clear interpretive principle. The traditions of Marx and Freud, on the other hand, set forth a clear conception of what themes are significant and a sophisticated method for relating these themes to each other and to the culture which produced them. In both cases, this method depends on a concept of function. Instead of the vagueness of the notion of reflection, we have in Marxian and Freudian criticism a commitment to the idea that literature can best be understood and analyzed through the way in which it accomplishes certain social or psychological functions. By focusing the interpretation around the concept of function, Marxian and Freudian criticism have the advantage of providing a uniform principle for the discussion of themes in relation to a conception of the whole work and of its social or psychological context.

From the Marxian point of view, the function of literature and the other arts is to express the ideology or fulfill some ideological need of the social group or class that sponsors, produces or otherwise controls the work. As Marxian criticism has developed, the concept of ideology has been elaborated in increasingly sophisticated ways. It is fairly easy to reject the primitive Marxian criticism which sees practically everything in modern European and American literature as a bourgeois plot against the working class. Such was the approach of the pedantic Marxist criticism of the 1930s which reduced great writers like Henry James to object lessons of bourgeois decadence and applauded the self-conscious proletarianism of such now forgotten novels as Clara Weatherwax's *Marching, Marching.* But we cannot so easily throw out the works of critics like George Lukacs and Raymond Williams, or the whole contemporary school of Neo-Marxism known as "cultural studies." Indeed, the power of the Marxian approach to literary interpretation is such that it has been adopted in part by many critics and historians who are quite uninterested in the revolutionary aspects of Marxian politics.

For example, in an early essay on the Western "Ten-Gallon Hero," David Brion Davis employed a method of analysis related to the Marx-

ian tradition. In essence his approach to the Western was to interpret it as a reflection of the ideologies of regional and age groups in the United States. He argued, for instance, that certain elements of the Western represent the ideology of the pre-Civil War South "purified and regenerated by the casting off of apologies for slavery." Without the burden of defending slavery, the Southern ideology could "focus all energies on its former role of opposing the peculiar social and economic philosophy of the Northeast. . . . Asserting the importance of values beyond the utilitarian and material, this transplanted Southern philosophy challenged the doctrine of enlightened self-interest and the belief that leisure time is sin." Davis further argued that the Western expressed ideological traits of the American pre-adolescent:

The volume of cowboy magazines, radio programs and motion pictures, would indicate a national hero for at least a certain age group, a national hero who could hardly help but reflect specific attitudes. The cowboy myth has been chosen by this audience because it combines a complex of traits, a way of life, which they consider the proper ideal of America. (3)

The ideological approach to a work like the Western involves the definition and interpretation of narrative elements in relation to the social position of the work's primary audience. Thus, according to Davis, American preadolescents need to express their feelings of tension about the increasing responsibilities society is thrusting upon them. The cowboy hero provides them with an embodiment and justification of the "carefree life" of childhood and thereby expresses their social ideology.

Davis is not always clear about his conception of function. Another comment in his essay suggests a very different principle of explanation from the concept of ideological expression that he uses at other points.

Physical prowess is the most important thing for the ten- or twelve-year-old mind. They are constantly plagued by fear, doubt, and insecurity, in short, by evil, and they lack the power to crush it. The cowboy provides the instrument for their aggressive impulses, while the villain symbolizes all evil. (4)

The last sentence of this quotation actually implies two different concep-
tions of function. To say "the villain symbolizes all evil," is consistent with the idea of ideological expression, since the statement may mean that the villain represents the social types or forces which the text's ideology defines as bad. However, the assertion that the cowboy "provides the instrument for their aggressive impulses" can only make sense as the expression of a psychological function. In this case, Davis implies that

the pre-adolescent audience has aggressive feelings that need to be discharged in some fashion. Through a process of identification with the cowboy hero, the preadolescent audience performs aggressive acts against the villain and thereby relieves its own pentup feelings. According to this line of interpretation, the elements of the Western (i.e., the clash between cowboy hero and villain) are determined by the capacity of these elements to perform a certain psychological function (i.e., to release the feelings of hostility and aggression). This kind of interpretation does not necessarily contradict the conception of ideological analysis since the objects of aggression may be determined ideologically, at least in part. One of the favorite Western villains, the tyrannical and unscrupulous banker, could be interpreted as an ideological enemy of the pre-adolescent audience, since the banker represents the adult world of power, responsibility, and respectability which the pre-adolescent seeks to reject. Similarly, it is quite possible to see certain psychological needs as determined by social position. One might argue that the high level of pre-adolescent aggressiveness is a result of the particular tensions which modern societies place on this age group. It is quite possible, therefore, to create a kind of synthesis of Marxian and Freudian methods of explanation, and many contemporary critics have done so.

To clarify the relationship between ideological and psychological functions, let us examine the conception of psychological function in isolation from the problem of social ideology. Critics of literature have often assumed some psychological basis for the appeal of the arts. Aristotle, for example, suggested that men enjoy literature because they find pleasure and instruction in the act of imitation. However, it was not until Freud fully developed his conception of manifold psychic processes operating beyond the full knowledge or control of the individual that psychological determinism became an important mode of literary analysis. Insofar as earlier theorists dealt with the problem of artistic determinants, it was usually in connection with some ideal of beauty or truth to which the artist might aspire by a combination of conscious choice and innate skill or genius. Freud thought that artistic form might be determined entirely or in part by psychological needs of which the artist and audience were not consciously aware. This idea gave rise to a view of art that would have seemed entirely paradoxical to most earlier thinkers: that art, which would seem by definition to be a matter of the most refined conscious choice, might be in fact the result of unconscious impulse. Since Freud, many critics have been interested in the psychological determinants of art, and some biologists such as Shepherd, Morris and Lorenz have even suggested hypotheses about the related problem of the biological determinants of art.

Two conceptions dominate the discussion of psychological function: a) the idea that art appeals to people by vicariously satisfying deeply felt impulses or desires which cannot normally be fulfilled, i.e., the conception of wish fulfillment; and b) the idea that art derives from some persistently disturbing psychic conflict which, failing of resolution in life, seeks it in the symbolic form of fantasy, i.e., the idea of repetition compulsion.

The quoted section from Davis' essay implies a rather simplified form of wish fulfillment. The audience identifies with the hero, who performs violent actions and thereby gratifies its own aggressive wishes, conscious or unconscious. A similar view connects popular literature with the wish fulfillment of sexual impulses, as, for example, in the argument that James Bond is appealing because he enables his readers to satisfy vicariously the wishes for sex and adventure that they cannot carry out in real life. Such commentary verges more on the ethical than on the cultural or psychological, however.

Freud transformed the moralistic conception of wish fulfillment by suggesting that the significant thing about the impulses that found expression in literary form was not their sinfulness but their unconscious character. In Freudian terms literature, like dreams, had to be at least partly understood as a disguised expression of wishes which the conscious mind was not prepared to admit. However, Freud's own conception of the psychological determinants of literature moved from the more simple conception of impulse gratification to the far more complex idea of repetition compulsion. According to Freud, many human impulses are not only blocked by the environment but are censored by the conscious mind because they represent desires too disturbing for the ego to consciously accept. However, these impulses continue to seek expression and fulfillment. Thus, a constant tension arises in the mind and ultimately these unconscious impulses find expression, sometimes in dreams, sometimes in neurotic behavior, and sometimes in art.

The conception of repetition compulsion assumes that certain unresolved conflicts can develop out of the relations between parents and children. If the child fails to resolve these conflicts at the proper time, he or she is doomed to constantly reexperience them through various analogies and disguises. For example, a man who never satisfactorily resolves his sexual feelings about his mother will, according to Freud, invariably find himself reenacting the original sexual conflict in most of his future dealings with the opposite sex. In addition, this conflict is likely to shape the kind of art he creates and enjoys. This kind of Freudian analysis applied to the Western appears in an 1958 essay by Dr. Kenneth J. Munden.

Beginning with an analysis of the neurotic conflict of feelings in a cowboy patient, Dr. Munden seeks to show how this same conflict shapes the central themes of the Western. According to Dr. Munden's analysis, the Western from a psychological point of view is particularly focussed on the rationalization and justification of acts of violent aggression. In other words, one of the major organizing principles of the Western is to portray the villains in such a way that the hero is both intellectually and emotionally justified in destroying them. Thus, the Western's narrative pattern develops and resolves the tension between a strong need for aggression and a sense of ambiguity and guilt about violence. Dr. Munden suggests that this kind of psychic tension is a classic symptom of the oedipus conflict, which is strongest among male adolescents, who, Dr. Munden suggests, are among the major fans of the Western. But, Dr. Munden goes on to argue that there are social-psychological reasons why this kind of tension also exists among lower-middle and working-class males. In modern industrial societies, these groups are constantly subjected to the pressures of social change in such a way that their sense of masculine independence is continuously threatened. For blue-collar and white-collar workers at the lower echelons of the large industrial organization, or for independent farmers facing the increasing competition of large industrial organizations, the corporation plays somewhat the same psychological role as the father does for the adolescent boy. It is recognized as an inescapable authority upon whose benevolence the individual is dependent, yet at the same time, it is an object of the most violent hostility and a basic threat to the individual's ego. Couple this with the fact that the culture of working-class groups has traditionally placed a strong emphasis on masculine dominance, and it is not hard to see how the Western might fill an important psychological function for these groups.

The idea of repetition compulsion seems particularly appropriate to the analysis of literary types like the Western or the detective story where certain character types and patterns of action are repeated in many different works. Indeed, it is tempting to hypothesize that strongly conventionalized narrative types like adventure and mystery stories, situation comedies and sentimental romances are widely appealing because they enable people to reenact and temporarily resolve widely shared psychic conflicts. Furthermore, this idea can bring together social and psychological conceptions of function, since it is quite likely that the childrearing practices and ideologies of different social groups have created characteristic psychic conflicts in various social groups or subcultures. These differences, in turn, might help account for changing themes and conventions in popular genres like the Western. Similarly, the char-

acteristic psychological syndromes of different groups and periods may be partly responsible for the evolution of a variety of popular story types like the classical detective story, the hard-boiled detective story, the sentimental romance and the spy story.

Unfortunately it soon becomes apparent that the Freudian oedipal interpretation is a handy pattern that can fit almost any form of narrative involving violence and conflict and that, therefore, it offers little insight into the particular significance of the Western. A similar difficulty arose with early Marxian interpretations of popular formulas. It proved very difficult to isolate a distinctive ideology for the Western in Marxian terms, for the same kinds of things could be said about other forms of popular literature as well. To get a more complex understanding of the Western's cultural significance, critics had to go beyond mass culture criticism's generalizations about social and psychological function to a fuller understanding of the way in which the Western was situated in the cultural history of nineteenth- and twentieth-century America.

II

This further development implied the integration of studies in American literature and history that led in the 1940s to the rise of the American studies movement. In terms of the Western, the great pioneering study of the myth of the West was Henry Nash Smith's *Virgin Land* (1950). Smith studied the origin of various myths of the West in the European imagination and then showed how these myths had developed in America both in political and economic movements like the settlement of the Great Plains and in literature about the West. He showed how the myth of the West as a new Garden of Eden had inspired a pursuit of wealth and abundance which quickly outran the ecological limits of the Great Plains leading to disastrous failures. As Smith saw it, the literature of the West arose out of the conflict between myth and reality, a conflict which was represented with some complexity in Cooper but became increasingly simplified and sensationalized in the popular literature of the later nineteenth century.

Smith's study was a brilliant analysis of certain aspects of the mythical history of the American West, and it helped pave the way for the redefinition of the Westward movement which has occupied the most recent generation of Western historians. It also greatly influenced the cultural study of popular culture. However, Smith's work was limited by the somewhat negative attitude toward contemporary popular culture characteristic of intellectuals of his generation. He was less aware of Western literature and film of the twentieth century and, of course, knew nothing of the extraordinary flourishing of the Western in film and litera-

ture during the 1950s and 1960s, which came after the publication of *Virgin Land.* Thus, Smith's view of the modern Western as a simplified and degraded version of Cooper's Leatherstocking Tales was soon challenged by a younger generation of scholars.

The most important of these younger scholars took up where Smith left off and created what will be for a long time to come, the definitive history of the myth of the frontier in America. Richard Slotkin's *Gunfighter Nation* (1992) was the final volume of a massive trilogy which will long stand as one of the major monuments of American studies. The first volume of Slotkin's study, *Regeneration through Violence,* appeared in 1973. In it he defined his conception of the myth of the West as associated with the frontier and certain characteristic stories. He then traced the myth's emergence in the New World and its development up until the mid-nineteenth century. Slotkin's second volume, *The Fatal Environment* (1985) analyzed the transformations which the myth of the West went through as it was carried forward into the industrial society of the later nineteenth century and showed how writers and politicians adapted the symbolism and rhetoric of the frontier myth to the war between capital and labor, and to the explanation and justification of the rise of classes and class conflict in an ostensibly democratic society. *Gunfighter Nation* brought this account up to the present. It dealt with the transformation of the myth of the frontier into a justification of America's position as a global power and, in particular, to the explanation of Cold War confrontations and third world imperialism. Slotkin saw this as the final stage in the evolution of the myth.

As Slotkin analyzed it, the myth of the West was primarily a myth of the frontier and of the confrontation between civilization and savagery, which resulted in the destruction of savagery and the regeneration of white America though the experience of violence in the war against savagery. In moral and political terms, Slotkin sees the influence of the myth as negative; in the seventeenth and eighteenth century its definition of cultural otherness as savagery was used to justify the expropriation of Native Americans and the enslavement of Africans. The same myth was adapted by the new industrial and national power elites of the later nineteenth century to celebrate the use of financial and military power against the working class and in the suppression of labor unrest. Finally, in the twentieth century, the myth of the frontier became a strong rhetorical resource for glorifying the global exercise of American power and the great shootout of the Cold War which eventuated in the tragedy of Vietnam.

Such a summary does oversimplify somewhat the political message which Slotkin clearly intends to deliver. In fact, he expresses some doubt

about the cultural function of the myth of the frontier, wondering if it was primarily an expression of American racist imperialism, or whether it sometimes took a more liberal democratic form. For example, in *Gunfighter Nation,* Slotkin distinguished between "progressive" and "populist" versions of the myth of the West. According to him, "the 'progressive' style used the Frontier Myth in ways that buttressed the ideological assumptions and political aims of a corporate economy and a managerial politics. It reads the history of savage warfare and westward expansion as a Social Darwinian parable, explaining the emergence of a new managerial ruling class and justifying its right to subordinate lesser classes to its purposes" (22). On the other hand, the "populist style" was more democratic in its uses of the myth. It "values decentralization, idealizes the small farmer-artisan-financier, and either devalues (or opposes) the assumption of a Great Power role or asserts that the nation derives both moral and political power from its populist character" (23). Theodore Roosevelt and Owen Wister are, for Slotkin, major exponents of the progressive version of the myth, while Frederick Jackson Turner saw the closing of the frontier as a symbol of the increasing erosion of populist values in America.

However, as Slotkin portrays it, in the dialectic between progressive and populist versions of the myth of the Frontier, the progressive version, adapted to celebrate Cold War imperialism, became dominant while the populist version proved increasingly insufficient to the ideological needs of the twentieth century. In the end, the imperialist version of the myth of the West not only came to dominate the Western film, but, through its popularity in American culture as a whole, helped shape the attitudes of the architects of the Vietnam War.

Vietnam dominated the last phase of the development of the myth. Slotkin brilliantly analyzes how the major Westerns of the 1960s and 1970s reflected the Vietnam conflict and its increasing ambiguities, leading up to a "crisis of public myth." This, in Slotkin's view, made it clear that the myth of the West could no longer establish meaning in the contemporary world. "We are in a 'liminal' moment of our cultural history. We are in the process of giving up a myth/ideology that no longer helps us to see our way through the modern world, but lack a comparably authoritative system of beliefs to replace what we have lost" (654). Like many revisionist historians of the West and others seeking to acknowledge the role of multiculturalism in American history, Slotkin imagines that a new myth of America will "have to respond to the demographic transformation of the United States and speak to and for a polyglot nationality. Historical memory will have to be revised, not to invent an imaginary role for supposedly marginal minorities, but to register the

fact that our history in the West and in the East, was shaped from the beginning by the meeting, conversation, and mutual adaptation of different cultures" (655). Slotkin thinks that this historical imperative has caused the decline of the long dominant myth of the West. "Even in its liberal form, the traditional Myth of the Frontier was exclusionist in its premises, idealizing the White male adventurer as the hero of national destiny" (655). Profoundly limited by its deep commitment to sexism, racism and WASP ethnicity, the myth of the West must inevitably be replaced by a new myth of multiculturalism.

Slotkin may be right that the Western frontier of the imagination is as dead as the geographical frontier whose obsequies Turner pronounced almost exactly a hundred years ago. In any case, his work is a major accomplishment and will stand as one of those profound syntheses of American cultural history which brilliantly reflects the vision of a particular era. One of the reviewers of *Gunfighter Nation* rightly compared Slotkin's trilogy to two great earlier syntheses of American studies, Vernon Parrington's two volume *Main Currents of American Literature* and Daniel Boorstin's trilogy *The Americans*. Parrington's social and economic analysis of American literature had grown out of the criticism of rampant industrialism and financial irresponsibility which created the climate for the New Deal. Boorstin celebrated the consensual politics and culture associated with the economic and technological changes which made America a world power, reflecting the confidence of the post World War II era. Slotkin's work is a major synthesis embodying the crisis of American faith brought about by Vietnam.

However, whatever one concludes about Slotkin's political and cultural message, his trilogy does not stand or fall by it. His analysis brilliantly traces how many aspects of American culture revolved around the myth of the west, and in the process he provides an unsurpassed account of the evolution of American popular culture both mythically and institutionally. Slotkin's trilogy says as much about the processes and patterns of American popular culture as it does about the myth of the West. It will long be required reading for students of popular culture.

III

Slotkin's view that our history "was shaped from the beginning by the meeting, conversation, and mutual adaptation of different cultures" has certainly been borne out by recent developments in the cultural analysis of the Western. Recent discussion of the Western has been strongly influenced by two major developments in our understanding of the meaning of the West. One is the new Western history with its emphasis on the encounter between diverse cultures and the increasing concern

with race and gender as major factors in the history of American culture. The new Western history culminated in the major historical syntheses of younger historians like Richard White, Patricia Limerick, and Donald Worster and in the 1996 television documentary series produced by Ken Burns *The West: A Film by Stephen Ives.* By exploring the importance of multicultural encounters, the impact of settlement on the Western ecology, and the central role of urbanization and industrialization in Western development, the new Western history offers a complex criticism of the Turner thesis and the assumptions about Western history underlying most Western films. The most widely read of these new histories, Limerick's *The Legacy of Conquest* (1987), not only rejected Turner's emphasis on the uniqueness of America's frontier experience but insisted on the American West as "an important meeting ground, the point where Indian America, Latin America, Anglo-America, Afro-America, and Asia intersected. In race relations, the West could make the turn-of-the-century Northeastern urban confrontation between European immigrants and American nativists look like a family reunion. Similarly in the diversity of languages, religions, and cultures, it surpassed the South" (27). The new Western history revises the traditional epic story of the Westward Movement as Euro-American conquest of the frontier into an account of the clash of cultures and its lasting implications for the present. As Limerick puts it, "The workings of conquest tied these diverse groups into the same story" (27). From this point of view, the West of the Western is largely a misleading mythical distortion of the real meaning and legacy of the Western experience.

Another important contemporary development is the great flowering of Native American fiction and poetry in English. More than anything else, the fascinating novels and poems of writers like Scott Momaday, Leslie Silko, James Welch, Gerald Vizenor, and Louise Erdrich have offered a new kind of insight into the cultures of a variety of Indian groups. One of the most striking of these works, Leslie Silko's contemporary novel of the West, *Almanac of the Dead* (1991) startlingly displaces our traditional sense of the West as American civilization's victory over savagery by representing the present as a time in which the temporary European incursion into the Americas is beginning to show signs of drawing to an end. These Native American fictions should provide a rich literary source for the Western films of the future.

IV

Our contemporary concern with the influence of ideologies of gender and race on the construction of culture circles back in some ways to the ideology-centered analysis which dominated cultural critiques of

the forties and fifties. However, contemporary cultural analysis is also very different in three important ways from the attack on "the vast wasteland" of popular culture typifying that era. First of all, the new kind of analysis—let's call it "neo-structuralist" for simplicity's sake— tries to avoid the distinction between high and popular culture that dominated earlier thinking. For contemporary critics, there is no fundamental difference between the analysis of the ideology of a major writer and an item of popular culture: both are seen as cultural or ideological structures that can be "deconstructed." Roland Barthes has applied the same kind of analysis to the language of fashion that he did to texts by Balzac while cultural critics like Foucault and Baudrillard deal as much with popular culture as they do with canonic literature. One consequence of this is that the neo-structuralist critic often really likes the texts he/she is deconstructing. Jane Tompkins, for example, is an avowed fan of Westerns. In spite of the fact that she finds many of the genre's ideological implications deeply disturbing, she is often able to suggest striking insights into the popularity of Western writers like Louis L'Amour and Zane Grey, both of whom she discusses extensively and interestingly.

Second, the neo-structuralists have developed a much more complex method of ideological analysis than that used by the more reductionistic Marxist critics of the fifties. Though its practitioners sometimes use an analytic jargon that seems impenetrable to ordinary minds, their basic assumption that all texts have latent as well as overt meanings and that these meanings are frequently in apparent conflict or contradiction with the surface meanings has produced some extremely interesting results. There's no doubt but that we can learn a great deal about the layers and levels of meaning in a text from neo-structuralist analysis.

Finally, the neo-structuralists have greatly expanded the traditional Marxian analysis of ideology as an expression of economic and class relationships to deal with other ideological areas, most notably sex, gender, and race. Not surprisingly, it is in this latter area that the most striking reinterpretations of popular cultural texts have been taking place. These reinterpretations have begun to suggest some important possible revisions of the history of American culture as well. Slotkin argues that the decline of the myth of the West has created a mythical and ideological crisis in America. This may be one way of accounting for the current vogue of what is often called "political correctness." As Slotkin suggests, the new center around which a contemporary American mythology seems to be forming is that of multiculturalism which includes a reaction against all forms of cultural exclusivity and discrimination such as racism and sexism. "Political correctness" with its determined avoidance of racism and sexism in language as well as in

behavior is one way of acknowledging and resisting the legacy of exclusivity and discrimination that constitutes the dark side of American democracy and was reflected in the myth of the West. This sensitivity to racism and gender inspired other ways of analyzing the Western in the 1990s. Some of the new writing about the Western developed a feminist critique of Western myths, while other writers explored and even, to some extent, celebrated the Western's construction of heroic masculinity.

According to Jane Tompkins in *West of Everything,* the modern Western emerged as a literary counter-statement to the ideology of Christian evangelical reform as it was expressed in the novel of domestic sentiment so popular in the mid-nineteenth century:

The Western *answers* the domestic novel. It is the antithesis of the cult of domesticity that dominated American Victorian culture. The Western hero, who seems to ride in out of nowhere, in fact comes riding out of the nineteenth century. And every piece of baggage he doesn't have, every word he doesn't say, every creed in which he doesn't believe is absent for a reason. What isn't there in the Western hasn't disappeared by accident; it's been deliberately jettisoned. The surface cleanness and simplicity of the landscape, the story line, and the characters derive from the genre's will to sweep the board clear of encumbrances. And of some encumbrances more than others. If the Western deliberately rejects evangelical Protestantism and pointedly repudiates the cult of domesticity, it is because it seeks to marginalize and suppress the figure who stood for these ideals. (39)

Though the popular Western is much older than the later nineteenth century, as we noted in chapter three the Western genre did change significantly at the turn of the century. The rise of the modern adult Western novel was exemplified by Owen Wister's *The Virginian* and other late nineteenth- and early twentieth-century novelists like Emerson Hough, Harold Bell Wright, and Zane Grey. Harold Bell Wright is an interesting case in point since we can see an interplay in his work between the traditional Christian evangelism and the new social Darwinism in *Shepherd of the Hills,* a combination which he applied to the West in *The Winning of Barbara Worth.* There also emerged at this time a new kind of Western art in painters and illustrators like Remington and Russell, who departed from the romantic Western landscapes of Thomas Moran and Albert Bierstadt to create a visual world of cowboys and Indians, cavalry, cattle, and horses. This was the image of the Wild West as we still know it. The 1890s and early 1900s were also a peak time for Buffalo Bill's Wild West Show and the Rough Riders, and for Theodore Roo-

sevelt's political exploitation of the myth of the cowboy and the wild west. These years also saw the first expression of Frederick Jackson Turner's frontier thesis and of the first Western films. Such a large number of contemporaneous developments in the imaginative construction of the West were clearly associated with major cultural changes.

The traditional way of accounting for these changes was along the lines which Turner himself set forth in his essay on "The Significance of the Frontier in American History." As the frontier experience receded in actuality due to the rapid rise of urbanization and industrialization, it became increasingly important in the imagination of American culture because it established a linkage between the present and the past. The Western, then, could be seen as a conservative and nostalgic genre seeking to preserve past values that were being increasingly eroded by the social and cultural changes related to industrialization and the rise of the city. It is interesting to note that this was essentially the explanation offered by Wister in his preface to the first edition of *The Virginian* when he said "What is become of the horseman, the cowpuncher, the last romantic figure upon our soil? . . . A transition has followed the horseman of the plains: a shapeless state, a condition of men and manners unlovely as that bald moment in the year when winter is gone and spring not come, and the face of Nature is ugly" (x). Yet nine years later when Wister rededicated a new edition, he gave a rather different emphasis to his story by suggesting that it represents a renaissance of true Americanism rather than a nostalgia for the past:

After nigh half-a-century of shirking and evasion, Americans are beginning to look at themselves and their institutions straight; to perceive that Firecrackers and Orations once a year, and selling your vote or casting it for unknown nobodies, are not enough attention to pay to the Republic. (vii)

Tompkins' explanation of the rise of the modern Western as a reaction against the traditional ideology of sentimental evangelical Christianity may help to account for some of the differences between nineteenth- and twentieth-century Westerns. Her thesis also points to the way in which the ethos promulgated by the Westerns of Wister and other twentieth-century filmmakers and writers was related to a whole constellation of emergent moral and social values. With this in mind, we can see that the modern Western constructed a new mythology departing fairly radically from the complex of values characteristic of the earlier genre. One sign of this change, as Tompkins indicates in her analysis, is a shift in the treatment of nature from the Edenic Virgin Land of nineteenth-century romanticism to the harsh desert and endless plains more characteris-

tic of the twentieth-century Western. In the modern Western, nature is not a source of fruitfulness and spirituality as it is in Cooper, but an obstacle course through which the protagonists must struggle in their quest for survival.

However, it still remains to be seen how this change in the Western relates to gender issues and why it came about at this particular time. It is certainly true that one of the major characteristics and limitations of the Western genre has been the rigidity of its gender roles. Just as the visual background of the typical Western emphasizes the binary opposi- tions of desert and mountain, town and wilderness, church and saloon, light and shadow, so the characters divide with equal rigidity along the lines of gender. Men are men and women are women, and attempts to blur this line or to have women playing a man's role have never worked very well. One of the most fascinating and bizarre of Western films, Nicholas Ray's *Johnny Guitar,* is also one of the few in which women enact the rites of conflict and violence which are usually the province of men. In this film, a struggle between two women leads up to the climac- tic shootout. Moreover, the ambiguity of women playing men's roles is clearly indicated by the strange sequence of costumes worn by Joan Crawford as the female protagonist. When Crawford first appears, near the opening of the film she is in the elegantly tailored black shirt and pants traditionally associated in Westerns with the gunfighter. Crawford, however, is clearly a gunfighter in drag, for before very long, she changes into the low-cut red dress symbolic of the dance-hall girl, and then into a demure white gown, and finally into bluejeans. These four outfits run the gamut of the major male and female roles in the Western, but in this case the shifting of costumes seems to symbolize the anxiety and restlessness resulting from the inverted gender roles.

The gender rigidity of the Western tradition becomes even clearer when we compare it to another leading popular genre, that of the detec- tive story. This genre has readily accommodated itself to women protag- onists and, in recent years, with the emergence of hard-boiled women detectives in writers like Sara Paretsky, Sue Grafton, and Linda Barnes, males and females have become virtually interchangeable in the leading roles in the genre. Even in earlier periods, though the majority of suc- cessful detective characters from the later nineteenth and earlier twenti- eth centuries were men, there were always a few female detectives. Such interchangeability of gender has never worked in the Western where women in men's clothing seem problematic, like the outfit worn by the archetypal Western gender bender, Calamity Jane. It may well be that this lack of flexibility in the portrayal of gender roles is one major reason why, after its heyday from the late thirties to the early seventies,

the Western film and television program has virtually ceased to constitute a significant popular genre.

But why should this particular insistence on the rigidity of gender roles have emerged when it did? Tompkins thinks that this was primarily a kind of male reaction against the dominant female-centered ideology of evangelical Christianity which gave women and the home the major role in the great life drama of the quest for salvation. Though the turn of the century did see some major changes in Christianity in America with the rise of the social gospel on one hand and of fundamentalism on the other, there were also other basic social and moral issues that the modern Western was probably responding to. In my opinion, the most important were the increasing mobility of American life, the beginning of the long-term decline of the home and family and the corresponding emergence of a new ideology of individualism de-emphasizing the virtues of community and family and glorifying male aggressiveness and competition. These changes in value are the same, which, in less popular literary and philosophical form, led to the movement we now refer to as naturalism or social Darwinism of which Ernest Hemingway became the most influential literary exemplar. Significantly, the world of Hemingway has many similarities to that of the modern Western.

The modern Western emerged along with the need to mythicize the new values of mobility, competitiveness, and rugged individualism which were replacing the more community and family-oriented values of the nineteenth century. The Western celebrated and dramatized these values in the struggles of the heroic male Western protagonist, making them the focus of American history as the characteristics responsible for the winning of the West. The rigidity and separation of gender roles in the Western related more to this, I think, than to the decline of evangelical Christianity, which in fact adapted itself rather effectively to the new circumstances. The male role in the Western symbolized the new world of individual male competition and aggression away from the support of community and family, in other words, the world of modern industrial and business work carried on with increasing separateness from the home. The woman represented the values of the past associated with family, home and community.

In the modern Western, the central female character usually came to see the necessity of the masculine ethos, and, even, in certain climactic cases, to share in it. Thus, the pacifist heroine of *High Noon* herself shoots one of the remaining outlaws when she sees her husband physically threatened. Such moments reverberate throughout the Western and seem to imply the significance of two archetypal plot structures dominating the tradition: one is the hero's struggle with nature and outlaws, the

other is the conversion of the female to the new ethos of violence and rugged individualism. However, in order to affirm the new values of mobility, competition, and individualism, the female must remain feminine while at the same time she is forced to recognize that when the chips are down, there is no moral resort beyond the strength and courage of the isolated individual.

Jane Tompkins' *West of Everything* and Robert Murray Davis's *Playing Cowboys* are alike in some ways, despite their totally different gender orientation. Both use a highly personal method of analysis and are extremely selective in the material they deal with, basing their analysis of the Western tradition on a very few texts (one reviewer remarked rather acerbically that Tompkins could have viewed the Western films she discusses in a long weekend). Both treat Owen Wister's *The Virginian* as the ur-text for the modern Western and finally, they agree that the Western is a genre primarily concerned with celebrating a masculinist vision of life, though, of course, they disagree about how they define and value that vision. Tompkins emphasizes the violence and destructiveness that seems to her to dominate the Western. Her analysis gives an almost unique twist to the discussion of the Western by emphasizing the treatment of animals, horses, cattle, and buffalo, in the Western. Tompkins acknowledges being "simultaneously attracted and repelled by the power of Western heroes, the power that men in our society wield." She even finds things to admire in such Western adventure writers as Zane Grey and Louis L'Amour, as well as in many Western films. However, she is also disturbed by "the extent to which the genre exists in order to provide a justification for violence." The massive slaughter of animals in Westerns evokes a vegetarian's nightmare for her and in a passage from the book's most controversial chapter she extrapolates from the many killed and stuffed animals she saw at the Buffalo Bill Historical Center in Cody, Wyoming a disturbing meditation on our nostalgia for historical artifacts:

The Buffalo Bill Historical Center, full as it is of dead bones, lets us see more clearly than we normally can what it is that museums are for. It is a kind of charnel house that houses images of living things that have passed away but whose life force still lingers around their remains and so passes itself on to us. We go and look at the objects in the glass cases and at paintings on the wall, as if by standing there we could absorb into ourselves some of the energy that flowed once through the bodies of the life things represented. A museum, rather than being, as we normally think of it a place most distant from our savage selves, actually caters to the urge to absorb the life of another into one's own life. (188)

One might ask, of course, why this is particularly connected with the Western. I think that Tompkins would answer that our attraction to the "righteous ecstasy" of violence in the Western is related to our fascination with the destruction represented in museums. If we seek to find "some better way for people to live" we must learn to acknowledge and reject the powerful attraction of this violence. Evidently Tompkins feels that a critical analysis of our fascination with the Western might help us to recognize our complicity in this violence.

West of Everything has exasperated some readers and fascinated others precisely because it offers a plethora of cultural and philosophical pronouncements like those we have just discussed, but offers little by the way of sustained argument or substantiation of these generalizations. This has led some critics to dismiss her analysis as superficial and misleading. Certainly, it is superficial in comparison to the great depth of evidence and learning that Slotkin offers, but the context of sexual politics is certainly an important one in which the Western must be more fully understood. Whatever her shortcomings, Tompkins does a provocative and challenging job of getting that discussion started.

Davis is no less superficial, but much less challenging than Tompkins. *Playing Cowboys* asserts that the Western as defined by Wister created an image of masculinity so powerful that it was imitated over and over again, and tended to become oversimplified and rigid. Because of this, the Western generic tradition continually spawned anti-Westerns that were attempts to question and test the traditional images of masculinity. Most of Davis's book is devoted to the analysis of these various forms of revised or reactionary Western: the Western novels of Oakey Hall, gothic and science-fiction Westerns and, finally, "post-modern" Westerns like Ishmael Reed's *Yellow Back Radio Broke-Down* and Mel Brooks' *Blazing Saddles* which Davis seems particularly fond of. It is a good idea for a book, but the author doesn't carry it through very well. The ideology of masculinity involved in the Western is never very fully defined, and the book goes off in a number of different directions. In the end, Davis tries to get things on track by invoking Robert Bly's *Iron John* and its neo-masculinism, but doesn't acknowledge that this represents a very different concept of maleness from that represented in most Westerns. In the end, it's difficult to tell just what Davis means by "playing cowboys."

Lee Clark Mitchell's *Westerns: Making the Man in Fiction and Film* (1996) is a much more sophisticated analysis of the construction of masculinity in Western literature and film, and the only recent book on the Western that has anything near the scope and complexity of Slotkin's *Gunfighter Nation*. What's particularly interesting about Mitchell's

analysis is that, unlike Davis, he does not see the image of masculinity in the Western as a single dominant myth but as a complex process through which the Western responded to changes in American culture.

Mitchell analyzes the treatment of gender in the Western in a very complex and subtle way. In certain respects his book recapitulates the history of scholarly criticism of Westerns and of popular genres in general. Therefore it is useful not only to those concerned with the West and Westerns, but to students of other popular genres as well. Mitchell's carefully developed methodological approach might well be applied effectively to such other popular generic traditions as the mystery story, horror, and romance.

Like Tompkins, Mitchell sees the Western as essentially gender-oriented and shaped by the ambiguities of gender politics of late nineteenth- and twentieth-century America. However, where Tompkins portrays the genre as a sexist strategy to subvert an established popular tradition dominated by women, Mitchell understands the Western as a complex reaction to new feminist upsurges, particularly those associated with the "New Woman" ideal and the movement for women's suffrage:

The emergence of the Western coincides with the advent of America's second feminist movement, and . . . the genre's recurrent rise and fall coincides more generally with interest aroused by feminist issues, moments when men have invariably had difficulty knowing how manhood should be achieved. (152)

It's clear from the beginning that Mitchell is wary of simple functional or ideological analyses of Westerns, including Tompkins' interpretation of the Western as an attack on feminine values. He also notes and rejects the kind of reductive ideological critiques that dominated the early stages of popular culture analysis under the rubric of mass culture criticism. He is generally critical of explanations of the Western "in terms of political allegory or social fable, of straightforward mutation of current anxieties into plots that stage and assuage them—the way, for instance, Bruno Bettleheim viewed fairy tales, as parables guiding children through adolescence. After all, we are not children; literature and film are rarely fables; reading and viewing are more complex than studies of fictional plot as a culture's 'talking cure' allows" (8).

Mitchell is equally suspicious of the kind of Marxian ideological analyses that pervaded early mass culture criticism. He believes, first of all, that it is not primarily the moral message, but the formal or artistic characteristics of successful westerns that make them popular. Highly popular Westerns have "won favor by sustaining *multiple* interpretations" (12). Here, Mitchell incorporates some of the ideas of popular

artistry which were so influential in the development of popular culture studies and in such discussions of popular genres from the seventies and eighties as my own *Six-Gun Mystique* and *Adventure, Mystery, and Romance.*

Mitchell tries to go beyond the celebration of popular artistry to a more complex examination of how, in the case of the Western, "the most popular texts are also always a culture's most powerful, most fragilely (sic) balanced" (8). Such texts, he believes, can reveal how "an era's inadmissible disparities, its covert social constructions, perhaps particularly its deepest concerns about gender [are] erased by fictional and cinematic dynamics" (8). Thus, we enter the landscape of contemporary cultural studies and particularly of gender analysis.

Mitchell defines the Western initially as a genre that characteristically constructs a mythical terrain of regeneration. This idea is commonplace in discussions of the genre, particularly through its centrality in the work of Richard Slotkin. However, Mitchell interestingly redefines the idea of transformation or regeneration in terms of cultural liminality: "the West in the Western matters less as verifiable topography than as space removed from cultural coercion, lying beyond ideology (and therefore, of course, the most ideological of terrains)" (4). This view of the generic "West" as a space of ideological ambiguity enables Mitchell to develop a dialectic between the Western's continual confrontation of new and currently problematic social and cultural issues and its persistent role as a vehicle for the recurrent cultural struggle with the construction of masculinity:

One of this book's two premises . . . is that any popular text engages immediately pressing issues—issues that become less pressing in time. With each generation, a genre's plots, narrative emphases, stylistic pressure, even scenic values have less in common with earlier versions of that genre than with competing genres, all striving to resolve the same contemporary anxieties. Yet the second premise is just as crucial and controverts the first: that from the beginning the Western has fretted over the construction of masculinity, whether in terns of gender (women) maturation (sons), honor (restraint), or self-transformation (the West itself). (4)

Though his analysis is not primarily historical, Mitchell does discuss the emergence of the modern Western in Owen Wister's *The Virginian.* As he presents it, Cooper's Leatherstocking Series created a literary landscape in which it would be possible to "constitute America itself as a mythic space where older ideals could be configured and made appropriate for current needs" (54). However, the modern Western further trans-

formed this landscape into a particular kind of spectacle. Mitchell ascribes this development to the romantic landscape painter, Albert Bierstadt. Then, it took Bret Harte to create a cast of characters who could enact various dramas of regeneration on such a stage. By putting together elements of Bierstadt's spectacular but empty landscapes with characters out of Harte's unsituated melodramas, Owen Wister developed the combination of mythic landscape and distinctive set of characters through which a complex drama involving the ambiguities of gender could be played out.

Where Tompkins in *West of Everything* argues that the Western represented a masculinist revolt against the feminine Christian sentimentalism and domesticity which had dominated mid nineteenth-century American popular culture, Mitchell rejects what he considers Tompkins' oversimplifications of sexual politics. What Tompkins treats as a sexist reaction against feminine values, Mitchell portrays as a complex struggle to resolve an emergent tension between conflicting ideas of gender characteristics and relationships. As he sees it these tensions became increasingly acute in the early decades of the twentieth century and eventually led to the enactment of woman's suffrage. Owen Wister and Zane Grey are key figures in Mitchell's account of the emergence of the modern version of the genre. His treatment of the period is somewhat restricted, because he does not treat the silent film Western to any significant extent and his discussion of Wister and Grey is based largely on *The Virginian* and *Riders of the Purple Sage.* However, this concentration enables him to deal with the cultural issues raised by these writers with considerable complexity. According to Mitchell, Wister and Grey created a "flexible ideological web" (118) in which the oppositions between masculine individualism and feminine concern with community and commitment become transcended. This made possible the creation of narratives that satisfied such contradictory expectations as "the desire for nostalgic escapism into an exclusively masculine West and yet the need for a resolution to the more immediately vexing national issue of gender relations" (118).

Wister does this in *The Virginian* by reaffirming the inequality between the sexes and the values of patriarchy after his heroine Molly Wood has cogently expressed the argument for feminine equality. Thus Wister "offered a muted resolution to the crisis over woman's suffrage developing at the turn of the century" (114). Grey carried the issue of gender ambiguity a step further by using a kind of popular social Darwinism to create a narrative of Western self-transformation which "celebrates the possibility of the New Woman even as it cautions against her" (124). Thus in the end, according to Mitchell, Grey imports into the

Western a profound duplicity about gender relations which makes it possible for the Western to bypass the issue of gender equality in the search for new and more compelling affirmations of masculinity:

Grey's triumph was to create a Western so radically ambivalent that it resists its own structures of exploitation, at once spurring and reining in attention to the sexual politics that are its recurrent theme. By eroticizing the landscape, for instance, the narrator invests the terrain with a strongly sexual identity that seduces the reader as successfully as it does any character. Yet the narrative itself never transgresses established bounds of sexual decorum, and characters never willingly act upon their transgressive desires. Likewise, the novel seems to offer women entirely new fictional freedoms [but] this utopian social vision is achieved . . . only as more traditional constraints on female behavior are reinscribed. (147)

After discussing the beginnings of the modern Western in the era of the New Woman and women's suffrage, Mitchell turns for the central portion of his analysis to the Westerns of the post World War II period. This he portrays as a "time . . . when women had gained more independence outside the home [and] men were increasingly anxious about the prospect of being 'domesticated' in the workplace even as they tried to become better helpmates in the suburbs" (153). The key themes that link the diverse Westerns of this climactic period of the genre center, according to Mitchell, around "the paradox involved in making true men out of biological men, taking their male bodies and distorting them beyond any apparent power of self-control, so that in the course of recuperating, an achieved masculinity that is at once physical and based on performance can be achieved" (155). This attempt to dramatize an unquestioned masculinity is the genre's response to those cultural ambiguities about gender which have come to dominate twentieth century American culture, deflecting "otherwise equally consequential issues involving class rivalries, racial conflict, and regional disputes . . . by this concentration on gender roles" (153).

Mitchell discusses the Western's treatment of the ambiguities of masculinity in the 1950s and 1960s through the way in which the hero's body is typically pushed to the limit of endurance by beatings and challenges and then shown as recuperating in time for the final meeting with the antagonist. As he sees it, this archetypal pattern of so many Westerns is a symbolic confrontation and resolution of "conflicting cultural demands in the construction of masculinity over the past century" (185). The key split is about whether masculinity is essentially biological and thus a given at birth or something learned and thus a matter of culture.

These scenes of physical torment are particularly important because they represent "the amount of effort it takes to *remain* a man" (186) and thus show how being a man is not only a matter or biology but of the constant effort involved in reaffirming a masculinity that seems continually besieged by temptations usually coded in modern American popular culture as feminine.

Mitchell also shows how this tension between biological maleness and the cultural ethos of masculinity appears in the relationship between established heroes and young men on the threshold of masculinity which figures in many central Westerns of this period. These Westerns show how "the process of growing into manhood only really exists in contrast with the idea of what it means to be a woman, represented . . . most compellingly as a breaching of borders, and erasure of limits, a bridging of otherwise incompatible possibilities" (218). To become a man, the male child must learn to resist these temptations by "standing stalwart in a world of suasions and humiliations coded as feminine" (218) as the male hero has learned to do. This presentation of the process of developing true masculinity is, for Mitchell, the central dynamic of the most successful Westerns of the 1950s and 1960s, like *High Noon, Shane,* and *Hondo*.

Mitchell concludes his study by analyzing the relationship of Leone's "spaghetti Westerns" and Peckinpah's *Wild Bunch* to the Western tradition. He emphasizes the way in which these two directors, different as they are, "share a joint sense of belatedness, of needing to revive the Western at a moment when it had come to seem exhausted as a form" (226).

Mitchell's *Westerns* is no more the last word on the true significance of the Western genre than Slotkin's trilogy, Fenin and Everson's history, or Smith's *Virgin Land*. Nonetheless, it is a rich and complex synthesis of cultural and artistic analysis worthy of being shelved along with these major studies of the Western tradition. Mitchell takes the gender analysis of the Western to a much more complex level than Tompkins achieves in *West of Everything,* and also develops an interesting analysis of the way in which Westerns of different periods responded to changing issues in the construction of masculinity. He also shows how these issues become embedded in the artistic and formal as well as the thematic texture of important creations within the tradition. Mitchell wisely limits his study to a few major creators and works so that he can deal with the interplay of theme and formal devices with the depth and complexity required for this kind of analysis. Yet, it is questionable whether the patterns to be found in, e.g., *Shane, Hondo,* and *High Noon* are fully representative of the enormous variety of Westerns created

during that particularly rich period of the 1940s, 1950s, and 1960s. Moreover, while it is clear that gender is a key element of the Western, we now need to see how Mitchell's more complex analysis of the Western's construction of masculinity relates to the other issues which were an important part of the Western tradition. For though we now see how many things can be understood through the mirror of gender politics, a concentration on this single aspect of Westerns can become as distorting and limited as the Western itself can be in its treatment of the relationship between the sexes.

As our new self-consciousness about gender inequality and sexism makes the Western's construction and celebration of masculinity increasingly problematic, our new awareness of the centrality of racism to American culture is still another source of moral ambiguity which haunts the traditional Western formula. Long before the publication of *The Six-Gun Mystique,* historians like Philip Durham and Everett Jones challenged the lily-white Anglo-Saxon version of Western mythology by pointing out how important Blacks and Latinos were in the development of the West. In addition, generations of dedicated anthropologists have increasingly set before the public their sense of the richness of Native American cultures in contrast to the simplistic versions of noble and violent savages which continued to dominate the mythology of the West. Especially important was the new perception of Native Americans, Blacks, and Latinos as something other than pathetic victims or evil resisters to the advance of White pioneers.

By the mid 1970s, the Civil Rights movement and the Native American movement it inspired had a considerable impact on the consciousness of the White public. African Americans, Latinos, and Native Americans developed their own spokespersons and perspectives about the history of American culture. While emergent Black and Latino perspectives have influenced all of American culture, the self-awareness of Native Americans has been particularly significant in our perception of Western history and myth. Writers like Vine Deloria, N. Scott Momaday, Leslie Silko, James Welch, Louise Erdrich, and Gerald Vizenor led a great flourishing of literature by Native Americans. This, along with the revisionist work in Native American history of white historians like Alvin Josephy and Dee Brown, have transformed our perception of the relationship between Indians and pioneers in the West. Books like Brown's *Bury My Heart at Wounded Knee,* a striking 1971 bestseller, Scott Momaday's *The Way to Rainy Mountain,* and Leslie Silko's *Almanac of the Dead* presented the history of the West from a Native American point of view. Reprinted masterpieces, like John G. Neihardt's *Black Elk Speaks* and the Native American photographs of Edward

Curtis further added dimension and complexity to our understanding of the West. Many of these threads came together in a highly successful 1996 television series on the West produced by Ken Burns. This series dramatized the new Western history and the new perception of Native Americans. Significantly, the dean of Native American Literature, Scott Momaday, was one of the major spokesmen used by Burns in his series.

4. The Western from the Late Eighties to the Present

There have been occasional flurries of Western production, such as the period in the early 1990s which produced *Dances with Wolves, Unforgiven, Geronimo, Tombstone, Wyatt Earp,* and a few others, but Westerns on television and in film have been infrequent in the last two decades of the twentieth century. While there remains an audience for new paperback Westerns and for reprints of established Western writers like Grey and L'Amour, this is a small and rather special segment of the larger public. On the popular level, other genres, like the action movie, the mystery, the horror film, various kinds of science fiction, and the popular romance have become increasingly important. Westerns constitute a very small proportion of film and television production, and in the area of popular publishing, romances and detective stories vastly outnumber new literary Westerns.

However, as is often the case, when an artistic movement begins to decline, criticism seems to flourish as if the energies that once went into the production of an art form become devoted to its interpretation and celebration. The last ten years have been particularly rich in the publication of criticism of the Western, not only by American, but significantly by British and French scholars, reflecting the international influence of the genre. (See the bibliography of Western criticism in the last ten years at the end of this volume.)

The approaches taken by this flourishing variety of Western critics are extremely diverse. We've already commented on several of the many contemporary discussions of gender and race in the Western, for example. The work of Tompkins, Mitchell, and others along with the large number of critics of the treatment of Native Americans, Chicanos, and African Americans in Westerns suggest that the areas of gender and race will continue to be important in future treatments of the genre. There has also been something of a revival of ethical criticism in the Western as exemplified in the studies of Peter French and Scott Emmert. Excellent encyclopedias and guides to the Western have appeared, most notably the work of British scholars like Ed Buscombe's *British Film Institute Companion to the Western,* Phil Hardy's encyclopedia of the Western, and Christopher Frayling's study of Italian and other European Westerns.

Further explorations of the Western need to analyze how it relates to other important aspects of modern American culture. One such area is that of modernization itself. In celebrating a hero who is the very symbol of a bygone agricultural and pastoral way of life, the Western raises the question of its significance as a popular genre in a society increasingly dominated by technology, industrialism, and large corporate organizations. Slotkin has a good deal to say about the use of Western mythology as rhetorical justification for corporate capitalism and imperialism. Marcus Klein takes still another approach to the relationship of the Western to modernization in *Easterns, Westerns, and Private Eyes*. He argues that the Western as well as two other turn-of-the-century genres, the Horatio Alger "rags-to-riches" story and the American detective story were literary reactions to modernism. Moreover, he thinks the three-story types developed in a sort of chronological sequence as successive reactions to the modernization of American culture. As Klein puts it:

From a distance . . . and regarding the three together, it might even be seen that they also have a serial nature and comprise a nice allegory for our times. Properly read . . . the tale Rags-to-Riches, in the Horatio Alger version, is assault from below and is not a celebration but an expose of the pretensions of the systems of wealth now in America. It celebrates the anarchic energies pitted against the systems of Business. The Western in its turn is also an effort to cancel the modern moment, by law and arms. It would reimpose social hierarchies, at the beginning directly and not infrequently on the part of authors who consider that they are the dispossessed. And the tale of the Private Eye might then be seen to record the failure all around, of both the street boys of Lower Manhattan and the cowboys of Medicine Bow. Sly subversion doesn't work, nor does armed suppression, and what is left is a disengagement, which in its turn is so absolute as to constitute a style. (7)

There are some serious problems with this thesis, but nevertheless Klein does a interesting job in treating that important moment in the Western tradition exemplified by the Western writing of Theodore Roosevelt and in Wister's *The Virginian*. Here, Klein draws heavily on G. Edward White's *The Eastern Establishment and the Western Experience*. His argument is that the modern Western grew out of the reaction of American aristocrats like Roosevelt and Wister who felt displaced by the new social and economic trends of modern America. They thus projected into their imagined West a regenerated Anglo-Saxon aristocracy: "if the West was not invented in its entirety by the members of an elite social class, the story did anyway almost invariably encounter the question of proper, rightful social authority" (75).

This approach can be applied to Owen Wister, who certainly felt himself to be a displaced aristocrat, and it leads to some insightful discussion about the role of social proprieties in *The Virginian*. However, displaced aristocracy is not the only thing to be said about *The Virginian*, as Jane Tompkins shows in her interesting analysis of the book as a reflection of Wister's problems with women. Even more important, Wister was not the only writer of Westerns in the early twentieth century. Emerson Hough, Harold Bell Wright, Zane Grey, and Clarence Mulford are only a few of Wister contemporaries and followers who do not entirely share Wister's elitist views. Also, though Roosevelt and Wister's aristocratic and racist view of the West had considerable influence, Klein seems to forget that another contemporaneous historian, Frederick Jackson Turner, had an enormous influence on the concept of the West. Turner was far less interested in the West as a potential arena for the regeneration of American aristocracy than he was on its influence on the values of democracy, individualism, and nationalism.

Klein makes a very interesting attempt to provide us with a single contextual explanation for three very complex American popular genres—the rags-to-riches story, the Western, and the hard-boiled detective story. While this approach does produce some interesting commentary on three popular genres and their cultural and literary backgrounds, the case for treating these genres together depends on our accepting a general thesis about them that is not at all persuasive. Most contemporary analysts of popular culture would question whether such complex popular forms as the Western and the hard-boiled detective story can be understood in terms of any single set of themes or allegories. While Klein's treatment of individual authors and works is often insightful and interesting, his discussion of the genres, themselves, and the weakness of the theoretical and methodological aspects of his study are problematic and lead to what seems to be oversimplified and distorted interpretations.

As these many different studies of the Western indicate, the problem of context is very complex and can easily be oversimplified. In any case, this variety of studies indicates that we have fairly conclusively put to rest the overly moralistic and simpleminded social, political, and cultural interpretations that once limited the study of popular culture. What we now need are more complex contextual studies adapting and improving on the analytical methods developed by such studies as those we have reviewed here.

Another area is greatly in need of further study. Though the Western may no longer be the major American genre it was in the 1950s and 1960s, it has increasingly become a significant international genre.

Indeed, as we observed at the end of chapter four, the myth of the West was initially created by Europeans and even in the nineteenth century, versions of the Western by European authors like the German Karl May and the French Gustave Aimard were highly popular in those countries. More recently, following the enormous international success in film of the Spaghetti Westerns, the genre has developed a new international appeal. While a few scholars like Christopher Frayling have dealt insightfully with this phenomenon, much remains to be studied.

One recent book suggests several interesting approaches to the internationalization of the West. *Les Hauts et Les Bas de L'Imaginaire Western* is a fascinating collection of essays by French Canadian scholars, largely from universities in Montreal and Quebec City, where an inter-university research group has developed a very important program of research and publication in popular culture studies. The most interesting aspects of the book are its studies of the relationship between the mythical traditions of the American Western and the way in which these traditions have become involved in significant artistic and cultural interplay with other popular genres, like the romance, with other cultural forms, such as "Country and Western" music, and with other cultural traditions. In short, these are important contributions to the analysis of the internationalization of popular genres and of the various forms of cultural exchange that have been influenced by the myth of the Western.

The key concept of this excellent collection is the "deterritorialization" of the Western. The term is an interesting way to describe the transnational use of the "genre états-unien par excellence" (13). The authors analyze the use of Western myths, symbols, themes, and motifs in such diverse forms as French Canadian country music, international advertising, Indian romances, Franco-Belgian comic books, and Western novels published in France by both American and French writers. They also suggest a number of new ways of dealing with what happens to the Western as it is increasingly separated from the history and the territory which originally inspired it.

For example, in his study of Western novels in France, Paul Bleton suggests a useful distinction between "Western" as it is now used in France to denote examples of the popular American genre imported into France and "Ouesterne," based on the French word for west. The term "Western" represents the imported culture which has played a significant role in shaping modern French popular culture, but "Ouesterne" might point to the complex strategies which French creators and audiences use to fill the cultural gaps between French and American cultures. The development of these patterns of cultural adaptation create, in effect, a new "deterritorialized" genre on the boundary between cultures. In his

survey of the different kinds of Westerns published in France over the last hundred years, Bleton begins to define this new "Ouesterne" terrain.

Julia Bettinotti and Chantal Savoie take another approach to the deterritorialization of the Western, discussing how the story of Indian captivity so basic to the traditional Western genre has, in recent years, become mixed with the increasingly popular generic romance. These have been popular enough to produce a significant new subgenre of Native American Romances which completely transform the meaning of "captivity."

Two other essays in the collection discuss the interrelationship between Western myths and themes and Country Music, both in America and in Quebec. Jean-Sébastien Dubé discusses developments in Country Music and Westerns in the 1990s that he sees as a response to an identity crisis in these related genres. Yves Claudé's essay on "Le country-western au Quebec" is particularly complex in dealing with the intersections between American Westerns, Country music and the folkloric traditions of Quebec. According to his analysis, the mythic Western figure of the cowboy, mediated through American country music, has become an important symbolic representative of a displaced rural proletariat in modern urban Quebec culture.

The essays in "Les Hauts et Les Bas" interestingly define several different forms of "deterritorialization": transformation through movement from one culture into a very different context; transformation through generic intermingling; and transformation through movement between classes and across the boundaries between urban and rural cultures. In all these cases, a significant shifting in context implies important differences in the meanings constructed around established motifs, myths, and themes. These analyses are highly suggestive and many of these ideas could be imaginatively applied to similar transformations of subcultures and genres in the evolution of American popular culture. The work in popular culture of these French Canadian scholars is impressive and deserves to be better known by American students of popular culture

5. As the Thundering Hoofbeats Recede into the Distance

"I've seen the Western declared dead three times during my writing career, but it always seems to come back." (qtd. in Emmert 11)

—Don Coldsmith (1994)

In spite of the relative dearth of new Western productions, audiences clearly continue to enjoy old Westerns on television. As of this writing the cable channel Movieplex shows one full day of old Westerns

each week while other channels frequently rerun the most popular older Westerns of John Wayne. Yet, this suggests that the Western has become a backward-looking genre steeped in nostalia. Significant new creations in the genre seem increasingly rare. For example, the only new Western television series announced for 1998 was based on the 1960 film *The Magnificent Seven,* which was in turn a takeoff on Akira Kurowawa's 1954 *Seven Samurai.* The future seems rather dim for further revitalization of the traditional Western genre. Certainly, the cinematic and artistic possibilities of Western formal and thematic conventions will continue to attract occasional writers and producers of film and television. This probably will result in occasional flurries of Western production like those which marked the early 1990s. In addition, the "Post-Western" use of myths and symbolism will doubtless continue to be a feature of American films and even those of other countries. However, though I would be delighted to be wrong about this, it seems doubtful that the Western will ever regain its place as the major American popular genre and myth.

Lee Clark Mitchell has wisely warned us that the Western has often been pronounced dead only to rise again, but Richard Slotkin's insight that America desperately needs a new set of myths seems more likely to be an important factor in the future. However, it is true that the Western once degenerated into the simplicities of the dime novel and was revitalized at the end of the nineteenth century by writers like Owen Wister, Emerson Hough, and Harold Bell Wright, and by the development of the Western film. Then after another dearth of serious Western films in the 1930s, the genre exploded into its golden age in the 1940s and 1950s. Even the Lone Ranger has recently ridden again, though not very successfully. So, let us not give up hope that we may hear, sometime again, out of the past, the thundering hoofbeats of the great horse Silver.

BIBLIOGRAPHIES AND FILMOGRAPHIES

Books
Works Cited in Chapters One through Five

Bleton, Paul, and Richard Saint-Germain. *Les Hauts et Les Bas de L'Imaginaire Western*. Montreal: Tryptique, 1997.

Buscombe, Ed, ed. *The BFI Guide to Westerns*. London: Athanaeum, 1988.

Cawelti, John. *The Six-Gun Mystique*. Bowling Green, OH: Bowling Green State University Popular Press, 1970.

Cooper, James Fenimore. *The American Democrat*. New York: Vintage, 1956.

——. *The Deerslayer*. Boston: Estes, 1909.

——. *The Last of the Mohicans*. New York: Putnam's, 1896.

——. *The Pioneers*. New York: Putnam's, 1896.

——. *The Prairie*. New York: Putnam's, 1896.

Davis, David Brion. "Tem-Gallon Hero." *The American Experience* by Hennig Cohen, ed. Boston: Houghton Mifflin, 1968.

Davis, Robert Murray. *Playing Cowboys: Low Culture and High Art in the Western*. Norman, OK: U of Oklahoma P, 1992.

"Don't Tread On Me: An Inside Look at the West's Growing Rebellion." *Time* 23 Oct. 1995: 52-71.

Eliade, Mircea. *Myth and Reality*. New York: Harper and Row, 1963.

Elkin, Frederick. "The Psychological Appeal of the Hollywood Western." *The Journal of Educational Psychology* 24 (Oct. 1950).

Emmert, Scott D. *Loaded Fictions: Social Critique in the Twentieth Century Western*. Moscow, ID: U of Idaho P, 1966.

Fiedler, Leslie. *Love and Death in the American Novel*. New York: Stein and Day, 1966.

French, Peter A. *Cowboy Metaphysics: Ethics and Death in Westerns*. Lanham, MD: Rowman and Littlefield, 1997.

French, Philip. *Westerns: Aspects of a Movie Genre*. New York: Oxford UP, 1977.

Frye, Northrop. *Anatomy of Criticism*. Princeton: Princeton UP, 1957.

Fussell, Edwin. *Frontier: American Literature and the American West*. Princeton, NJ: Princeton UP, 1965.

Grey, Zane. *Code of the West*. 1934. New York: Pocket, 1963.

——. *Riders of the Purple Sage*. New York: Grosset and Dunlap, 1912.

——. *To the Last Man*. 1922. New York: HarperCollins, 1991.

——. *Wild Horse Mesa*. New York: Harper and Bros., 1928.

Gruber, Frank. *The Pulp Jungle.* Los Angeles: Sherbourne P, 1967.

Haskell, Molly. *From Reverence to Rape: The Treatment of Women in the Movies.* New York: Holt, Rinehart and Winston, 1974

Haycox, Ernest. *The Man in the Saddle.* New York: Dell, 1966.

Homans, Peter. "Puritanism Revisited: An Analysis of the Contemporary Screen-Image Western." *Studies in Public Communication* 3 (Summer 1961): 73-84.

Klein, Marcus. *Easterns, Westerns, and Private Eyes: American Matters, 1870-1900.* Madison: U of Wisconsin P, 1994.

Limerick, Patricia. *The Legacy of Conquest: The Unbroken Past of the American West.* New York: Norton, 1987.

McCarthy, Cormac. *All the Pretty Horses.* New York: Knopf, 1992.

McMurtry, Larry. *Horseman, Pass By.* New York: Harper, 1961.

——. *The Last Picture Show.* 1966. New York: Pocket, 1992.

Mitchell, Lee Clark. *Westerns: Making the Man in Fiction and Film.* Chicago: U of Chicago P, 1996.

Munden, Kenneth J. "A Contribution to the Psychological Understanding of the Cowboy and His Myth." *The American Imago* 15.2 (Summer 1958).

Nabokov, Vladimir. *The Annotated Lolita.* Ed. Alfred Appel. New York: McGraw-Hill, 1970.

Nussbaum, Martin. "Sociological Symbolism in the "Adult Western.'" *Social Forces* 39 (Oct. 1960).

Pearce, Roy Harvey. *The Savages of America, A Study of the Indian and the Idea of Civilization.* Baltimore: Johns Hopkins, 1953.

Piaget, Jean. Quoted in *Mass Leisure.* Ed. Larrabee and Meyersohn. Glencoe, IL: Free P, 1958.

Prats, Armando. "Outfitting the First American: 'History,' The American Adam, and the New Hollywood Indian in *Dances with Wolves, The Last of the Mohicans,* and *Geronimo: An American Legend.*" *The Image of the American West.* Ed. Will Wright and Steven Kaplan. Pueblo, CO: U of Southern Colorado P, 1997.

Reed, Ishmael. *Yellow Back Radio Broke-Down.* New York: Athanaeum, 1968.

Ross, T. J. "Fantasy and Form in the Western: From Hart to Peckinpah. *December* 12 (Fall 1970): 158-69.

Sacks, Sheldon. "The Psychological Implications of Generic Distinctions." *Genre* 1.2 (Apr. 1968).

Schaeffer, Jack. *Shane.* 1949. New York: Bantam, 1963.

Slotkin, Richard. *Gunfighter Nation: The Myth of the Frontier in Twentieth Century America.* New York: Athanaeum, 1992.

Smith, Henry Nash. *Virgin Land.* New York: Vintage, n.d.

Tompkins, Jane. *West of Everything: The Inner Life of Westerns.* New York: Oxford, 1992.

Warshow, Robert. *The Immediate Experience.* Garden City: Doubleday, 1964.

White, G. Edward. *The Eastern Establishment and the Western Experience.* New Haven: Yale UP, 1968.

Wister, Owen. "The Evolution of the Cowpuncher." *Red Men and White.* vol. VI of *The Writings of Owen Wister.* New York: Macmillan, 1928.

——. *The Virginian.* Ed. John Seelye. New York: Viking Penguin, 1988.

Zoglin, Richard. "Return from Boot Hill." Time 15 Nov. 1993: 90-95.

A Basic Library of Books about the Western and the Myth of the West

Berkhofer, Robert. *The White Man's Indian: The History of an Idea from Columbus to the Present.* New York: Knopf, 1978.

> Berkhofer's work is an important early analysis of the "idea of the Indian" and its influence on the "White imagination" and "White policy." The study examines the foundation and construction of stereotypes of the Indian and illustrates how these stereotypes shaped U.S. government policy.

Billington, Ray Allen.*Westward Expansion: A History of the American Frontier.* 5th ed. New York: Macmillan, 1982.

> One of the most distinguished historians of the West of his generation, Billington has also written insightfully about the Turner thesis and the myth of the West. *Westward Expansion* is the most thorough and detailed western histories from the traditional perspective.

Bold, Christine. *Selling the Wild West: Popular Western Fiction, 1860 to 1960.* Bloomington: Indiana UP, 1987.

> The Western film has been much more fully and carefully studied than the Western novel. Bold's book is one of the first to treat the popular tradition of Western fiction in a complex fashion.

Buscombe, Ed, ed. *The BFI Guide to Westerns.* London: Athanaeum, 1988.

> By far the best of the many guides to the Western. In addition to extensive treatment of Western films, directors and stars, Buscombe's guide is also a mine of information on western culture and history.

Dippie, Brian W. *Custer's Last Stand: The Anatomy of an American Myth.* (Reprint) Lincoln, NE: U of Nebraska P, 1994.

> The most reliable recent study of the Custer Battle, one of the major episodes of the Western saga. Compare the analysis in Rosenberg, *Custer and the Epic of Defeat.*

——. *The Vanishing American: White Attitudes and U.S. Indian Policy.* Lawrence: UP of Kansas, 1982.

> Examines the "anatomy" of the image of the Indian as a "Vanishing American" and the impact of this particular stereotype on U.S. government policy.

Drinnon, Richard. *Facing West: The Metaphysics of Indian-Hating and Empire-Building.* Minneapolis: U of Minnesota P, 1980.

 Drinnon's work analyzes the role played by stereotyping of the Indian in establishing a sense of nationhood. In addition, Drinnon examines the connection between "Indian-hating" and U.S. foreign policy.

Etulain, Richard and Michael Marsden, eds. *The Popular Western: Essays Toward a Definition.* Bowling Green, OH: Bowling Green State University Popular Press, 1974.

 An excellent anthology representing several different critical theories and approaches to the Western.

Etulain, Richard W., and N. Jill Howard, eds. *A Bbiliographical Guide to the Study of Western American Literature.* Albuquerque, NM: U of New Mexico P, 1995.

The most current and useful bibliography in this area.

Fenin, George, and William K. Everson. *The Western, From Silents to the Seventies.* A new and expanded ed. New York: Grossman, 1973.

 One of the first histories of the Western, Fenin and Everson's work has been a standard account of the Western film since its first publication in 1962.

Fiedler, Leslie. *The Return of the Vanishing American.* New York: Stein and Day, 1968.

 A delightful and insightful study of the influence of the myth of the West on the youth "movement" of the 1960s. Foreshadows some of the major changes that the Western will undergo in the 1970s and 1980s and suggests some of the important aspects of the Post-Western.

Frayling, Christopher. *Spaghetti Westerns: Cowboys and Europeans from Karl May to Sergio Leone.* London: Routledge and Kegan Paul, 1981.

 A fine study of European versions of the Western with special emphasis on Sergio Leone and his four major Western films.

French, Philip. *Westerns: Aspects of a Movie Genre.* New York: Oxford, 1977.

 Very important early critical study of the Western film from an artistic perspective.

Gallagher, Tag. *John Ford.* Berkeley: U of California P, 1986, and Seydor, Paul with foreword by David Weddle. *Peckinpah: The Western Films: A Reconsideration.* Urbana: U of Illinois P, 1997.

 Two studies of particular film directors especially important for their impact on the Western.

Hamilton, Cynthia. *Western and Hard-boiled Detective Fiction in America: From High Noon to Midnight.* Iowa City: U of Iowa P, 1987.

 Analyzes the interesting interplay between two important American popular genres. Shows how the Western is related to larger American cultural and artistic patterns.

Hardy, Phil. *The Western: A Film Encyclopedia*. New York: Morrow, 1983.
> After Buscombe's *BFI Guide*, this is the best general guide to Western films.

Kitses. Jim. *Horizons West: Anthony Mann, Budd Boetticher, Sam Peckinpah: Studies of Authorship within the Western*. Bloomington: Indiana UP, 1969.
> Important work analyzing the relationship between directors and the Western genre.

Lamar, Howard, ed. *The Reader's Encyclopedia of the American West*. New York: Crowell, 1977.
> Massive compendium of information on the West.

Limerick, Patricia Nelson. *The Legacy of Conquest: The Unbroken Past of the American West*. New York: Norton, 1987.
> The best-known western history from a perspective stressing multiculturalism. Contains an impotant basic critique of the Turner thesis. See also: White, Richard. *"It's Your Misfortune and None of my Own": A History of the American West*. Norman: U of Oklahoma P, 1991.

Lyon, Thomas J. et. al. Western Literature Association. *Updating the Literary West*. Fort Worth, TX: Texas Christian UP, 1997.
> This volume is a sort of sequel to the important earlier collective history edited by J. Golden Taylor, *The Literary History of the American West*. Fort Worth, TX: Texas Christian UP, 1987. However, unlike the earlier volume which has relatively little material on the popular western, this book has a very useful section on that subject edited by Christine Bold and including articles on film, on westerns by women and Native Americans, on the popular West in Latin American and Chicano literature and on major writers in the popular tradition like Zane Grey and Louis L'Amour. Lee Mitchell's essay on contemporary critical theory and the western is also very suggestive.

Mitchell, Lee Clark. *Westerns: Making the Man in Fiction and Film*. Chicago: U of Chicago P, 1996.
> A fine critical study of the evolution of images of masculinity as reflected in the development of the Western.

Rosenberg, Bruce. *Custer and the Epic of Defeat*. University Park: Pennsylvania State UP, 1974.
> An important study that shows the extent to which the great Western legend of Custer's defeat was shaped by age-old archetypal traditions going back to Biblical accounts of similar heroic defeats

Slotkin, Richard. *Gunfighter Nation: The Myth of the Frontier in Twentieth Century America*. New York: Atheneum, 1992. *Regeneration through Violence: The Mythology of the American Frontier, 1600-1860*. Middletown, CT: Wesleyan UP, 1973. *The Fatal Environment: The Myth of Frontier in the Age of Industrialization, 1800-1890*. New York: Atheneum, 1985.

The definitive work on the history of the myth of the West.

Smith, Henry Nash. *Virgin Land: The American West as Symbol and Myth.* Cambridge: Harvard UP, 1950.

The classic study which applied the myth-symbol method to the study of images of the West. Though his account of the twentieth-century Western is very limited, Smith's study of the myth of the West in the nineteenth century was brilliant and greatly influenced Slotkin's study of the frontier myth and most other recent studies of the West as myth.

Steckmesser, Kent Ladd. *The Western Hero in History and Legend.* 1965. Norman U of Oklahoma P, 1997.

A basic study of the way in which history is transformed into legend.

Tatum, Steve. *Inventing Billy the Kid: Visions of the Outlaw in America, 1881-1981.* Albuquerque: U of New Mexico P, 1982.

An insightful study of how the legend of Billy the Kid developed.

Tompkins, Jane. *West of Everything: The Inner Life of Westerns.* New York: Oxford, 1992.

Analysis of the Western from a feminist perspective. Highly critical though insightful about the attractions of certain Western writers and films.

Turner, Frederick Jackson. *The Significance of the Frontier in American History.* New York: Holt, 1947.

The original work which defined the western experience as a major topic of American history and a central theme in American culture.

Tuska, Jon. *The Filming of the West.* Garden City: Doubleday, 1985.

Production histories of a great many Western films along with much useful information about the making of Westerns.

Wright, Will. *Six Guns and Society: A Structural Study of the Western.* Berkeley: U of California P, 1975.

Study of changes in the Western film employing the sociological methodology of content analysis.

Yoggy, Gary. *Riding the Video Range: The Rise and Fall of the Television Western.* Jefferson, NC and London: McFarland, 1995.

By far the best and most thorough study of TV Westerns. For a more thematic approach see also Ralph Brauer, with Donna Brauer. *The Horse, the Gun and the Piece of Property: Changing Images of the TV Western.* Bowling Green, OH: Bowling Green State University Popular P, 1975.

Major Guides to the Western

Andreychuk, Ed. *The Golden Corral: A Roundup of Magnificent Western Films.* Jefferson, NC: McFarland, 1997.

Bellour, Raymond, and Brion, Patrick, eds. *Le Western: Sources-Themes-Mythologies-Auteurs-Acteurs-Filmographies.* Paris: Union Generale d'editions, 1966.

Buscombe, Ed, ed. *The BFI Guide to Westerns.* London: Athanaeum, 1988.

Erisman, Fred, and Richard Etulain, eds. *Fifty Western Writers: A Bio-Bibliographical Source.* Westport, CT: Greenwood, 1982.

Etulain, Richard W., and N. Jill Howard, eds. *A Bbiliographical Guide to the Study of Western American Literature.* Albuquerque, NM: U of New Mexico P, 1995

Everson, William K. *Hollywood Western: Ninety Years of Cowboys & Indians, Train Robbers, Sheriffs & Gunslingers.* Secaucus, NJ: Carol, 1991.

Eyles, Allan. *The Western: An Illustrated Guide.* London: Zwemmer, 1967.

Garfield, Brian. *Western Films: A Complete Guide.* 1982. New York: Da Capo, 1988.

Hardy, Phil. *The Overlook Film Encyclopedia: The Western.* New York: Overlook P, 1995.

——. *The Western. Film Encyclopedia* 1. New York: Morrow, 1983.

Jackson, Ronald. *Classic TV Westerns: A Pictorial History.* New York: Citadel P, 1994.

Langman, Larry. *A Guide to Silent Westerns.* Westport, CT: Greenwood, 1992.

Miller, Don, et al. *The Hollywood Corral: A Comprehensive B-Western Roundup.* Burbank: Riverwood, 1992.

Nachbar, John G. *Western Films: An Annotated Critical Bibliography.* New York: Garland, 1975.

Nachbar, John G., Jackie R. Donath, and Chris Foran. *Western Films 2: An Annotated Critical Bibliography from 1974 to 1987.* New York: Garland, 1988.

Parish, James Robert, and Michael R. Pitts. *The Great Western Pictures II.* Metuchen: Scarecrow, 1988.

Pitts, Michael R. *Western Movies: A TV and Video Guide to 4200 Genre Films.* Jefferson, NC: McFarland, 1986.

Rieupeyrout, Jean-Louis. *La Grande Aventure du Western: du Far West a Hollywood.* Paris: Les Edition du Cerf, 1964.

Sarf, Wayne M. *God Bless You, Buffalo Bill; A Layman's Guide to Hitory and the Western Film.* Cranbury, NJ: Farleigh Dickinson UP, 1983.

Thomas, Tony. *The West That Never Was.* Secaucus: Carol, 1989.

Tuska, Jon. *The Frontier Experience: A Reader's Guide to the Life and Literature of the American West.* Jefferson, NC: McFarland, 1984.

Tuska, Jon, and Vicki Piekarski, eds. *Encyclopedia of Frontier and Western Fiction.* New York: McGraw-Hill, 1983.

Westbrook, Max (Pref.), and James H. Maguire (Intro.). *A Literary History of the American West.* Fort Worth: Texas Christian UP, 1987.

Western Literature Association. *Updating the Literary West.* Forth Worth, TX: Texas Christian UP, 1997.

Wilkinson, Charles F. *The American West: A Narrative Bibliography and a Study in Regionalism.* Niwot, CO: UP of Colorado, 1989.

Yates, Norris W. *Gender and Genre: An Introducton to Women Writers of Formula Westerns, 1900-1950.* Albuquerque: U of New Mexico P, 1995.

Yoggy, Gary. *Riding the Western Range: The Rise and Fall of the Western on Television.* Jefferson, NC: McFarland, 1996.

Your Movie Guide to Western Video Tapes and Discs. New York: Signet, 1985.

Important Books of the Last Ten Years

Allmendinger, Blake. *The Cowboy: Representations of Labor in an American Work Culture.* New York: Oxford, 1995.

Aquila, Richard, ed. *Wanted Dead or Alive: The American West in Popular Culture.* Urbana: U of Illinois P, 1996.

Bleton, Paul, ed. *Les Hauts et Les Bas de l'imaginaire Western.* Montreal: Tryptique, 1997.

Bold, Christine. *Selling the Wild West: Popular Western Fiction: 1860-1960.* Bloomington: Indiana P, 1987.

Busby, Mark. *Larry McMurtry and the West: An Ambivalent Relationship.* Denton: U of North Texas P, 1995.

Buscombe, Ed, ed. *TheBFI Guide to Westerns.* London: Athanaeum, 1988.

Cameron, Ian, and Douglas Pye, eds. *The Book of Westerns.* Continuum: New York, 1996.

Coyne, Michael. *The Crowded Prairie: American National Identity in the Hollywood Western.* London: Tauris, 1997.

Darby, William. *John Ford's Westerns: A Thematic Analysis, with a Filmography.* Jefferson, NC: Mc Farland, 1996.

Davis, Robert Murray. *Playing Cowboys: Low Culture and High Art in the Western.* Norman: U of Oklahoma P, 1992.

Dippie, Brian W. *Custer's Last Stand: The Anatomy of an American Myth.* (Reprint) Lincoln: U of Nebraska P, 1994.

Doyle, Michael. *American West on Film: The Agrarian Frontier.* Dubuque: Kendall-Hunt, 1996.

Emert, Scott D. *Loaded Fictions: Social Critique in the 20th Century Western.* Moscow, ID: U of Idaho P, 1996.

Engel, Leonard, ed. *The Big Empty: Essay on Western Landscapes As Narrative.* Albuquerque: U of New Mexico P, 1994.

Etulain, Richard. *Reimaging the Modern American West: A Century of Fiction, History and Art.* Tucson: U of Arizona P, 1996.

Etulain, Richard W., and N. Jill Howard, eds. *A Bibliographical Guide to the Study of Western American Literature.* Albuquerque: U of New Mexico P, 1995.

Everson, William K. *The Hollywood Western: 90 Years of Cowboys and Indians, Train Robbers, Sheriffs and Gunslingers, and Assorted Heroes and Desperadoes.* Secaucus, NJ: Citadel, 1992.

French, Peter A. *Cowboy Metaphysics: Ethics and Death in Westerns.* Lanham, MD: Rowman and Littlefield, 1997.

Hardy, Phil. *The Western.* New York: Morrow, 1983.

Jackson, Ronald. *Classic TV Westerns: A Pictorial History.* New York: Citadel P, 1994.

Johnson, Michael L. *New Westers: the West in Contemporary American Culture.* Lawrence: UP of Kansas, 1996.

Klein, Marcus. *Easterns, Westerns, and Private Eyes: American Matters, 1870-1900.* Madison: U of Wisconsin P, 1994.

Kowalewski, Michael, ed. *Reading the West: New Essays on the Literature of the American West.* New York: Cambridge UP, 1996.

Langman, Larry. *A Guide to Silent Westerns.* Wesport, CT: Greenwood, 1992.

Limerick, Patricia Nelson. *The Legacy of Conquest: The Unbroken Past of the American West.* New York: Norton, 1987.

Meldrum, Barbara Howard, ed. *Old West-New West: Centennial Essays.* Moscow: U of Idaho P, 1993.

Mitchell, Lee Clark. *Westerns: Making the Man in Fiction and Film.* Chicago: U of Chicago P, 1996.

Parks, Rita. *The Western Hero in Film and Television; Mass Media Mythology.* Ann Arbor: UMI Research P, 1988.

Powers, Meredith A. *The Heroine in Western Literature: The Archetype and Her Reemergence in Modern Prose.* Jefferson, NC: McFarland, 1991.

Rainey, Buck. *The Reel Cowboy: Essays on the Myth in Movies and Literature.* Jefferson, NC: McFraland, 1996.

Robinson, Forrest G. *Having It Both Ways: Self-Subversion in Western Popular Classics.* Albuquerque: U of New Mexico P, 1993.

Seydor, Paul. *Peckinpah: The Western Films: A Reconsideration.* Urbana: U of Illinois P, 1997.

Short, John Rennie. *Imagined Country: Environment, Cultue, and Society.* London: Routledge, 1991.

Simonson, Harold Peter. *Beyond the Frontier: Writers, Western Regionalism and a Sense of Place.* Fort Worth: Texas Christian UP, 1989.

Slotkin, Richard. *Gunfighter Nation: The Myth of the Frontier in Twentieth Century America.* New York: Atheneum, 1992.

Taylor, J. Golden, and Thomas J. Lyon, eds. *A Literary History of the American West.* Fort Worth: Texas Christian UP, 1987.

Thomas, Tony. *The West That Never Was.* Secaucus: Carol, 1989.

Tompkins, Jane. *West of Everything: The Inner Life of Westerns.* New York: Oxford, 1992.

Weisser, Thomas. *Spaghetti Westerns-The Good, the Bad, and the Violent: A Comprehensive, Illustrated Filmography of 558 Eurowesterns and the Personnel, 1961-1977.* New York: Jefferson, NC: McFarland, 1992.

Welch, James, with Paul Stekler. *Killing Custer: The Battle of the Little Bighorn and the Fate of the Plains Indians.* New York: Norton, 1994.

Western Literature Association. *Updating the Literary West.* Forth Worth, TX: Texas Christian UP, 1997.

Worster, Donald. *Under Western Skies: Nature and History in the American West.* New York: Oxford, 1992.

Yates, Norris W. *Gender and Genre: An Introducton to Women Writers of Formula Westerns, 1900-1950.* Albuquerque, NM: U of New Mexico P, 1995.

Yoggy, Gary. *Riding the Western Range: The Rise and Fall of the Western on Television.* Jefferson, NC: McFarland, 1996

The New Western History: Some Central Texts

Etulain, Richard W. *Re-imagining the Modern American West: A Century of Fiction, History and Art.* Tucson: U of Arizona P, 1996.

Limerick, Patricia Nelson, *The Legacy of Conquest: The Unbroken Past of the American West.* New York: Norton, 1987.

Malone, Michael P. *Historians and the American West.* Lincoln: U of Nebraska P, 1983.

Malone, Michael P., and Richard W. Etulain. *The American West: A Twentieth Century History.* Lincoln: U of Nebraska P, 1989.

Milner, Clyde A., ed. *A New Significance: Re-envisioning the History of the American West.* New York: Oxford UP, 1996.

Prown, Jules David. *Discovered Lands, Invented Pasts: Transforming Visions of the American West.* New Haven: Yale UP, 1992.

White, Richard. *"It's Your Misfortune and None of My Own": A History of the American West.* Norman: U of Oklahoma P, 1991.

Wiley, Peter, and Robert Gottlieb. *Empires in the Sun: The Rise of the New American West.* New York: Putnam, 1982.

Worster, Donald. *Under Western Skies: Nature and History in the American West.* New York: Oxford UP, 1994.

Violence and the Western, Peckinpah and Spaghetti Westerns: A Sampling of Criticism on a Specific Theme
General

Alloway, Lawrence. *Violent America: The Movies 1946-1964.* New York: Museum of Modern Art, 1971.

Beale, Lewis. "The American Way West." *Films and Filming* 18 (Apr. 1972): 24-30.

Blount, Trevor. "Violence in the Western." *Kinema* 3 (Autumn 1971): 14-19.

Blum, William. "Toward a Cinema of Cruelty." *Cinema Journal* 10 (Spring 1971): 19-33.

Cawelti, John G. "Myths of Violence in American Popular Culture." *Critical Inquiry* 1.3 (Mar. 1975): 521-41.

Marsden, Michael T. "Savior in the Saddle: The Sagebrush Testament." *Illinois Quarterly* 36 (Dec. 1973): 5-15.

Maynell, Jennifer. "Values and Violence: A Study of the Films of Clint Eastwood." *Journal of Moral Education* 7 (Jan. 1978): 109-13.

McKinney, Devin. "Violence: the Strong and the Weak." *Film Quarterly* 46.4 (1993): 16-22.

Pechter, William S. "Anti-Western." *Twenty-four Times a Second.* New York: Harper and Row, 1971. 91-96.

Ross, T. J. "Fantasy and Form in the Western: From Hart to Peckinpah." *December* 12 (Fall 1970): 158-69.

Tibbetts, John C. "Clint Eastwood and the Machinery of Violence." *Literature Film Quarterly* 21.1 (1993): 10-17.

Peckinpah and The Wild Bunch

Adam-Smith, C. "*The Wild Bunch.*" *Movie Maker* 19 (Mar. 1985): 43-45.

Alleva, R. "Nihilism on Horseback." *Commonweal* 122 (Apr. 1995): 17-18. *Review of 1994 restored version of film.

Andrews, N. "Sam Peckinpah: The Survivor and the Individual." *Sight and Sound* 42.2 (1973): 69-74.

Armes, Roy. "Peckinpah and the Changing West." *London Magazine* 9 (Mar. 1970): 101-06.

Butler, Terence. *Crucified Heroes: The Films of Sam Peckinpah.* London: Fraser, 1979.

Byrd, L. "*The Wild Bunch.*" *Classic Images* 155 (May 1988): 32-33.

Cook, David A. "*The Wild Bunch,* Fifteen Years After." *North Dakota Quarterly* 51.3 (1983): 123-30.

Engel, Leonard W. "Sam Peckinpah's Heroes: Natty Bumpo and the Myth of the Rugged Individual Still Reign." *Literature Film Quarterly* 16.1 (1988): 22-30.

——. "Space and Enclosure in Cooper and Peckinpah: Regeneration in the Open Spaces." *Journal of American Culture* 14.2 (1991): 86-93.

Evans, Max. *Sam Peckinpah, Master of Violence.* Vermillion, SD: Dakota P, 1972.

Farber, Stephen. "Peckinpah's Return." *Film Quarterly* 23.1 (Fall 1969): 2-11.

——. "*The Wild Bunch.*" *Movieline* 4 (Nov. 1992): 26-27.

Galperin, William. "History into Allegory: *The Wild Bunch* as Vietnam Movie." *Western Humanities Review* 35 (Summer 1981): 165-72.

Garfield, Brian. "*The Wild Bunch* Revisited." *Armchair Detective* 13.2 (1980): 141-44.

Girard, M. "*The Wild Bunch.*" *Sequences* 177 (Mar./Apr. 1995): 45-48.

Gomez, J. A. "Sam Peckinpah and the 'Post-Western.'" *American Classic Screen* 4 (Spring 1980): 31-34.

Graham, Allison. "The Final Go-around: Peckinpah's *Wild Bunch* at the End of the Frontier." *Mosaic: A Journal for the Interdisciplinary Study of Literature* 16.1-2 (Winter-Spring 1983): 55-70.

Holtsmark, E. B. "The Katabis Theme in Modern Cinema." *Bucknell Review* 35.1 (1991): 60-80.

Humphries, Reynold. "The Function of Mexico in Peckinpah's Films." *Jumpcut* 18 (Aug. 1978): 17-20.

Lenihan, John H. "Western Film and the American Dream: The Cinematic Frontier of Sam Peckinpah." *The Frontier Experience and the American Dream: Essays on American Literature.* Ed. Mark Busby and Paul Bryant. College Station: Texas A & M UP, 1989.

McCarty, John Alan. "Sam Peckinpah and *The Wild Bunch*." *Film Heritage* 5 (Winter 1969-70): 1-10, 32.

McKinney, Doug. *Sam Peckinpah*. Boston: Twayne, 1979.

Miller, Mark Crispin. "In Defense of Sam Peckinpah." *Film Quarterly* 28 (Spring 1975): 2-17.

Pettit, Arthur G. "Nightmare and Nostalgia: The Cinema West of Sam Peckinpah." *Western Humanities Review* 29 (Spring 1975): 105-22.

——. "The Polluted Garden: Sam Peckinpah's Double Vision of Mexico." *Southwest Review* 62 (Summer 1977).

Pilkington, William, and Don Graham, eds. *Western Movies*. Albuquerque: U of New Mexico P, 1979.

Roth, P. A. "Virtue and Violence in Peckinpah's *The Wild Bunch*." *Post Script* 7.2 (1988): 29-42.

Sanderson, J. "Identity and Distance in *The Wild Bunch*." *Classic Images* 92 (Feb. 1983): 23-25.

Seydor, Paul. *Peckinpah: The Western Films*. Urbana: U of Illinois P, 1980.

——. *Peckinpah: The Western Films: A Reconsideration*. Urbana: U of Illinois P, 1996.

Sharrett, C. "Peckinpah the Radical: *The Wild Bunch* Reconsidered." *Cineaction* 13-14 (Summer 1988): 94-100.

Shelton, R. "*The Wild Bunch*." *American Film* 14 (Apr. 1989): 18+.

Shrader, Paul. "Sam Peckinpah Going to Mexico." *Cinema* (California) 5.3 (1969): 19-25.

Simmons, Garner. *Peckinpah: A Portrait in Montage*. Austin: U of Texas P, 1982.

Simon, J. "Wild and Wilder." *National Review* 47 (Apr. 1995): 66-67. *Review of 1994 restored version of film.

Simons, John R. "The Tragedy of Love in *The Wild Bunch*." *Western Humanities Review* (Spring 1985): 1-19.

Sragow, Michael. "The Homeric Power of Peckinpah's Violence." *Atlantic Monthly* 273.6 (June 1994): 116-22.

Sturhahn, Lawrence. "'It's a Long Way from Your Heart and on the Wrong Side . . .'" *North American Review* 260 (Spring 1975): 74-80.

Strug, Cordell. "*The Wild Bunch* and the Problem of Idealist Aesthetics, or, How Long Would Peckinpah Last in Plato's Republic?" *Film Heritage* 10.2 (Winter 1974-5): 17-26.

Triggs, Jeffery Alan. "*The Wild Bunch*: Scourges or Ministers?" *New Orleans Review* 18.3 (1991): 64-69.

Weddle, D. "Dead Man's Clothes: The Making of *The Wild Bunch*." *Film Comment* 30 (May/June 1994): 44-57.

Westerbeck, C. L., Jr. "Perishable Peckinpah." *Commonweal* 98 (July 1973): 385-86.

Whitehall, Richard. "Talking with Peckinpah." *Sight and Sound* 38 (Autumn 1969): 172-75.

Spaghetti Westerns

Bondanella, Peter. *Italian Cinema: From Neo-Realism to the Present*. New York: Ungar, 1983.

Cumbow, Robert C. *Once Upon a Time: The Films of Sergio Leone*. Lanham, MD: Scarecrow, 1987.

Fox, William Price. "Wild Westerns, Italian Style." *Saturday Evening Post* 241 (6 Apr. 1968): 50-52, 54-55.

Frayling, Christopher. *Spaghetti Westerns: Cowboys and Europeans, From Karl May to Sergio Leone*. London: Routledge and Kegan Paul, 1981.

Jamieson, R. T. "Something to do with Death: A Fistful of Sergio Leone." *Film Comment* 9 (Mar.-Apr. 1973): 8-16.

Kaminsky, Stuart. "The Genre Director." *American Film Genres*. Chicago: Hall, 1985. 2nd ed. 171-224.

——. "The Grotesque West of Sergio Leone." *Take One* 3 (Jan.-Feb. 1972): 26-32.

——. "Once Upon a Time in Italy: The Italian Western Beyond Leone." *The Velvet Light Trap* 12 (Spring 1974): 31-33.

Mayne, Richard. "Adventure Playgrounds: On Spaghetti Westerns." *Encounter* 58 (Jan. 1982): 72-79.

Nichols, David. "Once Upon a Time in Italy." *Sight and Sound* 50.1 (Winter 1980-81): 46-49.

Ramonet, Ignacio. "Italian Westerns as Political Parables." *Cineaste* 15.1 (1986): 30-35.

Roth, Lane. *Film Semiotics, Metz and Leone's Trilogy*. New York: Garland, 1983.

Sarris, Andrew. "The Spaghetti Westerns." *Confessions of a Cultist: On the Cinema 1955/1969*. New York: Simon and Schuster, 1971. 386-92.

Simsolo, Noel. "Sergio Leone Talks." *Take One* 3 (Jan.-Feb. 1972): 26-32.

Staig, Lawrence, and Tony Williams. *Italian Westerns: The Opera of Violence.* London: Lorimer, 1975.

Starrs, P. F. "The Ways of Western: Mortality and Landscape in Cormac McCarthy's Novels and Sergio Leone's Films." *Wide Angle* 15.4 (1993): 62-74.

Wallington, Mike, and Chris Frayling. "The Italian Western." *Cinema* (Cambridge) 6-7 (Aug. 1970): 31-38.

Weisser, Thomas. *Spaghetti Westerns—The Good, the Bad and the Violent: A Comprehensive, Illustrated Filmography of 558 Eurowesterns and Their Personnel, 1961-1977.* Jefferson, NC: McFarland, 1992.

Women, Indians, and Ethnics in the West and the Western

Bataille, Gretchen M., and Charles L. P. Silet, eds. *Images of American Indians on Film: An Annotated Bibliography.* New York: Garland, 1985.

——. *The Pretend Indians: Images of Native Americans in the Movies.* Ames, IA: Iowa State UP, 1980.

> Bataille's and Silet's study of images of Native Americans in film is a collection of essays by various scholars of film and social imagery. The subjects include developing stereotypes, early and later images of the Indian in film, and reviews of contemporary films that include Indians as subjects. The text also includes a helpful annotated bibliography and photographic essay on Hollywood's portrayal of the American Indian.

Berkhofer, Robert F. *The White Man's Indian: The History of an Idea from Columbus to the Present.* New York: Knopf, 1978.

> Berkhofer's work is an important early analysis of the "idea of the Indian" and its influence on the "White imagination" and "White policy." The study examines the foundation and construction of stereotypes of the Indian and illustrates how these stereotypes shaped U.S. government policy.

Bernardi, Daniel, ed. *The Birth of Whiteness: Race and the Emergence of U.S. Cinema.* New Brunswick: Rutgers UP, 1996.

Bordewich, Fergus M. *Killing the White Man's Indian: Reinventing the Native American at the End of the Twentieth Century.* Garden City, NY: Doubleday, 1996.

Deloria, Philip J. *Playing Indian.* New Haven: Yale UP, 1998.

Dippie, Brian W. *The Vanishing American: White Attitudes and U.S. Indian Policy.* Lawrence: UP of Kansas, 1982.

> Examines the "anatomy" of the image of the Indian as a "Vanishing American" and the impact of this particular stereotype on U.S. government policy.

Drinnon, Richard. *Facing West: The Metaphysics of Indian-Hating and Empire-Building.* Minneapolis: U of Minnesota P, 1980.

Drinnon's work analyzes the role played by stereotyping of the Indian in establishing a sense of nationhood. In addition, Drinnon examines the connection between "Indian-hating" and U.S. foreign policy.

Friar, Ralph, and Natasha Friar. *The Only Good Indian . . . The Hollywood Gospel.* New York: Drama Book Specialist, 1972.

Chronicles the misrepresentation of Native Americans in Hollywood film and in American culture in general. Includes a useful list of non-Indian actors who have held Indian roles and an extensive list of films with Indians as subjects.

Hilger, Michael. *The American Indian in Film.* Metuchen, NJ: Scarecrow P, 1986.

A useful filmography organized chronologically from silent films through 1984.

Moses, L. G. *Wild West Shows and the Images of American Indians, 1833-1933.* Albuquerque: U of New Mexico P, 1996.

Myth of the West. Introduction by Chris Bruce; essays by Chris Bruce et. al. New York: Rizzoli; Seattle: Henry Art Museum, U of Washington, 1990.

The Native Americans: An Illustrated History. Introduction by Alvin M. Josephy, Jr. Betty Ballantine and Ian Ballintine, eds. Atlanta: Turner, 1993.

Pearce, Roy Harvey. *Savagism and Civilization: A Study of the Indians and the American Mind.* 1965. Baltimore: Johns Hopkins P, 1971.

Pioneering study that examines socially constructed notions of savagism and civilization. Analyzes how these notions or ideas have influenced images of the Indian in drama, poetry and fiction.

Prats, Armando José. "His Master's Voice(over): Revisionist Ethos and Narrative Dependence from *Broken Arrow* (1950) to *Geronimo: An Amerian Legend.*" *ANQ* 9.3 (Summer 1996): 15-29.

——, "The Image of the Other and the Other *Dances with Wolves.*" *Journal of Film and Video* (forthcoming, Summer 1998).

——, " 'Outfirsting' the First American: 'History,' the American Adam, and the Hollywood Indian in Three Recent Westerns." *Proceedings of the Society for the Interdisciplinary Study of Social Imagery.* Colorado Springs: Colorado State UP, 1996.

Prown, Jules David, et. al. *Discovered Lands: Invented Pasts: Transforming Visions of the American West.* New Haven: Yale UP, 1992.

Riley, Glenda. *Women and Indians on the Frontier, 1825-1915.* Albuquerque: U of New Mexico P, 1984.

Rollins, Peter, and John E. O'Connor, eds. *Hollywood's Indian: The Portrayal of the Native American in Film.* Lexington, KY: UP of Kentucky, 1998.

Includes essays on *Dances with Wolves, The Last of the Mohicans,* and *Pocohontas* as well as earlier films.

Sadoux, Jean-Jacques. *Racism in the Western Film from D. W. Griffith to John Ford: Indians and Blacks.* New York: Revisionist P, 1980.

Stedman, Raymond William. *Shadows of the Indians: Stereotypes in American Culture.* Norman, OK: U of Oklahoma P, 1982.

 Stedman's work examines stereotypes of Indians throughout history in advertising, photography, fiction, film, and comic strips.

Truettner, William H., ed. *The West as America: Reinterpreting Images of the Frontier, 1820-1920.* Washington, D.C.: Smithsonian Institution P, 1991.

Ward, Geoffrey C. *The West: An Illustrated History.* (Companion volume to the PBS Series *The West* by Stephen Ives, produced by Ken Burns.) Boston: Little, Brown, 1996.

Women and the West

Butler, Anne M. *Daughters of Joy, Sisters of Mercy: Prostitutes in the American West.* Urbana: U of Illinois P, 1985.

Jordan, Teresa. *Cowgirls: Women of the American West.* Lincoln: U of Nebraska P, 1992.

Lee, L. L., and Merrill Lewis. *Women, Women Writers and the West.* Troy, NY: Whitston, 1979.

Pascoe, Peggy. *Relations of Rescue: The Search for Female Authority in the American West 1874-1939.* New York: Oxford UP, 1993.

Riley, Glenda. *A Place to Grow: Women in the American West.* Arlington Heights, IL: Harlan Davidson, 1992.

Schlissel, Lillian, Vicki L. Ruiz, and Janice Monk, eds. *Western Women: Their Land Their Lives.* Albuquerque: U of New Mexico P, 1988.

The Western and Women

Armitage, Shelley. "Rawhide Heroines: The Evolution of the Cowgirl and the Myth of America." *The American Self: Myth, Ideology and Popular Culture.* Ed. Sam B. Girgus. Albuquerque: U of New Mexico P, 1981. 166-81.

Breihan, Carl, W. *Wild Women of the West.* Hampton: Chivers, 1992.

Calder, Jenni. *There Must be a Lone Ranger: The American West in Film and in Reality.* New York: Taplinger, 1975.

Dowell, Pat. "The Mythology of the Western: Hollywood Perspectives on Race and Gender in the Nineties." *Cineaste* 21.1-2 (1995): 6-10.

Foote, Cheryl J. "Changing Images of Women in the Western Film." *Journal of the West* 22.4 (Oct. 1983): 64-71.

Jefchak, Andrew. "Prostitutes and Schoolmarms: On Women in Western Films." *American Renaissance and American West.* Ed. Christopher S. Durer, Herbert R. Dieterich et al. Laramie: U of Wyoming P, 1982. 133-40.

Lackman, Ron. *Women of the Western Frontier in Fact, Fiction and Film.* Jefferson, NC: McFarland, forthcoming.

Levitin, Jacqueline. "The Western: Any Good Roles for Feminists?" *Film Reader* 5 (1982): 95-108.

McCormack, Peggy A. "Women in Westerns: Four Archetypal Characterizations." *Re: Artes Liberales* 8.2 (Spring 1982): 15-23.

McDonald, Archie P., ed. *Shooting Stars: Heroes and Heroines of Western Film.* Bloomington: Indiana UP, 1987.

O'Brien, Sheila Ruzycki. "Leaving Behind 'The Chisolm Trail' for Red River: Or, Refiguring the Female in the Western Film Epic." *Literature Film Quarterly* 24.2 (1996): 183-92.

Rich, B. Ruby. "At Home on the Range." *Sight and Sound* 3.11 (Nov. 1993): 18-22.

Swann, Thomas Burnette. *The Heroine or the Horse.* New York: Barnes, 1977.

Tompkins, Jane P. *West of Everything: The Inner Life of Westerns.* New York: Oxford UP, 1992.

——. "Women and the Language of Men." *Old West - New West: Centennial Essays.* Ed. Barbara Howard Meldrum. Moscow, ID: U of Idaho P, 1993.

Yates, Norris Wilson. *Gender and Genre: An Introduction to Women Writers of Formula Westerns 1900-1950.* Albuquerque: U of New Mexico P, 1995.

The Western and Hispanics

Hall, Kenneth E. "The Old Gringo and the Elegiac Western." *University of Dayton Review* 23.2 (Spring 1995): 137-47.

Hickman, Larry. "Along the Rio Grande." *Southwest Media Review* 3 (Spring 1985): 9-13.

King, John, Ana M. Lopez, and Manuel Alvarado, eds. *Mediating Two Worlds: Cinematic Encounters in the Americas.* London: British Film Institute, 1993.

Lamb, Blaine P. "The Convenient Villain: The Early Cinema Views the Mexican-American." *Journal of the West* 14.4 (1975): 75-81.

Mindiola, Tatcho, Jr. "El Corrido de Gregorio Cortez." *Southwest Media Review* 3 (Spring 1985): 52-56.

Pettit, Arthur G. *Images of the Mexican American in Fiction and Film.* College Station, TX: Texas A &M UP, 1980. *Includes useful bibliography and filmography.

——. "The Polluted Garden: Sam Peckinpah's Double Vision of Mexico." *Western Movies.* Ed. William Pilkington and Don Graham. Albuquerque: U of New Mexico P, 1979. 97-107.

Woll, Allen L. "Bandits and Lovers: Hispanic Images in American Film." *The Kaleidoscopic Lens: How Hollywood Views Ethnic Groups.* Ed. Randall M. Miller. Englewood Cliffs, NJ: Ozer, 1980. 54-72.

The Western and Asian-Americans

Man, Glenn. "Marginality and Centrality: The Myth of Asia in 1970's Hollywood." *East-West Film Journal* 8.1 (Jan. 1994): 52-67.
Discusses Altman's *McCabe and Mrs. Miller.*

European Studies of the Western

Bakker, Jan. *The Role of the Mythic West in Some Represenative Examples of Classic and Modern American Literature.* Lewiston, NY: Mellen P, 1991. (Dutch)

Bazin, *What is Cinema?* Volume II. Trans. Hugh Gray. Berkeley: U of California P, 1971. (French)

> Bazin's two essays "The Western, or the American Film *par excellence*" and "The Evolution of the Western" were very influential in the recognition of the Western as an important art form.

Bellour, Raymond, and Brion, Patrick, eds. *Le Western: Sources-Themes-Mythologies-Auteurs-Acteurs-Filmographies.* Paris: Union Generale d'editions, 1966. (French)

Bleton, Paul, and Richard Saint-Germain. *Les Hauts et Les Bas de L'Imagiaire Western.* Montreal: Tryptique, 1997. (Canadian)

Di Claudio, Gianni. *Il Cinema Western.* Rome: Libreria Universitaria Editrice, 1986. (Italian)

Ford, Charles. *Histoire du Western.* Paris: Albin Michel, 1976. (French)

Frayling, Christopher. *Spaghetti Westerns: Cowboys and Eurpeans from Karl May to Sergio Leone.* London: Routledge and Kegan Paul, 1981.

> A superb study of Sergio Leone and the Italian Western with chapters on other European versions of the American West including that of Karl May. (British)

Hanisch, Michael. *Western: Die Entwicklung eines Filmgenres.* Leipzig: Henschelverlag Kunst und Gesellachaft, 1984. (German)

Hembus, Joe. *Western Lexicon.* Munich: Hanser Verlag, 1976. (German)

Holm, Claus Krohn, Mette Weisberg, and Niels Wesiberg. *Westerns: Theory and Analysis.* Copenhagen: Gjellerup and Gad, 1986. (Danish)

Rieupeyrout, Jean-Louis. *La Grande Aventure du Western: du Far West a Hollywood.* Paris: Les Edition du Cerf, 1964. (French)

Western Novels and Stories: A Brief Tour

There are many good guides and bibliographies to the Western novel and story, including the excellent recent Richard Etulain, and N. Jill Howard, eds. *A Bibliographical Guide to the Study of Western American Literature* (Albuquerque: U of New Mexico P, 1995). Etulain and Fred Erisman's earlier *Fifty Western Writers: A Bio-bibliographical Sourcebook* (Westport, CT: Greenwood P, 1982) is also still very useful. In addition, two volumes sponsored by the Western Literature Association give a broad-ranging survey of western literature in all its dimensions—Westbrook, Max (Pref.), and James H. Maguire (Intro.), *A Literary History of the American West* (Fort Worth: Texas Christian UP, 1987); and Western Literature Association, *Updating the Literary West* (Forth Worth, TX: Texas Christian UP, 1997). Useful recent anthologies of Western

fiction and other related materials include William Kittredge, ed., *The Portable Western Reader* (New York: Penguin, 1997); Jon Tuska, *The Western Story: A Chronological Treasury* (Lincoln, NE: U of Nebraska P, 1995); and Jon Tuska and Vicki Piekarski, *The Morrow Anthology of Great Western Short Stories* (New York: Morrow, 1997).

The distinction between western literature and American literature and between the Western as a popular genre and nongeneric fiction about the West is sometimes a difficult one to make because American literature and culture have been pervasively influenced by the Western experience and its mythology. Frederick Jackson Turner's frontier thesis with its emphasis on the uniqueness of America's frontier experience is only one of many ways of defining that influence. Two major studies reflecting this concern with the significance of the frontier in American culture are particularly important to the study of the Western. The first, Henry Nash Smith's *Virgin Land,* sees the West as a pervasive myth deeply influencing American thought and action. Smith's study sets the Western in the larger context of cultural myths and is an indispensable reading for the student of the Western. The second work, Edwin Fussell's *Frontier,* argues the frontier served as a controlling symbol in many of the major works of American literature in the first half of the nineteenth century. In effect, Fussell suggests that not only Cooper, but most of our major writers including Melville, Hawthorne, and Thoreau should be considered as creators of Westerns. Two earlier studies along Turnerian lines are Lucy L. Hazard, *The Frontier in American Literature,* and Ralph L. Rusk, *The Literature of the Middle Western Frontier.*

However, the whole subject of the West is too complex for a set of notes. We'll concern ourselves mainly with fiction about the romantic or legendary West, which employs the literary and cultural formulas defined and discussed in *The Six-Gun Mystique.* This kind of fiction is most directly related to the Western film. This mythic Western fiction was quite different in some ways from the realistic and the humorous or satirical treatment of Western material. For an excellent discussion and bibliography of the nineteenth century tradition of Western humor, the reader should consult Walter Blair, *Native American Humor* (New York: American, 1937); and Blair Hill and Hamlin Hill, *America's Humor: From Poor Richard to Doonesbury* (New York: Oxford UP, 1978).

However, the distinction between the Western as formulaic romance and the Western novel as realistic historical treatment of its subject is not a perfectly clear one. Instead, we find a continuum which ranges from purely legendary sagas like *The Lone Ranger* to harsh and realistic accounts of Western experience without epic or romantic qualities like Hamlin Galand's *Main Travelled Roads* (1891). In between these poles lie a number of major works which are largely true to historical reality, but which do reflect the mythical or legendary aspects of the West in significant ways, works like Stephen Crane's "The Blue Hotel" or Walter Van Tilburg Clark's *The OxBow Incident.* These works must be

included in any serious study of the Western along with the more formulaic and romantic creations of writers like Zane Grey and Ernest Haycox.

This leaves us with an enormous literature that we will sample sparingly in an effort to indicate the most important works and types of works from both artistic and cultural points of view.

Early Shapers of the Western

James Fenimore Cooper created the Western and the enormous nineteenth-century popularity of his Western novels provided both model and impetus for most of the early development of the Western. Cooper's most important Western work is, of course, the "Leatherstocking Tales," including *The Pioneers* (1823), *The Last of the Mohicans* (1826), *The Prairie* (1827), *The Pathfinder* (1840), *The Deerslayer* (1841). Though Cooper wrote other novels with Western settings, including *The Wept of Wishton Wish* (1829) and *Wyandotte* (1843), the absence of the Western hero Natty Bumppo from these latter novels makes them distinctly less successful and suggests the extent to which a particular kind of hero has been central to the Western as a literary and cultural form.

Though Cooper originated the Western as we know it, he drew on several existing literary forms, such as the English historical romance primarily created by Sir Walter Scott; the cultural tradition of the noble savage, (cf. Hoxie N. Fairchild, *The Noble Savage* for a study of that tradition), a number of American works concerning the Indian, and the historical figure of Daniel Boone, already somewhat mythicized in the supposed autobiographical narrative included in John Filson, *Discovery, Settlement, and Present State of Kentucke* [sic] (1784).

Scholars have established that Cooper's primary source of Indian history and customs was John *Heckewelder's Account of the History, Manners, and Customs of the Indian Nations, Who Once Inhabited Pennsylvania and the Neighboring States* (1819) and Paul Wallace, in an essay on "Cooper's Indians" (*New York History* XXXV [Oct. 1954], 423446), has analyzed the impact of this book on Cooper's imagination. However, many other sources probably influenced Cooper's vision of the Indians. As Leslie Fiedler has pointed out, the Indian has always played a vital role in the tradition of the Western. Thus it is worth noting that the earliest form of Western account was the Indian captivity narrative, the first of which, was *The Sovereignty and Goodness of God . . . Being a Narrative of the Captivity and Restoration of Mrs. Mary Rowlandson* (1682). The captivity narrative continued to be an important form of Western literature throughout the eighteenth and nineteenth centuries.

Following Cooper, a number of other midnineteenth-century novelists used the frontier setting for at least some of their novels. The closest of these to Cooper's example and hence to the modern Western is Robert Montgomery Bird's *Nick of the Woods* (1837) written at least partly in response to what its

author believed to be Cooper's highly sentimentalized and fanciful, not to say dangerously misleading portrayal of the Indians. It was the first in a tradition of literary attacks on Cooper's version of the West which includes such minor gems as Mark Twain's "Literary Offenses of James Fenimore Cooper," Bret Harte's "Mucka-Muck," and Thackeray's "The Stars and Stripes."

Other significant Western novels of the period:

French, James S. *Elkswatawa; or the Prophet of the West. A Tale of the Frontier,* (1836).

Hall, James. *Sketches of History, Life and Manners in the West* (1834), *Legends of the West* (1853).

Paulding, James K. *Westward Ho!* (1832).

Simms, William Gilmore. *The Yemassee* (1835).

Several of Simms's other novels such as *The Scout* (1841), Woodcraft (1854), *The Forayers* (1855), and *Border Beagles* (1840), have frontier settings.

Tucker, Nathaniel B. *George Balcombe* (1836).

Webber, Charles W. (1848). *Old Hicks, the Guide, Or, Adventures in the Camanche Country in Search of a Gold Mine* (1848).

This period also created a very different kind of frontier figure, best illustrated in the public character and autobiographical narratives of Davy Crockett. Another writer of great importance in presenting a vision of the West was Francis Parkman, the historian. His *Oregon Trail* (1849) was a classic account of a Western journey and his multivolume history of the conflict of England and France in the New World has the kind of epic sweep and grandeur often attempted but rarely achieved by the writers of Western novels.

The Latter Half of the Nineteenth Century

During this period the Western evolved into a distinctive formula and diverged more sharply from the realistic novel of the West. With the shift of Western settlement to the Great Plains and the Far West, the cowboy emerged as the key heroic figure in popular Western fiction. The realistic novel tended to turn away from the Wild West and the frontier to represent the harsh and difficult life of farmers and small town dwellers in the Great Plains. The Western story was a staple of the dime novel and the pulp weekly and became increasingly formulaic and stereotyped. Finally, the emergence of the Wild West Show as a great public spectacle gave a new kind of vitality to the Western theme and paved the way for the Western's translation to the screen.

A few of the most important realist novels about the West are:

Cather, Willa. *O Pioneers!* (1913), *My Antonia* (1918).
Garland, Hamlin. *Main Travelled Roads* (1891).
Howe, Edgar Watson. *The Story of a Country Town* (1883).
Norris, Frank. *The Octopus* (1901).

Alongside this treatment of the agricultural West in fiction there emerged a more colorful and mythically oriented fictional treatment of the West, leading to the creation of the modern adult Western in the works of Owen Wister. Some of the central works in this development are:

Crane, Stephen. *The Open Boat and Other Tales of Adventure* (1898), and *The Monster and Other Stories* (1899).
Harte, Bret. *The Luck of Roaring Camp and Other Sketches* (1870), *Mrs. Skagg's Husbands and Other Sketches* (1873).
Twain, Mark. *Roughing It* (1872).

These collections include the two great Western stories "The Bride Comes to Yellow Sky" and "The Blue Hotel," which deconstruct the mythical West of the Western just as it is being formulated. But it is in the dime novel and the pulp weekly that the romantic Western flourished most widely in this period. Some of the books treating this development are:

Bragin, Charles. *Bibliography of Dime Novels 1860-1964.*
Johannsen, Albert. *The House of Beadle and Adams*, a definitive study of the largest dime novel publisher including a complete listing of their publications.
Noel, Mary. *Villains Galore*, a study of the Weekly Storypaper which was another major medium for the publication of Westerns in the later nineteenth century.
Pearson, Edmund. *Dime Novels.*
Reynolds, Quentin. *The Fiction Factory*, a history of the large publishing firm of Street and Smith.
Smith, Henry Nash. *Virgin Land* contains an excellent discussion of the development of the Western hero in the dime novel.

A convenient paperback reprint of two important dime novels is Philip Durham, ed., *Seth Jones and Deadwood Dick on Deck*. Charles W. Bragin of Brooklyn, NY, has made a great many dime novels available in facsimile reprints and most large libraries hold substantial collections, the largest being probably that of the New York Public Library.

The immense popularity of the Wild West Show played an important part in the making of the Western. For an excellent bibliography on this subject as well as a thorough scholarly study of the life of Buffalo Bill Cody, the major

figure in the development of the Wild West Show see Don Russell, *The Lives and Legends of Buffalo Bill.*

In the later nineteenth century, legends rapidly evolved around many of the scouts, soldiers, cowboys and badmen of the West. As Daniel Boone had become a national hero in the early nineteenth century, so individuals like Kit Carson, General Custer, Wild Bill Hickok, and Billy the Kid become mythical figures in the later nineteenth century. For a careful study of this process and a good bibliography of legendary books and stories about a number of these figures, see Kent Ladd Steckmesser, *The Western Hero in History and Legend.* On the relationship between Western heroes and other American herotypes, see Dixon Wecter, *The Hero in America*, and Marshall Fishwick, *The American Hero.*

The Early Twentieth Century

With the appearance of Owen Wister's *The Virginian* (1902) and Porter's film *The Great Train Robbery* (1903) the modern Western was born, synthesizing some of the adventurous and mythical qualities of the dime novels with more sophisticated and adult treatments of history, setting and character. Six writers stand out as particularly significant creators of Westerns in the first two decades of the twentieth century.

a. Owen Wister. Wister's *The Virginian* (1902) was a brilliant synthesis of the romantic and the realistic. In his cowboy hero, Wister combined aspects of the Leatherstocking tradition with the newer image of the heroic horseman of the Great Plains and created a figure and a type of story so successful that it can be called the basis of the modern Western. Wister's novel has sold over two million copies, has served as the basis of several movies and a successful television series. Wister wrote one other good Western novel, *Lin McLean,* and a number of fine stories.

b. Andy Adams' *The Log of a Cowboy* (1903), a semifictionalized account of the author's participation in a cattle drive, is one of the great Western classics and perhaps the closest thing to a realistic treatment of the cowboy's life. A number of other works follow more or less the same lines though less successfully.

c. Eugene Manlove Rhodes. Though even the most realistic of Western writers are basically romantics at heart, some like Adams and Rhodes achieve a strong sense of verisimilitude in their work rather like the best films of John Ford. Rhodes' major works are *Good Men and True* (1910), *West Is West* (1917), and *The Proud Sheriff* (1935). A convenient collection is Frank Bearing, ed., *The Best Novels and Stories of Eugene Manlove Rhodes* (1949).

d. Zane Grey. Grey's purple extravagances are sometimes painful for modern readers, but as one of the most prolific, best-selling writers of all time, he is of great cultural interest.

A selected list of his works follows:

Betty Zane, 1904	*The Call of the Canyon*, 1924
The Spirit of the Border, 1905	*The Thundering Herd*, 1925
Riders of the Purple Sage, 1912	*The Man of the Forest*, 1929
Desert Gold, 1913	*Code of the West*, 1934
The Border Legion, 1916	*Western Union*, 1939
The U.P. Trail, 1918	*Majesty's Rancho*, 1942
The Mysterious Rider, 1921	*Twin Sombreros*, 1942
To the Last Man, 1922	*Shadow on the Trail*, 1946

e. Emerson Hough. Another prolific creator of Western fiction, similar to Grey in his combinations of history, romance, and landscape.

The Story of the Cowboy, 1897	*The Broken Gate*, 1917
The Girl at the Half-Way House, 1900	*The Man Next Door*, 1917
The Way to the West, 1903	*The Way Out*, 1918
The Law of the Land, 1905	*The Passing of the Frontier*, 1918
The Story of an Outlaw, 1907	*The Sagebrusher*, 1919
The Way of a Man, 1907	*The Covered Wagon*, 1922
5440 or Fight, 1909	*North of 36*, 1923
The Sowing, 1909	*Mother of Gold*, 1924
The Purchase Price, 1911	*The Ship of Souls*, 1925
The Magnificent Adventure, 1916	

f. Alfred Henry Lewis. Creator of the fine "Wolfville" stories and a writer in the tradition of Bret Harte.

List of Western Pulps

In the twentieth century the pulp magazine and the cheap paperback have been two of the major forms of literary Western and their number is legion. Some idea of the immensity of Western publications in this form can be seen in another section of this guide, which presents a list of pulp Western magazines published in the heyday of that form. To get some idea of the nature of a pulp writing career, the student should consult Frank Gruber's *The Pulp Jungle*, a memoir of the writer's years as a creator of pulps. To represent this group of writers, I have selected four of the most successful and prolific.

Max Brand (Frederick Faust)

The Untamed, Putnam, 1918

The Night Horseman, Putnam, 1920

Trailin', Putnam, 1920

The Seventh Man, Putnam, 1921

Dan Bary's Daughter, Putnam, 1924

Gun Tamer, Dodd, Mead, 1929

Destry Rides Again, Dodd, Mead, 1930

Valley Vultures, Dodd, Mead, 1932

Twenty Notches, Dodd, Mead, 1932

The Longhorn Feud, Dodd, Mead, 1933

The Outlaw, Dodd, Mead, 1933

Brothers on the Trail, Dodd, Mead, 1934

Rancher's Revenge, Dodd, Mead, 1934

The Haunted Riders, Dodd, Mead, 1935

The Rustlers of Beacon Creek, Dodd, Mead, 1935

South of the Rio Grande, Dodd, Mead, 1936

The Iron Trail, Dodd, Mead, 1937

The Trouble Trail, Dodd, Mead, 1937

Dead or Alive, Dodd, Mead, 1938

Singin' Guns, Dodd, Mead, 1938

Gunman's Gold, Dodd, Mead, 1939

The Dude, Dodd, Mead, 1949

Ernest Haycox

Chaffee of Roaring Horse, Doubleday, Doran, 1930

All Trails Cross, Doubleday, 1931

Starlight Rider, Doubleday, 1933

Smoky Pass, Doubleday, 1934

Riders West, Doubleday, 1934

Trail Smoke, Doubleday, 1936

Deep West, Doubleday, 1937

Trouble Shooter, Doubleday, 1937

Man in the Saddle, Little, Brown, 1938

Sundown Jim, Little, Brown, 1938

Rim of the Desert, Little, Brown, 1941

Trail Town, Little, Brown, 1941

Alder Gulch, Little, Brown, 1942

Bugles in the Afternoon, Little, Brown, 1944

Canyon Passage, Little, Brown, 1945

Rough Justice, Little, Brown, 1950

By Rope and Lead, Little, Brown, 1951

Murder on the Frontier, Little, Brown, 1953

The Adventurers, Little, Brown, 1954

Luke Short (Frederick Glidden)

Marauders' Moon, Dell, 1937 (pub. 1953)

The Branded Man, Dell, 1938 (pub. 1953)

Hard Money, Doubleday, 1940

Ride the Man Down, Doubleday, 1942

Ramrod, Macmillan, 1943

Coroner Creek, Macmillan, 1946

Station West, Houghton Mifflin, 1947

Fiddlefoot, Houghton Mifflin, 1949

Vengeance Valley, Houghton Mifflin, 1950

Play a Lone Hand, Houghton Mifflin, 1950

Barren Land Murders, Fawcett, 1950

Saddle by Starlight, Houghton Mifflin, 1952

Silver Rock, Houghton Mifflin, 1953

Bought with a Gun, Dell, 1955

Rimrock, Random House, 1955

Frank Gruber

Peace Marshal, Morrow, 1939	*Johnny Vengeance*, Rinehart, 1954
Outlaw, Farrar & Rinehart, 1941	*Bugles West*, Rinehart, 1954
Gunsight, Dodd, Mead, 1942	*The Highwayman*, Rinehart, 1955
Fighting Man, Rinehart, 1948	*Buffalo Brass*, Rinehart, 1956
Broken Lance, Rinehart, 1949	*Lonesome River*, Rinehart, 1957
Smoky Road, Rinehart, 1949	*Town Tamer*, Rinehart, 1958
Fort Starvation, Rinehart, 1953	*The Marshal*, Rinehart, 1958
Quantrell's Raiders, Ace, 1953	*The Bushwackers*, Rinehart, 1959
Bitter Sage, Rinehart, 1954	*Tales of Wells Fargo*, Bantam, 1958

Western Novels and Stories: A Brief Tour

There are many different varieties and levels of Western writing at the present time.

Continuing the Generic Tradition. The pulp-paperback tradition continued unabated in the works of writers like Will Henry (Henry W. Allen), Todhunter Ballard, Louis L'Amour, Iwe Hoffman, Donald Hamilton, Lewis Patten and their many contemporary successors. The Western Writers of America is dedicated to sharing trade secrets and interests. The group publishes a regular magazine called *Roundup*, and maintains a useful homepage on the internet. Popular histories and historical novels of the West continue to come out at a tremendous rate and lavish publications like *the American Heritage History of the Great West* and the *American Heritage Book of the Pioneer Spirit*. In addition, television series such as *The Real West*, and *Big Guns Talk*, and popular magazines like *Wild West* testify to the continuing fascination of the mythical West.

The Modern Western Novel—a new generation of Western writer came of age in the 1940s, publishing novels and stories which went beyond the myths and legends of popular Western adventure to create a more complex and realistic portrayal of the West and its history. Two major figures in this development were: A. B. Guthrie, Jr., whose *The Big Sky* (1947) established a new standard of realism for representations of the early West and Wallace Stegner, whose *The Big Rock Candy Mountain* (1943) used the techniques of the modern realistic novel to portray the twentieth century West. Both were very influential on the further development of Western writing. Stegner, as head of the creative writing program at Stanford taught many important younger writers, while his 1971 *Angle of Repose* is perhaps the greatest modern novel about the Western experience. Other contemporary writers who have made important contributions to the enrichment of Western fiction include Walter Van Tilburg Clark, Conrad Richter, Frederick Manfred, Wright Morris, Ivan Doig, Larry McMurtry,

Norman Maclean, Ken Kesey, Edward Abbey, Terry Tempest Williams, and Cormac McCarthy.

Recreating Native Americans—one of the most important aspects of contemporary Western literature is the literary exploration of Native American cultures seeking to demythologize traditional Western stereotypes and to portray these cultures and their history in a more complex and sympathetic fashion. While some white writers like Frank Waters, Thomas Berger, Milton Lott, and Mari Sandoz made important contributions to this effort, the most significant work has been done by Native American Writers themselves. Since the late 1960s when N. Scott Momaday published his path-breaking works, *House Made of Dawn* (1968) and *The Way to Rainy Mountain* (1969), a number of important Native American writers have published striking and memorable fiction about Native Americans. These include Leslie Marmon Silko, James Welch, Linda Hogan, Gerald Vizenor, Louise Erdrich and Sherman Alexie. In addition, a new group of hispanic writers like Rudolfo Anaya, Rolando Hinojosa, and Denise Chavez have given voice to the traditions of Latino cultures.

The Post-Western—see Chapter Five for a discussion of some of the major trends in this area.

A Selected List of Western Pulp Magazines

Sources

Hanrahan, John Keith. *The Literary Market Place.* vol 1. New York: Bowker, 1940. 32-34.

The Literary Market Place. vol. 4. 1945. 96-98.

Matthieu, Arron M., and Ruth A. Jones, eds. Writer's Market, Cincinnati: *Writer's Digest Magazine*, 1945: 132-36.

Ace-High Western Stories (Fictioneers)
Action Packed Western (Double Action Group)
Best Westerns (American Fiction Group)
Big Book Western Magazine (Popular Publications Group)
Blue Ribbon Western (Double Action Group)
Complete Northwest (Double Action Group) Complete Cowboy
Complete Western Book Magazine (American Fiction Group)
Cowboy Short Stories (Double Action Group)
Dime Western (Popular Publishing Company)
Doc Savage (S & S All Fiction Group)
Double Action Western (Double Action Group)

Exciting Western (The Thrilling Group)
Famous Western (Double Action Group)
44 Western (Popular Publishing Company) Frontier Stories
Lariat Story Magazine (Newsstand Fiction Unit)
New Western (Fictioneers)
Popular Western (The Thrilling Group)
Ranch Romances (Newsstand Fiction Unit)
Range Riders Western (The Thrilling Group)
Rangeland Romances (Popular Publishing Company)
Real Western (Double Action Group)
Red Seal Western (Ace Fiction Group)
Rio Kid Western (Double Action Group)
Rodeo Romances (The Thrilling Group)
Romantic Range (S & S All Fiction Group)
Smashing Western (Double Action Group)
Star Western Magazine (Popular Publishing Group)
Ten Story Western (Popular Publishing Group)
Texas Rangers (The Thrilling Group)
Thrilling Ranch Stories (The Thrilling Group)
Thrilling Western (The Thrilling Group)
Two Gun Western Novels (American Fiction Group)
Variety Western (Ace Fiction Group)
Western Aces (Ace Fiction Group)
Western Action (Double Action Group)
Western Story (S & S All Fiction Group)
Western Trails (Ace Fiction Group)
Western Yarns (Double Action Group)
Wild West Weekly (All Fiction Field)

Films
A Chronological Listing of Major and Representative Western Films

1903 *The Great Train Robbery,* Edwin S. Porter
1911 *Fighting Blood,* D. W. Griffith
1913 *The Squaw Man,* Cecil B. DeMille
1915 *The Spoilers,* Colin Campbell
1916 *Hell's Hinges,* William S. Hart
1919 *The Outcasts of Poker Flat,* John Ford
1920 *The Last of the Mohicans,* Mourice Tourneur
1923 *Covered Wagon,* James Cruze
1924 *The Iron Horse,* John Ford
1925 *Riders of the Purple Sage,* Lynn Reynolds (Tom Mix)
1925 *Tumbleweeds,* King Baggott, William S. Hart

1926 *The Vanishing American*, George B. Seitz
1929 *The Virginian*, Victor Fleming
1930 *Billy the Kid*, King Vidor
1931 *Cimarron*, Wesley Ruggles
1936 *The Plainsman*, Cecil DeMille
1937 *Wells Fargo*, Frank Lloyd
1939 *Destry Rides Again*, George Marshall
1939 *Drums Along the Mohawk*, John Ford
1939 *Stagecoach*, John Ford
1939 *Union Pacific*, Cecil B. DeMille
1940 *Jesse James*, Henry King
1940 *Kit Carson*, George B. Seitz
1942 *They Died with Their Boots On*, Raoul Walsh
1943 *The Ox-Bow Incident*, William Wellman
1946 *My Darling Clementine*, John Ford
1947 *Red River*, Howard Hawks
1948 *Fort Apache*, John Ford
1948 *The Treasure of the Sierra Madre*, John Huston
1949 *She Wore a Yellow Ribbon*, John Ford
1950 *Broken Arrow*, Delmer Daves
1952 *The Big Sky*, Howard Hawks
1952 *High Noon*, Fred Zinneman
1953 *Hondo*, John Farrow
1953 *Shane*, George Stevens
1955 *The Searchers*, John Ford
1957 *The Run of the Arrow*, Samuel Fuller
1958 *The Left-handed Gun*, Arthur Penn
1959 *The Horse Soldiers*, John Ford
1959 *One-Eyed Jacks*, Marlon Brando
1959 *Rio Bravo*, Howard Hawks
1960 *The Magnificent Seven*, John Sturges
1961 *The Misfits*, John Huston
1962 *Lonely Are the Brave*, David Miller
1962 *The Man Who Shot Liberty Valance*, John Ford
1962 *Ride the High Country*, Sam Peckinpah
1963 *How the West Was Won*, Henry Hathaway, John Ford
1963 *Hud*, Martin Ritt
1964 *Cheyenne Autumn*, John Ford
1964 *A Fistful of Dollars*, Sergio Leone
1965 *For a Few Dollars More*, Sergio Leone
1965 *The Sons of Katie Elder*, Henry Hathaway
1966 *A Big Hand for the Little Lady*, Fielder Cook

1966 *The Good, the Bad, and the Ugly,* Sergio Leone

1967 *El Dorado,* Howard Hawks

1968 *Hang 'em High,* Ted Post

1969 *True Grit,* Henry Hathaway

1969 *The Wild Bunch,* Sam Peckinpah

1970 *The Battle of Cable Hogue,* Sam Peckinpah

1970 *Little Big Man,* Arthur Penn

1970 *A Man Called Horse,* Elliot Silverstein

1970 *Soldier Blue,* Ralph Nelson

1970 *Two Mules for Sister Sara,* Donald Siegel

1971 *McCabe and Mrs. Miller,* Robert Altman

1972 *Jeremiah Johnson,* Sydney Pollack

1972 *Ulzana's Raid,* Robert Aldrich

1973 *High Plains Drifter,* Clint Eastwood

1975 *Rooster Cogburn,* Stuart Millar

1976 *Buffalo Bill and the Indians: Or Sitting Bull's History Lesson,* Robert Altman

1976 *Missouri Breaks,* Arthur Penn

1976 *The Outlaw Josey Wales,* Clint Eastwood

1976 *The Shootist,* Don Siegel

1980 *Heaven's Gate,* Michael Cimino

1980 *The Long Riders,* Walter Hill

1981 *Legend of the Lone Ranger,* William Fraker

1982 *Ballad of Gregorio Cortez,* Robert M. Young

1982 *The Shadow Riders,* Andrew McLaglen

1984 *Draw!* Steven Stern

1985 *Pale Rider,* Clint Eastwood

1985 *Silverado,* Lawrence Kasdan

1986 *Three Amigos,* John Landis

1988 *Young Guns,* Christopher Cain

1989 *The Heist,* Stuart Orme

1989 *Lonesome Dove (TV Mini Series),* Simon Wincer

1990 *Dances with Wolves,* Kevin Costner

1992 *Unforgiven,* Clint Eastwood

1994 *Geronimo,* Walter Hill

1994 *Wyatt Earp,* Laurence Kasdan

1995 *Dead Man,* Jim Jarmusch

1996 *Lone Star,* John Sayles

1997 *Buffalo Soldiers,* Charles Haid

1998 *Two for Texas,* Rod Hardy

The Best Westerns: Various Versions

Source: Phil Hardy, *The Western*. Film Encyclopedia. vol. 1. New York: Morrow, 1983.

Ed Buscombe

Ed Buscombe has written extensively about genre and the Western. He is the author of the important *BFI Companion to the Western*. The films are listed in order of preference.

The Searchers, 1956	*Comanche Station*, 1960
Rio Bravo, 1959	*Man of the West*, 1958
Ride the High Country, 1962	*Vera Cruz*, 1954
Duel in the Sun, 1946	*One-Eyed Jacks*, 1961
Heller in Pink Tights, 1960	*High Plains Drifter*, 1972

This is a list not of the "most significant contributions" to the genre; simply of the ones I'd most like to see in an all-night screening if I were being hanged in the morning. They are chosen on an *auteur* principle in one sense, that I've only allowed myself one by each director.'

Allen Eyles

Allen Eyles is the author of *The Western* and the definitive book about the films of John Wayne. The films are listed in chronological order.

Pursued, 1947	*The Searchers*, 1956
She Wore a Yellow Ribbon, 1949	*The Tall T*, 1957
Bend of the River, 1952	*The Hanging Tree*, 1959
Shane, 1953	*Ride the High Country*, 1962
The Man from Laramie, 1955	*Support Your Local Sheriff*, 1968

Christopher Frayling

Christopher Frayling is Professor of Cultural History at the Royal College of Art (London). He is the author of *Spaghetti Westerns* and of numerous articles about the American Western and American society. The films are listed in chronological order.

High Noon, 1952	*The Man Who Shot Liberty Valance*, 1962
Rancho Notorious, 1952	
Shane, 1953	*The Professionals*, 1966
Johnny Guitar, 1954	*Once upon a Time in the West*, 1968
Run of the Arrow, 1957	*The Ballad of Cable Hogue*, 1970
Terror in a Texas Town, 1958	*McCabe and Mrs Miller*, 1971
Rio Bravo, 1959	*Ulzana's Raid*, 1972
Comanche Station, 1960	*The Missouri Breaks*, 1976
One-Eyed Jacks, 1961	*The Shootist*, 1976

Although this list is restricted to American Westerns of the sound era—films financed or shot in America—one film for each director (and omitting Eastwood, Hellman, Muston, King, Mann, McLaglen, Nelson, Pollack, Ritt, Sturges, and Walsh), I still could not prune it down to less than seventeen items. The list clearly shows a preference for "modernist" Westerns—films which aim to extend the basic rules of the genre, which re-mix the staple ingredients in an interesting way, which import ideas from other areas of lilm work, or which use other Westerns as reference points: it also shows a preference for the work of certain directors (hence the "one of each" look to it). Top American Westerns illustrates my strong belief that it was only when the cowboy stopped kissing his horse (or singing about his horse, or using him as an excuse for rodeo stunts) that the Western was able to grow up: as one of the cowhands says in *The Culpepper Cattle Company* (Dick Richards, 1972), "S,',', you don't give a name to something you may have to eat."

In view of the fact that Frayling's book Spaghetti Westerns is the seminal book on the Italian Western, it seemed appropriate to ask him for a separate list of Italian Westerns.

A Bullet for the General, 1966	*A Professional Gun,* 1968
Django, 1966	*Django Kill,* 1969
The Good, the Bad and the Ugly, 1966	*They Call Me Trinity,* 1970
The Hills Run Red, 1966	*A Fistful of Dynamite,* 1971
Face to Face, 1967	*My Name Is Nobody,* 1973

Like my Top American Westerns list, this is in chronological order rather than order of preference: unlike that list, I've included more than one work by important directors (Corbucci, Leone) and several which were scored by the same composer—Ennio Morricone. Although William S. Hart originally coined the phrase "horse opera," it took the land of Puccini to show what the phrase really means. The reason these Top Italian Westerns were all made in the relatively brief time span of 1965-73, is that the "Spaghetti" phenomenon only lasted eleven years and took two years to get going. Nevertheless there were about 400 Italian Westerns made between 1963 and 1973—and the choice was not as easy as some film critics might think.

Phil Hardy

The films are listed in chronological order.

Winchester '73, 1950	*The Searchers,* 1956
Bend of the River, 1952	*Forty Guns,* 1957
Rancho Notorious, 1952	*Fury at Showdown,* 1957
Johnny Guitar, 1954	*Man of the West,* 1958

The Shooting/Ride in the Whirlwind, *The Wild Bunch,* 1969
 1966 *The Last Movie,* 1971
A Time for Dying, 1969

Ten films, four directors. Not what you'd call a balanced list. Yet it seems to me to cover most of the classic genre themes—the search for lost kinsmen, the building of empires, the taming of towns (or anyway the ridding of bad influences in them), the cavalry and Indian conflict, or "civilization" versus "savagery" and even "the end of the west Western." If we were not confined to the apparently immutable dimensions of the ten best concept—has anyone ever traced that one back to its source?—I would want to add that great elegy, *Ride the High Country* (1962); the gloriously spacious and only half-specious *The Big Country* (1958); Clint Eastwood's neo-classic *The Outlaw Josey Wales* (1976); two successful Italianate coals-to-Newcastle efforts, *Once Upon a Time in the West* (1968), and *My Name Is Nobody* (1973), and, for obscurity's sake, a forgotten Audie Murphy quickie that ought at least to have a cult following, *No Name on the Bullet* (1959).

David Thomson

Amongst David Thomson's publications is the invaluable *A Biographical Dictionary of the Cinema.* The films are listed in order of preference.

Red River, 1948 *Pursued,* 1947
Rio Bravo, 1959 *Pat Garrett and Billy the Kid,* 1973
Man of the West, 1958 *Run of the Arrow,* 1957
The Searchers, 1956 *The Missouri Breaks,* 1976
The Far Country, 1955 *The Shooting,* 1966

You ask for ten top Westerns, on the assumption that we have a shared understanding of the range covered by the genre. So be it—these are my ten favorites of the moment. But for the last couple of years I have begun to live in the West, and so I feel more intrigued by the possibilities of twentieth-century Westerns.

Robin Wood

The films are listed in chronological order.

Drums along the Mohawk, 1939 *Heller in Pink Tights,* 1960
Duel in the Sun, 1946 *The Man Who Shot Liberty Valance,*
She Wore a Yellow Ribbon, 1949 1962
Rancho Notorious, 1952 *McCabe and Mrs. Miller,* 1971
Man of the West, 1958 *Heaven's Gate,* 1980—especially the
Rio Bravo, 1959 original version

Colin McArthur

Colin McArthur has written extensively about genre. He has been film critic of *The Tribune* for several years in which capacity he has probably been the only regular newspaper critic to attempt to apply recent developments in film criticism in a consistent fashion. The films are listed in chronological order.

The Covered Wagon, 1923
Union Pacific, 1939
The Westerner, 1939
My Darling Clementine, 1946
Run of the Arrow, 1957
Lonely Are the Brave, 1962

The Man Who Shot Liberty Valance,
 1962
Ride the High Country, 1962
Cheyenne Autumn, 1964
Once upon a Time in the West, 1968

The criteria on which my choice is based are neither the individual excellence of the films nor, still less, the sensibilities of their makers. The criteria are firmly social. The above films seem to me to pose most sharply the particular historical debates which underpin the Western: whether the West is garden or desert; whether industrialization or agrarianism carries the greater moral cachet; whether the Indian is a cruel savage or a noble primitive; whether Western energy is to be preferred to Eastern refinement; and how the traditional West (and Western) copes with the onset of modernity. The presence of these debates has the effect of troubling these films, of making them perform curious manoeuvres in an attempt to resolve incompatible ideological demands.

Tom Milne

Tom Milne is the author of *Mamoulian* and editor of *Godard on Godard,* amongst others. The films are listed in chronological order.

Three Bad Men, 1926
They Died with Their Boots On, 1941
My Darling Clementine, 1946
She Wore a Yellow Ribbon, 1949
Wagonmaster, 1950

Run of the Arrow, 1957
RioBravo, 1959
Little Big Man, 1970
Ulzana's Raid, 1972
Pat Garrett and Billy the Kid, 1973

Ted Reinhart

Ted Reinhart reviews both A and series Westerns in several video magazines.

Top Ten A Westerns

Stagecoach, 1939	*The Gunfighter,* 1950
The Westerner, 1940	*Wagonmaster,* 1950
Red River, 1948	*High Noon,* 1952
The Three Godfathers, 1948	*Shane,* 1953
Broken Arrow, 1950	*Ride the High Country,* 1962

Western Series Stars and Their Career Best Movie

Rex Allen	*The Arizona Cowboy*
Gene Autry	*Blue Montana Skies*
Don Barry	*The Tulsa Kid*
William Boyd	*Three Men from Texas*
Johnny Mack Brown	*The Gentleman from Texas*
Buster Crabbe	*The Drifter*
Bill Elliott	*Beyond the Sacramento*
Monte Hale	*Home on the Range*
Tim Holt	*The Arizona Ranger*
George Houston	*Lone Rider Rides On*
Buck Jones	*White Eagle*
Allan Lane	*Sheriff of Wichita*
Ken Maynard	*The Strawberry Roan*
Tim McCoy	*The Westerner*
Tom Mix	*The Rider of Death Valley*
George O'Brien	*Gun Law*
Jack Randall	*Across the Plains*
Tex Ritter	*Oklahoma Raiders*
Roy Rogers	*My Pal Trigger*
Charles Starrett	*Outlaws of the Prairie*
Bob Steele	*Brand of the Outlaws*
Range Busters	*Wranglers Roost*
Rough Riders	*Ghost Town Law*
Three Mesquiteers	*Wyoming Outlaw*
Trailblazers	*Arizona Whirlwind*
John Wayne (as a 'B' star)	*Born to the West*

Richard Schickel

Richard Schickel is the film critic of *Time* magazine. The films are listed in chronological order.

Stagecoach, 1939	*She Wore a Yellow Ribbon,* 1949
My Darling Clementine, 1946	*The Searchers,* 1956
Fort Apache, 1948	*Rio Bravo,* 1959
Red River, 1948	

French Critics Select the Ten Best Westerns

Source: *The Six-Gun Mystique*, 1st ed.

Compilation of the movies mentioned in the Ten Best Westerns lists in *Le Western*. Rank based on the number of citations in the lists of the 27 critics:

1. *Johnny Guitar*, Nicholas Ray
2. *Rio Bravo*, Howard Hawks
3. *The Big Sky*, Howard Hawks
4. *The Naked Spur*, Anthony Mann
5. *Rancho Notorious*, Fritz Lang
 Man without a Star, King Vidor
6. *My Darling Clementine*, John Ford
 The Left-Handed Gun, Arthur Penn
 The Searchers, John Ford
 Ride the High Country, Sam Peckinpah
 Silver Lode, Allan Dwan
 Red River, Howard Hawks
 Duel in the Sun, King Vidor
 The Hanging Tree, Delmer Daves
 Run of the Arrow, Sam Fuller
 Seven Men from Now, Budd Boetticher
7. *The Last Hunt*, Richard Brooks
 The Far Country, Anthony Mann
 Colorado Territory, Raoul Walsh
 Wagonmaster, John Ford
 The Unforgiven, John Huston
 Man of the West, Anthony Mann
 Heller in Pink Tights, George Cukor
8. *Man From Laramie*, Anthony Mann
 The Plainsman, Cecil B. DeMille
 Western Union, Fritz Lang
 Winchester 73, Anthony Mann
 Warlock, Edward Dmytryk
 They Died with Their Boots On, Raoul Walsh
 The Last Frontier, Anthony Mann
 The Last Wagon, Delmer Daves
 River of No Return, Otto Preminger
9. *Stagecoach*, John Ford
 The Outlaw, Howard Hughes
 Billy the Kid King Vidor

Comanche Station, Budd Boetticher
The Wonderful Country, Robert Parrish
Wichita, Jacques Tourneur
3 Hours to Yuma, Delmer Daves
The Magnificent Seven, John Sturges
Gunfight at the OK Corral, John Sturges
Tennessee's Partner, Allan Dwan

10. *Backlash,* John Sturges
Lonely Are the Brave, David Miller
Shane, George Stevens
The Tin Star, Anthony Mann
The Horse Soldiers, John Ford
Silver River, Raoul Walsh
A King and Four Queens, Raoul Walsh
The Misfits, John Huston
Union Pacific, Cecil B. DeMille
The Covered Wagon, James Cruze
The Indian Fighter, Andre de Toth
Rio Conchos, Gordon Douglas
Major Dundee, Sam Peckinpah
Westward the Women, William Wellman
Dallas, Stuart Heisler
Jesse James, Henry King
Buffalo Bill, William Wellman
Bend of the River, Anthony Mann
Broken Arrow, Delmer Daves
Run for Cover, Sam Fuller
Yellowstone Kelly, Gordon Douglas
The Law and Jack Wade, John Sturges
The Sheriff of Fractured Jaw, Raoul Walsh
Pursued, Raoul Walsh
Forty Guns, Sam Fuller
The Unconquered, Cecil B. DeMille
A Distant Trumpet, Raoul Walsh
Oneeyed Jacks, Marlon Brando
Two Rode Together, John Ford
The Sheep Man, George Marshall
Last Train from Gun Hill, John Sturges
Apache, Robert Aldrich
The Iron Horse, John Ford
The Singer Not the Song, Roy Baker
Yellow Sky, William Wellman

The Treasure of the Sierra Madre, John Huston
The Gold Rush, Charlie Chaplin
Go West, Buster Keaton
The True Story of Jesse James, Nicholas Ray
Buchannan Rides Alone, Budd Boetticher
The Devil's Doorway, Anthony Mann
The Gunfighter, Henry King
Fort Bravo, John Sturges
Taza, Son of Cochise, Douglas Sirk

Source: Internet www.americanwest.com/films/htm

Classic "Westerns" Viewing & Discussion Series

Much of our cultural understanding of the American frontier is a reflection of the images we have seen in darkened movie theaters or on fuzzy, late-night television screens. The Western is a universally recognized, but uniquely American film genre. As literary critic Richard Slotkin has observed, "the western towns of false-front saloons and board sidewalks are as instantly familiar to us, as recognizable, and as dense with memory and meaning, as the streets we grew up on." Westerns allow us to explore safely value conflicts, such as communal ideas versus individualistic impulses, and traditional ways of life versus progress. These formulaic works provide viewers with a vehicle for escape and moral fantasy.

The suggested films offer a retrospective of some of the best of the genre, and allow the viewers to probe how these films have influenced American culture and society and have been influenced in turn by social change.

Stagecoach. Dir. John Ford, Warner, 1939. [Swank]
Young Mr. Lincoln. Dir. John Ford, Paramount, 1939. [Films, Inc.]
Shane. Dir. George Stevens, Paramount, 1953. [Films, Inc.]
The Searchers. Dir. John Ford, Warner Brothers, 1956. [Swank]
The Wild Bunch. Dir. Sam Peckinpah, Warner Brothers, 1969. [Swank]
Little Big Man. Dir. Arthur Penn, Fox, 1972. [Swank]
Dances with Wolves. Dir. Kevin Costner, Paramount, 1990. [Swank]
The Unforgiven. Dir. Clint Eastwood, Warner Brothers, 1993. [Swank]

The Best Western Films of All Time

Listed below are the thirteen best western films of all time according to a few reputable sources. They all have in common that they each have received four stars (which is the maximum) from Leonard Maltin's *Annual Movie and*

Video Guide. There are some excellent films with up to 3 1/2 stars but they did not qualify for this list. Most recent film is listed first:

Dances with Wolves, 1990 (Col.)
Little Big Man, 1970 (Col.)
Butch Cassidy and the Sundance Kid,
 1969 (Col.)
The Wild Bunch, 1969 (Col.)
Ride the High Country, 1962 (Col.)
The Searchers, 1956 (Col.)
High Noon, 1952 (B&W)

Shane, 1952 (Col.)
Red River, 1948, (B&W)
The Treasure of the Sierra Madre,
 1948 (B&W)
My Darling Clementine, 1946 (B&W)
Destry Rides Again, 1939 (B&W)
Stagecoach, 1939, (B&W)

Source: Internet: www.filmsite.org/westernfilms.html

Selection of Greatest Western Films
Greatest Early Western Films

The Great Train Robbery, 1903
The Covered Wagon, 1923
The Iron Horse, 1924
The Virginian, 1929
The Big Trail, 1930
Cimarron, 1931
Viva Villa! 1934
Annie Oakley, 1935
The Last of the Mohicans, 1936
The Plainsman, 1937
Santa Fe Trail, 1938
Allegheny Uprising, 1939
Destry Rides Again, 1939
Dodge City, 1939
Jesse James, 1939
Stagecoach, 1939
Union Pacific, 1939
Northwest Passage, 1940
The Return of Frank James, 1940
The Westerner, 1940
They Died With Their Boots On, 1941

The Outlaw, 1943
The Ox-Bow Incident, 1943
Duel in the Sun, 1946
Pursued, 1947
Red River, 1948
The Treasure of the Sierra Madre,
 1948
The Gunfighter, 1950
Winchester '73, 1950
Bend of the River, 1952
The Big Sky, 1952
High Noon, 1952
The Naked Spur, 1952
Shane, 1953
Johnny Guitar, 1954
The Far Country, 1955
The Man from Laramie, 1955
The Big Country, 1958
Man of the West, 1958
Rio Bravo, 1959
The Alamo, 1960

Greatest John Ford Western Films

Drums along the Mohawk, 1939
Stagecoach, 1939
My Darling Clementine, 1946
Fort Apache, 1948
She Wore a Yellow Ribbon, 1949

Rio Grande, 1950
The Searchers, 1956
The Man Who Shot Liberty Valance, 1962

Greatest Recent Western Films

The Magnificent Seven, 1960
Ride the High Country, 1962
How the West Was Won, 1963
Hud, 1963
Cat Ballou, 1965
Butch Cassidy and the Sundance Kid, 1969

Once Upon a Time in the West, 1969
The Wild Bunch, 1969
Little Big Man, 1970
McCabe and Mrs. Miller, 1971
Dances with Wolves, 1990
Unforgiven, 1992

Source: Phil Hardy, *The Western.* Film Encyclopedia. vol. 1. New York: Morrow, 1983.

Most Successful Westerns: Inflation Adjusted

1. *Duel in the Sun,* 1946
2. *Butch Cassidy and the Sundance Kid,* 1969
3. *Blazing Saddles,* 1974
4. *Shane,* 1953
5. *How the West Was Won,* 1962
6. *Unconquered,* 1947
7. *The Outlaw,* 1943
8. *The Covered Wagon,* 1923
9. *Jeremiah Johnson,* 1972
10. *The Alamo,* 1969
11. *Red River,* 1948
12. *Little Big Man,* 1970
13. *The Tall Men,* 1955
14. *True Grit,* 1969
15. *California,* 1946
16. *They Died with Their Boots On,* 1941
17. *The Searchers,* 1956
18. *The Virginian,* 1946
19. *Cat Ballou,* 1965
20. *Vera Cruz,* 1954
21. *The Professionals,* 1966
22. *Gunfight at the O.K. Corral,* 1957
23. *San Antonio,* 1945
24. *Fort Apache,* 1948
25. *Broken Arrow,* 1950
26. *Rio Bravo,* 1959
27. *Honda,* 1953
28. *Pursued,* 1947
29. *Cimarron,* 1931
30. *Yellow Sky,* 1948
31. *Shenandoah,* 1965
32. *My Darling Clementine,* 1946
33. *She Wore a Yellow Ribbon,* 1949
34. *High Noon,* 1952
35. *Across the Wide Missouri,* 1951
36. *Bend of the River,* 1952

37. *The Iron Mistress,* 1952
38. *Distant Drums,* 1951
39. *The Outlaw Josey Wales,* 1976
40. *One-Eyed Jacks,* 1961
41. *Drums Along the Mohawk,* 1939

42. *Jesse James,* 1939
43. *North West Mounted Police,* 1940
44. *Northwest Passage,* 1940
45. *Santa Fe Trail,* 1940
46. *The Sons of Katie Elder,* 1965

Major Western Directors
(compiled by Barbara Bernstein)

CLINT EASTWOOD
Directed by Sergio Leone
A Fistful of Dollars, 1964
For a Few Dollars More, 1965
The Good, the Bad and the Ugly, 1966

Directed by others
Coogan's Bluff, 1968
Hang Em High, 1968
Paint Your Wagon, 1969
Two Mules for Sister Sara, 1969

Directed by Eastwood
High Plains Drifter, 1972
Joe Kidd, 1972
The Outlaw Josey Wales, 1976
Bronco Billy, 1980
Pale Rider, 1985
Unforgiven, 1992

JOHN FORD (from Bogdanovitch,
 John Ford)
Bucking Broadway, 1917
Cheyenne's Pal, 1917
A Marked Man, 1917
The Scrapper, 1917
A Secret Man, 1917
The Soul Herder, 1917
Straight Shooting, 1917
The Tornado, 1917
The Phantom Riders, 1918
Thieves' Gold, 1918
Wild Women, 1918

JOHN FORD *(continued)*
Hell Bent, 1918
The Scarlet Drop, 1918
A Woman's Fool, 1918
Bare Fists, 1919
A Fight for Love, 1919
The Fighting Brothers, 1919
The Freeze Out, 1919
By Indian Post, 1919
Gun Law, 1919
The Gun Packer, 1919
The Last Outcast, 1919
Marked Men, 1919
The Outcasts of Poker Flat, 1919
The Rider of the Law, 1919
Riders of Vengeance, 1919
Roped, 1919
The Rustlers, 1919
Action, 1921
Desperate Trails, 1921
The Wallop, 1921
North of Hudson Bay, 1923
Three Jumps Ahead, 1923
The Iron Horse, 1924
Lightnin', 1924
Three Bad Men, 1926
Drums along the Mohawk, 1939
Stagecoach, 1939
My Darling Clementine, 1946
Fort Apache, 1948
Three Godfathers, 1948
She Wore a Yellow Ribbon, 1949
Rio Grande, 1950

JOHN FORD *(continued)*
Wagon Master, 1950
The Searchers, 1956
Sergeant Rutledge, 1960
Two Rode Together, 1961
*How the West Was Won (Civil War
 Episode),* 1962
The Man Who Shot Liberty Valance,
 1962
Cheyenne Autumn, 1964

WILLIAM S. HART (from Eyles, *The
 Western*) Directed by Hart
The Passing of Two-Gun Hicks, 1914
My Silent Haskins, 1915
The Scourge of the Desert, 1915
The Sheriff's Streak of Yellow, 1915
The Taking of Luke Mc Vane, 1915
The Darkening Trail, 1915
The Ruse, 1915
Cash Parrish's Pal, 1915
The Conversion of Frosty Blake, 1918
Keno Bates, Liar, 1915
The Disciple, 1915
The Aryan, 1916
The Desert Man, 1916
The Devil's Double, 1916
Hell's Hinges, 1916
Pinto Ben, 1916
The Primal Lure, 1916
The Return of Draw Egan, 1916
The Cold Deck, 1917
The Gunfighter, 1917
The Silent Man, 1917
The Square Deal Man, 1917
Truthful Gulliver, 1917
Wolf Lawry, 1917

Directed by Lambert Hillyer
The Narrow Trail, 1917
Blue Blazes Rawden, 1918
Border Wireless, 1918

WILLIAM S. HART *(continued)*
Branding Broadway, 1918
Riddle Game, 1918
Selfish Yates, 1918
Shark Monroe, 1918
The Tiger Man, 1918
Wolves of the Rail, 1918
Breed of Men, 1919
John Petticoats, 1919
The Money Corral, 1919
Sand, 1919
Square Deal Sanderson, 1919
Wagon Tracks, 1919
O'Malley of the Mounted, 1920
The Roll Gate, 1920
Tree Word Band, 1921
Travelin' On, 1921
White Oak, 1921
The Testing Black, 1929

Directed by Cliff Smith
Wild Bill Hickock, 1923
Singer Jim McKee, 1923

Directed by King Baggott *Tumble-
 weeds*
ANTHONY MANN (from Kitses,
 Horizons West)
The Devil's Doorway, 1950
The Furies, 1950
Winchester 73, 1950
Bend of the River, 1952
The Naked Spur, 1953
The Far Country, 1955
The Man from Laramie, 1955
The Last Frontier, 1956
The Tin Star, 1957
Man of the West, 1958
Cimarron, 1960

HOWARD HAWKS
Red River, 1948
The Big Sky, 1952
Rio Bravo, 1959
El Dorado, 1967
Rio Lobo, 1970

SERGIO LEONE
A Fistful of Dollars, 1964
For a Few Dollars More, 1965
The Good, the Bad and the Ugly, 1966
Once Upon a Time in the West, 1968
Duck, You Sucker, 1971

SAM PECKINPAH (from Kitses)
The Deadly Companion, 1962
Ride the High Country, 1962
Major Dundee, 1965
The Wild Bunch, 1968
The Ballad of Cable Hogue, 1970

BUDD BOETTICHER (from Kitses)
The Cimarron Kid, 1951
Bronco Buster, 1952
Horizons West, 1952
The Man from the Alam, 1953
Seminole, 1953
Wings of the Hawk, 1953
Seven Men from Now, 1956
Decision at Sundown, 1957
The Tall T, 1957
Buchanan Rides Alone, 1958
Ride Lonesome, 1959
Westbound, 1959
Comanche Station, 1960
A Time for Dying, 1969

SAMUEL FULLER
I Shot Jesse James, 1949
The Baron of Arizona, 1950
Forty Guns, 1957
Run of the Arrow, 1957

SAMUEL FULLER *(continued)*
Merrill's Marauders, 1962
Shark (Twist of the Knife) Shot, 1968-
 69, Unreleased

HENRY HATHAWAY (from Eyles, *The Western*)
Heritage of the Desert, 1933
Man of the Forest, 1933
Sunset Pass, 1933
To the Last Man, 1933
Under the Tonto Rim, 1933
Wild Horse Mesa, 1933
Last Round Up, 1934
Thundering Herd, 1934
Go West, Young Man, 1936
Trail of the Lonesome Pine, 1936
Brigham Young, 1938
Rawhide, 1951
From Hell to Texas, 1958
North to Alaska, 1960
How the West Was Won, 1963
The Sons of Katie Elder, 1965
Nevada Smith, 1966
True Grit, 1969

WILLIAM WELLMAN
The Man Who Won, 1923
The Circus Cowboy, 1924
Not a Drum Was Heard, 1924
The Vagabond Trail, 1924
The Conquerers, 1932
Stingaree, 1934
Robin Hood of El Dorado, 1935
The Great Man's Lady, 1942
The Ox-Bow Incident, 1943
Buffalo Bill, 1944
Across the Wide Missouri, 1950
Westward the Women, 1950
Yellow Sky, 1951
Track of the Cat, 1954

MICHAEL CURTIZ (from Eyles)
Under a Texas Moon, 1930
River's End, 1931
Mountain Justine, 1937
Gold Is Where You Find It, 1938
Dodge City, 1939
Santa Fe Trail, 1940
Virginia City, 1940
Jim Thorpe, All American, 1951
The Boy from Oklahoma, 1954
The Proud Rebel, 1958
The Hangman, 1959
The Commancheros, 1961

RAOUL WALSH (from Eyles)
The Life of Villa, 1912
Betrayed, 1917
The Conqueror, 1917
In Old Arizona, 1929
The Big Trail, 1930
The Dark Command, 1940
They Died with Their Boots On, 1942
Cheyenne, 1947
Pursued, 1947
Silver City, 1948
Colorado Territory, 1949
Along the Great Divide, 1951
Distant Drum, 1951
The Lawless Breed, 1951
Gun Fury, 1953
Saskatchewan, 1954
The Tall Men, 1955
The King and Four Queens, 1956
The Sheriff of Fractured Jaw, 1958
A Distant Trumpet, 1964

FRITZ LANG
The Return of Frank James, 1940
Western Union, 1941
Rancho Notorious, 1952

ALLAN DWAN (from Eyles)
The Pretty Sister of Jose, 1915
The Good-Bad Man, 1916
The Half-Breed, 1916
Frontier Marshal, 1939
Trail of the Vigilantes, 1940
Montana Belle, 1952
The Woman They Almost Lynched, 1953
Cattle Queen of Montana, 1954
Passion, 1954
The Silver Lode, 1954
Tennessee's Partner, 1955
The Restless Breed, 1957

ARTHUR PENN
The Left-Handed Gun, 1958
The Chase, 1966
Little Big Man, 1970

KING VIDOR
Billy the Kid, 1930
The Texas Rangers, 1936
Duel in the Sun, 1944
Man without a Star, 1955

NICHOLAS RAY
The Lusty Men, 1952
Johnny Guitar, 1954
Run for Cover, 1955
The True Story of Jesse James, 1957
Wind across the Everglades, 1958

RICHARD BROOKS
The Last Hunt, 1955
The Professionals, 1966

MARLON BRANDO
One-Eyed Jacks, 1961

GEORGE ROY HILL
Butch Cassidy and the Sundance Kid, 1969

SYDNEY POLLACK
Scalphunters, 1968

DON SIEGEL
Battle at Silver Creek, 1953
Flaming Star, 1960
Two Mules for Sister Sara, 1970

Westerns with Native American Subjects

A Man Called Horse, Elliot Silverstein, 1969
Across the Wide Missouri, William Wellman, 1951
Apache, Robert Aldrich, 1954
The Battle at Elderbush Gulch, D. W. Griffith, 1914
Broken Arrow, Delmer Daves, 1950
Cheyenne Autumn, John Ford, 1964
Chief Crazy Horse, George Sherman, 1955
Colorado Territory, Raoul Walsh, 1949
Dances with Wolves, Kevin Costner, 1990
The Devil's Doorway, Anthony Mann, 1950
Drums along the Mohawk, John Ford, 1939
Fort Apache, John Ford, 1948
Geronimo, Walter Hill, 1994
Geronimo, Arnold Laven, 1962
Geronimo, Paul H. Sloane, 1940
Hombre, Martin Ritt, 1967
Hondo, John Farrow, 1953
Jeremiah Johnson, Sydney Pollack, 1973
The Last of the Mohicans, Michael Mann, 1992
Little Big Man, Arthur Penn, 1970
Pawnee, George Waganer, 1957
Pillars of the Sky, George Marshall, 1956
Run of the Arrow Samuel, Fuller, 1957
The Savage, George Marshall, 1951
The Searchers, John Ford, 1956
She Wore a Yellow Ribbon, John Ford, 1949
Sitting Bull, Sidney, Salkow, 1954
Soldier Blue, Ralph Nelson, 1970
Son of the Morning, Star, Robe, 1991
Stagecoach, John Ford, 1939
Stalking Moon, Robert Mulligan, 1968
Taza, Son of Cochise, Douglas Sirk, 1954
Ulzanna's Raid, Robert Aldrich, 1972
The Unforgiven, John Huston, 1960
The Vanishing American, George B. Seitz, 1925-26

Selected Western Films by Subject

Note: This is not by any means a complete list but a sampling of the variety of Westerns with different emphases and themes.

The Building of the Railroad

Canadian Pacific, Edwin L. Marin, 1949
Denver and Rio Grande, Byron Haskin, 1952
The Iron Horse, John Ford, 1924
Kansas Pacific, Ray Nazarro, 1953
Santa Fe, Irving Pichel, 1951
Union Pacific, Cecil B. deMille, 1939

Outlaws

The Bad Men of Tombstone, Kurt Neumann, 1949
Badman's Territory, Tim Whelan, 1946
The Dalton Gang, Ford Beebe, 1949
I Shot Jesse James, Sam Fuller, 1949
Jesse James, Henry King, 1939
The Left-Handed Gun, Arthur Penn, 1958
The Outlaw, Howard Hughes, 1939
The Outlaw Josey Wales, Clint Eastwood, 1976
Pat Garrett and Billy the Kid, Sam Peckinpah, 1973
Rancho Notorious, Fritz Lang, 1952
The Return of Frank, James Lang, 1940
310 to Yuma, Delmer Daves, 1957
Tribute to a Bad Man, Robert Wise, 1956
The True Story of Jesse James, Nicholas Ray, 1957
Unforgiven, Clint Eastwood, 1992
The Wild Bunch, Sam Peckinpah, 1969
The Younger Brothers, Edwin I. Marin, 1949

Comedies and Parodies

Alias Jesse James, Norman Z. McLeod, 1959
Blazing Saddles, Mel Brooks, 1974
Buck Benny Rides Again, Mark Sandrich, 1940
Carry On, Cowboy, Gerald Thomas, 1966
Cat Ballou (Jane Fonda, Nat (King) Cole, Elliot Silverstein, 1965
Destry Rides Again, George Marshall, 1939
Go West (Marx Bros.), Edward Buzzell, 1940
My Little Chickadee (W. C. Fields & Mae West), Eddie Cline, 1940
Out West, Fatty Arbuckle, 1918
The Paleface, Norman Z. McLeod, 1948

Pardners (Martin & Lewis), Norman Taurog, 1956
Red Garters, George Marshall, 1954
Ride 'Em Cowboys (Abbott & Costello), Arthur Lubin, 1942
Son of Paleface, Frank Tashlin, 1952
The Stooges Go West (Gold Raiders), Edwards Bernds, 1951
Support Your Local Sheriff, Bud Yorkin, 1969
True Grit (John Wayne), Henry Hathaway, 1969
Way Out West (Laurel & Hardy), James W. Horne, 1937

The Cavalry

Bugles in the Afternoon, Roy Rowland, 1954
Cavalry Scout, Lesley Selander, 1951
A Distant Trumpet, Raoul Walsh, 1964
Escape from Ft. Bravo, John Sturges, 1953
Fort Apache, Ford, 1948
Geronimo, Walter Hill, 1994
Indian Fighter, Andre de Toth, 1955
The Last Frontier, Anthony Mann, 1955
Major Dundee, Sam Peckinpah, 1965
Rio Grande, Ford, 1950
Sgt. Rutledge, Ford, 1960
She Wore a Yellow Ribbon, Ford, 1949
They Died with Their Boots On, Walsh, 1944
Thunder of Drums, Joseph Newman, 1961

The Modern West

Bronco Billy, Clint Eastwood, 1980
Bronco Buster, Delmer Daves, 1952
Bucking Broadway, John Ford, 1917
The Cowboy and the Lady, H. C. Potter, 1938
The Electric Horseman, Sydney Pollack, 1979
Giant, George Stevens, 1937
Hud, Martin Ritt, 1963
Jim Thorpe, All American, Michael Curtiz, 1951
A Lady Takes a Chance, William A. Seitzer, 1943
The Lusty Men, Nicholas Ray, 1952
The Misfits, John Huston, 1961
Return of the Texan, Delmer Daves, 1952
Rodeo, William Beaudine, 1952
The Rounders, Butt Kennedy, 1937
Singing Spurs, Ray Nazarro, 1948

Musicals

Note: Not including the innumerable and highly popular singing cowboy Westerns made by Gene Autry, Roy Rogers, and others.

Annie Get Your Gun, George Sidney, 1950
Calamity Jane, David Butler, 1953
The Harvey Girls, George Sidney, 1946
The Kissing Bandit, Laslo Benedek, 1948
Oklahoma, Fred Zinneman, 1955
Paint Your Wagon, Joshua Logan, 1969
The Second Greatest Sex, George Marshall, 1955
Seven Brides for Seven Brothers, Stanley Donen, 1954

The Marshal (Sheriff)

El Dorado, Hawks, 1967
Gunfight at the OK Corral, John Sturgis, 1957
High Noon, Fred Zinneman, 1952
Last Train from Gun Hill, John Sturges, 1959
My Darling Clementine, Ford, 1946
Ride the High Country, Sam Peckinpah, 1962
Rio Bravo, Hawks, 1959
The Tin Star, Anthony Mann, 1957
Wichita, Jacques Tourneur, 1955
Wyatt Earp, Lawrence Kasdan, 1994

Cowboys and Cattle Kings

Cowboy, Delmer Daves, 1957
Duel in the Sun, King Vidor, 1947
Jubal, Delmer Daves, 1956
Man from Laramie, Mann, 1954
Man without a Star, King Vidor, 1954
Red River, Hawks, 1948
The Sheepman, George Marshall, 1958
These Thousand Hills, Richard Fleisher, 1962

Gunmen

Buchanan Rides Alone, Budd Boetticher, 1958
The Fastest Gun Alive, Russell Rouse, 1956
The Gunfighter, Henry King, 1950
The Gunman's Walk, Phil Karlson, 1958
Invitation to a Gunfighter, Richard Wilson, 1964

The Last of the Fast Guns, George Sherman, 1958
Saddle the Wind, Robert Parrish, 1958
Shane, George Stevens, 1953

Pioneers and Settlers

The Big Trail, Raoul Walsh, 1930
Brigham Young, Frontiersman, Henry Hathaway, 1940
California, John Farrow, 1946
Cimarron, Wesley Ruggles, 1931
The Covered Wagon, James Cruze, 1926
Drums along the Mohawk, Ford, 1939
How the West Was Won, Ford, Hathaway, and Marshall, 1963
Kit Carson, George B. Seitz, 1940
The Last Wagon, Delmer Daves, 1956
Shane, George Stevens, 1953
Two Rode Together, Ford, 1961
Wagonmaster, Ford, 1950